CITIES IN TRANSITION
the moving image and the modern metropolis

CITIES IN TRANSITION
the moving image and the modern metropolis

edited by Andrew Webber and Emma Wilson

WALLFLOWER PRESS
LONDON & NEW YORK

First published in Great Britain in 2008 by
Wallflower Press
6 Market Place, London W1W 8AF
www.wallflowerpress.co.uk

A catalogue record for this book is available from the British Library.

ISBN 978-1-905674-31-2 (pbk)
ISBN 978-1-905674-32-9 (hbk)

Book design by Elsa Mathern

Printed and bound in Poland; produced by Polskabook

Photographs for chapter 2 courtesy of BFI Stills.

Video still photographs for chapter 10 reproduced courtesy of Bioskop Film Studios, Munich; every effort has been made to gain permission from the copyright holders of the images from *Die bleierne Zeit*.

CONTENTS

NOTES ON CONTRIBUTORS

Giuliana Bruno is Professor of Visual and Environmental Studies at Harvard University. She is the author of *Atlas of Emotion: Journeys in Art, Architecture, and Film* (Verso, 2002), which won the 2004 Kraszna-Krausz Book Award for 'the world's best book on moving images', and was named a 'Book of the Year 2003' in the *Guardian*. Her *Streetwalking on a Ruined Map* (Princeton University Press, 1993) won the Kovács Prize for best book in film studies. Her latest book is *Public Intimacy: Architecture and the Visual Arts* (MIT Press, 2007).

Sarah Cooper is Senior Lecturer in Film Studies at King's College London. She is the author of *Relating to Queer Theory* (Peter Lang, 2000), *Selfless Cinema?: Ethics and French Documentary* (Legenda, 2006) and *Chris Marker* (Manchester University Press, 2008).

Edward Dimendberg is Associate Professor of Film and Media Studies and Visual Studies at the University of California, Irvine. He is the author of *Film Noir and the Spaces of Modernity* (Harvard University Press, 2004) and is currently completing a book on post-1970 documentary media in Los Angeles.

Thomas Elsaesser is Research Professor in the Department of Media and Culture at the University of Amsterdam. His *European Cinema: Face to Face with Hollywood* (Amsterdam University Press, 2005) was awarded the Limina-Carnica Prize for best international book in film studies at the Udine Film Studies Conference. He has published extensively on many areas of film studies.

Henry Jenkins is DeFlorz Professor of Humanities and Co-Director of the Comparative Media Studies Programme at the Massachusetts Institute of Technology. He is the author/editor of twelve books on various aspects of media and popular culture, including: *Convergence Culture: Where Old and New Media Collide* (NYU Press, 2006), *Fans, Bloggers, and Gamers: Exploring Participatory Culture* (NYU Press, 2006) and *The Wow Climax: Emotion in Popular Culture* (NYU Press, 2006).

Geoffrey Kantaris is Director of the Centre of Latin American Studies in the University of Cambridge and Senior Lecturer in the Department of Spanish and Portuguese. His current research is on contemporary urban cinema from Argentina, Colombia and Mexico, and he has contributed to several volumes in this area. He has also worked extensively on women's writing and dictatorship in Argentina and Uruguay.

Patrick Keiller is an internationally-acclaimed filmmaker. His works include *London* (1994) and *Robinson in Space* (1997), a study of the UK's landscape and economic geography later extended as a book. He is currently a research fellow at the Royal College of Art, where a recent project is *The City of the Future*, an exploration of the landscapes of early film.

Richard Koeck is an architect, filmmaker and researcher whose practical and theoretical work is dedicated to the interface between architecture and the moving image. He completed his PhD, entitled 'The Cinematic Representation of the Near-Future City, 1926–36', at Cambridge University. He is currently a Research Associate at the University of Liverpool, where he works on an AHRC-funded research project exploring the relationship between Liverpool's urban landscape, architecture and the moving image.

Isabelle McNeill is Lecturer in French at Trinity Hall, Cambridge. She is the co-editor of *Transmissions: Essays in French Thought, Literature and Cinema* (Peter Lang, 2007). She is currently working on a book about postcolonial journeys and displacement in recent French and Francophone cinema.

François Penz is Reader in Architecture and the Moving Image in the Department of Architecture, University of Cambridge. He is the co-editor, with Maureen Thomas, of *Cinema and Architecture* (British Film Institute, 1997) and *Architectures of Illusions – From Motion Pictures to Navigable Interactive Environments* (Intellect, 2003). His research focuses on the narrative organisation of space and the expressive use of digital media as an aid to design and communications in architectural and city related issues.

Chris Petit is a celebrated filmmaker and writer. His feature films include *Radio On* (1979) and *Chinese Boxes* (1984), and he is known for his film collaborations with Iain Sinclair, among them *The Falconer* (1997) and *London Orbital* (2002). Of his novels, *Robinson* (Jonathan Cape, 1993) and *The Hard Shoulder* (Granta, 2001) are about London, and he has also written several political conspiracy thrillers, the latest of which is *The Passenger* (Simon & Schuster, 2006). His most recent film is *Unrequited Love* (2006), on stalking and being stalked.

Elena Pollacchi is Lecturer at the Department of East Asian Studies of the University of Venice. She obtained her PhD at the University of Cambridge, researching the impact of privatisation on the contemporary Chinese film industry. She has worked as programme consultant for major film festivals (including Venice and Turin) and co-edited, with Marco Müller, *Ombre Elettriche. Cento anni di cinema cinese (1905–2005)* (Electa, 2005).

Charity Scribner teaches English and Cultural Studies at the City University of New York. She has published on literature and art after the collapse of communism, including *Requiem for Communism* (MIT Press, 2003) and is working on a book about the cultural response to left-wing terrorism in Germany. Before becoming a professor she had a close encounter with the alternate reality of filmmaking, when she served as Assistant Director on Jennifer Montgomery's film *Troika* (1998).

Paul Julian Smith is Professor of Spanish at the University of Cambridge. His most recent books are *Spanish Visual Culture: Cinema, Television, Internet* (Manchester University Press, 2006) and *Television in Spain: From Franco to Almodóvar* (Boydell and Brewer, 2006). He is a frequent contributor to *Sight and Sound*.

David Trotter is King Edward VII Professor of English Literature at the University of Cambridge, and Director of the University's M Phil programme in Screen Media and Cultures. His most recent book is *Cinema and Modernism* (Blackwell, 2007).

William Uricchio is Professor and Co-Director of Comparative Media Studies at the Massachusetts Institute of Technology, Professor of Comparative Media History at Utrecht University in the Netherlands, and a Guggenheim, Humboldt and Fulbright Fellow. His research considers the transformation of media technologies into media practices, in particular their role in (re-)constructing representation, knowledge and publics. Recent publications include *Media Cultures* (Universitätsverlag Winter, 2006) and *We Europeans? Media, Representations, Identity* (Intellect, 2008).

Andrew Webber is Reader in Modern German and Comparative Culture at the University of Cambridge. His last book, *The European Avant-Garde: 1900–1940* (Polity Press, 2004), includes a section on city films. From 2004–07 he held a Major Research Fellowship from the Leverhulme Trust, and the resulting book, *Berlin in the Twentieth Century: A Cultural Topography*, is published by Cambridge University Press (2008).

Emma Wilson is Reader in Contemporary French Literature and Film at the University of Cambridge and a Fellow of Corpus Christi College. Her recent publications include *Cinema's Missing Children* (Wallflower Press, 2003) and *Alain Resnais* (Manchester University Press, 2006).

INTRODUCTION: MOVING IMAGES OF CITIES
Andrew Webber

This volume gathers together select contributions to a conference held at Trinity College, Cambridge in March 2004, sponsored by the British Academy and by Cambridge University's Centre for Research in the Arts, Social Sciences and Humanities (CRASSH) and Department of German. The event brought together three constituencies in order to foster debate between them: filmmakers with a pronounced theoretical and archival interest; scholars specialising in film and media studies; and scholars with moving image interests located in disciplines other than film and media studies. The aim of the volume is to explore the interactions between the technologies and aesthetics of the moving image and the modern metropolis. Its main historical focus is divided between the formative decades of the film medium in relation to the modernist city and the contemporary diversification of audiovisual technology in relation to the postmodern city. These provide two substantial channels of investigation in their own right, but they also serve to highlight a variety of mutually illuminating parallels. The book's geographical focus encompasses European, US and 'World' Cinemas, asking questions about the national, international and global reach of film cultures as evidenced by city-based genres, especially in the age of the globalised city.

The city as the dominant organising structure of modern culture has become a key place of interest for a variety of disciplines in the humanities and social sciences, focusing on issues such as control and disorder, mapping and disorientation, transportation and fixation, memory and oblivion, inclusion and exclusion. While an 'urban turn' has perhaps not yet been identified, successive other 'turns' in critical discourse – such as the visual, or the topographical, or the more recent temporal turn that is cited in Paul Julian Smith's chapter in this collection – focus significantly on the particular conditions of urban territory. Different disciplines have developed their own methods of orientation in the study of the city, but it has also become a meeting-place, a site of encounter, exchange and transition between disciplinary perspectives. Similarly, the moving image media are increasingly used as a material focus for different modes of social and cultural study, and here too methodological challenges and dialogues have emerged. This volume airs cutting-edge contributions to these debates, and it joins a number of other recent volumes (see, for example, Penz & Thomas 2003; Sheil & Fitzmaurice 2003) in asserting the particular importance of the city/screen relation as a defining cultural nexus.

This volume divides into a group of chapters on the earliest decades of moving image technology and a group on the latest. In each case, emphasis is put on issues of transit and transition as a fundamental condition of both urbanity and screen media. Three chapters are used to provide a framework for the collection, representing the respective voices of the three constituencies gathered together here. The first set of chapters, on

the early history of film, is introduced by visual art historian Giuliana Bruno's chapter, setting the development of film as medium and architectural system against the context of proto-filmic technologies of viewing. The bridge to the second set, on more recent developments in film and associated media, is provided by media studies specialist William Uricchio's chapter, ranging from pre-cinematic to post-cinematic modes of representation. And the collection is rounded off by filmmaker Chris Petit's survey of the chequered cinematographic history and the specific filmic quality (in part, the ironic-melancholic lack of it) of London.

This introduction has an establishing function, albeit one that, following the transitional character of the book's topic, sites itself in mobility. It provides an initial discussion of historical and theoretical aspects of the nexus between metropolis and moving image to be explored in more detailed treatment across the chapters of the collection. It focuses on the different types of transition that run through the volume: historical, technical, ideological, psychical, topographical and sensory, considering how moving image media serve as vehicles for cities in transit within and between such categories. And it considers how successive developments in media environments, from the panorama and the stereoscope to computer simulation, have mobilised our understanding of the city, and how – reciprocally – modern urban experience has challenged and determined the development of those media.

Transit and Transition

The city is understandable both as a spatial structure, a more or less fixed system of spaces and places, and as the motions or transitions that traverse that structure. The railway station is a model example of this duality: the site of arrival, transfer or departure, at once fixed in itself – precisely as station – and enabling motion within and beyond its confines. The fascination which early films, from the notorious Lumière brothers short *L'Arrivée d'un train à La Ciotat* (*Arrival of a Train at the Station in La Ciotat*, 1895) to Walter Ruttmann's *Berlin: Die Sinfonie der Grosstadt* (*Berlin: The Symphony of the Big City*, 1927) have with railway stations, turns on this dialectical relationship between moving and holding. Thus, in Ruttmann's Berlin the exhilarating impact of the train ride into the metropolis at the start of the film is brought to a halt in the station and the film then has to be brought back to life out of the prolonged sequence of stationary imagery that follows. When Walter Benjamin aligns railway stations with the already historical technology of still photography, and Siegfried Kracauer extends this to the railway system as a whole, they indicate the element of fixture of space in time that is transmitted from photography into its motion picture form. If city films celebrate transition, they also depend upon – and may be revisited by – the station from which they depart.

The mapping of urban space at once fixes locations and provides a basis for motion around them and along the channels between them. And the technology of the moving image is, in part, an advanced cartographical apparatus, combining the act of location and the enabling and tracking of motion and locomotion. The sort of plot maps that Franco Moretti (1998) has developed for nineteenth-century novels are also eminently transferable to the mobilised narratives of urban film that succeeded that tradition. Such cinematic plot maps show the city as a place of movement both orderly and disorderly, a place of assignation and appointment, but also of random encounter and traumatic

accident (see Webber 2004: 130–66). The mappings of Parisian *mises-en-scène* between empirical and creative models of geography in François Penz's chapter provide a graphic sense of the mobile maps of the city on screen. As Giuliana Bruno (2002) has shown, that mobilisation has a history as old as that of mapping itself, and it is carried in transitions through pre-modern, early modern and modern forms of visualisation of space, which prepare for and inform the cartographical or topographical apparatus of film. The maps and panoramas of Bruno's *Atlas of Emotions* are more or less fixed forms that nonetheless impart motion. And film standardly begins with that same mobilisation out of stasis. The establishing shot that is an inaugural convention in the grammar of film is in that sense the locating gesture, the fixing of and placing in scene, that prepares for the dynamics of spatial exploration.

Few features of film are more routine than such shots of city landmarks, and yet rarely does the establishing sequence of urban filmmaking simply place the film in a fixed site, map- or postcard-style. We might consider the opening of E. A. Dupont's *Piccadilly* (1929), which adopts the conceit of advertising itself on the side of a bus filmed in the eponymous location of London's Piccadilly. The title thus becomes a sign of mobility in location. The film's narrative is in fact driven by a form of bilocation, turning on the tensions and the transitions between the high-life of the Piccadilly of the title and its other, the working-class and immigrant district of Limehouse. As the bus will emerge as a vehicle of the movement between the two it therefore serves as a nice emblematic device for transporting that mobility into the *mise-en-scène* of the establishing sequence. This bus finds its place amongst the kinds of transport technologies used to mobilise early generations of film, both as a key object and a vehicle for the camera, which Patrick Keiller describes in his chapter in this volume.

Transportation and motion pictures are coupled in the experience of the image rush, of location in transit, a heightened experience of space through time. Transport is, as Paul Julian Smith puts it in his chapter, a mobile 'site of intersection for time and space', and in this it has a particular affinity to the cinema, especially in its urban forms. The *mise-en-scène* of *Piccadilly* is at the same time a *mise-en-abyme*: this is a film of the entertainment district that can also be viewed in that district. And the bus as mobile technology in the city of lights also transports an image of film, itself a technology of light in movement. For Dupont, the émigré from Weimar Berlin, the bus is also a kind of vehicle between that city and its cinematic and other varieties of urban glamour in motion, the city of lights referenced by Thomas Elsaesser in his chapter here, and a city waiting to be lighted and moved in similar ways. From the migrant culture of the East End to the migration of its director and aesthetic, *Piccadilly* represents a key theme in the filmic treatment of cities in transition: the metropolis as a site of migration from and to other places.

Piccadilly is figured in Dupont's film as a location of confluence or attraction and of transition and dispersal. It corresponds in this to the sort of theorising of urban space that has accompanied the ascendancy of the metropolis over the last century. Place and motion are a binary that critical thinking about the city has increasingly sought to trouble, for it is in the character of urban dynamics to unsettle location, to merge one place with another. This was already the case in the modernist city of the early twentieth century and is all the more so in the contemporary, postmodern city. It is the kind of discourse that leads the doyen of modernist urban thinking, Walter Benjamin, to take the arcade, the *Passage*, as a paradigm space of the modern city as what can be called, following the

German title of his Arcades project (1927–1940), a 'passage-work'. More recently, it has led Marc Augé (1995) to conceptualise the contemporary city of 'supermodernity' through the figure of the non-place, the site of transition between places proper.

On one hand, the city is defined by a congestion of fixed spatial organisation, a challenge for the sort of 'A–Z' logic of mapping that Chris Petit explores in the final chapter. It is a grounded network that will always exceed and elude in its complexity the 'knowledge' of the cabbie or of the itinerant cinematographer. On the other, it is a mass dynamics, both organic and technical, that provides the ultimate challenge both to the collection and transfer technology of urban transportation and that of the moving image. At the same time, the density of the metropolis in its exterior spatial organisation – which is often taken, metonymically, to be 'the city' – is massively complicated by its character as an agglomeration of interiors, which often tends to be effaced from 'the city'. Thus, Petit's 'A–Z' is at once a lexicon of exteriors, seen or unseen in films of London, and a charting of urban interiors, looking to see the public space of the former with the more intimate and slowed eye of the latter. This is the sort of viewing of urbanity, askance and in duration, combining inward and outward points of view, at which both Chris Petit and Patrick Keiller are so adept in their filmmaking.

Time Zones

A key part of the transition that characterises the city in moving images is that between the outside and inside, the conversion of external surface into interior and vice versa. Again, Benjamin's passages, passing between interior and exterior, are an archetype here. This transition from public to private space, in its turn, tends to involve a move from public to private time, and an amplification of temporal as well as spatial representation. Benjamin's passages are also conduits into degrees of temporal suspension. This is the sort of move that Petit follows in the deliberate cinematographic motions of Roman Polanski's *Repulsion* (1965) under 'F for focus-pulling' in his 'A–Z'. In urban film, the focus is recurrently pulled between the external surface, often seen panoramically and at speed, and the interior. Where the generic car chase provides a model for the first, the inside of a car can mediate between this and more domestic forms of interior (Martin Scorsese's *Taxi Driver* (1976) would be an example here). The motions of city films, and the transitions within and between locations that they afford, are, more or less from the start, complex. We might consider the sort of lateral motion that David Trotter describes in his chapter on the cinematography of D. W. Griffith, where the penetrative logic that might seem to govern film in its movement down city streets is turned into the transversal via an exploratory rhetoric of transitional moves across the visual field into the 'space beside'. In both *Repulsion* as read by Petit and Griffith's *Death's Marathon* (1913) as read by Trotter, when the camera moves inside it is as much to pan or track across the scene as to penetrate into the perspectival space of the city; and this movement across also suggests a transition from a diachronic, or linear, logic of time towards a synchronic, or amplified one. Cities, in their external dynamics, present dense spatio-temporal activity, but their interiors extend such time zones further.

The media of the moving image exercise mobility in both space and time, and between those dimensions. In these media, spatial transit is dialectically bound up with temporal transition: geographical development with historical development, space with

narrative line. The description in Sarah Cooper's chapter of the time zones of urban transit as spaces of encounter with the other, as elaborated in Chris Marker's *Sans soleil* (1983), provides a model case here. And not for nothing do the new models of theorisation of the relations between temporal and spatial orders that emerge around 1900 coincide with the move into the technology of the moving image. The interrogation of spatial extension and temporal duration in Henri Bergson, Albert Einstein's relativisations of the physical dimensions of, and interactions between, time and space, and Benjamin's theorisation of the transitional dimension of *Zeitraum*, or time-space, all have an affinity with the new mobility of medial technologies, and their intermedial networks, in the late nineteenth and early twentieth centuries. The camera at work in the city is therefore, in an extension of the sense developed by Mikhail Bakhtin, understandable as a particular kind of chronotope: a representative scene of conjunction between time and space, cultural history and cultural geography (see Morris 1994: 184). It is in the character of that chronotope to be on the move, in transition, from the earliest film cameras capturing short snatches of real-time footage on the streets of Paris, London or New York, to the elaborately self-conscious, real-time Hollywood screen-play of Mike Figgis's *Timecode* (2000).

Primal Scenes

The early twentieth century was also the age of the definitive emergence of the modern metropolis, and the birth of film arises very much out of the material and imaginative conditions that this new version of the city constructed. One of the very earliest sequences of motion images might stand for many here: the recording of one of the pioneers of the cinema, Emil Skladanowsky, by another, his brother Max, performing a marionette-like waving dance on top of a building in the Schönhauser Allee in Berlin in 1892.

It is the pioneering scene nostalgically recreated by Wim Wenders and a team of film students in *A Trick of the Light* (1996). Before the age of studios as cities within or beside cities, this early home-movie document, recorded in open space outside the attic that the Skladanowsky brothers used as a laboratory for their version of early cinema, represents a kind of metropolitan primal scene for film. It institutes the moment of transition into a new medial age through the image of the body in movement, sustained by urban architecture and set against the backdrop of a cityscape. In its waving gesture it at once greets the viewer, as if seeking to elicit a response in kind, and it beckons the new technology into the space of the city. It anticipates, amongst other things, the particular fascination that film will have with bodies on top of the city: dancing, jumping, running, clinging, falling, or – in the case of King Kong – not waving but fighting for life and love. The Skladanowskys were a model case of early cinematographers as showmen, and they set in motion a use of the cityscape as both spectacle in itself and background for bodily spec-

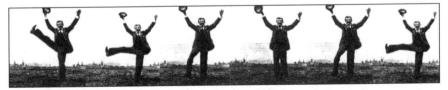

One of the first experiments with moving image, shot by the Skladanowsky brothers on the roof of their studio in the Schönhauser Allee, 1892

tacle that is then recurrently deployed in the show logic of films like *King Kong* (1933). As Henry Jenkins shows in his chapter here, it continues both in the spectacular views, vertical and horizontal, in contemporary urban films like the *Matrix* trilogy (1999–2003), and in the parkour-style scaling (in both senses) of those vertiginous perspectives by bodies on buildings.

At the same time, the puppet-like character of the actor's movements in the Skladanowsky short, accentuated by the still crude character of the technology, exposes that which film, at least in its mainstream forms, will be so anxious to hide: the attachment of the moment of transition that defines it to the mechanics of the means of transport. If this is a primal scene from the infancy of the new medium, this suggests that fascination is meshed here with the sort of impediment of motion and disarticulation of bodily coherence that is displayed by film machinery in its earliest forms. And this combination of attraction and separation runs as an ambivalent memory through the subsequent history of the apparatus of the moving image. Thus it is also at work in the machine within the simulacrum that is Kong, be it the mechanics of the original or the digitised form of the 2005 remake.

In one sense, the cinematic apparatus moves to elicit affect; it is, in Bruno's terms, both motive and emotive, the one through the other. Again, Kong, through his gestures and mimicry, is one of the triumphant moments of such an e-motion in and of the apparatus of film. This applies in particular in the final scene at the apex of New York, when the film derives from its melodramatic climax motion picture emotion on the epic scale of its architectural *mise-en-scène*. At the same time, Kong and his wild motions and emotions are duly removed from the city. Film can of course also work to contain, suppress or attenuate emotion, after the model of streamlined activity to which city planning aspires. That is, the same ambiguity can be seen in film as in the formative accounts of the modern metropolis by such as Benjamin and Georg Simmel, caught between stimulation and anaesthesia, shock and distraction, disorder and order.

Urban Uncanny

The appeal, however ambiguous, of the motion pictures to emotion, also implies an engagement with the psyche, as witnessed in species of non-humans from Kong or the robot Maria in Fritz Lang's *Metropolis* (1926) to the proliferating cyborgs of contemporary film, in their questionable relationship to that special human faculty. The late nineteenth century was not only the age of electrification that mobilised the city and its images, but also the age of the birth of psychoanalysis as a theory of and therapy for modern humanity. Psychoanalysis is also particularly bound to the conditions of the modern city and set to inform films made out of those conditions, from the suburban psycho-terror of the first explicitly psychoanalytic film, *Secrets of a Soul* (1926) by G. W. Pabst, to Alfred Hitchcock's casebook of urban neurotics and psychotics. One of the key concepts of psychoanalytic thinking, the uncanny or un-homely, is a recurrent feature of the treatment of architectural and topographical forms in urban film in both its modernist and postmodern forms. The sort of uncanny effects that Anthony Vidler (1992) describes as subversive work in the modern and postmodern city are also transferred between the urban environment and its cinematic versions. And technically-enhanced motion sustains the uncanny effect. Not for nothing are the early images filmed from the front of trains and other vehicles, as

Keiller points out, known as 'phantom rides'. Film, and not least film as it travels apparently disembodied through the spaces of the city, can be understood to have a ghost in its machine.

A key scenario of Freud's essay 'The "Uncanny"' is that in which he describes being lost in an Italian town and being returned, apparently involuntarily, again and again, to the red-light district and the 'painted women' on display in its windows. When Freud records the experience of departing repeatedly 'only to arrive by another detour at the same place' (1955: 237), he describes an uncanny version of the *dérive*, as cited below by Penz after Guy Debord, where the off-track experience of the city results in a failure to 'exit from certain zones'. Freud's recursive encounter with highlighted bodies and faces in the city also indicates the sort of interest that Cooper pursues in her chapter of the city insistently experienced as face or as skin. Freud's scene resonates with the story that provides the main material for his chapter, E. T. A. Hoffmann's novella *The Sandman* (1816), where the alluring view of the doll through the window is a repeated scene. Not least in the form of the shop window mannequin that would become an obsessive lure for photography and film in the 1920s, the doll is a specific moulding of the body in urban modernity, representing its always potentially uncanny attachment to the twin forces of commerce and technology.

Both Hoffmann's and Freud's uncanny scenes also look to the way that film works, especially in its negotiation of the city, through its narrative scenarios of errancy, fixation and recurrence. Both Freud and Hoffmann's protagonist, Nathanael, are at a loss in the city, playing out in adulthood the archetypal scenario, and not least film scenario, of the lost child (see Wilson 2003). In the strangely filmic scenes from Freud and Hoffmann, this scenario moves from fairytale woods to the urban jungle (not for nothing is Nathanael fixated upon a doll and persecuted by a nursery-tale character who visits and revisits the city). It remains an open question as to whether the scene of the workers' children, 'safe' and reunited with their 'brothers and sisters' in the pleasure garden of *Metropolis*, as discussed at the end of Elsaesser's chapter, can be understood as overcoming the different kinds of loss – from the comic pathos of Charlie Chaplin's *The Kid* (1921) to the haunting bogeyman scenario of Lang's *M* (1931) – to which childhood in the city is subject. As Geoffrey Kantaris shows in his chapter on contemporary Mexican film, adulthood, youth and childhood remain traumatically intermeshed in their urban performances, not least in Francisco Athié's *Lolo* (1991), with its reference to *The Sandman*.

The scenes from Freud and Hoffmann also project this at once alluring and fearful infantile fantasy of being lost into another particular condition of urban cinema: fixation upon obscure objects of desire, as screened by the architectural and topographical frames of the cityscape. The voyeuristic view through windows – from the opening sequence of Hitchcock's *Rear Window* (1954) to Pier Paolo Pasolini's *Oedipus Rex* (1968) or Krzysztof Kieslowski's *A Short Film About Love* (1988) – is a staple feature of urban film fantasy in its desirous and/or uncanny forms. *The Sandman*, with its panoply of apparatus of visual surveillance and projection, is an uncanny city film *avant la lettre*, and a precursor of various classic filmic visitants. One need only think of F. W. Murnau's *Nosferatu* (1922), and the vampire figure as importing a Gothic uncanny into the architectural and topographical space of the home-city, a figure that is also understandable as embodying film in its fantasy versions (see Webber 1999). Or, there is Robert Wiene's *Das Cabinet des Dr. Caligari* (*The Cabinet of Dr Caligari*, 1919), featuring a pseudo-psychoanalytic doctor

who exhibits his patient/automaton like an early film in a cabinet on an urban show-ground, and which introduces in its painted scenery and strange animations a blueprint for subsequent forms of uncanny film architecture and bodily motions.

The Skladanowskys' puppet show also reminds us of the uncanniness that attaches to the figure of the automaton, not least in Weimar film in the style of *The Cabinet of Dr Caligari*. Their pioneering city film is also arguably vested with the uncanny principle: a figure of repetition, more undead than properly alive (this is how those first ghostly ex-periments in moving images were bound to be seen), and at once without a proper home in the city and yet strangely, uncannily, at home there. Again, it is a prescient moment. It looks towards the urban uncanniness of a later generation of films shot in Berlin: Lang's robot fantasy in *Metropolis*, the machinations of his Dr Mabuse as psychoanalyst-cum-terrorist, or the fascination for knives and automata in shop windows in his *M*. And from there, it looks in turn towards the *noir* tradition that responded to such urban fantasies as the metropolitan genre *par excellence* (see Elsaesser 2000; Dimendberg 2004), and towards the city cyborg film in the style of Ridley Scott's *Blade Runner* (1982) that mutates in turn out of the scenarios and aesthetics of *noir*. Here, the sort of uncanny moment of stillness that Laura Mulvey (2005) finds in the workings of film on celluloid, especially in its earliest versions, and revisiting the technology of the moving image in its digitally-mastered variety, marks the convergence of city and moving image in both basic and advanced forms as haunted by an undead quality. As Edward Dimendberg notes in his chapter to this volume, during the discussion of scenes from Bernard Rose's *ivans xtc.* (2002), the 'mythmaking apparatus' of Los Angeles as speeding film city is also subject to exposure as halting and exhausted.

Dial S for Surveillance?

From *M* and the *Mabuse* films to *Blade Runner* or the villainous versions of New York in the Metropolis of the *Superman* movies (1978–2006) and the Gotham of the *Batman* films (1989–2008), the city is aligned with criminality as a particular feature of its transi-tional character. The permeability between criminal quarters and the city at large is one of the ways in which transition can develop in the direction of paranoia; and the spectre of criminality duly activates the camera as an apparatus of surveillance and the fantasy of urban cinema as panopticon. The Skladanowskys' rooftop showpiece for the camera is thus superseded by the all-seeing mechanical eye mounted on a rooftop of Dziga Vertov's city symphony, *Chelovek s kino-apparatom* (*Man with a Movie Camera*, 1929).

From the *flâneur* as the privileged urban pedestrian described in Bruno's chapter, and providing a model for a perambulating camera taking stock of the less evident sites and sights of the metropolis, film moves towards a kind of optic from above that previews the surveillance work of the CCTV camera. As Petit notes, under 'S for Surveillance', the film he made out of CCTV camera footage (*Surveillance* (1993)) is curiously nostalgic in its ordinary quality, reminiscent of the Lumière brothers and the 'beginning of cinema'. The same can be said of his more recent collaboration with Greg Dart, *Unrequited Love* (2006), exploring the city as the special habitat of both the stalker and the cinematogra-pher, where the capturing unawares of figures on CCTV and other cameras is so reminis-cent of early urban documentary filmwork. The modern technology is seen to look back to origins. On the one hand, moving image technology is always looking beyond itself, in

transition to views of the future. It is in this sense that the 'near future' scenario as discussed here by Richard Koeck comes into play. But, at the same time, it remains attached to, and haunted by, the past – both cultural and technological – from which it emerges. In this sense, Lang's *Metropolis* is a telling counterpart to Maurice Elvey's *High Treason* (1929) in Koeck's account, with the near-future fantasy of the metropolitan upper world and its advanced televisual systems subtended by a Gothic underworld, where the cinematic is represented by the primitive projective technology of a torch in a catacomb, and a play of shadows reminiscent of that primordial cinema, Plato's cave.

Modern surveillance technology is also divided between the grainy and static character of the earliest film experiments and a more futuristic fantasy of total vision. The fixed camera, perhaps pivoting in a pan, focused on a spatial frame and watching what passes through it, is always also understandable as an element in a total viewing network, where transition is not just the passing of a body over the visual field of the camera in question but also on to the next. This is the invisible camera system of a film like Michael Haneke's *Caché* (*Hidden*, 2005), as discussed in Isabelle McNeill's chapter; a system trained upon exterior and interior spaces in contemporary Paris and tracking evidence of hidden personal and political histories. The city is the privileged location of viewing in its perverse modes, voyeurism and vigilantism, and the video camera in its various forms gives a new technical impetus to such stalking practices.

While Petit finds nostalgic charm in surveillance technology, it can be seen as an apparatus of terror in the hands of Lang's urban panoptician Dr Mabuse, or of the terror of counter-terror, as described by Charity Scribner in her account of counter-terrorist surveillance regimes. Another film made of compilations of video surveillance footage is Michael Klier's *The Giant* (1983), which opens with the monitoring of a plane taxiing down a runway at Berlin Tegel aiport, in what James Hoberman calls a 'discomfiting echo of Hitler's entrance in *The Triumph of the Will*' (2001). Whether on individual or mass scales, the private agent – stalker or stalked – on the one hand, or the urban crowd on the other, the surveillance mode relates as much to crime as it does to control, or to control as in the service of crime. For Benjamin, the figure of the *flâneur* in his attachment to urban space as always a potential scene-of-the-crime is identified both with the detective and the criminal. Following that logic, we might say that the murderer in Lang's *M* is the *flâneur* turned street predator. And the moving image technologies that are harnessed in pursuit of the surveillant figure of the *flâneur* are no less liable to turn to crime. From Mabuse the psychopathic media mastermind to the focus-pulling killer in Michael Powell's *Peeping Tom* (1960), as discussed by Chris Petit, urban cinema seems as bent on the pleasures of crime as on its detection. At limit, this involves the crime-ridden city as paranoid dystopia, where urban serial killers like Hans Beckert in *M* or Mark Lewis in *Peeping Tom* are multiplied by cyborg technology or other fantastic means. Or it is the sub-city ghetto ruled by the (dis)order of gun crime in Fernando Meirelles and Kátia Lund's *Cidade de Deus* (*City of God*, 2002): the *civitas dei* as *civitas diaboli*, where the indiscriminate gun always threatens to outshoot the discriminating camera as dominant technology.

In an alternative dystopian form, this can imply the sort of transition from the city to the concentration camp as templates for modern life after the Holocaust that Giorgio Agamben (1998) has identified, giving new definition to structures of transportation and termination. As in the case of *Pola à 27 ans* (2002), as discussed in McNeill's chapter, the camp casts its shadow map over the contemporary city. What Scribner describes in

her reading of Margarethe von Trotta's *Die bleierne Zeit* (*The German Sisters*, 1981) is the carceral effects of that transition under the sign of paranoia in the post-Auschwitz German city. As she points out, the city as prison in *The German Sisters* is haunted by the camp, via the screening into the film of Alain Resnais' *Nuit et brouillard* (*Night and Fog*, 1955). The 'city films' of the Holocaust range from the mock-up that the Nazis made in their show-film of Theresienstadt to *Night and Fog* or Claude Lanzmann's *Shoah* (1985), films of the camp as dystopian anti-city in ruins. They can be seen as the uncanny siblings of the post-Holocaust city film. *Night and Fog* and *Shoah* enact the ghostly gestures of watching and tracking over the evacuated remainders of those anti-cities and their regimes of total technological surveillance.

... Or S for Sex in the City?

What sort of transition is this? The sort one might say that operates constantly and uncannily between extremes in modern metropolitan and moving image cultures, shocking aesthetic, ideological and ethical boundaries. Cities have always been ambiguously placed between control (the walled city) and freedom (the open city), with particular zones of contestation between the two models, often located underground or in the margins. As Kantaris's chapter shows, the coercive regime of the city is apt to be imbricated with the orders of gender and sexuality, breeding hybrid forms of sex and violence. And yet, in the domain of sex and gender, as elsewhere, coercion is rendered unstable by the transitional character of urban life, even in its most fixed social forms. Cities are intensively marshalled in their movements and yet always ready to produce coincidental or disordering encounters and creating possibilities for spaces that elude or divert control. Petit's 'A–Z' is emblematic in this sense, nicely designed to display that sort of dialectic: the ambiguities and slippages that exceed the city system, whether in its film history or other respects. The appropriate counterforce to the spectral or criminal forms that this excess can take is that of more life-affirming kinds of alternative agency. To follow Smith's programmatic move in his chapter, this involves an exploration of the critically less fashionable territory of everyday pleasures.

On one level, city films commonly represent the recreational spaces of the city as sites of escapist delusion through sexual and other forms of sport, shoring up rather than subverting dominant practices. This is the function of the pleasure gardens of *Metropolis* and Slatan Dudov's *Kuhle Wampe* (1932), as described in Elsaesser's chapter. But there are also other forms and spaces available for the kind of more autonomous urban practices that Michel de Certeau (1984) has described. These are the kinds of transitional urban practices that are in evidence across various of the chapters in this collection with particular regard to gender, sexuality and sex in the city: Bruno's streetwalkers as subversive *flâneuses*; the transversal gender mobilities traced by Trotter; the alternative space of dissidence mapped out between women in Scribner's chapter; and the queer city space opened up in and between the print media of the *movida* and film as explored by Smith. In these and other examples, the chapters also find sites of more progressive resistance in the modern city. The entry under 'Q for Queers & Queens' in Petit's 'A–Z', also shows some of this creative energy, nominating Derek Jarman's *Jubilee* (1977) as offering the best London marriage (in ironic counterpoint to 'W for Weddings, as in Four and a Funeral'). And it might be tempting to reread the judgement of Sidney J. Furie's *The*

Leather Boys (1964) that Petit borrows from Manny Farber, to see Rita Tushingham's sex-kitten performance 'which might look better in a comic strip than a movie' as queerly of a piece with the 'old-fashioned elegance' of Dudley Sutton's homosexual. Seen through the lens of Smith's queer marriage between the *movida* comics and Pedro Almodóvar, *The Leather Boys* could be understood as setting the stage for gender and sexual performance in the city and thereby projecting a version of what contemporary queer theory calls queerspace.

... Or for Senses in the City?

'Leather Boys' is also a distinctive kind of metonymy, indicating a conflation of identity with costume, body with surface texture. And this inherent urban cultural moment of the fashioning of self and crowd also indicates a telling characteristic of the city in moving images. While modernity, not least through the mediation of the moving image, is under what Elsaesser here calls the 'primacy of the eye', it also, to varying degrees, engages the other senses. The second skin of the leather boys is at once a visual effect and an appeal to touch, marking the transition from the visual to the haptic, from optical distance to immediacy of touch, that informs Bruno's thinking about the technologies and aesthetics of the moving image. The city in visual motion at once elides texture, resists touch and creates rich possibilities for encounter, against the flow, with textured surfaces. Key scenes from this book show, or perform, that kind of textural attention at work in the transition between vision and hapsis: the scene from Petit's account of *Repulsion*; Scribner's description of the passage of clothing between the bodies of von Trotta's sisters; the tracing of the memory map in McNeill's reading of *Pola à 27 ans*; and the attention to skin as urban-cinematic pellicle in both Cooper's and Kantaris's chapters. In each case, the relationship that Scribner draws out between textile/texture and architectural surface is at work in the incorporation of body into city and vice versa.

And the same principle applies to the effects of sound. Here, too, the moving image of urban structures and life flows in the direction of the image-track, but as Elena Pollacchi shows here in her reading of recent Chinese film, soundtrack may as much interfere with the visual flow as sustain it. And in the case of so-called World Cinema for the Western viewer – for which we should also read listener, and perhaps toucher or touched – where soundtrack is so often 'lost in translation' (to borrow Cooper's nice formulation for the cultural transmission of Orientalism in Western film), that sound of resistance to the seduction of visual flow appears all the more critical. It can help delineate in sensory form the boundaries to making-sense that still obtain in the age of the multiply mediated and mediating global city. Following the work of Laura Marks (2000) on the senses in film, visual primacy is set in a potentially productive tension with the more subaltern sensory faculties. And the city, famously seen by Simmel in its early twentieth-century form as impacting on the psychological skin of the viewer, provides an exemplary case of the contradictory appeal to the senses, caught between pain and pleasure. It is the thrill that we feel seeing erotic and other pleasures of the city on screen and the shudder we feel seeing its violence; it is the warmth that we feel seeing the urban sun on screen, and the cold that we feel (following Marker's *Sans soleil*) in seeing the zone 'without sun'; and it is the transitions between the two in the more seductive forms of violence and the colder or darker suns of many urban films.

From *Caligari* to the *Sims*

The transition from comic strip to movie that features in the chapters by Petit and Smith also indicates a more general domain of pleasure in the urban moving image. It takes animation as the foundational moment of film (Cesare in *The Cabinet of Dr Caligari* as both fairground automaton and cartoon character, animated against its puppet-theatre and comic-book *mise-en-scène*) and plays and replays with it. This playing out of the transition from still to motion picture, from scene to action, whether pleasurable or uncanny, is also the key feature of the city in motion in the age of digital and interactive media. As Uricchio shows in his chapter, the simulated urban environments of contemporary digital media have their avatars in the still forms of the memory palace and the panorama, and the halting motions of early city films. The memory palace of the moving image media also houses remainders and reminders of the forms that precede them. This gives rise to the sort of mixed media and synthesised transitional effects between comic strip and film that Cooper describes in *Sans soleil*. It is the logic of the computer game as played out, for instance, in the replay scenario of Tom Tykwer's *Run Lola Run* (1998), with its recurrent transitions between, and play with, still and mobile forms, cartoon picture and feature film. And it is also at work, or at play, in one of the classic play-and-replay vehicles of contemporary science fiction film, Andy and Larry Wachowski's *The Matrix* (1999). Henry Jenkins' chapter, in its play with storyboard or comic-book style, nicely performs the creative tension involved in such medial transitions.

Whether in early film or the new media, there is a recurrent ambiguity in the appeal that the city in transition provides for the viewer. The ambiguous status of the city between citadel, prison or camp on the one side and site of experiment, energy and autonomy on the other also transfers to the agency of the viewer, whether in the apparently acquiescent collective form of the cinema (part pleasure palace, part penitentiary) or in the more diffuse, personal and interactive viewing contexts of the digital age (part pleasure booth, part cell). To take a cue from Elsaesser's chapter, a key question is always about the position of the viewer, caught between being 'in the picture', subject to its surveillant constraints or its delusory freedoms, and 'in the picture' in a more critical sense: able to adopt and adapt the transits and transitions of the city in moving images for her own critical practice and enjoyment.

That is to say that urban motion pictures represent a particularly acute arena for thinking questions of performativity, as these have been developed over recent years by feminist, queer, post-colonial and other theorists. A model case might be the reading by Judith Butler (1993: 121–40) of the representation of the black drag artist scene in New York in Jennie Livingston's film *Paris Is Burning* (1991), where performances on stage and on the street at once work in conformity with, and act to resignify, dominant practices in gender, sexuality, ethnicity and class. The types of travel that such moving pictures of the city afford can certainly serve to reinforce the performance codes that modern culture instills, not least in its urban forms, further entrenching the reification of sameness and difference and the bounding of self and other. The murdered drag queen Venus Xtravaganza in *Paris Is Burning* is as much a victim of the clinch between gender, sex and violence as those that Kantaris describes. But such urban travel can also provide space and time for more transverse moves into spaces beside or between, for the kinds of transition that can work to interrogate and redefine the conditions of culture. Across a variety of forms and

sites, from the earliest moving images of urban experience to the most recent, this collection aims to show work of that kind on cities in transition.

WORKS CITED

Agamben, G. (1998) *Homo Sacer: Sovereign Power and Bare Life*. Stanford: Stanford University Press.

Augé, M. (1995) *Non-Places: Introduction to an Anthropology of Supermodernity*, trans. J. Howe. London: Verso.

Bruno, G. (2002) *Atlas of Emotion: Journeys in Art, Architecture, and Film*. London: Verso.

Butler, J. (1993) *Bodies that Matter: On the Discursive Limits of 'Sex'*. London: Routledge.

de Certeau, M. (1984) *The Practice of Everyday Life*, trans. S. Randall. Berkeley: University of California Press.

Dimendberg, E. (2004) *Film Noir and the Spaces of Modernity*. Cambridge, MA: Harvard University Press.

Elsaesser, T. (2000) *Weimar Cinema and After: Germany's Historical Imaginary*. London: Routledge.

Freud, S. (1955 [1919]) 'The "Uncanny"', in *Standard Edition of the Complete Psychological Works of Sigmund Freud*, vol. 17, trans. J. Strachey. London: Hogarth Press, 217–56.

Hoberman J. (2001) 'Science Fictions'. Online. Available at: http://ctrl-space.zkm.de/d/texts/26 (accessed 18 July 2006).

Marks, L. (2000) *The Skin of the Film: Intercultural Cinema, Embodiment, and the Senses*. Durham: Duke University Press.

Moretti, F. (1998) *Atlas of the European Novel: 1800–1900*. London: Verso.

Morris, P. (ed.) (1994) *The Bakhtin Reader: Selected Writings of Bakhtin, Medvedev and Voloshinov*. London: Edward Arnold.

Mulvey, L. (2005) *Death 24 x a Second: Stillness and the Moving Image*. London: Reaktion.

Penz F. and M. Thomas (eds) (2003) *Architectures of Illusions – From Motion Pictures to Navigable Interactive Environments*. Bristol: Intellect.

Sheil, M. and T. Fitzmaurice (eds) (2003) *Screening the City*. London: Verso.

Vidler, A. (1992) *The Architectural Uncanny: Chapters in the Modern Unhomely*. Cambridge, MA: MIT Press.

Webber, A. (1999) 'On the Threshold to/of Alterity: *Nosferatu* in Text and Film', in N. Saul, D. Steuer, F. Möbus and B. Illner (eds) *Schwellen: Germanistische Erkundungen einer Metapher*. Würzburg: Königshausen & Neumann, 333–48.

_____ (2004) *The European Avant-garde: 1900–1940*. Cambridge: Polity Press.

Wilson. E. (2003) *Cinema's Missing Children*. London: Wallflower Press.

1 MOTION AND EMOTION: FILM AND THE URBAN FABRIC

Giuliana Bruno

Spatial design today means a weaving together of spatial elements, which are mostly achieved in invisible but clearly discernible relationships of multidimensional movement and in fluctuating energy relationships.

— LÁSZLÓ MOHOLY-NAGY

Couldn't an exciting film be made from the map of Paris? ... From the compression of a century-long movement of streets, boulevards, arcades, and squares into the space of half an hour?

— WALTER BENJAMIN

On the eve of the invention of cinema, a network of architectural forms was producing a new spatio-visuality. Arcades, bridges, railways, the electric underground, powered flight, skyscrapers, department stores, the pavilions of exhibition halls, glass houses and winter gardens, among other forms, incarnated the new geography of modernity. These were all sites of transit. Mobility – a form of cinematics – was the driving force of these new architectures. By changing the relationship between spatio-temporal perception and bodily motion, the architectures of transit prepared the ground for the invention of the moving image, the very epitome of modernity.[1]

Cinema – the motion picture – emerges out of this shifting perceptual arena, partaking in the architectural configurations of modern life. An outcome of the age of travel culture, it has much in common with this geography, especially with regard to its constant, tangible reinvention of time-space. In more particular ways, film viewing inhabits the moving urban culture of modernity: it is an imaginary form of *flânerie*. A relative of the railway passenger and the urban stroller, the film spectator – today's *flâneur* – travels through time in architectural montage.

Modern Horizons: The Celluloid City

It is, in fact, by way of architecture that film turns into cinema, for, in order to exist, the cinematic apparatus needs a home – a movie 'house'. And because housed in the city, 'since the beginning of the twentieth century ... the screen ... became the city square' (Virilio 1991: 25). Film was a product of the era of the metropolis, expressing an urban viewpoint from the very origin of its history. The city is present as *mise-en-abyme*. Addressed primarily to urban audiences, early film fed on the metropolitan consciousness

and unconscious. An international genre of panorama films, in particular, made travelling through sites an extensive practice in the very early days of film. In a mirroring effect the life of the street, views of the city and vistas of foreign lands were offered for viewing to urban audiences. This travel genre was instrumental in the development of the language of fiction films and created ground for the city to emerge as fiction.

During the 1920s, the city dominated the panorama of film history, becoming the subject of a number of landmark films that narrated urban space, including *Manhatta* (1921), *Paris qui dort* (1923), *L'Inhumaine* (1924), *Metropolis* (1926), *Rien que les heures* (*Nothing But Time*, 1926), *Berlin: Die Sinfonie der Grosstadt* (*Berlin: The Symphony of the Big City*, 1927), *Sunrise* (1927), *The Crowd* (1928), *Chelovek s kino-apparatom* (*Man with a Movie Camera*, 1929) and *À Propos de Nice* (1930). The city space also became a genre in the German street drama and in the Italian cinema of the street, both of which opened the road to women.

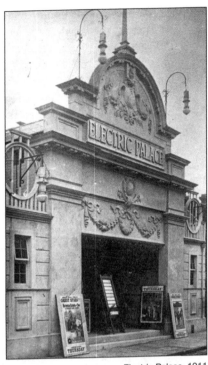

Electric Palace, 1911

It was René Clair, the maker of a celebrated cinematic city film, who claimed that 'the art that is closest to cinema is architecture' (quoted in Virilio 1991: 69). In his filmic view, the tempo of the city is rendered as if it were the rhythm of cinema itself. Thus, in the 1920s, the film apparatus joins the mechanics of the city. And moving with time, cinema begins to define itself historically as an architectural practice: an art form of the street, an agent in the building of city views. The image of the city ends up closely interacting with filmic representations; thus, in the age of cinema, the streetscape is as much a filmic construction as it is an architectural one.

Material Cities

One's body takes root in the asphalt.

– SIEGFRIED KRACAUER

Botanising on the asphalt.

– WALTER BENJAMIN

The link between film and urban culture that emerged in film history was also a function of film criticism. Think of Siegfried Kracauer, whose writings paved the way for, or intersected with, the reflections of his friend Walter Benjamin. Kracauer had a career as a trained architect and, as a critic, was always attracted to the urban pavement. He called attention to the German street film by dwelling on film's *material* attraction for the street, the pavement, feet walking over stones (see Kracauer 1947: esp. 157–60). Kracauer was

interested in architectural physicality as well as material historicity. He constructed a bond between history and the street, showing that 'when history is made in the streets, the streets tend to move onto the screen' (1960: 98).

Attuned to 'the establishment of physical existence', Kracauer cited motion as the driving force behind this phenomenon.[2] In developing his material-based *Theory of Film*, he called attention to the transient and to refuse, and turned to the street for its potential to express 'the flow of life' (see 1960: 52–3, 71–3). For Kracauer, the affinity between cinema and the city street pertains to the transient, for the street – like the cinema – is the site where fleeting impressions take place, along with the sense of life itself flowing. As he put it, 'the medium's affinity for the flow of life would be enough to explain the attraction which the street has ... exerted on the screen' (1960: 72).

Kracauer's interest in the material texture of the city is evident even in the title of his collection of Weimar essays, *The Mass Ornament* (1995). Here, the affinity between the urban fabric and the filmic surface is clearly revealed. His reflections on such urban topics as the 'Hotel Lobby' and the 'City Map', which for him become places of 'Travel and Dance',[3] suggest how these phenomena make modernity's desire for the moving image rise to the surface as they mark the transformation of space and time. The urban dweller, at home in the hotel lobby or the city's arcade, inhabits the map of modernity; so does the film spectator, a *flâneur* who genealogically resides in the arcade, itself a place of transit.[4] For Kracauer this dance of modernity linked body to image, for, as he notes: 'it is precisely as a passage that the passageway is also the place where, more than almost anywhere else, the voyage which is the journey from the near to the far and the linkage of body and image can manifest itself' (1995: 338). It was a clever coincidence, then, that the entrance to the Berlin Linden Arcade, a *passage*, was flanked by two travel offices. The Anatomical Museum – a place of transport – towered inside this arcade amidst the world panorama. Here, cities looked like faces, and film showed its material façade.

The Architecture of the Movie Theatre

The fiction of the city transfers even to the anatomy of the movie house. As Kracauer shows, a consideration of the space of the cinema must include the architecture of movie theatres, one of the most important yet least researched areas of film studies. In 1926, Kracauer wrote an article titled 'Cult of Distraction', on Berlin's picture palaces of the 1920s, in which he demonstrated that 'the life of the street' transforms itself there 'into the street of life', giving rise to the cosmopolitan cinema audience (see 1995: 325). As the street turns into a movie house, the movie house turns into the street. The movie theatre thus houses the city, which is itself a movie house, a theatre of modernity's journeys.

This fluid urban thinking is further developed as Kracauer pictures the matter of modernity as surface. His grasp of the modern era touches upon a variety of surface-level experiences, of which the cinematic situation is a part.[5] As a prominent element of his discussion of the mass 'ornament', he shows that the film experience takes shape both as and in public architecture, noting how 'The Little Shopgirls Go to the Movies' (see 1995). Moreover, he makes clear that the architecture of the film image is reflected in the architecture of the film theatre, itself home to phenomenological externality. In describing the architecture of the movie palace, he stresses the fact that 'elegant *surface splendor* is the hallmark of these mass theaters. Like hotel lobbies, they are shrines to

the cultivation of pleasure … The architecture of the film palaces [creates a] community of worshipers' (1995: 323). The movie palace shares with the hotel lobby the ability to become a modern place of worship: a place of encounter where a community of strangers gathers to practise a public intimacy. Flaunting the surface splendour of its architecture, the film theatre becomes a secular church devoted to the cult of images: fleeting projections of light on an elusive surface.

By looking at that surface which is architectural décor, Kracauer most importantly arrives at an understanding of the texture of the film experience. In *The Mass Ornament*, he theorises the function of architectural design in film as follows:

> The interior design of movie theaters serves only one purpose: to rivet the viewer's attention to the peripheral, so they will not sink into the abyss. The stimulations of the senses succeed one another with such rapidity that there is no room left between them for even the slightest contemplation. Like life buoys, the refractions of the spotlights and the musical accompaniment keep the spectator above water. The penchant for distraction demands and finds an answer in the display of pure externality … Here, in pure externality, the audience encounters itself; its own reality is revealed in the fragmented sequence of sense impressions. (1995: 325–6)

Suspended in tension between absorption and dislocation, the film spectator is attracted to the surface, encountering herself in the sheer externality of impressions and stimuli. As subject, she 'senses' a fragmented space in constant, electrifying motion.

This play of fraction and refraction, embedded in the architecture of the theatre, appears to reflect early cinema's own attraction for 'superficial' experiences. Think of *Coney Island at Night* (1903), in which New York's Coney Island becomes a play of pure externality. The amusement park is represented as a mere black surface decorated with lights, flashing and dancing across the texture of the screen. As the camera pans across this electrical

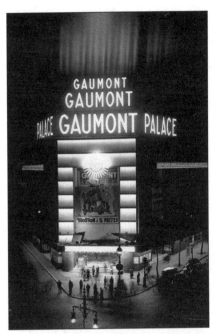

Gaumont Palace, Paris (exterior).
Architect Henri Belloc, 1931

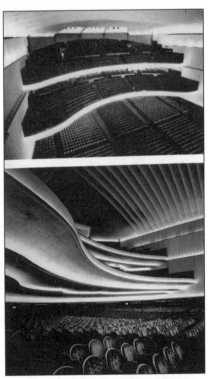

Gaumont Palace, Paris (interior).
Architect Henri Belloc, 1931

landscape, the screen itself becomes a permeable surface. The electrifying experience of the city is reflected in the film as the screen itself becomes a surface encounter with the energy of urban culture. The material fabric of the city becomes fully visible in the surface splendour of film architecture. As Kracauer puts it, the interior design of the film theatre is fundamentally urban, for it keeps drawing our attention away from the centre, pulling us towards the periphery and the surface. Ornament and the refraction of the light display in the movie palace keep the viewer from 'sinking into the abyss'. In keeping the spectator alert and afloat, the design of the movie palace serves an important function: it reflects the electric texture of the urban surface and enables our absorption in its fabric.

Street (Movie) Theatre

Turning to the architecture of movie theatres – 'palaces' in which a tourism of images takes architectural form – is a productive way to approach film spectatorship itself as an architectonics. Located in the public architecture of the movie theatre, film is an architectural manifestation of social texture. Participants in the urban fabric, film theatres offer a variety of possible cinematic experiences and diverse means of mapping spectatorship. One can never see the same film twice, for the reception is changed by the space of the cinema and by the type of physical inhabitation the site yearns for, craves, projects and fabricates, both inside and outside the theatre. We thus can be utterly different spectators when we watch the same film in different places, for different models of spectatorship are figured in the architecture of the theatre itself. The fabric of the film experience involves an intimate spatial binding – an experience always in flux.

As cities are spaces of transitions so are movie theatres, whose shape and concept have changed over time in the urban environment, yet always remain an intricate part of its fabric. Cinema is primarily of the street, even as a form of spectatorship. If we consider the history of exhibition in the early days of cinema's invention, we can better see the root of this urban bond. The motion picture was largely born out of the pavement and has closely

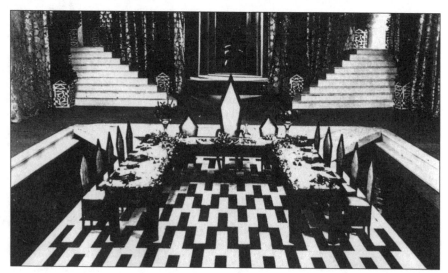

L'inhumaine (Marcel L'Herbier, 1924). Set by Robert Mallet-Stevens

participated in its urban development. At the origin of cinema, one would watch films by moving from pavements into cinemas that were fundamentally 'storefronts'. The theatre was not only located at street level but also shaped like any other store. Many retail shops were remodelled and adapted for the new use of showing films – for the new urban fashion. It was true urban recycling. Watching film remained inseparable from one's activity of *flâne-rie*: it was part of 'street-walking', a peripatetic use of the street and a variation on strutting. The reception was fluid, for one would move to and from the pavements, entering and exiting different kinds of stores. One would spend as much time in the storefront cinema as shopping or loitering on the street. One could 'suit' oneself either in new clothes or in novel images. Related in this way to the urban display of images and to the remodelling of urban patterns, the storefront theatre participated in the actual 'fashioning' of the street.

Film Architectures

> Film's undoubted ancestor [is] architecture.
> – SERGEI M. EISENSTEIN

Moving along this urban route to extend the theoretical bridge between film and architecture, we turn to the seminal contribution made by Sergei Eisenstein in his essay 'Montage and Architecture'.[6] Writing in the late 1930s, Eisenstein contributed to the effort to link the architectural ensemble to the language of film by offering a pioneering theoretical articulation of the construction of these forms. In claiming that there is a genealogical relation between the two, he set out to design a moving spectator for both. His method for accomplishing this was to take the reader, quite literally, for a walk. Built as a path, his essay guides us on an architectural tour. *Path*, in fact, is the very word Eisenstein uses to open his exploration. Underscored in his text, it becomes almost an indexical mark, a street sign. An arrow points to the itinerary we are to take:

> The word *path* is not used by chance ... Nowadays it [is] the path followed by the mind across a multiplicity of phenomena, far apart in time and space, gathered in a certain sequence ... in front of an immobile spectator ... In the past, however, the opposite was the case: the spectator moved between [a series of] carefully disposed phenomena that he observed sequentially with his visual sense. (1989: 116)

The (im)mobile film spectator moves across an imaginary path, traversing multiple sites and times. Her fictional navigation connects distant moments and far-apart places. Film inherits the possibility of such a spectatorial voyage from the architectural field, for the person who wanders through a building or a site also absorbs and connects visual spaces. In this sense, the consumer of architectural viewing space is the prototype of the film spectator. Thus, as Eisenstein claimed elsewhere, the filmic path is the modern version of an architectural itinerary:

> An architectural ensemble ... is a montage from the point of view of a moving spectator ... Cinematographic montage is, too, a means to 'link' in one point – the screen – various elements (fragments) of a phenomenon filmed in diverse dimensions, from diverse points of view and sides. (1980: 16–17)

Film follows the geographic course of architectural exploration: it ventures to draw on the multiple viewpoints of a picturesque route. It reinvents this practice in modern ways by allowing a spectatorial body to take unexpected paths of exploration.

Filmic and Architectural Promenades

From this mobile viewpoint we have observed that an act of traversal conjoins film and the city. An architectural ensemble is read as it is traversed. This is also the case for the cinematic spectacle, for film – the screen of light – is read as it is traversed, and is readable insofar as it is traversable. As we go through it, it goes through us. A visitor is the subject of this practice: a passage through the surface of light spaces.

This passage through textures of light is an important issue for both cinema and architecture. As Le Corbusier put it, developing the idea of the *promenade architecturale* by way of Auguste Choisy, as Eisenstein would do,[7] architecture 'is appreciated *while on the move*, with one's feet ... while walking, moving from one place to another ... A true architectural promenade [offers] constantly changing views, unexpected, at times surprising' (Le Corbusier & Jeanneret 1964: 24). Le Corbusier's articulation of the architectural promenade, first developed in 1923, describes architecture as if it were a film. It is only fitting, then, that the filmmaker and film theorist Eisenstein, who was a former architect, would 'picture' this notion similarly, and that it would resonate in his work.

In building the conceptual construction that connected architecture and cinema, Le Corbusier met Eisenstein in many ways on the grounds of the architectural promenade. Claiming that 'architecture and film are the only two arts of our time', Le Corbusier went on to state that 'in my own work I seem to think as Eisenstein does in his films' (quoted in Cohen 1992: 49).[8] Indeed, Le Corbusier and Eisenstein not only admired each other's work but fashioned their thoughts similarly: they crossed paths in the production of space, just as their theories intersect profoundly as the practice of mobilised space. Filmmaker and architect 'street-walked', side by side, on a filmic-architectural promenade.

Architecture and film came to be related on the cultural map that resulted, on which viewing ended up designed as a successive, picturesque, peripatetic activity. If film derives its penchant for *flânerie* from the architectural field, it is because architecture itself houses a version of cinematics. As a form of imaginary perambulation, the moving image shares the dynamics of an architectural promenade and has the ability to create its own architectural motion: a *promenade architecturale* is inscribed into, and interacts with, film's own 'street-walking'.

Film Panoramas

As we look back at the origin of cinema through this theoretical lens, we can now fully recognise the historical root of the architectural promenade. Genealogically speaking, the turn-of-the-century travel-film genre, which would become instrumental in the development of the fiction film, clearly exhibits the generative bond of film to architectural peripatetics. Early film envisioned 'panoramic views' that turned sights into sites: it incorporated modernity's desire for 'site-seeing' – its taste, that is, for viewing sites in motion. In these films, which were produced *en masse* at the origins of cinema, the camera practices circular pans, up-and-down tilts and forward, vertical and lateral tracking motions, offer-

ing a variety of picturesque vistas across the city space. A film like *Panorama from Times Building, New York* (1905), for example, portrays the aerial cityscape by first tilting upward and then panning across an urban bird's-eye view. In panoramas like this, the camera strives for diverse viewing possibilities from the height of buildings or from different perspectival points in the city. As seen in *Panoramic View of Monte Carlo* (1903), the genre of city travelogues offers not only panoramic perspectives but also street-level views. In this way, film reproduces a practice of urban space that involves the city's public and its daily activities.

The travel genre is attracted to the street motion of urban strolling and represents the urban circulation of male and female urban dwellers. In films such as *At The Foot of the Flatiron* (1903), architectural tours turn into diverse gender travelogues. As the urban panoramas show, the pavement houses sexual mobility and freer circulation for a growing female urban public. Public circulation takes cinematic shape, and the pavement becomes the site where gender dwells in various ways.

In these films, not only the subjects of urban views move; the very technique of representation aspires to motion. Film cameras are placed on railroad cars, incline rail cars, subway cars, boats, moving street vehicles and even balloons for attempted aerials. Movement was also simulated. Beginning with Hale's Tours and Scenes of the World, in 1905, phantom rides were offered to spectators who would watch films in theatres designed like railroad cars, with the screen placed at the front of the vehicle.

Panoramic views from *Pan-American Exposition by Night* (Thomas Edison, 1901)

When the camera is placed in this way – in trains, most typically; in subway cars, as in *Panoramic View of Boston Subway from an Electric Car* (1901); on streetcars, as in *Panoramic View of the Brooklyn Bridge* (1899); or on vehicles moving through the street, as in *Panorama of 4th St., St Joseph* (1902) – the camera becomes the vehicle: that is, it becomes, in a literal sense, a spectatorial means of transportation. The travel-film genre inscribed motion into the language of film, transporting the spectator into space and creating a multiform travel effect that resonated with the architectonics of the railroad-like movie theatre that housed it.

The Art of Cultural Travel

> Space exists in a social sense only for activity – for (and by virtue of) walking ... or travelling.
> **– HENRI LEFEBVRE**

In re-viewing the history of early film through the lens of cultural theory, the relationship between film and the architectural ensemble has unfolded an architectonics of travelled space. The panoramic views, the shifts in viewing positions, the traversal of diverse spa-

tio-temporal dimensions and the movements of the spatial consumer have linked the city to travel to film. Cinema, born out of the theatre of urban motion, exhibits a fascination for the very means that produced the modern, moving visual space.

In this respect, film reworks another aspect that contributed to the evolving image of the city. It is genealogically related to *vedutismo*: the 'art of viewing' the city that emerged in early modernity, before panorama paintings.[9] By the time cinema was born, paintings of city views were well established as a form of urban representation. They had become an autonomous artistic genre in the late seventeenth century, evolving from a pandemic of urban imaging and the drive to geographical expansion. View painting, developed as an art of looking at the city, introduced a real 'taste' for viewing sites. This hunger for viewing was inseparable from the history of travel and the development of urban culture. At times, the *veduta* was even produced as a souvenir of a city, becoming a literal visual memento of the experience of a town. In this way, view painting participated in the composite construction of the image of the city and materialised its memory.

As an integral part of early modernity, view painting affected the creation of cultural memory even as it projected itself forward, towards a cinematic future. The city in transition that came to be embodied in film first became representable in the art of topographical viewing that made moving portraits of the city in the history of art. The city views produced by *vedutismo* moved from painting to film, taking up steady residence in early cinema. The genre of panorama films in particular, whilst insisting on portraying the city, followed in the footsteps of urban view painting with modes of representation directly derived from the art-historical rendering of city views. At a representational level, for example, film rendered feasible the imaginary bird's-eye views of view painting, which had been impossible aerial perspectives in *vedutismo*. It also materialised the street-level portrait of the city present in the art of viewing. Early cinema recollected the city: it made its own sweeping panoramas and montage of streetscapes, fixing the fleeting moment of passing through a site on the wax-like texture of celluloid and the surface of the screen. In the visual style of view painting, film created a modern image of the city while making more space for viewing, perusing and wandering on the surface.

The architecture of view painting thus became transferred to the urban techniques of early film panoramas, dwelling there as a memory trace. Film's own art of viewing is the trajectory drawn by a visitor to/dweller in a city, projecting herself onto the cityscape and engaging the close anatomy of the streets – the city's underbelly – traversing all different urban configurations in multiple perspectives. Heterotopic perspectives and a montage of 'travelling' shots with diverse viewpoints and rhythms guide the cinema. Changes in the height, size, angle and scale of the view, as well as the speed of the transport, are embedded in the language of filmic shots, editing and camera movements. Travel culture is written on the very techniques of filmic observation derived from city views.

Narratives of Lived Space

> Geography includes inhabitants and vessels.
> – GERTRUDE STEIN

As we have seen, the genealogical architectonics of film is an aesthetic touristic practice of absorption in a spatio-temporal surface. As in all forms of imaginative journey, space

is physically consumed here as a vast commodity. In film, architectural space becomes framed for viewing and offers itself for consumption as travelled space – for further cultural travel. Attracted to vistas, the spectator becomes a visitor, simultaneously threading past and future in the representation of the city. This film viewer is a tourist of cultural memory.

Acting as such a cultural voyager, the itinerant spectator of the architectural-filmic ensemble reads moving views – constructions of the flow of life. In the ciné city, the framing of space and the succession of sites organised as shots from different viewpoints, adjoined and disjoined by way of editing, constitutes a montage of forms of dwelling. Incorporating the subject as the inhabitant (or intruder) in this space is a narrative passage. It means not simply reproducing but reinventing her various trajectories through space and charting the narrative and the memory these navigations create. Architectural frames, like filmic frames, are transformed by an open relation of movement to events. Not just vectors or directional arrows, these movements are practices of space, that is, veritable plots of everyday life.[10] Motions are territories mobilised internally, mappings of practised places, landscapes of emotions. This is how urban experiences – dynamics of space, movement and lived narrative – embody the effect of the cinema and its intimate promenades.

Haptic Routes

> How could I know that this city was made to the measure of love?
> How could I know that you were made to the measure of my body?
> **– FROM** *HIROSHIMA MON AMOUR*

Hiroshima mon amour (1959) written by Marguerite Duras and directed by Alain Resnais, charts an amorous map that conflates the self and the city, showing that the link between urban space and film is a haptic geography, referring to the sense of touch. As Greek etymology tells us, *haptic* means 'able to come into contact with'. As a function of the skin, then, the haptic – the sense of touch – constitutes the reciprocal contact between the environment and us. It is by way of touch that we apprehend space, turning contact into communicative interface. As a sensory interaction, the haptic is also related to kinesthesis, or the ability of our bodies to sense their own movement in space. As Henri Lefebvre wrote regarding this haptic architectonics:

How could I know that this city was made to the measure of love?

How could I know that you were made to the measure of my body?

Hiroshima mon amour (Alain Resnais, 1959)

Space – *my* space – ... is first of all *my body* ... it is the shifting intersection between that which touches, penetrates, threatens or benefits my body on the one hand, and all the other bodies on the other. (1991: 184; emphasis in original)

In this conception of 'the production of space', the history of urbanity is read as a history of a socio-sexual body. Film and architecture meet on this route, for they are both productions of material representation – constructions lived by users.

Film and the city share a dimension of living that in Italian is called *vissuto*, the space of one's lived experiences. In other words, they are about lived space, and about the narrative of place. When these tangibly lived sites are narrativised by motion, they become spaces for further inhabitation. Such types of dwelling always invite, and construct, a subjectivity. This is a self who occupies space and leaves traces of her history on the surface of the wall and the texture of the screen.

Dressing the Surface, Addressing the Skin of the City

This experiential dimension – a haptic closeness – was recognised by Walter Benjamin when he related cinema's new mode of spectatorship to the way we respond to buildings. As Benjamin put it, 'buildings are appropriated ... by touch and sight ... Tactile appropriation is accomplished ... by habit ... This mode of appropriation developed with reference to architecture ... today [is] in the film' (1969b: 240). Thus the bond between cinema and architecture is ultimately understood in the particular sense: space can be 'touching'.

In writing about this haptic experience, Benjamin furthermore noted that 'architecture has always represented the prototype of a work of art the reception of which is consummated' (1969b: 239). An heir to this practice, film continues the architectural *habitus*: it makes a custom of building sets of dwelling and motion, and has a habit of consuming

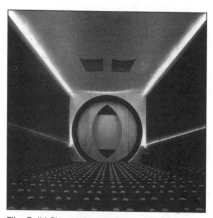

Film Guild Cinema, New York City.
Architect Frederick Kiesler, 1928

space. By being repeatedly used and appropriated, lived space is modelled or, in other words, 'fashioned'. In fact, just like an *abito* – a dress – a habitat 'suits' us; and in the consumption of space a site is 'worn', and also worn out, by a user. Thus one lives a film as one lives the space that one inhabits – in haptic intimacy. In this psycho-physical domain of intimacy, one absorbs, and is absorbed by, moving images and their tales of inhabitation. The absorption of the subject in the narrative of space involves a series of inner transformations, played on the *surface* of the space. As in fashion, this mode of consumption involves the 'skin' of things – the very touch of intimate space. The fashioning of space is a living 'architexture'.

Providing space for living and lodging sites of biography, film and architecture are thus constantly reinvented by stories of the flesh. Apparatuses *à vivre*, they house the erotic materiality of tactile interactions – the very terrain of intersubjectivity. Their geome-

try consists in the making of a connection between public sites and private spaces: doors that create a passage between interior and exterior, windows that open this passage for exploration. As moving views, the spatial perimeter of film and architecture always stretches by way of intimate incorporation. Appropriated in this way, both forms expand through emotional lodgings and liminal traversals. Fantasies of habit, habitat, habitation, they map the transmission of affects in the circulation of material culture.

Transiti, an Urban Psychogeography

When urban culture – a haptic geography – thrives on tangible interactions and the transitory space of intersubjectivity, it filmically extends its inner perimeter. In the city, as when travelling with film, one's self does not end where the body ends nor the city where the walls end. The borders are fluid, as permeable as epidermic surfaces. As Georg Simmel wrote in 1903, in the metropolis, 'a person does not end with limits of his physical body … In the same way, the city exists only in the totality of effects which transcend their immediate sphere' (1971: 335). Thus the city, laid out as social body, is also laid bare as both surface and passage. In this way, it would eventually become 'the naked city', joining up with cinema again, by way of situationist cartography, in the form of a psychogeography – a map of *dérive*, or drift.[11] Named after *The Naked City* (1948) – a *film noir* bearing the title of the 1945 book of urban images by the photographer Weegee – the city is here made into a map of passages. This filmic metropolis is a palimpsest of lived experiences: the nude surface of this city was modelled on an ancient map that has the texture – the very skin – of 'lived space'. The origin of the composite situationist map is, in fact, the celebrated *Carte du Pays de Tendre*, a map of the land of tenderness, drawn by Madeleine de Scudéry in 1654.[12] A haptic map that connects affects and space, and represents the movements between exterior and interior landscapes, this site bears the motion of emotion. Metropolis, the mother-city of film, thus becomes a peculiar means of transport – one that includes the transmission of affects.

The filmic city, finally, can be charted as a tangibly moving landscape: a map of experiential situations, an emotional cartography. Unreeling a sequence of views, the architectural-filmic ensemble has ended up revealing maps of psychogeographic mobility. In many ways, then, adopting this 'emobilised', inhabited perspective for both architecture and film viewing – two seemingly static and optical activities – has involved transforming our sense of these art forms. The act of joining architecture and cinema, not optically but haptically, has been aimed at corroding oppositions such as immobility/mobility, inside/outside, private/public, dwelling/travel. Remapped as permeable intersubjective spaces, in between housing and motion, architecture and cinema ultimately question the very limits of the opposition. They force us to rethink cultural expression itself as a site of interior/exterior travel and dwelling – a porous geo-psychic in-between. We can conclude, then, that a dweller-voyager moving through intimate space drives the architectural itinerary of the city, the activity of travel and film. All involve motion through culturally transmitted space — a form of *transito*. Embracing not only physical motion, the epistemology of *transito* is circulation that includes migrations, passages, traversals, transitions, transitory states, spatial erotics and, last but not least, affects and that motion which is emotion.

Trasporto: Motion and Emotion

It is here – in the energy of *emotion* – that the moving image was ultimately implanted, with its own psychogeographic version of transport. After all, cinema was named after the ancient Greek word *kinema*. It is interesting to note that *kinema* means both motion and emotion. Film is therefore a modern means of 'transport' in the full range of that word's meaning. Transport includes the sort of carrying that is a carrying away by emotion, as in transports of joy, or in *trasporto*, which in Italian encompasses the attraction of human beings to one another.

Sunrise (F. W. Murnau, 1927)

Cinematic motion carries a haptic, affective transport, which is more than the movement of bodies and objects as imprinted in the change of film frames and shots, the flow of camera movement or any other kind of locomotive shift in viewpoint. Motion pictures move not only through time and space or narrative development but also through inner space. Film moves, and fundamentally 'moves' us, with its ability to render affects and, in turn, to affect. It also moves to incorporate, and interface with, other spaces that can touch us and affect us, such as the dynamic energy of the city. The emotion of cinema pervades not only the walls of the movie house but extends beyond them. As we have shown, it was most prominently implanted, from the time of pre-cinema, in the urban itinerary: film, intricately bound in the making of modern space, *affected* its mobilisation.

Emotion Pictures

Like the city, motion pictures move, both outwards and inwards: they journey, that is, through the space of the imagination, the site of memory and the topography of affects. It is this mental itinerary that, ultimately, makes film the art that is closest to architecture. Like architecture, cinema creates mental and emotional maps, acting as membrane for a multifold transport. Layers of cultural memory, densities of hybrid histories, emotional transport are all housed by film's spatial practice of cognition. As a means of psychic travel-dwelling, cinema designs cultural voyages, traversals and transitions: its haptic space offers tracking shots to travelling cultures and vehicles for psychospatial journeys. A frame for these cultural mappings, film is modern cartography. It is a mobile map – a map of geo-psychic differences and cross-cultural travel. A voyage of identities in *transito* and a complex tour of identifications, film is an actual means of exploration: at once a housing for and a tour of our narrative and our geography. A touching – *moving* – geography. An atlas of emotion pictures. A *kinema*, indeed.

NOTES

1 For a more extended treatment of this subject see Bruno 2002. See also Bruno 1993, Friedberg 1993 and Charney & Schwartz 1995.

2 He devotes a whole section to the topic of 'the establishment of physical existence' in his *Theory of Film* (1960). Furthermore, as Miriam Hansen (1993) shows, Kracauer thought of film as something 'with skin and hair'. See also Schlüpmann 1987.

3 See 'The Hotel Lobby', 'Analysis of a City Map', 'Travel and Dance', and other Weimar-era essays in Kracauer 1995.

4 The culture of the arcade is notably developed by Walter Benjamin, especially in Benjamin 1969a and 1999.

5 For an entry on this topic see Koch 2000.

6 The text (Eisenstein 1989) was written *c*. 1937, to be inserted in a book-length work.

7 In Eisenstein 1989 the filmmaker-theorist used Auguste Choisy's 'picturesque' view of the Acropolis from the latter's *Histoire de l'architecture* (1899), following Le Corbusier's own appropriation of Choisy to picture his notion of the *promenade architecturale* in *Vers une architecture* (1923).

8 This statement is from the only interview Le Corbusier gave during his stay in Moscow in 1928.

9 For an introduction to this subject see, among others, de Seta 1996.

10 See de Certeau 1984.

11 For some English translations of situationist texts on space, see Knabb 1989, and 'Selected Situationist Texts on Visual Culture and Urbanism', published in McDonough 1997, 84–142.

12 The *Carte du Pays de Tendre* (commonly known as the *Carte de Tendre*) was published as illustration for the anonymous 'Urbanisme unitaire à la fin des années 50', in *Internationale situationniste*, 3 (Anon. 1959). It was juxtaposed with an aerial photograph of Amsterdam, a city of situationist drift. The montage suggests a joining of aerial and navigational practices in traversing space, affirming an intimacy with the city.

WORKS CITED

Anon. (1959) 'Urbanisme unitaire à la fin des années 50', *Internationale situationniste*, 3, 11–16.

Benjamin, W. (1969a) *Charles Baudelaire*, trans. H. Zohn. London: Verso.

_____ (1969b [1936]) 'The Work of Art in the Age of Mechanical Reproduction', in H. Arendt (ed.) *Illuminations*, trans. H. Zohn. New York: Schocken Books, 217–52.

_____ (1999) *The Arcades Project*, ed. R. Tiedemann, trans. H. Eiland and K. McLaughlin. Cambridge, MA: Harvard University Press.

Bruno, G. (1993) *Streetwalking on a Ruined Map*. Princeton: Princeton University Press.

_____ (2002) *Atlas of Emotion: Journeys in Art, Architecture, and Film*. New York: Verso.

Charney, L. and V. Schwartz (eds) (1995) *Cinema and the Invention of Modern Life*. Los Angeles: University of California Press.

Choisy, A. (1899) *Histoire de l'architecture*. Paris: Rouveyre.

Cohen, J.-L. (1992) *Le Corbusier and the Mystique of the USSR*, trans. K. Hylton. Princeton: Princeton University Press.

de Certeau, M. (1984) *The Practice of Everyday Life*, trans. S. Rendall. Los Angeles: University of California Press.

de Seta, C. (ed.) (1996) *Città d'Europa: Iconografia e vedutismo dal XV al XIX secolo*. Naples: Electa.

Eisenstein, S. M. (1980 [1937]) 'El Greco y el cine', in F. Albera (ed.) *Cinématisme: Peinture et cinema*, trans. A. Zouboff. Brussels: Editions complexe, 16–17.

_____ (1989 [1937]) 'Montage and Architecture', intro. Y.-A. Bois. *Assemblage*, 10, 111–31.

Friedberg, A. (1993) *Window-Shopping: Cinema and the Postmodern*. Los Angeles: University of California Press.

Hansen, M, (1993) '"With Skin and Hair": Kracauer's Theory of Film, Marseille 1940', *Critical Inquiry*, 19, 437–69.

Knabb, K. (ed. and trans.) (1989) *Situationist International Anthology*. Berkeley: Bureau of Public Secrets.

Koch, G. (2000) *Siegfried Kracauer: An Introduction*, trans. J. Gaines. Princeton: Princeton University Press.

Kracauer, S. (1947) *From Caligari to Hitler*. Princeton: Princeton University Press.

_____ (1960) *Theory of Film: The Redemption of Physical Reality*. New York: Oxford University Press.

_____ (1995) *The Mass Ornament*, ed. and trans. T. Y. Levin. Cambridge, MA: Harvard University Press.

Le Corbusier [C.-E. Jeanneret] (1923) *Vers une architecture*. Paris: Vicent Fréal et Cie.

Le Corbusier and P. Jeanneret (1964) *Oeuvre complète*, vol. 2, ed. W. Boesiger. Zurich: Editions Girsberger.

Lefebvre, H. (1991) *The Production of Space*, trans. D. Nicholson-Smith. Oxford: Blackwell.

McDonough, T. F. (ed.) (1997) 'Guy Debord and the *Internationale Situationniste*', special issue *October*, 79.

Schlüpmann, H. (1987) 'Phenomenology of Film: On Siegfried Kracauer's Writings of the 1920s', *New German Critique*, 40, 97–114.

Simmel, G. (1971 [1903]) 'The Metropolis and Mental Life', in D. N. Levine (ed.) *Georg Simmel on Individuality and Social Forms*. Chicago: University of Chicago Press, 324–39.

Virilio, P. (1991) *Lost Dimension*, trans. D. Moshenberg. New York: Semiotext(e).

2 URBAN SPACE AND EARLY FILM
Patrick Keiller

Until the mid-1900s, most films were between one and three minutes long, and consisted of one or very few unedited takes. The Lumière Company's films, for example, are typically 48–52 feet long and last about a minute. They were made by exposing a complete roll of film, usually without stopping. Most early films were actualities, not fiction, and many were street scenes or views of other topographical subjects, some of them photographed from moving vehicles and boats. Cinematographers would sometimes pause if there was a lull in the ambient action, or if the view was blocked, but other kinds of editing were unusual. The reconstruction of time by joining individual shots together was an aspect of filmmaking that began to dominate only after about 1907.

Tom Gunning has called this early cinema 'the cinema of attractions' (1990: 56–62), a reference to Eisenstein's 'montage of attractions', conceived as a new model for theatre. Eisenstein took the term from the fairground, where his favourite attraction was the roller coaster, the Russian for which translates as 'the American Mountains'. There is an early Biograph film, *A Ride on a Switchback* (1900, or possibly 1898), which was made by mounting a camera not on a roller coaster, as early films sometimes were, but on a railway engine. A switchback was a railway engineer's device for negotiating steep gradients with a siding and a set of points, entering by one branch and backing out into the other, so as to avoid the construction of a hairpin bend. Biograph's film was photographed in mountains near Fort Lee, New Jersey, which one might imagine were *the* (or at least some) American Mountains. Films photographed from the front of railway engines were known as 'phantom rides', presumably because of the supernatural sensation of disembodied consciousness that they offer. Views from other moving vehicles – trams and, later, cars – are sometimes described as phantom rides, but the term seems to have been most specific to the view from the front of a locomotive, which was then seldom encountered in ordinary experience, even by an engine driver.

As Gunning writes, after 1907 'the cinema of attractions does not disappear with the dominance of narrative, but rather goes underground, both into certain avant-garde practices and as a component of narrative films' (1990: 57). There is a story that Andy Warhol's *Kiss* (1963) was prompted by an archive viewing of Thomas Edison's *Kiss of May Irvin and John C Rice* (1896), and whether or not it was, the evolution of Warhol's films – from the 100-feet rolls of *Sleep* (1963) and *Kiss* to the 1,200-feet rolls of the two-screen *The Chelsea Girls* (1966) – strikingly resembles that of early film (see Rayns 1989: 164). In narrative cinema, phantom rides appear in *films noirs*, often at the beginning of a film or in title sequences, as in Fritz Lang's *Human Desire* (1954), Mike Hodges' *Get Carter* (1971) and the car shots in Edgar G. Ulmer's *Detour* (1945) (looking backwards), Jacques Tourneur's *Out of the Past* (1947) and Robert Aldrich's *Kiss Me Deadly* (1955).

Since the 1960s, the cinema of attractions has emerged from underground, in films and installations by a wide variety of artists and other filmmakers, most of them outside the mainstream of Western cinema. Whether in the gallery or in what used to be called art cinema, there is a tendency towards some of the forms of early film. One of the ways in which both early films and these more recent examples differ from what became the dominant form is in the way they represent space on a screen. In films constructed as montage, space is assembled in time, as an implied continuity of fragments. In most early films, space is represented within a single frame, either static or moving. Early films are also less likely to direct the viewer's attention to a single subject in the frame: one's eye can more easily wander in their spaces and because of this they invite (or even require) repeated viewing. Moving-camera films often create a striking illusion of three dimensionality, which early filmmakers sometimes referred to explicitly as 'the stereoscopic effect'.

Between the mid-1900s and the outbreak of World War One, the spaces and spatial experiences characteristic of industrialised economies appear to have undergone significant transformation. At about the same time, architectural theorists began to develop new concepts of architectural space. These transitions have been described in a variety of ways: for example, in his afterword to the English translation of Henri Lefebvre's definitive *The Production of Space*, first published in 1974, but in English only in 1991, the geographer David Harvey quoted a passage in Lefebvre's opening chapter:

> The fact is that around 1910 a certain space was shattered. It was the space of common sense, of knowledge (*savoir*), of social practice, of political power, a space thitherto enshrined in everyday discourse, just as in abstract thought, as the environment of and channel for communications; the space, too, of classical perspective and geometry, developed from the Renaissance onwards on the basis of the Greek tradition (Euclid, logic) and bodied forth in Western art and philosophy, as in the form of the city and the town ... Euclidean and perspectivist space have disappeared as systems of reference, along with other former 'commonplaces' such as the town, history, paternity, the tonal system in music, traditional morality, and so forth. This was truly a crucial moment. (Lefebvre 1991: 25)

Harvey had already quoted from this passage in his *The Condition of Postmodernity*, following mention of 'the incredible confusions and oppositions across a spectrum of possible reactions to the growing sense of crisis in the experience of time and space, that had been gathering since 1848 and seemed to come to a head just before the First World War' and 'that 1910–14 is roughly the period that many historians of modernism (beginning with Virginia Woolf and D. H. Lawrence) point to as crucial in the evolution of modernist thinking' (1990: 266). For Harvey, the crisis was one 'of technological innovation, of capitalist dynamics across space [and] cultural production' (ibid.). He notes the slightly different emphasis of Stephen Kern who, in *The Culture of Time and Space 1880–1918*, offered 'generalisations about the essential cultural developments of the period' (1983: 5). Other writers have dealt with these in detail: for John Berger 'The Moment of Cubism' was the period between 1907 and 1914, and during the period 1900–14 'the developments which converged at the beginning of the twentieth century in Europe changed the meaning of time and space' (1969: 6). Berger listed these as:

An interlocking world system of imperialism; opposed to it, a socialist international; the founding of modern physics, physiology and sociology; the increasing use of electricity, the invention of radio and the cinema; the beginnings of mass production; the publishing of mass-circulation newspapers; the new structural possibilities offered by the availability of steel and aluminium; the rapid development of the chemical industries and the production of synthetic materials; the appearance of the motor car and the aeroplane. (1969: 5)

More recent writing (including that of Kern and Harvey) has stressed the role of telecommunications; others mention emigration (both within and away from Europe).[1] Some of these developments suggest comparisons with the present.

For Reyner Banham, in *Theory and Design in the First Machine Age*, 'a series of revolutionary gestures around 1910, largely connected with the Cubist and Futurist movements, were the main point of departure for the development of Modern architecture' (1960: 14). Banham's narrative is that of evolving concepts of space, specifically 'the change-over from the Lippsian idea of space, as *felt volume* ... to the later concept of space as a three-dimensional continuum, capable of metrical subdivision, without sacrifice of its continuity' (1960: 67; emphasis added). The idea of space as volume enclosed by solid surfaces (characteristic of early modern architects such as Voysey or Berlage, and of Cerda's Barcelona) began to give way to concepts in which the solidity of matter was less certain, just as the early modernist city, with its bicycles and electric trams, would give way to the city of the motor car. By 1929 László Moholy-Nagy was able to formulate the minimum definition: 'space is the relation between the position of bodies' (Banham 1960: 317), which for Banham confirmed 'the whole revolution in architectural theory that had been going on since 1908' (1960: 311). One of Moholy-Nagy's earlier spatial expositions was his 1921–22 proposal for a film *Dynamik der Gross-stadt* (*Dynamic of the Metropolis*, which somewhat anticipates Dziga Vertov's *Chelovek s kino-apparatom* (*Man with a Movie Camera*, 1929)). *Dynamic of the Metropolis* was never realised, but by 1929 Moholy-Nagy had made *Berliner Stilleben* (*Berlin Still Life*, 1926) and perhaps also *Marseille, Vieux-Port* (1929), so that the 'minimum definition' of modernist space was put forward by a theorist who was also an experienced filmmaker.

Banham saw the distinction between Lipps's and Moholy-Nagy's spatial concepts as sequential, but the idea of space as 'felt volume' only slightly pre-dated the subsequent, more abstract formulation – it appears that the word 'space' (*Raum*) was not used in Lipps's (or any other architectural) sense before about 1900 (see Banham 1960: 66) – and Lipps's concept never really went away. The distinction between the two spatial concepts is very like that between Gunning's two kinds of cinema, and the spatiality of the early films – their depiction of architectural space within a single frame, their uninterrupted, lengthy spatio-temporal continuities (the tram rides especially) and the 'stereoscopic effect' – is easy to identify with Lipps's formulation. Banham's *Theory and Design* was published in 1960, before the revival of urbanism in architectural theory in the mid-1970s, since when architects and others have attempted to revive this early modernist space, just as filmmakers have revived some of the forms of early cinema. Both Lipps's space and the cinema of attractions might be seen as early modernist forms which were eclipsed in the late 1900s, as part of a wider cultural transformation, but have since re-emerged, usually in opposition to the mainstream architectures and cinemas of Western and other capitalist cultures.

In *The Condition of Postmodernity*, Harvey also quoted the famous passage from Walter Benjamin's 'The Work of Art in the Age of Mechanical Reproduction':

> Our taverns and our metropolitan streets, our offices and furnished rooms, our railroad stations and our factories appeared to have us locked up hopelessly. Then came the film and burst this prison-world asunder by the dynamite of the tenth of a second, so that now, in the midst of its far-flung ruins and debris, we calmly and adventurously go travelling. (Benjamin 1973: 238)

Benjamin's 'now' refers to film as it had evolved after the mid-1900s – his essay, published in 1936, mentions nothing earlier than the films of Vertov, Abel Gance and Joris Ivens – but it is not entirely clear at what date 'came the film and burst this prison-world asunder'. If the development of cinema was a significant factor in the transformation of urban and other space during the 1900s, one wonders whether this was the development of cinema *per se*, or the development of cinema with editing, narrative and close-up as it was undertaken after the middle of the decade. The fragmentation Benjamin describes can be identified in post-1910 experience as a breaking up of space into individual shots, in which case 'the dynamite of the tenth of a second' is the interval between the end of one shot and the beginning of the next, rather than the medium's primary fragmentation of continuous duration into the discontinuous individual frames of a single shot. But the essay also famously stresses 'the incomparable significance of Atget, who, around 1900, took photographs of deserted Paris streets' (1973: 228), and it might seem to us that in some ways one could 'calmly and adventurously go travelling' (even) more easily in the early 1900s than in the period of Gance and Vertov.

Whatever the date of the films that Benjamin had in mind, something happened to the medium in the mid-1900s. The change that Gunning identified seems to have followed a distinct lull in output, during or soon after which many of the pioneers ceased production. After the mid-1900s films are generally longer, but with shorter shots, close-ups and, increasingly, fiction and studio sets; few of them show very much of ordinary landscapes. When they do, the shots are usually so short as to permit relatively little exploration, even when examined frame by frame. In contrast, the brief, continuous or near-continuous films of spatial subjects made by the Lumière and Biograph companies and their contemporaries before about 1903 accumulate an extensive document of ordinary, everyday spaces of their period: the spaces that Lefebvre and others suggest were radically transformed soon afterwards. In enabling us to see so much of this environment, these early films are truly extraordinary, as they offer the most extensive views of the landscape of another time at or just before the moment of that landscape's transformation, a transformation brought about (at least in part) by the development of the very medium in which the opportunity to explore these long-lost spaces was constructed.

Early cinematographers were quick to grasp the possibilities of the moving camera. Although movement of the camera on its tripod was unusual, and largely confined to fairly irregular pans, moving vehicles and boats offered a means to extend the spectacle of a film a long way beyond what was visible in a static frame. The earliest railway film is probably the Lumière company's *Le Départ de Jerusalem en chemin de fer* (*Leaving Jerusalem by Railway*), photographed by Alexandre Promio in 1896, an oblique rearward view of a station platform from a departing train. Promio's travels for the Lumière company

included two visits to the UK – in 1896, to London, and again in 1897 to London, Liverpool and Ireland. There are eight films of Liverpool, four of them – *Panoramas pris du chemin de fer électrique 1–4* – a series of spectacular views of the docks photographed from the Liverpool Dock Railway, which had opened in 1893, the first elevated electric metropolitan railway in the world. The films are particularly striking in that they show to what extent large ocean-going sailing ships were still in everyday commercial operation. In this, they exemplify the complex temporality of spaces seen in archive film. The railway's moving, cinematic view of the docks appears very modern, and the docks themselves were undergoing continual, mechanised development, but the ships convey the spatial experiences of a very different, earlier time.

Panorama pris du chemin de fer électrique (1897)

These Lumière company films are *panoramas* – views resembling those of passengers from railway carriage windows (or fairground panoramas that simulated such views). The first phantom ride was the American Mutoscope and Biograph Company's *Haverstraw Tunnel*, made in 1897. One of Biograph's four founders was William Kennedy-Laurie Dickson, who had previously developed and designed much of Edison's moving picture technology. Dickson arrived in the UK in May 1897 as the technical manager and cinematographer of Biograph's new subsidiary, the British Mutoscope and Biograph Company. He travelled with Biograph's 68mm 40fps electric camera in the UK and Europe, then in South Africa during the Boer War. Dickson's Biograph films include the first UK phantom ride *Conway Castle – Panoramic View of Conway on the L & NW Railway* (1898) and the spectacular *Irish Mail – L & NW Railway – Taking Up Water at Full Speed* (1898), photographed near Bushey station from the rear of a train on a parallel track, which is overtaken by the express towards the end of the film.

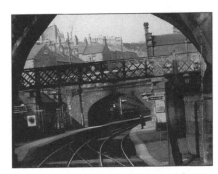

Conway Castle – Panoramic View of Conway on the L & NW Railway (1898)

The earliest surviving UK tram-ride film appears to be Charles Goodwin Norton's *Horse Drawn Traffic in Seven Sisters Road* (1898), a view from the top of a horse tram, but tram rides were more usually photographed from electric trams. The earliest surviving British Biograph example is *Tram Journey through Southampton* (1900), a single shot from an electric tram passing through the Bar (a stone gateway with arches) and along Above Bar Street, a continuation of Southampton's High Street. Biograph's *Panorama of Ealing from a Moving Tram* was photographed on (or very soon after) Wednesday 10 July 1901. The film looks forward from the upper deck of an electric tram travelling east along The Broadway, The Mall and Uxbridge Road towards Ealing Common, a short length of the (then) main London to Oxford road in the neighbourhood of Ealing Broadway railway station. The left side of the street is visible, lined by what look like plane trees about thirty feet tall, behind which most of the shops have awnings. There are a great many flags and

banners, some of them very large Union flags, others less easy to decipher, and a lot of people out walking who appear rather smart, as if the day is a public holiday or weekend of some national or other significance.

The film lasts about eighty seconds. Near the beginning, the tram passes the London and County Bank (previously the Town Hall, now a branch of the NatWest Bank), which has put out two particularly large flags, and later a music shop with a sign saying 'pianos'. Towards the end, an electric tram passes in the opposite direction, fairly full on top, with several of the passengers carrying parasols, as are many people in the street.

Panorama of Ealing from a Moving Tram (1901)

There are cyclists on the road, a pony and trap and other horse-drawn vehicles, but not many tradespeople and no motor cars. The orthochromatic stock probably exaggerates the brightness of the weather a little, but the people's dress, the large number of parasols carried, and the degree of movement of the flags and the leaves of the trees, together with the celebratory atmosphere, suggest a euphoric, breezy day in summer. The unusually sharp definition of the image – a result of both the original 68mm format and the good condition of the surviving copy – and the extraordinary lighting effect, create a degree of heightened photographic realism, so that one might easily mistake the film for a fragment of a costume drama made in the 1940s.

At first sight, despite anything we might know of the imperial and other insecurities of the period, it appears to depict a space in which there exists a marked sense of stability (as films often do). One might guess that the flags signify some monarchical or imperial event, but the celebrations are of something quite different – and perhaps much easier to imagine – and the space contains a tension no less dynamic than that in the films of Liverpool. The film is one of four 'arranged' by James Clifton Robinson – chief engineer and managing director of the London United Tramways – to record the inauguration of the first electric tramway network in London, which took place on the same day as Ealing's celebration of its Charter of Incorporation as a Borough, the first in Middlesex.[2] This was a moment of modernisation, a day of truce between the tramway company, backed by an alarming array of international financiers, and Ealing's local authority, which had vigorously opposed the coming of the trams in the belief that by making it possible for working-class people to commute from Ealing into London, they would undermine Ealing's exclusivity and its status as 'the queen of the suburbs'.

Perhaps the Ealing film survives in such good condition because – although produced by a multinational company to celebrate a project backed by international finance – it was of primarily local interest, and so was not projected as many times as films which were more widely exhibited. This seems to have been one of the reasons for the survival of 826 Mitchell & Kenyon negatives from 1900–13, rediscovered in extraordinarily good condition in 1994 in the basement of the company's former premises in Blackburn, Lancashire. Mitchell & Kenyon produced an enormous number of actuality films for local exhibition, including many tram rides. These are generally longer and more fragmentary than other surviving examples, but their films of Bradford, Nottingham, Sheffield, Roch-

dale and other towns and cities, most of them in the north of England, create a virtual landscape of the period more extensive than anything comparable in UK cinema. The longest of these spatial continuities is a series of three *Tram Rides through Nottingham* (1902), which depicts a near-continuous 7-minute journey from the Midland Railway Station – at the location of the present station, built in 1904 – through the city centre to the former Victoria Station, which had opened in 1901 and was demolished in the 1960s.

Tram Rides through Nottingham (1902)

What do these films mean for us? On looking at them, what struck me first, as someone who can just about remember UK towns and cities in the 1950s, was a contrast between their sometimes familiar-looking landscapes and the unfamiliarity of the society glimpsed in them. The people in the films are visibly unlike us. Many of their attitudes – to sexuality, children, religion, the state, each other and so forth – were probably unlike those of people today (though any knowledge of these attitudes is probably very partial). They might have looked forward to material and social progress – socialism, even – more confidently than we do, but they might also have been familiar, as we are, with predictions of future catastrophe – those of H. G. Wells, for instance – some of which were later confirmed. Most of them were poorer than most people in the UK are today.

In the last hundred years the material, and other, circumstances of the UK's population have altered enormously,[3] but much of the urban fabric of the 1900s survives, often – like much of the rest of the built environment – in a surprisingly dilapidated condition. This might suggest that while we are far better off than our predecessors of one hundred years ago in terms of life expectancy, physical health, income, mobility and so forth, some aspects of everyday life have been impoverished. In this sense, the films might be thought subversive, in that they echo questions about the ways in which present-day societies assess their wealth. Although developed economies experience unprecedented levels of consumption and GDP per person, in other respects – especially when measured in terms of social, cultural and environmental assets – wealth has not increased anything like as much. In some ways, in some places, it has probably decreased.[4]

Walking in the streets of UK towns and cities today, the decline of what Lefebvre described as 'the environment of and channel for communications … in the form of the city and the town' (1991: 25) is easily recognised. With the increasing centralisation and seclusion of political and financial power, and the shift of economic and other activity into virtual space, one often detects a sense of absence, even in the centre of London. Also, despite the suburban expansion and city-centre redevelopments of the twentieth century, the centres of many UK towns and cities still consist largely of ageing fragments of late nineteenth- and early twentieth-century landscapes, overlaid with a thin and often ephemeral layer of modernity. In this context, the survival of quite so much ageing urban fabric, often in a strikingly dilapidated condition, might be seen as part of a decline: the failure of the space to properly renew itself.

However much one might qualify these observations, it is clear that the various modernist projects of rebuilding epitomised by the Futurists' assertion 'Things will endure less

than us. Every generation must build its own city' (see Kern 1983: 100) did not develop as anticipated. As Orwell wrote in *Nineteen Eighty-Four*: 'In the early twentieth century, the vision of a future society unbelievably rich, leisured, orderly and efficient – a glittering antiseptic world of glass and steel and snow-white concrete – was part of the consciousness of nearly every literate person' (2000: 196). Building was never much mechanised or automated, and is now considerably more expensive than other kinds of production. This vision – if it was ever widely shared outside fiction (the snow-white concrete, at least, anticipates the London Borough of Camden's public housing programme up to about 1973) – had faded by the mid-1970s, as signalled in London by the successful resistance to the Greater London Council's plan to redevelop Covent Garden. Instead, present-day cities often slightly resemble Orwell's vision of London, in which a few palatial modern structures are surrounded by miles and miles of largely residential streets of more or less decayed dwellings (about seventy per cent of urban land is residential) which are assumed to be capable of lasting forever. One hundred years ago, much of outer London was not yet built, but inner districts of the capital and many other UK cities often appear unexpectedly familiar when seen in films from the 1900s.

In the older advanced economies, cities now more often evolve through processes that begin with new perceptions of existing fabric, most familiar in the UK as gentrification. Some of these perceptions follow developments in communications and transport technology, others involve art, literature and, occasionally, films. One of the turning points in the history of twentieth-century urban transformations was the publication in 1961 of Jane Jacobs' *The Death and Life of Great American Cities*, in which she wrote: 'Old ideas can sometimes use new buildings. New ideas must use old buildings' (1964: 201). At around the same time, Warhol began his reinvention of cinema in a previously industrial space, a loft that became known as The Factory. In 2002, some of the films were displayed in the exhibition 'Warhol' at Tate Modern in London, which used to be a power station and was conceived partly as a catalyst for urban regeneration, as distinct from redevelopment.

As it has become more expensive to renew the built environment, its retention has become a cultural priority. The UK's National Trust was founded in 1895, the year that projected moving pictures were first publicly exhibited. Conservation was no less a modernist phenomenon than cinema, and their coincidence hints at one of the effects the rapid expansion of virtual space (of which cinema was a part) would have on actual everyday surroundings. The qualities one seems to detect in so many early films are very like some of those that attract tourists to less advanced or (some) socialist economies – to places where artisanal production (or the past products of it) survive; where domesticity is still found in city centres; and where there are fewer cars, or at least less traffic engineering. In advanced economies, such environmental qualities are typically achieved or retained through socialist (as in, say, Barcelona) or social-democratic (as in the Netherlands) politics.

In this context, Lefebvre's shattered 'space of common sense' suggests both the spatial concepts of Lipps and the urban design of Camillo Sitte. In 1903 Lipps 'argued that our bodies unconsciously empathised with architectural form' (Kern 1983: 157) and Sitte, 'rooted in the craftworker tradition of late nineteenth-century Vienna ... sought to construct spaces that would make the city's people "secure and happy" ... He therefore set out to create interior spaces – plazas and squares – that would promote the pres-

ervation and even re-creation of a sense of community' (Harvey 1990: 276). These and similar ideas re-emerged in the postmodern urbanism of the 1970s, for which the urban landscapes glimpsed in early films might initially seem to offer some support, with their depiction of what to us appear 'traditional' urban spaces in which we might imagine we could be 'secure and happy'. We might also imagine, as present-day urban designers sometimes do, that such spaces 'would promote the preservation and even re-creation of a sense of community'. Sitte's polemic, however, was not in favour of the actually-existing spaces of the 1900s – the spaces that appear in the films – but against them, 'abhorring the narrow and technical functionalism that seemed to attach to the lust for commercial profit', and seeking 'to overcome fragmentation and provide a "community life-outlook"' (ibid.), rather as we might today. Also, though Sitte is popular with present-day urban designers, his desire for spaces that he believed would promote 'community' was not unproblematic. As David Harvey writes: 'many of the Viennese artisans whom Sitte championed ... were later to mass in the squares, piazzas and living spaces that Sitte wanted to create, in order to express their virulent opposition to internationalism, turning to anti-Semitism ... and the place-specific myths of Nazism' (1990: 277).

The spaces of UK cities in the early 1900s might appear 'traditional', but they were subject to transformations at least as sudden as any we experience today. One of the more visible of these was the introduction of electric trams, which became widespread during the late 1890s and early 1900s. These were not always the first powered vehicles to appear in city streets – steam trams already ran in towns near coalfields – but the films photographed from electric trams, and those in which they appear, seem of a very different era to that seen in the films in which all the vehicles are horse-drawn. In London, for instance, electric trams did not run until 1901, and then only in the suburbs, so that the city often appears particularly old-fashioned, especially in the centre, where top hats and hansom cabs are very common.

The electric tram offered an ideal platform for the camera (more stable than horse trams, which rocked) and the films publicised the trams, so that a kind of symbiosis developed between tramway operators and film production companies. Many people's first and possibly only encounter with a ciné camera would have been with one mounted on a tram, so that we might see the tram-ride films as both celebratory (electric trams were generally popular, and the people in the streets appear to have been happy to co-operate with the filmmakers) and predatory: the combination of electric tram and ciné camera a harbinger (like the 'dragon sandstrewer' in *Ulysses [xx] date]*, or the tram that knocked down Gaudi) of modernity, of fragmentation, after whose passing nothing was ever the same again.

The trams moved relatively slowly; they are often overtaken by bicycles – another innovation of the 1890s – and do not appear to have diminished the tendency of people to walk and gather in the roadway. The streets were surfaced with a variety of materials, including rolled and rough macadam, granite squares, wood blocks and asphalt paving, but asphalt, much of it a by-product of oil refining, only became widespread with motor traffic, another change that dates from later in the decade.[5] With the road surface handmade with 'natural' materials, and pedestrians more likely to linger on it, the distinction between pavement and roadway was less marked than it is today, suggesting a space not unlike the 'urban room' so widely sought by postmodernist urban designers, typically achieved now only by banishing or severely restricting vehicular traffic. This is perhaps

one of the ways in which our perceptions of the space differ from those of people of the time, who probably found the streets extremely busy.[6]

The films might seem to offer a polemic for this – for streets without cars, for architecture, for public transport, and for a less centralised, less dematerialised economy. They convey the qualities of a space in which there are electricity and telecommunications, but not much oil, so that the transformations of circa 1910 can be seen in the context of the coming of the oil economy and the motor car, which since the mid-1970s has been so widely cast in opposition to conventional formulations of *dwelling*, and to certain kinds of urban space and architecture. With oil production approaching or passing its peak, and with world demand for oil and other resources rapidly increasing, the films begin to resemble science fiction: the suggestion of a future in which global inequalities have reduced, and energy – and hence transport – has become much more expensive, so that production becomes once again more local and more labour-intensive. At the same time, we can assume that, as images, the films bestow an illusory coherence on their subjects. The spaces seen in the films were dynamic, subject to tensions as unsettling as (and sometimes surprisingly similar to) those we experience today. Cities are increasingly seen as processes structured in time. In these remarkable films, we can explore some of the spaces of the past, in order to better anticipate the spaces of the future.

NOTES

1 According to Kern (1983: 220), thirty million emigrants left Europe between 1890 and 1914.

2 The other films were *Distinguished Guests Leaving the Power House*, *The First Trams Leaving Shepherd's Bush for Southall* and *Panorama at Ealing Showing Lord Rothschild Declaring Line Open* (see Brown & Anthony 1999: 295). Brown and Anthony give the date 10 July 1901 for all 4 titles. Geoffrey Wilson (1971) writes that 'the film' was arranged by Robinson and in the *Tramway and Light Railway Association Journal* (1932) Mr E. H. Edwardes, an LUT employee in 1901, recalled that it was shown the same evening, and that the company had booked the entire stalls as a condition of the screening.

3 Average income in employment increased about three times as much as indices of retail prices. The cost of housing has generally increased more than average income.

4 See, for instance, Jackson, Marks, Ralls and Stymne 1997, who report that the UK's Index of Sustainable Economic Welfare (ISEW) peaked in 1976, and has since dropped by 25 per cent to the level of the 1950s, increases in GDP per head and so on having been offset by environmental decline, increased inequality and other factors. Similar patterns have been found in other advanced economies, notably the US.

5 The surviving incomplete print of Cecil Hepworth's *City of Westminster* (1909) begins with a caption 'The City of Westminster Seen from an Argyll Car' and a 90-second moving-camera view photographed by Gaston Quiribet from a car that drives from the north end of Whitehall, up the east side of Trafalgar Square into St Martin's Lane. The traffic includes cars, horse buses, horse-drawn carts and vans, bicycles, hackney cabs, motor taxis, a steam lorry, and many people crossing the road between them. After the mid-1900s such shots are rare, and mostly confined to films promoting motor vehicles.

6 See, for instance, Georg Simmel, 'The Metropolis and Mental Life', in 1971: 324–9. The essay was first published in 1903.

WORKS CITED

Banham, R. (1960) *Theory and Design in the First Machine Age*. London: Architectural Press.

Benjamin, W. (1973 [1936]) 'The Work of Art in the Age of Mechanical Reproduction', in *Illuminations*, trans. H. Zohn, ed. and intro. H. Arendt. London: Fontana, 219–53.

Berger, J. (1969) 'The Moment of Cubism', in *The Moment of Cubism and Other Essays*. London: Weidenfeld and Nicholson, 1–32.

Brown, R. and B. Anthony (1999) *A Victorian Film Enterprise – The History of the British Mutoscope and Biograph Company 1897–1915*. Trowbridge: Flicks Books.

Gunning, T. (1990) 'The Cinema of Attractions: Early Film, its Spectator and the Avant-Garde' in T. Elsaesser (ed.) *Early Cinema: Space, Frame, Narrative*. London: British Film Institute, 56–62.

Harvey, D. (1990) *The Condition of Postmodernity*. Oxford: Blackwell.

Jackson, T., N. Marks, J. Ralls and S. Stymne (1997) *Sustainable Economic Welfare in the UK 1950–1996*. London: New Economics Foundation.

Jacobs, J. (1964) *The Death and Life of Great American Cities*. London: Penguin.

Kern, S. (1983) *The Culture of Time and Space 1880–1918*. Cambridge, MA: Harvard University Press.

Lefebvre, H. (1991) *The Production of Space*, trans. D. Nicholson-Smith. Oxford: Blackwell.

Moholy-Nagy, L. (1969 [1921–22]) 'Dynamik der Gross-stadt', in *Painting, Photography, Film*, trans. J. Seligman. Cambridge, MA: MIT Press, 124–37.

Orwell, G. (2000) *Nineteen Eighty-Four*. London: Penguin.

Rayns, T. (1989) 'Death at Work: Evolution and Entropy in Factory Films', in M. O'Pray (ed.) *Andy Warhol Film Factory*. London: British Film Institute, 160–9.

Simmel, G. (1971) 'The Metropolis and Mental Life', in *On Individuality and Social Forms*. Chicago: University of Chicago Press, 324–9.

Sitte, C. (1965) *City Planning According to Artistic Principles*. London: Phaidon.

Wilson, G. (1971) *London United Tramways*. London: George Allen and Unwin.

3 THE SPACE BESIDE: LATERAL EXPOSITION, GENDER AND URBAN NARRATIVE SPACE IN D. W. GRIFFITH'S BIOGRAPH FILMS
David Trotter

The aim of this chapter is to define and explore an episode in the development of the classical continuity system, with regard to what it might have to tell us about the construction of urban narrative space in (early) American cinema, and in particular about the gendering of that construction.

Lateral Exposition

According to the standard account, the classical continuity system – a specific set of guidelines for cutting shots together, whether by scene dissection or by montage – was firmly in place by 1917 (see Bordwell *et al.* 1985). The outcome of American cinema's steadily increasing commitment to narrative, from around 1903 onwards, continuity editing made it possible to situate the spectator at the optimum viewpoint in each shot, and to keep that viewpoint on the move as the story developed. The optimum viewpoint is not that from which an action can be seen in its entirety, but that from which it can be understood in its essence. For cinema's 'turn' to narrative was not in any straightforward sense the outcome of an urge to tell stories. It involved, as Thomas Elsaesser and Adam Barker put it, 'the contradictory articulation of a logic of space and time, within the context of a new industrial commodity, the reel of film, itself standing for new experiences of spectatorship' (1990: 293).[1] Classical Hollywood cinema, David Bordwell observes, is 'a cinema of narrative *integration*, which absorbs cinematic techniques and engaging moments into a self-sufficient world unified across time and space' (1997: 127).

One problem confronting a cinema bent on narrative integration, perhaps *the* problem, was how most effectively to co-ordinate the multiple spaces required by stories of any degree of complexity. 'There are two basic patterns', as Kristin Thompson puts it, 'for editing multiple spaces together: joining contiguous spaces and cross-cutting (i.e. joining non-contiguous spaces)' (1985: 203). From 1903 onwards, various methods were developed to demonstrate to the viewer that the spaces understood to be contiguous were indeed so: the movement of an identifiable character or object from one to another; direction matching, which ensures the intelligibility of such movement from the position of the viewer; and, from around 1909, eyeline matches, which cut from a character looking to what that look might encompass, though not from her or his point of view. The purpose of these methods was of course to establish the diegetic (if not actual) homogeneity of the self-sufficient world to which the multiple spaces belong. Cross-cutting, by contrast,

moves between simultaneous events in non-contiguous locations (see Thompson 1985: 203–12).[2] In this case, the implied homogeneity of the film's self-sufficient world derives entirely from narrative structure: the story, and the story alone, will in the fullness of time establish a relation between one space and another.

Promoting film's 'increased narrativity' was, as Charlie Keil observes, the main objective of the 'group style' developed by American filmmakers between 1907 and 1913, in the transition from a cinema of attractions to a cinema of narrative integration (2001: 127). The more than 400 films D. W. Griffith made for the Biograph company during this period have most often been regarded as a laboratory for the development and testing of methods or 'patterns' by which actions spread across multiple spaces might be edited together in such a way as to generate and clarify narrative. Cross-cutting, in particular, became with Griffith, as Tom Gunning observes, a 'narrative structure', a means to shape the relations of time and space for various purposes: to create suspense, in races to the rescue; to disclose feeling, as when one person so occupies the thoughts of another that he or she comes into view, is actually 'seen', at the moment of the thought, in a distant place; or, polemically, in essays in social criticism, to establish a contrast between the conditions of wealth and poverty (1991: 186–207, 243–9). The pattern thus developed is always in some measure abstract. 'Griffith's cinema', Elsaesser and Barker note, 'is a kind of orgy of metaphor: everything can be combined with everything else, stand for everything else, rhyme with everything else' (1990: 302). There is nothing in the image that cannot become the basis of an analogy. Thus, for example, the person 'seen', in her or his distant place, becomes a metaphor for what the person seeing feels. Cross-cutting has the power to resolve heterogeneity.

To put it another way: cross-cutting creates space by the destruction of place. Each narrative space brought into relation with another by cross-cutting has to be understood as a zone. In cross-cut races to the rescue such as *The Lonely Villa* (1909) and *The Lonedale Operator* (1911), assailant and rescuer, each closing in space by space (yard by yard, or mile by mile, it is all the same) on their shared destination, only ever *pass through*, on their way to somewhere else, to where the victim is – or, rather, to where the victim awaits their arrival, since she too occupies a zone rather than a space (an expectancy). More or less the only furnishing of any note in the room where the victim awaits rescue is that which connects one zone to another, such as the telephone in *The Lonely Villa*, or time present to time future: the clock in *The Fatal Hour* (1908) whose hands will trigger the gun aimed at the female detective when they reach twelve. These are not inhabited environments.

Griffith did not in fact give up all that easily, as cross-cutting required him to, on the implied homogeneity of some of the multiple spaces through or across which he spread the action of his films. He did not always convert an inhabited environment into a zone, place into space. At the beginning of the transitional period, Keil notes, filmmakers sometimes 'attempted to retain a sense of spatial wholeness by marking out contiguous spaces within a single set' (2001: 106). They might, for example, split the set and film it so that the division appears as a vertical bar running down the centre of the frame. Griffith experimented with this device in early Biograph films such as *The Devil* (1908), *An Awful Moment* (1908), *The Girls and Daddy* (1908) and *Those Boys* (1909). The split set, however, created its own problems. It was only appropriate to a handful of narrative situations; even then, it might either keep the action at too great a distance from the viewer to be

readily intelligible, or, on the contrary, reveal too much too soon (see Jesionowski 1987: 27; Keil 2001: 107). Gradually the practice of splitting the set into two rooms gave way to the practice of cutting from one room to another (that is, from one set to another: the scenes arising out of each set would have been shot together, at the same time, then the set struck and another mounted in its place). From 1909, room-to-room cutting became the method or pattern by which Griffith rendered the homogeneity of the sub-spaces constituting a single narrative space (for example, the rooms in a house).

According to Barry Salt, Griffith developed in his first films for Biograph 'the practice of transferring part of the action of a scene into adjoining hallways and rooms even when this was not strictly necessary, although in his case what the actors were doing was certainly always relevant to the development of the story' (1992: 98). By 1911, Salt continues, that fondness for movement from room to room had become an obsession, as Griffith sought consistently to explore the 'space beside' (1992: 99). *Three Sisters* (1911), for example, includes a climactic sequence of 28 shots alternating between three set-ups: a kitchen, a hall and a bedroom, established as contiguous by movement from one to another. The house, Ben Brewster and Lea Jacobs remark, is like a doll's house, 'the front wall of the three adjacent rooms being as it were transparent to the camera' (1997: 189). It only exists as a whole, they rightly add, by inference. My argument will be that the inference the viewer can make about the homogeneity of narrative space, in Griffith's Biograph films, is often a strong one; and that we need to take account of, and examine the reasons for, its strength. In my view, the strength of the inference derives neither from *mise-en-scène* alone, nor from contiguity editing alone, but from a practice I shall term 'lateral exposition'. Lateral exposition is the art of the space beside.

Lateral exposition was a road not taken, or, if taken, soon abandoned by Griffith and by American filmmakers in general. The practice stubbornly insisted, at a time when the commercial and dramatic advantages of the synthesising of narrative space had become too obvious to ignore, that the viewer should infer its homogeneity by mapping the images projected onto a 'world' whose internal relations can readily be grasped in detail as well as in outline (are, as it were, palpable). My claim here is that by examining what Griffith thought he might achieve in this fashion, and indeed what he *did* achieve in this fashion, we may be in a better position to understand an imaginative opportunity in and for cinema, not only during the transitional period, but subsequently. The focus will be on *Death's Marathon* (1913), one of the last films he made for Biograph, and, although by no means representative of his work there, a wonderfully vivid demonstration of what could be done, in describing the modern city, with the space beside.

Contexts

Griffith's experiment with lateral exposition had a bearing both on the emergence in the years before World War One of an 'American' cinema, and on the strategies developed during that process at once to explore and to exploit ideas of femininity.

Tom Gunning has argued that by 1913 it had become possible to distinguish between national styles in narrative filmmaking, or at least by European and American 'models'. The European style of deep staging achieved some sense of 'formal perfection' around 1913 or 1914, Gunning suggests, as an alternative to cross-cutting, and to the kinds of scene dissection already apparent by then in Biograph and Vitagraph films. Conversely,

American filmmakers had for some years been making strenuous efforts to differentiate home-grown from foreign product. The greatest consequence of the formation of the Motion Picture Patents Company (MPPC) in 1908 was the relative exclusion of foreign manufacturers: foreign share of the market dropped from sixty per cent to about ten per cent by 1914. Gunning contrasts two methods for the development and clarification of narrative event: cross-cutting, in Griffith's Biograph films; and composition in depth, in Feuillade's *Fantômas* series of 1913–14 (see 1993).[3] Feuillade, as David Bordwell has shown compellingly, used composition in depth to create a 'subtle choreography' which guides the viewer's attention to the 'key dramatic material' in a scene (1996: 19, 22). Bordwell calls for greater nuance in our understanding of the supposed dichotomy between European and American filmmaking in these years. The nuance is needed on Griffith's side as well as Feuillade's. I shall try to show that lateral exposition was a way to be American, and yet not wholly reliant on cross-cutting or scene dissection.

It may also have been a way to vary that representation of romantic love culminating in the lawful wedded union of 'suitable' partners, which was from first to last the main ideological business of Griffith's filmmaking. It is generally thought that Griffith staunchly upheld a patriarchal view of the family which economic, social and political developments had placed under severe threat, and that his characteristic narrative methods constitute a response to that threat. As Miriam Hansen has observed, many of the Biograph films 'register a traumatic breakdown of boundaries – between domestic and public space, between good and evil, between virgin and prostitute – and the work of the narrative usually consists of reaffirming these boundaries. Staged most forcefully through last-minute rescue races, the ideological project relies crucially on parallel narration, on subcodes of cross-cutting and accelerated editing' (1991: 223). 'For Griffith', Virginia Wright Wexman concludes, after noting how the themes identified with the campaign for women's suffrage 'found their way' into his films, 'parallel montage is a way of constituting the couple' (1993: 44).

Scholars pursuing this line of argument have understandably chosen to focus on the feature films of Griffith's 'Gish period': *Birth of a Nation* (1915), *Intolerance* (1916), *Broken Blossoms* (1919) and *Way Down East* (1920).[4] Lilian Gish, whom Griffith recruited for Biograph in 1912 with her sister Dorothy, was to prove 'the perfect embodiment of the highest feminine principle as he understood it' (Schickel 1984: 177). Gish's persona was 'ideally suited', Wexman points out, to the (re)constitution of the lawfully-wedded couple through a montage which alternates medium and long shots of a bustlingly active male rescuer with close-ups of a passive (tortured) female victim (1993: 47).

It may well be to my purpose that Griffith's leading woman in *Death's Marathon* was not Lilian Gish, but Blanche Sweet. Sweet subsequently featured as the patriarch-toppling heroine of *Judith of Bethulia* (1913). Griffith had originally intended that she should play Elsie Stoneman in *Birth of a Nation*. Gish only secured the part when substituting for Sweet in a rehearsal of the scene in which Elsie is violently accosted by the mulatto Silas Lynch (George Siegmann). 'I was very blonde and fragile-looking', Gish recalled. 'The contrast with the dark man evidently pleased Mr Griffith, for he said in front of everyone, "Maybe she would be more effective than the more mature figure I had in mind"' (1969: 133). Blanche Sweet was neither white enough nor sweet enough to play Elsie Stoneman (see Rogin 1985: 163–4).

We may or may not be able to speak of a 'sweet period' in Griffith's filmmaking. I shall propose here that in *Death's Marathon* the homogeneous narrative spaces constructed

by lateral exposition made it possible for him to imagine a woman's part in marriage differently, and to subtle, if not radical, effect. I want to ask what the space beside might have done for Sweet's 'more mature' figure.

Thematised Space in the Early Biographs

The homogeneity of the spaces defined by lateral exposition in Griffith's Biograph films could of course only ever be a matter of inference. But the inference is often, as I have already suggested, a strong one. Charlie Keil speaks of the sense these films consistently generate of the 'emphatic contiguity' of adjacent spaces (2001: 88). Upon what basis might Griffith have expected us to infer a house from an assortment of rooms?

There is plenty of evidence that Griffith meant to design, and to gain dramatic advantage from, film sets that were socially as well as topographically intelligible. The social whole of which particular sub-spaces could be imagined as parts was as often as not the tenement block and, by implication, the neighbourhood. Thus, by 1912, in films like *The Root of Evil*, the hallway or vestibule had emerged as the provocation to urban narrative. As Griffith used it, Russell Merritt notes:

> the vestibule was both a playing area and a proleptic space, a gateway that always denoted space beyond the margins of the frame. It was the ... staging area for entry into adjacent rooms (including that Biograph specialty, the forced entry), a site for eavesdropping or spying, a space for greetings and farewells, and, above all, a space for chance encounters between characters headed in opposite directions. (2001: 193)

The vestibule had become the 'master image' of the Griffith tenement neighbourhood; and so it remained, in later films such as *The Musketeers of Pig Alley* (1912), and, indeed, the modern story in *Intolerance*. In these films, the staging of the action relies for its coherence on the viewer's knowledge of the organisation of urban space for social purposes.

Griffith, it would seem, suspected that such knowledge might not be enough; or at least might not be enough when the narrative space in question was somewhat removed from the familiar terrain of the tenement neighbourhood. Barry Salt points out that by 1910 he had expanded his enquiry into the 'space beside' to include 'action spread backwards and forwards across what were effectively adjoining spaces in exterior scenes' (1992: 99). Of particular interest from this point of view is the 'cave-man' epic *Brute Force* (1913). By mid-1913 Griffith was acutely restless at Biograph. The commercial and critical success of his 'Indian' films had nurtured in him the ambition to fabricate, as Joyce Jesionowski puts it, 'wholly realized social orders'. The 'Indian' films develop 'carefully crafted gestural systems' whose purpose is to realise the 'patterns of social interchange' regulating a specific community (2003: 113). The system in operation in *Brute Force* covers the full range of socially expressive behaviour, from grooming to genocide. Equally fabricated is the terrain, or milieu, within which the film's two warring tribes do battle. Griffith maps the positions occupied by the tribes at opposite ends of an evolutionary spectrum onto the ground they contest. A pair of shots renders each tribal home in terms of the evolutionary stage at which their inhabitants might be thought to have arrived. 'These com-

parative constructs', Jesionowski explains, are connected on a 'grand left-to-right lateral' (2003: 114) that spans the Stone Age world in shots of varying scale. The contention over women between the two tribes moves backwards and forwards across this grand lateral so comprehensively as to constitute a world war. Narrative space, in this film, is symbolic through and through: to step to the left is to evolve, or at least to enact evolution.

The example of *Brute Force* would suggest that it sometimes took extreme measures to establish the homogeneity of non-urban narrative space. Griffith appears to have felt that where urban settings were concerned the viewer's grasp of the organisation of space for social purposes would do the trick. That organisation of space is the theme explored by the staging of the action in side-by-side spaces, by emphatic contiguity. By defining the use the Biograph films make of the space beside as lateral exposition, I have meant to bring out their argumentative side. The New York *Dramatic Mirror* described *A Corner in Wheat* (1910), Griffith's fierce (and fiercely experimental) indictment of speculation in commodities, not as a 'picture drama', but as 'an argument, an editorial, an essay on a subject of deep interest to all' (quoted in Gunning 1991: 241). *Death's Marathon* amounts, if not exactly to an editorial, then, through its exposition of narrative space – it makes us think again about the organisation of the urban environment for social purposes – at least to an argument or an essay (without ever ceasing to be a picture drama). This is something, I would argue, that Feuillade did not achieve, and perhaps could not have achieved, with the methods at his disposal.

Death's Marathon

Death's Marathon, a domestic melodrama illustrative of modern urban experience, is best known for the cross-cut race to the rescue, or non-rescue, which brings the main action to a violent conclusion. A young woman (Blanche Sweet) chooses between two suitors. The marriage brings happiness at first, and a child, then disillusion. The husband (Henry B. Walthall) gambles heavily, and covers his losses by stealing from the company he runs with his ex-rival (Walter Miller).[5] The latter realises what is going on, but covers the theft with his own money in order to protect the woman he still loves. Sinking deeper and deeper into debt, the husband decides that suicide is the only way out, and (rather oddly) calls his wife to inform her of the decision. She desperately tries to keep him on the phone while her old suitor races to the rescue. Griffith cuts between the gun-toting Walthall, to whom desperation has lent a certain suaveness, an agonised Sweet and Miller's frantic mercy-dash.[6] Miller arrives too late. Sweet, rooted to the phone, takes the full force of Walthall's death. Griffith thus disabled the narrative system he had so authoritatively made his own. This is one piece of cross-cutting which most certainly will not reconstitute the couple.

Death's Marathon includes three primary interior spaces: an office suite (inner and outer); the main room of the family home, divided into two sections by a curtain; and a saloon in the club of which both men are members, where the husband gambles. There is a fourth interior space, loosely connected to the second: the bedroom in which, during the early years of the marriage, the wife fondly expects her husband's return home from work, their child in a cradle at her side. This fourth space is linked graphically to the film's only significant exterior: parkland where the proposal of marriage takes place.[7] In the proposal scene Walthall insinuates himself around the post supporting the bower in which

Sweet sits; when he arrives home after work, he insinuates himself around the post of the bed in which she lies. Bower and bedroom are spaces linked metaphorically to each other rather than metonymically to the spaces beside them. The contiguity emphasised here is one of time rather than space: in the trajectory of idealised marriage, marriage has seamlessly given rise to parenthood. We are meant to suppose that the bedroom lies immediately to the right of the main room; the baby seems always to be on hand from that direction when its presence is required. That the trajectory of marriage as traditionally understood, with its rigid attribution of gender roles, might in fact pass aslant rather than through the narrative spaces which constitute lived (urban middle-class) life is the basis of the argument Griffith made in this film. If the onset of marriage is conceived as a sprint, then its dissolution may turn into a marathon.

The three primary interior spaces are all defined by scenes of arrival and departure, that is, by a certain relation between the inside and the outside of the building: cars draw up, people climb out and go in; people come out, climb into cars and depart. That relation between inside and outside is the 'theme' which enables us to infer their homogeneity as spaces and their function within the urban environment as a whole. The scenes at the club are set apart by the fact that they are staged in depth and on the diagonal: the corner of the room in which the gambling takes place occupies the centre of the frame, and there is a further room beyond in which activity is sometimes visible, and through which people enter and exit. In these club scenes the relation between the interior and the exterior of the building is so mediated that it does not emerge as a theme. In the scenes played in the main domestic and business spaces, by contrast, it most certainly does.

The primary domestic space and the primary business space each consist of a pair of contiguous sub-spaces arranged laterally. The domestic space is an altogether odd construction. A curtain divides it into a more public section, on the left, which gives access, directly or indirectly, to the street, and which contains a desk and a telephone; and a more private section, on the right, connecting to the bedroom, and containing a dressing-table with a mirror on it. The main business interior is equally odd. It consists of an inner office, on the left, in which a great deal happens, including suicide; and an outer office, on the right, which, although replete with furniture, is never occupied. As in *Brute Force*, though for very different purposes, Griffith has devised a 'grand left-to-right lateral'. At the far left stands the inner office, from which the outer office can be entered by movement to the right; at the far right, the inner living room, from which the outer living room can be entered by movement to the left. Between the outer office and the outer living room stretches an expanse of vestibule, pavement and street which the film does not need to render because nothing of any significance in itself will take place there.[8]

The function of this arrangement of narrative space is to figure or make intelligible the relation between interior and exterior, which is also, according to the 'social logic' identified by Bill Hillier and Juliette Hanson (1984) in a wide range of architectural modes, the relation between a public and a private realm. The most important distinction that logic maintains, Hillier and Hanson argue, is between a 'deep' space within a building attainable only by passage through other spaces, and thereby adapted for its owner's exclusive use, as sanctuary or shrine, and the 'shallow' spaces (neutral, inclusive, open-ended) through which the visitor must pass in order to attain it. A deep space, we might say, is one in which power and desire renew themselves and each other, or are finally found out. The area of transit which social elites have traditionally interposed between

that deep space and the vulgar public street gives rise, by contrast, to actions which are in some measure inessential, to behaviour amounting to ceremony rather than to revelation.

In *Death's Marathon* the inner office, at the far left of the film's grand lateral, is where dark deeds are done. Walthall takes money from the safe it contains (that recess within a recess), to feed his gambling frenzy. When he later finds his way back there (as to a sanctuary or anti-sanctuary), to kill himself, the room is in darkness and he must grope his way into it, before lighting a lamp. The illumination from the lamp creates an isolated playing space for him in the foreground of the shot. The outer office, empty throughout, though well enough equipped with desks and telephones, is an area of transit (though never just a zone, since what takes place there is of significance in itself, albeit as ceremony rather than revelation). Visitors cross and re-cross this area of transit on their way to and from the deep space it permits access to.

On one occasion a boy delivering a telegram to Miller in the inner office enters the outer office through the door in the rear wall of the set, takes an elaborate puff of his cigarette, deposits the cigarette neatly on the edge of a desk and pushes open the door to the inner office. On his way out after having delivered the telegram he retrieves the cigarette; we even catch a glimpse of him putting it to his lips again as he closes the door in the rear wall of the set. The business with the cigarette is, of course, entirely incidental. It does not advance the story. It establishes the shallow space of the outer office as precisely a space in which something other than the renewal of power and desire, something other than truth-telling, customarily occurs. That something is *performance*: an excess of symbolism over function. The business with the cigarette makes the telegram boy someone who knows he is a telegram boy. It is also, of course, business for the actor playing this character (Robert Harron): the kind of flourish which might just have caught a producer's attention.

When truth-telling rather than performance is at issue – when the story requires advancing – the outer office ceases to exist. The telegram Robert Harron has brought informs Miller that the firm will require its entire cash reserve for immediate use. Miller, who has witnessed Walthall's theft, acts swiftly to replace the stolen money with his own. Just as well, too. No sooner has he done so than the firm's backer (Lionel Barrymore) blusters directly into the inner office to confront the startled Miller, impatiently setting aside his hat and stick and pulling off his gloves. These garments bring with them the vulgar public street. We have not witnessed Barrymore's passage through the outer office's shallow space, a space made vivid for us by Harron's business with the cigarette. Power goes straight to the point. Our sense of the threat posed by Barrymore depends on our understanding that he is not someone whose actions are bound by the social logic of space. That logic has been articulated for us by lateral exposition.

There is no equivalent to the thematised homogeneous narrative spaces of *Death's Marathon* in the *Fantômas* films. Feuillade could not have accomplished by staging in depth what Griffith accomplishes by lateral exposition. David Bordwell has shown that Feuillade most certainly knew how to 'choreograph the shot'. In a scene set in the Crocodile nightclub, in Montmartre, in *Juve versus Fantômas* (1913), a violin player strolls down the aisle to the centre left of the shot and serenades Joséphine, the female protagonist, who is seated at a table in the foreground. His fiddling directs our attention to this area of the shot; when he moves aside, his movement discloses the arrival in the room of the

detective Juve and his sidekick Fandor. Juve and Fandor proceed down the aisle towards Joséphine. 'The violin player', Bordwell concludes, 'an extra, has been a spatial pretext, a mere pointer marking a zone for the major characters to occupy' (1997: 190). The telegram boy in *Death's Marathon* is also an extra; he, too, could be considered a 'spatial pretext'. The difference is that the space for which he is the pretext is not *itself*, as it would be in the *Fantômas* films, a pretext for narrative event. It is text rather than pretext: always already thematised. In the restaurant scene in *Juve versus Fantômas*, by contrast, the aisle for which the violin-player is the pretext only holds our attention for as long as it will take Juve and Fandor to fill it. It does not exist as a space organised architecturally for social purposes. It is, in fact, a time rather than a space: the seconds which must elapse before Juve and Fandor can be brought convincingly into relation with Joséphine. It is no less of a zone (no less abstract) than the spaces through which the protagonists speed in one of Griffith's races to the rescue.

More often than not, Feuillade's staging in depth divides narrative space into a foreground, in which or towards which meaningful action occurs, and a decorative background. In *Juve versus Fantômas*, Juve and Fandor pose as potential purchasers in order to gain entrance to the deserted villa belonging to Lady Beltham, Fantômas's accomplice, mistress and victim. The tour of inspection led by the custodian proves desultory in the extreme until the party reaches Lady Beltham's bedroom. Here, Juve advances towards the camera, while Fandor and the custodian retreat into the background. Juve notices an inkstand on the table at the foot of the bed. Narrative space has been divided into two areas or planes: a foreground replete with narrative meaning and a background of no interest whatsoever. Juve shows the pen to the other two, thus bringing them forward into significance. Used less than three days ago! The villa clearly remains a place of rendezvous. A medium close-up shows Juve scrutinising the pen, framed by Fandor and the custodian. Although the episode at the villa has involved passage from the vulgar public street to deep space, it has done nothing at all to expound the social logic which renders urban space intelligible.

'Griffith', as Bordwell quite rightly remarks, after an instructive survey of staging in depth in European cinema before World War One, 'seems to have had little recourse to the fine-grained intrashot choreography developed by his contemporaries' (1997: 196). It is not that Griffith did not conceive of staging in depth as the basis for such a choreography. The scene at the club in *Death's Marathon* demonstrates a full awareness of the dramatic advantages it might yield. As Salt points out, the outdoor subjects he produced from 1909 onwards often have Native Americans or fisher-folk going about their colourful business in a 'space behind' that in which the main action unfolds (1992: 104). But he seems also to have wanted to find out what advantage other methods might yield. There is choreography, of a kind, I would argue, in the lateral exposition of the Biograph films: a choreography of spaces rather than persons.

Gender and the Space Beside

It was by such 'choreography' that Griffith developed his critique of the patriarchal family. Sweet's marriage to Walthall runs rapidly into trouble. The brief scene of contented homecoming is followed immediately by a scene at the club and an ominous intertitle: 'The self-centred husband bored with the monotony of married life.' A further scene, consist-

ing of three shots, and played out across or between the sub-spaces which together compose the thematised narrative space of the family home, gives substance to Walthall's boredom and the pain it causes Sweet. In the first of these shots, Walthall, in the inner or right-hand domestic space, and dressed to go out, pulls on his gloves. He has already, in effect, left home. A hand reaches out from off-screen right (that is, from the bedroom), to proffer his hat, and rests on his arm, detaining him.[9] Sweet enters and Walthall glances down at the hand resting on his arm, and, in particular at the wedding-ring on one finger. In shaking Sweet off, he seems also to have shaken off marriage itself. The next shot shows Walthall alone in the outer or left-hand domestic space, speaking and gesturing off-screen right, to Sweet, we assume, who has remained on the other side of the curtain; he puts his hat on his head and leaves. Griffith then cuts back to Sweet, in the inner domestic space. She seats herself on a chair at frame right, stares into the mirror on a dressing-table at the back of the set and bursts into tears. Gunning notes that this is the only occasion in the Biograph films on which Griffith used a mirror to reveal state of mind. Sweet's removal from the camera's direct gaze reinforces her isolation: 'the pushing of her to the right edge of the frame' (2003: 62). Like the safe in the inner office, the mirror is a recess within a recess: the deepest space of all, where there is no hiding from the truth. Sweet looks into the mirror and sees that there is nothing to marriage, to Walthall as a husband. Miller will later look into the safe and see that there is nothing to partnership, to Walthall as a professional man.

This pattern of cuts from one side of the curtain dividing the main room of the house to the other is repeated in a later scene. 'Soon estranged from his wife', an intertitle announces. Walthall, in the inner domestic space, pulls on his gloves. Sweet appears from the left, dressed to go out for the night, gloves in hand. They quarrel. He almost strikes her, before storming out in the direction of the outer domestic space. We see him there, speaking and gesturing off-screen right, as on the previous occasion (it is hard to tell whether or not Griffith has simply used the same shot again). A final shot of a distraught Sweet in the inner domestic space brings the triptych to its completion. The repetition of the pattern of shots firmly identifies her with that space. Griffith thus stages Walthall's departure from home, and from marriage, across a gendered distinction operating between deep and shallow sub-spaces.

The thematisation of the homogeneous narrative space of the family home does more to define Sweet's part in the climactic race to the rescue than any amount of cross-cutting. It defines her conduct, as she tries desperately to stay her husband's hand, as a transformation or emergence. She comes out from the paralysis brought on by her humiliating confinement to deep space. Crisis will oblige her to negotiate the exposure to what others know or sense about her, and to what they expect of her, which an occupation of shallow space always entails. As the crisis begins to unfold, Miller arrives at the family home by car, having failed to locate Walthall. Sweet is seated in the outer room, to the right of the frame. The maid announces Miller, who enters hat in hand. Griffith has thus gently re-thematised narrative space by reminding us of the connection between this semi-public interior and the public street. Walthall is soon on the phone, declaring suicide. An intertitle informs us: 'The wife holds him on the wire until the friend can reach the office in town.' Sweet achieves this by putting on a performance of which we might well have thought she was not capable. She expresses the loving concern of a wife for her husband, of a mother for the father of her child. There is a rigour to the expression of

these feelings which raises it above expression into performance; no more so than when, in a sequence of shots traversing inner and outer domestic spaces, the baby is brought to the phone. The baby's evident fascination with the apparatus itself, as Walthall continues to declare suicide, confirms that shallow space is indeed the realm of the inessential. Sweet has put herself at risk in that realm. In narrative terms, her intervention proves a failure. But the performance she puts on in failing (that excess of symbolism over function) has made her a new person.

Griffith's races to the rescue invariably involve three parties, each active in his or her own way: the assailant assailing, the victim staving off assault and the rescuer racing to the rescue. In a suicide attempt, however, the victim is also the assailant. In *Death's Marathon*, Sweet takes the spare role, which is really that of narrative process itself since it is her appalled reaction which first informs us that Walthall has taken his own life. Her response alone conveys the meaning of the event; the performance she puts on has made her a new person in a new film, a film which cannot do without her. The phone conversation is shot in relative close-up throughout; Sweet could be said to have stepped forward for the first time into that abstract space between screen and audience which mirrors the depth of the image. Her look, Joyce Jesionowski observes, 'directed out of the fragile frontal plane, creates a link with the image of her husband that reflects the fluctuation between the real and the imaginary in the film, between expectations and resolution, between anxiety and knowledge' (1987: 45). By thus developing the extreme foreground position Sweet occupies as the 'abstract limit of the frame' (1987: 46), Griffith has brought forward into view not only her new strength of purpose, but filmmaking itself.

Griffith, of course, was no feminist. After it is all over Miller comes courting again, finding Sweet in confident occupation of the outer domestic space, but now viewed in long shot. The solution to a bad marriage is a good marriage. It would take little short of a further marital cataclysm, we imagine, to bring her back to the frame's absolute limit – or get her out of the house. Even so, the film can be considered to have had its say about the ways in which a woman might come into her own within marriage; about the overcoming of patriarchally-enforced distinctions. Griffith's lateral exposition has expounded a point of view as well as a narrative space.

If the telegram boy's incidental business with the cigarette might have been an opportunity for Robert Harron, then how much more might Blanche Sweet's far from incidental business with telephone and baby have provided for her? In June 1913, the month in which *Death's Marathon* was first shown, Biograph, which had hitherto been slow to promote its players, released a striking head shot of Sweet in one of the first fan magazines (see Gunning 2003: 61). The extreme foreground position into which she had stepped forward in the climax to *Death's Marathon* was that of stardom.

Thematisation after Continuity

Lateral exposition was the road not taken either by Griffith, in his subsequent work, or by American filmmakers in general. But it is worth considering, by way of brief, speculative conclusion, whether the idea which informs it – of a 'world' expounded, rather than edited or staged, into being – might not have continued to inform American filmmaking, in one way or another, long after the establishment of the classical continuity system. When Elsaesser and Barker consider the afterlife of the distinctive 'spatial articulations'

of Griffith's Biograph films, they make reference primarily to the 'counter-cinema' of the post-World War One European avant-gardes (1990: 312–13). Jacques Aumont speaks, with Jean-Luc Godard's *La Chinoise* (1967) in mind, of a '*return of Griffith* in certain modern films' which is 'in no way, of course, a return *to* Griffith' (1990: 353; emphasis in original). But there are other ways to conceive of that afterlife. Scott Simmon, for example, has identified Griffith's Biograph domestic melodramas as the origin of the Hollywood 'woman's film' (see 1993: 68–103). My suggestion here is that Howard Hawks, master of continuity editing, also found a use for thematised homogeneous narrative space.

I have in mind the openings of two films which exemplify the two basic types to which, in Peter Wollen's view, Hawks reduced the genres available to him: crazy comedy and adventure drama (Wollen 1998: 53). *His Girl Friday* (1940) and *The Big Sleep* (1946) are of course far from silent; and the techniques which fashion their openings bear little resemblance to the static camera, frontal staging and room-to-room cuts of the Biograph melodramas. However, those openings do make supremely inventive use of the principle of emphatic contiguity. They ensure the homogeneity of narrative space by expounding a social logic comparable to that expounded in *Death's Marathon*.

In *His Girl Friday*, we are introduced to the newsroom of the *Morning Post* by a sequence of lateral tracking shots which carries us across it from the vicinity of the editor's office to the foyer where visitors can be deposited until someone finds time to attend to them. Hawks's grand lateral thus comprises, from left to right, a foyer (in effect, an extension of the public street); an outer office, open-plan and full of activity, marked off from the foyer by a barrier and a 'No Admittance' sign; and a hermetically enclosed inner office where, we soon learn, power and desire renew themselves. The sequence of tracking shots comes to rest on the figure of Hildy Johnson (Rosalind Russell), emerging from a lift in the company of Bruce Baldwin (Ralph Bellamy), her insurance salesman suitor. Bruce, whose full panoply of rainwear has brought the vulgar public street in with it, stays in the foyer; meanwhile a second sequence of tracking shots conveys Hildy across the newsroom, through a relay of rapid-fire exchanges, to the editor's office, where Walter Burns (Cary Grant) is murkily engrossed in dealings with henchmen. Here, Walter receives the double stimulus, to desire and to power, of the news that Hildy is about to marry Bruce, and that Earl Williams (John Qualen) is about to be executed for a crime he did not intend. A third and final sequence of tracking shots then accompanies Walter and Hildy as they trade gallantries on the way back to the foyer, and shows us a memorable encounter with the handle of Bruce's umbrella. A social logic informs this arrangement of narrative space, just as a social logic had informed the emphatic contiguity of the inner to the outer office, and the outer office to the public street, in *Death's Marathon*. The camera movements which cross it from one side to the other are its lateral exposition.

Those movements answer, it would seem, to something in the sort of behaviour generally thought appropriate to areas of transit: behaviour emblematic of the virtues of performance rather than of revelation. Stanley Cavell has argued that in Hollywood remarriage comedies, which begin in (or from) separation, the attempt to escape from an ex-partner 'is forever transforming itself into (hence revealing itself as) a process of pursuit' (1981: 113). During that process, 'we are permanently in doubt who the hero is, that is, whether it is the male or the female, who is the active partner, which of them is in quest, who is following whom' (1981: 122). During the scenes in the inner office and in the foyer, in *His Girl Friday*, the male is the hero, the active partner. Walter's authority as editor, supplemented

by wit and an ability to improvise, gives him the edge. Once the camera has begun to move, however, on the way back across the outer office to the foyer, the balance of desire and power shifts. Hildy, after all, has already shown us, during the second sequence of tracking shots, that she is master (both as newspaperman and as embodiment of feminine elegance) of that domain. Getting ahead of Walter, but only in order to usher him eloquently through the next gate ('Allow *me*'), she enacts the comic transformation of flight into pursuit. Robin Wood has argued that the interest of Hawks's women lies in the fact that they are 'anomalous and threatening, but *there*' (1996: 169). But there *where*? In the opening scenes of *His Girl Friday*, lateral exposition shows us exactly where.

It is no surprise that the opening of *The Big Sleep* should offer a comparable grand lateral because the novel by Raymond Chandler from which the film was adapted opens with an intricate exposition of the social logic of narrative space. Marlowe (Humphrey Bogart) has dressed for his visit to General Sternwood's (Charles Waldron) Bel-Air mansion with pedantic dandyism. He is staunchly in uniform, right down to the black wool socks with dark blue clocks on them. After all, he is calling on 'four million dollars' (Chandler 1948: 9). He passes through the hall, where Carmen Sternwood (Martha Vickers) flirts with him and falls against him, round the lawn behind the building, to the greenhouse where the General sits in absolute recession, at the heart of darkness. The greenhouse is the mansion's primary cell, a deep space adapted for its owner's exclusive use. To reach it from the street Marlowe must negotiate a whole series of shallow areas of transit, with the butler Norris (Charles D. Brown) as guide. 'Here, in a space of hexagonal flags, an old red Turkish rug was laid down and on the rug was a wheelchair, and in the wheelchair an old and obviously dying man watched us come' (ibid). The syntax mimics Marlowe's deferentially circuitous approach to the source of power and desire. The source, however, is no longer a source. General Sternwood still has the capacity to renew his far-reaching authority. The four million dollars will see to that. But he has run out of desire:

'A nice state of affairs when a man has to indulge his vices by proxy', he said dryly. 'You are looking at a very dull survival of a rather gaudy life, a cripple paralysed in both legs and with only half of his lower belly.' (Chandler 1948: 13–14)

Sweating heavily in the intense heat, Marlowe proceeds to drink and smoke on the General's behalf. Absorption into deep space has already cost him his dapperness. On the way back out, however, he encounters the General's other daugher, Vivian (Lauren Bacall), the far from dull survival of a less than gaudy life, and starts to do some desiring on his own account. 'She was worth a stare', we learn in the novel. 'She was trouble' (1948: 22).[10] Shallow space is where the action is, in Chandler's Los Angeles.

In adapting the novel, Hawks and his scriptwriters reproduced the structuring social logic of its inaugural scene for cinema. As in *His Girl Friday*, fluid camera movements (this time in the form of pans rather than tracking) unlock the potential of shallow space: its subtle incitement to performance. The room in which Vivian entertains Marlowe on his way out of the house has been given a new location, so that it now opens (somewhat incongruously) off the hall, opposite the staircase down which Carmen had dawdled to intercept him on his way in. It has also been equipped with a conspicuous double bed. In the film, as in the novel, Marlowe smokes and drinks on behalf of impotent male authority, resigned, it would seem, to an unpleasant if highly profitable subservience. In

both, he rediscovers his effrontery, and a good deal else besides, while in transit back across the unpredictable hallway. On his way in, he still belongs to authority (to his own dapper subservience to authority): hence the ease with which he repels Carmen, and his patronising remark that they ought to wean her. But his spell in the greenhouse prompts in him a new and countervailing urgency. On his way out, he looks to desire rather than to comply. This time, he even cheeks the silver-haired butler. For Hawks, as for Chandler, shallow space is where the action is.

Folds in narrative space have opened up to reveal Carmen and Vivian, both anomalous, both threatening, both exactly *there*. Yet it would be hard not to conceive of a revitalised Marlowe (a revitalised Bogart) as the force which opens up the fold concealing an expectant Vivian (an expectant Bacall). On the way in, an uninquisitive pan carries Marlowe, who has just disentangled himself from Carmen, across the hallway – the entrance to Vivian's bedroom briefly glimpsed – in the direction of the greenhouse. On the way back out, a two-shot of Marlowe and Norris frames the (now open) bedroom-door at some length, as the two men discuss financial terms and generally bristle at each other. Norris then leads the way to the open door. 'Go right in, sir, you're expected.' Hawks cuts to the interior of the bedroom. A further track and pan carries Marlowe across it – the double-bed conspicuous in the background – to where Vivian awaits him. The sight of Vivian's legs will launch him not so much on an enquiry as on a riotous serial exhibition of sexual magnetism. Generic and other determinants have ensured that in this case it's the male who gets to perform in shallow space.

My argument has been that what made it possible for Griffith and Hawks to explore as inventively as they did the idea of performance – performance as identity, performance as what an actor or actress does in order to become a star, performance as movie-making itself – was a certain understanding, which their audiences could be assumed more or less to share, of the social logic of urban narrative space. Griffith's abortive experiment in lateral exposition had demonstrated what could be done with that logic. The conclusions to be drawn from it would thereafter vary, from historical moment to historical moment, from director to director, from film to film.

NOTES

1 On the transition to story films in American cinema, see Musser 1990: 337–69.

2 Thompson reserves the term 'parallel editing' for cuts between events which do not occur at the same time. Other historians use the terms 'cross-cutting' and 'parallel editing' interchangeably. For simplicity's sake, I will observe Thompson's distinction here.

3 Gunning draws on Brewster 1990, and Salt 1992: 113–19.

4 Rogin argues that the 'collapse of gender and social differences' apparent in the Biograph films prompted Griffith to generate a 'new and deeper system of differences' (1985: 159) in *Birth of a Nation*. On *Intolerance*, see Hansen 1991 and Rogin 1989; on *Broken Blossoms*, see Browne 1987; and on *Way Down East*, see Wexman 1993.

5 Since the characters in this film were not named in the intertitles or in Biograph publicity material, I shall identify them by reference to the actor or actress.

6 Walthall had played a comparably suicidal widower in *The Usurer* (1912). Blowing his brains out on screen was evidently something of a specialism.

7 There is a second exterior 'space', examined to illuminating effect by Tom Gunning. A shot of Sweet seated demurely in an elaborate garden renders by its 'dream-like aspect' the vision Miller has of her (the feelings he has for her). It is, as Gunning points out, 'one of the most deliberately subjective images Griffith had yet achieved at Biograph' (2003: 60–1). It does not belong to the thematised homogeneous spaces established throughout the film by lateral exposition.

8 One consequence of the artificiality of this arrangement of sub-spaces is that they are rather hard to identify. Gunning, for example, describes the inner or right-hand domestic sub-space as a 'sort of hallway' (2003: 62). It does not, however, lead directly or indirectly to the street. A further complication is introduced by the fact that, as Gunning points out, the same set does service both for this inner sub-space and for the bedroom where Sweet and her baby await Walthall's return from work.

9 Gunning says that the hand appears from the left of the frame (ibid.). In a scene like this, constituted by lateral exposition, it matters that the hand should in fact appear from the right, which in the family home is the direction of interiority.

10 For a discussion of this scene at greater length, in the context of hard-boiled fiction, and its distinctive fantasies, see Trotter 2000.

WORKS CITED

Aumont, J. (1990) 'Griffith: the Frame, the Figure', in T. Elsaesser (ed.) *Early Cinema: Space, Frame, Narrative*. London: British Film Institute, 348–59.

Bordwell, D. (1996) '*La Nouvelle Mission de Feuillade*: or, What Was Mise-en-Scène', *Velvet Light Trap*, 37, 10–29.

_____ (1997) *On the History of Film Style*. Cambridge, MA: Harvard University Press.

Bordwell, D., J. Staiger and K. Thompson (1985) *The Classical Hollywood Cinema: Film Style & Modes of Production to 1960*. London: Routledge.

Brewster, B. (1990) 'Deep Staging in French Films, 1900–1914', in T. Elsaesser (ed.) *Early Cinema: Space, Frame, Narrative*. London: British Film Institute, 45–55.

Brewster, B. and L. Jacobs (1997) *Theatre to Cinema: Stage Pictorialism and the Early Feature Film*. Oxford: Oxford University Press.

Browne, N. (1987) 'Griffith's Family Discourse: Griffith and Freud', in C. Gledhill (ed.) *Home is Where the Heart Is: Studies in Melodrama and the Woman's Film*. London: British Film Institute, 223–34.

Cavell, S. (1981) *Pursuits of Happiness: The Hollywood Comedy of Remarriage*. Cambridge, MA: Harvard University Press.

Chandler, R. (1948) *The Big Sleep*. Harmondsworth: Penguin Books.

Elsaesser, T. (1990) (ed.) *Early Cinema: Space, Frame, Narrative*. London: British Film Institute.

Elsaesser, T. and A. Barker (1990) 'Introduction' to 'The Continuity System', Part 3 of T. Elsaesser (ed.) *Early Cinema: Space, Frame, Narrative*. London: British Film Institute, 293–317.

Gish, L. (1969) *The Movies, Mr Griffith, and Me*. Englewood Cliffs: Prentice-Hall.

Gunning, T. (1991) *D. W. Griffith and the Origins of American Narrative Film: The Early Years at Biograph*. Urbana: University of Illinois Press.

___ (1993) 'Notes and Queries about the Year 1913 and Film Style: National Styles and Deep Staging', in T. Lefebvre and L. Mannoni (ed.) *L'Année 1913 en France*. Paris: A.F.R.H.C., 195–204.

___ (2003) '*Death's Marathon*', in P. C. Usai (ed.) *The Griffith Project*, vol. 7. London: British Film Institute, 55–66.

Hansen, M. (1991) *Babel & Babylon: Spectatorship in American Silent Film*. Cambridge, MA: Harvard University Press.

Hillier, B. and J. Hanson (1984) *The Social Logic of Space*. Cambridge: Cambridge University Press.

Jesionowski, J. (1987) *Thinking in Pictures: Dramatic Structure in D. W. Griffith's Biograph Films*. Berkeley: University of California Press.

___ (2003) '*Brute Force*', in P. C. Usai (ed.) *The Griffith Project*, vol. 7. London: British Film Institute, 110–16.

Keil, C. (2001) *Early American Cinema in Transition: Story, Style, and Filmmaking, 1907–1913*. Madison: University of Wisconsin Press.

Keil, C. and S. Stamp (2004) *American Cinema's Transitional Era: Audiences, Institutions, Practices*. Berkeley: University of California Press.

Merritt, R. (2001) '*The Root of Evil*', in P. C. Usai (ed.) *The Griffith Project*, vol. 5. London: British Film Institute, 192–4.

Musser, C. (1990) *The Emergence of Cinema: The American Screen to 1907*. Berkeley: University of California Press.

Pearson, R. (1992) *Eloquent Gestures: The Transformation of Performance Style in the Griffith Biograph Films*. Berkeley: University of California Press.

Rogin, M. (1985) '"The Sword Became a Flashing Vision": D. W. Griffith's *The Birth of a Nation*', *Representations*, 9, 150–95.

___ (1989) 'The Great Mother Domesticated: Sexual Difference and Sexual Indifference in D. W. Griffith's *Intolerance*', *Critical Inquiry*, 15, 3, 510–55.

Salt, B. (1992) *Film Style and Technology: History and Analysis*, second edition. London: Starword.

Schickel, R. (1984) *D. W. Griffith: An American Life*. New York: Proscenium.

Simmon, S. (1993) *The Films of D. W. Griffith*. Cambridge: Cambridge University Press.

Thompson, K. (1985) 'The Formulation of the Classical Style, 1909–1928', in D. Bordwell, J. Staiger and K. Thompson, *The Classical Hollywood Cinema: Film Style & Modes of Production to 1960*. London: Routledge, 157–240.

Trotter, D. (2000) 'Fascination and Nausea: Finding Out the Hard Way', in W. Chernaik, M. Swales and R. Vilain (eds) *The Art of Detective Fiction*. Basingstoke: Macmillan, 21–35.

Usai, P. C. (1999–2004) (ed.) *The Griffith Project*. London: British Film Institute.

Wexman, V. W. (1993) *Creating the Couple: Love, Marriage, and Hollywood Performance*. Princeton: Princeton University Press.

Wollen, P. (1998) *Signs and Meaning in Cinema*, expanded edition. London: British Film Institute.

Wood, R. (1996) 'Retrospect', in J. Hillier and P. Wollen (eds) *Howard Hawks: American Artist*. London: British Film Institute, 163–73.

4 SYMPHONY OF A CITY: MOTION PICTURES AND STILL LIVES IN WEIMAR BERLIN

Andrew Webber

Prelude – Trauma in Transit

Trauma is generally taken to be an experience of shocking and blocking: an untoward freeze-frame, as it were. This model is established in Freud's description in his *Moses and Monotheism* of a train crash as exemplary of traumatic experience: a violent halting on and of the transportation network (Freud 1985: 309). In the early twentieth century this form of technologically advanced trauma enters into and impacts upon the city, where modes of movement, and especially travel technologies, are at their most dense and loaded. An example would be the dramatic derailment of a train on an overhead stretch of Berlin's urban railway at the Gleisdreieck interchange in 1908. At the same time, in Freud's account, while the journey is catastrophically interrupted by the train crash, the trauma survivor may leave the site of the accident apparently unharmed. That is, the traumatic stop articulates the routine dynamics of transportation with another form of, apparently unimpeded, onward motion. In fact, this continuation in another form will come to be symptomatically marked by the after-effects of the traumatic impact, in the form of 'severe psychical and motor symptoms' (ibid.) that return upon the 'un-dead' traveller. Indeed, the earlier part of the broken journey will also, in some sense, have anticipated the moment of impact. The knowledge of an accident like that at Gleisdreieck makes it ready to happen again at any point. The implication of this is that trauma takes effect not just in the actual impact of stopping, but also in the sorts of anticipations and after-shocks that have a latent hold on the dynamics of walking, riding and driving in the city. Modern mass movement is shadowed by both kinds of uncanny effect.

This essay will consider, then, the effects of trauma in transition. In doing so, it will pursue a particular kind of affinity between urban transportation systems and the media of the moving image. From the early 'phantom rides' of the film camera mounted on vehicles of various kinds to the unremitting CCTV filming of under- and overground station platforms today, the two technologies are coupled, the one a prosthetic enhancement of the capabilities of the other. But the traumatic moment of the accident haunts that double enhancement of closely observed and observing trains and stations: a phantom indeed for the phantom ride of the camera. If the accident on the train or other means of transport means a seizure of the mobility that defines it, so for the film camera it implies a violent, incursive version of still photography. While the entry and coming to rest of the train in the station can be understood as an analogy for the still photograph (Walter Benjamin draws such an analogy between railway station and photography),[1] the unsched-

uled stop suggests a kind of negative version of that stillness, a seizure of the image-flow and an exposure of the frame: the phantom structure that is hidden by the mobility of the moving image.

First Movement – Phantom Ride and Dead City: Ruttmann

I have considered varieties of this stopping effect in a number of Weimar films elsewhere, in particular through the impact of the train-crash that opens Robert Wiene's *Orlacs Hände* (*The Hands of Orlac*, 1924) (see Webber 2002). Here, the aim is to consider its implications further through the transitions between film – in particular one of the defining city films, Walter Ruttmann's *Berlin: Die Sinfonie der Grosstadt* (*Berlin: The Symphony of the Big City*, 1927) – and the contemporary aesthetics of the still image. The famous opening sequence of Ruttmann's film enacts this transitional relationship in two ways. Firstly, it incorporates the aesthetics of animation into the filming of the image-stream seen from the train as it speeds towards the city. The high-speed imaging creates both a powerful effect of abstract shape and light in motion, and the sort of image of stillness that is paradoxically produced by intensely repetitive movement. Secondly, the slow sequence representing the sleeping city after the train has entered the station reduces the filmic flow to virtual stasis in a sequence of evacuated street scenes reminiscent of Eugène Atget's Paris photographs. The first conjures the still image that is the basis of animation out of what was perhaps the most accelerated sequence yet to have been filmed at that point. The second, in its representation of what the director calls the 'dead city' (quoted in Goergen 1989: 27),[2] rolls back the moving image technology into that of still photography, mortifying the dynamics of film that had just been displayed to such virtuoso effect. It serves to show that the exhilaration of the opening sequence constituted a false start, and that the life of the city that will drive the dynamics of the main body of the film rests upon a condition of dead stop.

In the opening sequence, then, the film incorporates in its montage two other forms of visual representation: the cartoon and the still photograph. As the animation-style effects of the film's opening, signature sequence show, Ruttmann's film should be seen against the background of the avant-garde trend towards an absolute cinema, whereby the medium would free itself from the literary apparatus of drama and narrative and experiment with its own technical and aesthetic specificity.[3] In the terms used by Moholy-Nagy, it was to become 'filmic',[4] self-standing rather than supplementary. If this new, autonomous cinematic art was to relate to any other medium, then it was music, conceived as the least figurative of artistic forms: the film image would work in the mode of a compositional structure, through repetition with variation and the dialectical energy of contrapuntal organisation. Movement, as motor of contrastive effects of shape and light, was thus the stuff of the new filmic mode of composition. Ruttmann was the champion of this filmic avant-garde in the early 1920s, and his *Opus* series of abstract shorts (1921–25) a laboratory for the new aesthetic programme. As Walter Schobert (1989: 14) has argued, Ruttmann's Berlin symphony can be seen less as an exercise in documentary work than as a continuation of the experiments with light and rhythm in the earlier, abstract shorts.

The montage structure of the film of the city certainly gives the opportunity for an elaborate, abstracted study in both sequential and variable motions of figures against

ground. This image-track functions dialectically with Edmund Meisel's film music, in which the montage principle is also at work, creating a contrapuntal acoustic space. A consequence of the understanding of the film as, above all, a more extended exercise in audiovisual experimentation is a tendency away from the sort of political responsibility that the material object of the film – a metropolis in a time of massive socio-political upheaval – might seem to demand. This is the basis of the sort of critique that has been levelled at it, most notably by cultural theorist and film critic Siegfried Kracauer (1927), as a film that fails to engage with the realities of life. Certainly, the film seems content to represent abject poverty as just another aspect of the urban spectacle, to organise the images of other races in the film around carnivalesque figures of colonialist commerce, and to collude with the logic of women as objects of display, on and off the street.[5]

Ruttmann's film appears in this analysis as an elaborate extension of the sort of photographic image famously critiqued by Brecht (2000: 164), and, after him, by Benjamin (1997a: 255): a representation of the outside of an AEG or Krupps factory that, however, effaces the functional apparatus of capital and consumption that sustains the corporate image from without and that of labour that sustains it from within. The factory is thus rendered as an aesthetic surface, an object of contemplation, mimicking social realism but inevitably remaining at the level of the fetish; and, on the face of it, Ruttmann's film indeed seems open to this kind of reading. It is perhaps no coincidence that the film does record the entry of workers into, and emergence from, the factory, a key topos of early film.[6] While his camera also goes inside factories, it apparently does so in order to orchestrate the mechanical energy of the production system into the cinematic spectacle rather than to expose the iniquities of the apparatus in a critical representation of the world of industrialised labour. While the moving camera of film is, in principle, able to probe into the structures that lie behind the surface image of Brecht's factory photograph, it can also merely serve the sort of attachment to the aesthetic surface that Janet Ward (2002) has described in her work on Weimar visual culture. Urban photography might appear to address social reality in an indexical fashion, and so attach itself to that reality; but it is also liable to resolve the depth and texture of social reality into effects of light, form and surface. When it is adopted as a paradigm for filmmaking, as in the case of *Berlin: The Symphony of the Big City*, it can serve to elide the documentary potential of the camera into formalistic experiment.

The opening sequences of the film show how Ruttmann, like many of his contemporaries, approached his experiments in the film medium through the still media of graphic art and photography, and their convergence in the avant-garde praxis of photomontage. In 1920s Berlin, developments in the media of still and moving image ran in parallel, with significant crosscurrents. Such films as *Berlin: The Symphony of the Big City* have to be understood through the medial complex that surrounds them, not least the graphic images projected in posters and other publicity material. Three migrants who joined, and then helped to shape, the Berlin avant-garde of the 1920s – El Lissitzky, Moholy-Nagy and Umbo (Otto Umbehr) – can serve to outline this framework here.

A significant effect of the rise of the film medium in its early decades was a galvanisation of other media, pictorial and literary, towards filmic effects of mobile extension in time and space. The 'Neues Sehen' (New Seeing) that became a key slogan of the avant-garde around the Bauhaus,[7] proclaiming new forms of optical discipline, was substantially informed by a transfer of the 'filmic', in Moholy-Nagy's definition, to cultural

perception at large. That is, film was to be established as an autonomous form, only to be yoked to new versions of old forms of representation. Thus, Russian Constructivist El Lissitzky developed his concept of the 'Proun': graphic – and not least typographic – art that is projected into a new time-space continuum. For El Lissitzky, the typographic image would be cast into topography. His short statement 'Topography of Typography', published in the journal *Merz* in 1923, conceives of the book as three-dimensional space, with the language of print projected into that of architectonics.[8] In his theory and practice, El Lissitzky projects the poster into the urban environment and artwork into the integral and demonstrative experience of the installation space as what he calls 'Prounenraum'. The new exhibition aesthetic requires a new optics, a 'Neues Sehen', consonant with the complexity and mobility of modern urban experience. Conventional aesthetic contemplation in two dimensions would thus be converted into an active negotiation of the third spatial dimension and this, in turn, opens up a new temporal experience of the work of art. The medial mobility of this architectural and topographical modelling of graphic art is nicely envisioned as a process of transfer on the urban transport system, with the 'Proun' as what he calls a 'transfer station from painting to architecture' (quoted in Lissitzy-Küppers 1967: 325). It thus emulates the topographical movement of film as prime vehicle in the transport and transfer system of the new, exploratory urban optics.

Second Movement – Dynamics and Statics of the Metropolis: Moholy-Nagy

In his film-scenario in storyboard form written in 1921–22, *Dynamik der Gross-stadt (Dynamic of the Metropolis)*, often seen as an influence on Ruttmann's film, Moholy-Nagy projects the new typo-topography more explicitly into cinematographic form. The scenario develops from an early sketch in ideographic form into an orchestrated structure incorporating typographic experiment, photography and photomontage. As 'typophoto' film-text, the work incorporates the whole space of the page as if on screen, suspending, as Dimendberg (2003: 114) has argued, conventional graphic relations between figure and ground. As an exercise in dynamics – with the repetitive Weimar Berlin watchword 'Tempo Tempo' figuring as leitmotif – the intermedial film-text strains at the limits of its printed form.

One embodiment of the metropolitan tempo is the wild cat caged in the urban jungle. Thus, the tiger is dialectically split between the unimpeded onrush that might seem to embody the affinity between urban and cinematic dynamics and the 'oppression' and 'constriction' (L. Moholy-Nagy 1969c: 125) of the cage and the page. The turning of the wild animal in its urban setting can serve as an emblem of the ambivalent construction of the urban film-text and, at the same time, suggest a projection of that constraint into the apparently unimpeded form that the text would be assumed to take on the screen. The city film is akin to the vehicles of its transport system, rushing openly but also containing and contained, made to stop, turn and circulate. Moholy-Nagy's dynamics are recurrently held up in the processes of construction (of houses or zeppelins) and in spaces of deferment (shunting yards, sidings). The film displays procedures of preparation in order to control its shock effects; the appearance of the tiger is designed 'to accustom the public from the outset to surprises' ibid.). This is then redeployed through the work by the 'frequent and unexpected appearance of the lion's head', intended to challenge

the pleasure of the audience again and again with 'uneasiness and oppression' (1969c: 135). The element of surprise inherent in the rush of images will be broken by the counter-surprise of hold-up.

The film-text moves at variable speeds and in multiple directions and depths of field, repeatedly going into frame-hold or slow-motion, into extreme close-up or long shot, into reverse or spiral. At its end it is relayed on by the typographical doubling up of the final full stop into a colon, so that it goes into potentially infinite replay: 'THE WHOLE THING TO BE READ THROUGH AGAIN QUICKLY' (1969c: 137). What the quick rerun emphasises, however, is the texture of slowing and holding in this dynamic notation, and especially those points at which the vitality of the spectacle is subjected to mortification. The glass of water, which is a key prop throughout, providing the film with effects of containment, flow and overflow, introduces by metonymic logic a scene of death by water. Out of the prospect of the stuff of life comes the perspective of the mortuary: 'Glass of water/Identification of corpses (morgue) from above.' (1969c: 134). The glass as a more or less immaterial body becomes a vehicle of inspection of the dead body, a scene that is reprised at the end of the scenario in the spectacle of a cadaver swimming in the water 'very slowly' (1969c: 137). The shadow-side of this transparently graphic and dynamic urban film-study is displayed here in the slowed mobility of the corpse, configured with a photograph of the semi-transparent body-image of a dead bird. Part of what the film wishes to surprise with is the event of death that is integral to the life of the city and always ready to strike unexpectedly.

Elsewhere in the film-text, this traumatic impact is associated with transportation technologies, in each case perceived through glass and in association with water. There is a sequence of shots of intersecting roads, waterways and railways, leading to a view of a passing train from beneath, the viewpoint of the accident victim. This is then relayed to that of a watchman, beholding the passing train with 'glassy eyes' (1969c: 126), as if a closely observing camera. While a train features later as a vehicle of recreational viewing in the amusement park, here it is an object of a mortified form of vision. A little later, a scene in a telephone booth ('glass-glass-glass'), leads to a view up to an aeroplane above the city and then a 'low aerial' view from the plane onto a waterside section of the city below (see 1969c: 127–8).

The speeding vehicles of transportation are at once followed in accelerated form in their centripetal and centrifugal motions in a horizontal plane and then propelled into a downward movement, with fatal implications for the plane and the shot from above. The camera rises to view a wireless mast, then 'is swiftly tilted over' with a 'sense of plunging downwards' (1969c: 128). The pyrotechnical movements of the film-text are recurrently returned to the shock of impact and the threat of paralysis. While city-dwellers are, Moholy-Nagy argues in his 'Simultaneous or Poly-cinema' essay (see 1969b), apparently attuned to the optical and acoustic hyper-mobility of such spaces of urban convergence as Berlin's Potsdamer Platz, there is always the danger that they might revert to the condition of the man from the country, so overwhelmed by the assault of sound and image 'that he stood as though rooted to the spot before an oncoming tram' (1969b: 43). The perpetual mobility of the city is always ready to be struck by mortal freezing of this kind.

The programmatic dynamics of Moholy-Nagy's film-text are set in counterpoint with the shock of the still and thus with the sort of mortuary effects that have been recognised as inherent to the work of stills photography by such key theorists as Benjamin, Barthes

and Sontag. In this sense, *Dynamic of the Metropolis* should be considered in conjunction with Moholy-Nagy's short filmwork with another kind of programmatic title for urban representation, *Berliner Stilleben* (*Berlin Still Life*, 1926). While *Berlin Still Life* registers the motions of city life, as viewed both in its most representative spaces (with a sequence shot on the Potsdamer Platz) and in its more abject, marginal sites, it also bears an attachment to still life, to the stopping of vital energies. Streets are both conduits for movement, human and mechanical, and held under a halting camera that scrutinises their material surfaces, exposing the scarring of the urban fabric. The camera modulates between face-to-face encounters with living subjects (an old woman performing a song-and-dance routine on the street looks at the camera, knowingly, at one point) and a more schematic, abstracted view of bodies and vehicles both still and moving in urban space, often taken from Moholy-Nagy's trademark bird's-eye perspective.

As Sibyl Moholy-Nagy describes it, this is a film with a pronounced dimensional awareness, following 'a horizontal-vertical planar organisation' (1969: 75) in its multi-perspectival negotiation of city space. Living bodies alternate with inorganic ones, humans are juxtaposed with statues and a cat with mechanical birds being sold on the streets. Behind the filmic vision of busy life in the big city lies a series of more uncanny views of 'still life': a woman transfixed on a street before furniture that has been unloaded there, apparently a scene of expulsion, of an interior turned out and made uninhabitable; children playing under the wheels of a stationary cart, intercut with dangerous shots of racing traffic; and the movement of the camera through a sequence of inner courtyards of tenements in a working-class area, recurrently held up in its penetration of this dark, recessive space. As Sibyl Moholy-Nagy notes, the 'motion and counter-motion of men and vehicles' (ibid.) is repeatedly robbed of direction by the camera's encounter with spatial blocks such as walls and fences. The high-speed transportation of the camera by a tram and the leitmotif of shots directed obliquely through the windscreens of vehicles, moving or still, involves the camera in the alternation between motion and immobilisation that characterises the traffic system of the film. When it follows a handcart into the rear courtyards, stretching back in a *mise-en-abyme* structure of frames within frames, the camera is subjected to the sort of uncanniness of spatial experience that Sibyl Moholy-Nagy sees in the buildings as backcloths for an eerie stage (ibid.),[9] leading into abject depths.

There is thus a compositional crossover between the image-text of *Dynamic of the Metropolis* and the cinematic logic of *Berlin Still Life*, where the halting of the flow more than once takes the form of fixing upon textual tableaux, posters or inscriptions on buildings. This affinity also transfers to Ruttmann's *Berlin: The Symphony of the Big City*, which too is marked by such fixing on writing, in the form of signs and advertising. The repertoire of images that *Dynamic of the Metropolis* has in common with Ruttmann's film – from the zoo animals, to the traffic of the Potsdamer Platz, the legs of dancing girls and soldiers, the jazz band, the shiny surfaces of the city of light and the fireworks of the Lunapark[10] – arguably transport with them from the still-life form they necessarily take in the film text this type of apparently anti-filmic effect. Indeed, the mortuary scene from *Dynamic of the Metropolis* can also be said to be there in *Berlin: The Symphony of the Big City*, albeit, much as in the still-life aesthetics of Moholy-Nagy's film, in a less explicit form. Ruttmann's film includes both a scene of drowning and a sequence that focuses on a hearse, a moving spectacle of death on the city streets, seen through the glass of tram windows.

Third Movement – Life and Death in and of Photography: Benjamin

If *Dynamic of the Metropolis* is stilled in this way, then it corresponds to the phenomenology of the photograph developed by Walter Benjamin in response to the experimental photo-aesthetics of such as Moholy-Nagy. Benjamin's genealogical account of photographic technology and aesthetics in his 'A Small History of Photography' turns on the relationship between figures and the dimensions of time and space around them. In his account, photography is suspended between the capture of life and capture by death. In its representation of places and people, and the relationship between them, it can both confer degrees of immortality (to the philosopher's clothes in the case of the photograph of F. W. J. Schelling or to David Octavius Hill's New Haven fishwife) and provide an uncanny perspective on death (as in the case of the step-mother of the author Max Dauthendey, whose gaze on the wedding photograph seems to foresee her suicide). The photograph can both preserve what 'was alive there' (Benjamin 1997a: 242), even in the anonymous shape of the fishwife, and work more traumatically (as in the case of Mme Dauthendey) to catch the sort of image that Roland Barthes recognises as peculiar to the photograph, especially in its portrait form, that of a mortgaged future. It is what Barthes defines as the temporal *punctum* of the photographic image, the poignant indication of *what will have been*, combining the future and the past: '*This will be* and *this has been*' (2000: 96).

Photography is thus cast between times and tenses. While it is a technology burdened by its history, never really of the moment, it also carries traces of an urgent presence, what Benjamin calls the spark of coincidence, of the 'Here and Now' (1997a: 243), that has singed it. This burn mark is at once vital and morbid, both in its presence and in its reach into the future, its anticipation of what will have been. The memorial character of the early image with its long exposure is such that the subjects are at once bound into death (the Edinburgh cemetery is the 'studio' of choice for Hill) and yet drawn into the duration of a living moment. Hill's models are thus, either uncannily or transcendentally, 'at home' in the urban 'interior' of the cemetery (see Benjamin 1997a: 245). It is this that accounts for their aura, the capture of a visual space around the figure that holds them in the paradoxical spatial and temporal condition of remote proximity, what Benjamin calls the 'strange weave of space and time: the unique appearance or semblance of distance, no matter how close the object may be' (1997a: 250).[11]

Newer modes of photography tend towards the snapshot and the peeling away or decimation of the aura. Thus Atget's evacuated Parisian street scenes are considered to prepare the way for the photographic avant-garde and its isolation of images from the lived environment. A new photograph might feature a lifebuoy with the name of a city on it, and Atget's technique is to isolate the city from the romance of its name, sucking the aura out of it like 'water from a sinking ship' (ibid.). It is a salvaging process that is designed to suspend the auratic distance and expose the reproducibility of the scene at close quarters. Following Moholy-Nagy's analysis of the dialectics of cultural development, Benjamin sees the old forms – city scenes and portraits – as being superseded by, but also reborn in, avant-garde versions. A work like Moholy-Nagy's *Dynamic of the Metropolis* thus responds to pictorial art by projecting it towards the techniques of film. In its exposure of its means of construction, it therefore corresponds to the need identified by Brecht to reveal the institutional functions behind the photographic representation of the factory.

This is elaborated, in its turn, in the experimental cinema of the Russian avant-garde, and the debate between 'creative' and 'constructivist' photography that informs their work (see Benjamin 1997a: 255).[12] While the logic of Benjamin's argument is to stress the constructivism of that cinematic project, there is a powerful undertow in his account towards what he here calls the 'creative' and might equally be glossed as the iconic or the auratic. As much as the technology of the moving image is a key vehicle for Benjamin's critique of auratic art in the age of its technical reproducibility, it can also be stalled in its own effects of aura, caught in the posture of the early photograph. Old forms of photography and their alluring but ideologically suspect auratic effects are not dead in the age of cinema, any more than painting was killed off by the daguerreotype (ibid.). These objects of nostalgic curiosity – as important it seems in the motivation of Benjamin's essay as the new 'post-auratic' techniques – are in a condition somewhere between redemptive galvanisation and the more uncanny state of the living dead. They are figured as undead golems, sparked into suspended motion, coming closer and yet remaining remote, as the shadowy, spectral regime of the aura demands: 'It is in the illumination of these sparks that the first photographs emerge, beautiful and unapproachable, from the darkness of our grandfathers' day' (Benjamin 1997a: 256–7).

Final Movement – Racing Reporter and Phantom *Flâneur*: Umbo

The combination of the creative and the constructive, whether in the still or the moving image, is certainly at work in *Berlin: The Symphony of the Big City*. This dialectic, with its uncanny implications, can also be seen in the photographic work of one of the film's collaborators, Umbo, not least in the photomontage *Der rasende Reporter* (*The Racing Reporter*) used to publicise it. Much of Umbo's early work is in the old, academic genre of portraiture, lending an avant-garde twist to it through unconventional angles and extreme close-ups, but also with an attachment to time-honoured iconographic principles of shaping and lighting. He moves between highly posed studio-type shots, which give a sense of hold in time and space, and more spontaneous snapshots. When he transfers his perspective to the urban environment, these contradictory elements are held in the mode of the photographer as *flâneur*. On the one hand, he spends time and covers ground in the expansive style of *flânerie*, on the other he is ready to use new camera technology to take quick shots of the changing faces and dispositions of the city. Herbert Molderings describes the account of this project from Umbo's photographic notebook as follows:

> The talk there is of simultaneous photos of the traffic on the Potsdamer Platz and of 'reflections in shop windows'; he sets out to photograph 'mosque and power station – the smallest things – foreigners in Berlin – policeman posted in a dangerous spot'. 'Factory close-down and end of the working-day', 'Light and shadow in the city', 'nocturnal advertisements' and 'street gestures'. (1995: 86; my translation)

In other words, Umbo prepares here a photographic album of Berlin that might well be compared to Ruttmann's film, on which he worked as assistant cameraman as well as producing the publicity images in collaboration with Sasha Stone.[13]

In 1926, when he produced the photomontage works for the film, he was clearly pursuing the ascendant tendency of *Neue Sachlichkeit* (New Objectivity), announcing in

a diary entry his abandonment of the 'problems of the soul' for a more *sachlich* style (see Molderings 1995: 93). The two photomontage works used to publicise Ruttmann's film, *Perspektiven der Straße* (*Perspectives of the Street*) and *The Racing Reporter*, are indeed exemplary works of *Neue Sachlichkeit*. The first constructs a figure combining the shapes of tower and propeller, high-rise architecture and machinery, out of human acrobats; the second mounts a photograph of the face of Egon Erwin Kisch, the eponymous 'racing reporter' onto a body constructed out of the machinery of an age dominated by new technologies of transportation and communication. If the problems of the soul are still present here, it is in more oblique forms. In an ironically archaic gesture, the *photomonteur* introduces a signature image of himself into *Perspectives of the Street*, his face looking out from a lifebuoy on the boat that is part of the traffic montage in the foreground.[14] While Benjamin saw work such as Atget's as salvaging the wrecked boat of urban photography, saving its name on a lifebuoy (see 1997a: 250), here it is the name of the artist that is inscribed on the lifebuoy, whether as a saviour figure for urban artwork or as one adrift in the Berlin waterways and in need of saving (the suicide scene in the film will have a particularly morbid take on this scenario). In this latter perspective, the acrobatic tower could be viewed as presenting the danger of imminent collision to the aeroplane flying in behind it.

In *The Racing Reporter*, the artist creates a version of the emblematic figures of the baroque tradition, the incomplete bodies that Benjamin sees as exemplary forms of the allegory.[15] Indeed, the dismembered figure, with its multiple prostheses, recalls in particular such forms as the sculptures and reliefs by Andreas Schlüter that decorate perhaps the model building of Berlin baroque, the Zeughaus or arsenal building on Unter den Linden, which appears as part of the *mise-en-scène* of Ruttmann's film. The emblematic figures of military prowess on the top of the building and its doors, made up entirely of body armour and weapons of war around absent warriors, are converted in Umbo's design into the allegorical machine-man of the new media age. The time-travelling figure, bestriding city and nature, is at once one of enhanced power and of practical impossibility. The casting of the allegorical racer, made up of active machineries in the seized up, cut-and-paste mode of the photomontage, arguably only emphasises the sort of *vanitas* that shadows the model of baroque emblematics. There is, in other words, in this hyper-activated body, a sort of death-cast that recalls Benjamin's claim that the corpse, conceived as a compilation of parts, provides the most energetic form of allegory in the baroque tradition.[16] Umbo's allegorical body-image casts the vital impulsion of its subscription, 'The Racing Reporter', into mortified form. This ambiguity is certainly drawn out when the filmmaker is substituted for the 'racing reporter', and Ruttmann constructs his version of metropolitan reportage in a medium of photographic montage that is technically able to race. Here, the corpse is arguably dispersed throughout the film (in the artificial and damaged bodies, in the suicide scene, in the sequence tracking the hearse), though never directly put on display.

The soubriquet Umbo resonates with the idea of 'Umbau' (reconstruction), and indeed one of his most powerful Berlin images (in collaboration with Stone) is that of *Der Alexanderplatz im Umbau* (*The Alexanderplatz under Reconstruction*, 1928/29). Like the fountain pen that forms the – slightly old-fashioned – arm of the 'rasende Reporter', disjointed at the elbow, his work tends to challenge, re- or deconstruct, the programme for which it is an apparent instrument. Working alongside and against the constructive prin-

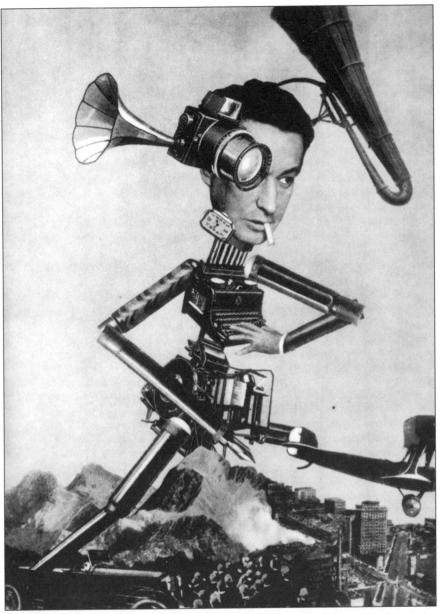

Otto Umbehr (Umbo), *Der rasende Reporter* (*The Racing Reporter*, 1926). Courtesy of the Deutsche Kinemathek, Berlin

ciple is a more unruly, creative one, a vestigial attachment to a more expressive, spiritual mode. In one of his best-known sequences of images, Umbo takes the principle of urban 'Umbau' as an emblematic focus for that subversive procedure of recording the ghosts in the machine of urban objectivity. The three images from 1928, *Unheimliche Straße* (*Uncanny Street*), *Mysterium der Straße* (*Mystery of the Street*) and *Schattenwunder* (*Shadow Miracle*), are Berlin street scenes taken from above and turned ninety degrees in order to displace the point of view from a window over the street into a more mysterious site

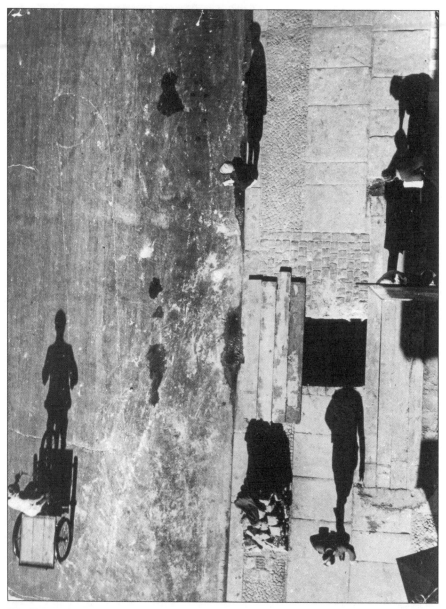

Otto Umbehr (Umbo), *Unheimliche Straße* (*Uncanny Street*, 1928). Courtesy of the Rheinisches Bildarchiv, Cologne

hovering above it. The implication of this turning is that the road and its shadows are uncannily projected into and under the building. This projection is equivalent in its effect to Moholy-Nagy's strategy in *Berlin Still Life*, where the establishing scene, shot from a high window and emphasising the accompanying, active but lifeless figures of shadows cast on the street, prepares for penetration underneath and behind the building into the uncanny, shadowy spaces of the inner courtyards. In each case, the shadow projections gravitate between an uncanny sense of topophobia and playfulness.

Each image in Umbo's triptych is dominated by the elongated shadows cast by bodies that are reduced to a minimum by the near-vertical perspective: the space of the street is preternaturally distended by these shadow effects. The photographer captures street images in the documentary mode of *Neue Sachlichkeit*, indexical snapshots of the everyday street scene, but invests them with the sort of shadow-life that characterises the representational worlds of expressionism and surrealism. This is a street being dug up, but what emerges is less an act of urban utility than of urban archaeology, digging up what is under the spatio-temporal surface. This, in turn, suggests an enigmatic, potentially uncanny exhumation, with urban existence cast in the sort of melancholic still life that is familiar, say, from the evacuated street scenes of Giorgio de Chirico.[17] While the photographs appear to be a sequence of snapshots, what they capture is structures that seem uncannily predetermined, frozen in space and time. As Molderings (1995: 99) points out, the street-diggers can seem to be performing the function of gravediggers, the pit they are digging a street-grave. And if the shadow-hole is readable in this way, then it casts each of the other shadows in the photographs into a void condition, suggesting that the material world of the street is full of negative matter.

At the same time, the implication of the turning of the images is that the boundaries between architecture and street are uncannily crossed. The street and its shadow-effects are projected through the building, undercutting the support structure of the surveillant photographer. Umbo's street, in other words, follows the model of a Berlin spectacle fea-

Overhead railway cutting through a domestic building at Dennewitzplatz, from *Berlin: Die Sinfonie der Grosstadt* (*Berlin: The Symphony of the Big City*, 1927). Courtesy of the Deutsche Kinemathek, Berlin

tured in Ruttmann's film: the overhead railway cutting through a domestic building at Dennewitzplatz, making a rail tunnel out of a house. As Umbo repeats the projection of the street into the building through his three images, so the film repeats the footage of the train running through domestic architecture as if compulsively fixed, like the spectral figures at the windows of the house above, upon this scandal of urban design. Repeated movement is thus halted in its tracks. It is as though Ruttmann's sequence is haunted by the 1908 accident just along the line at Gleisdreieck. The uncanny passage of the railway through the house could be said to mimic the ghostly 'Bahn' or track, the incursion of street into building that Benjamin sees in the arcades.[18] From this point of view, the urban excavations of the city that are also a motif in the film, leaving rail tracks suspended over gaping holes in the ground, also have an uncanny effect on the reliability of the street as ground for pedestrians, architecture and traffic. They open up the point of view from below the wheels that we saw in *Dynamic of the Metropolis*, the counter-view to that of the figure on the tram beholding the abyss below the tracks.

In *Uncanny Street* the uncanniness derives not least from a sort of double mutilation, operating along the axis of the gutter, which seems to act as a mirror-line. The cyclist's body suspended in motion at the left of the image is splayed onto the asphalt in the form of a distorted, invalid shadow; and the pedestrian walking in the opposite direction, but with his shadow cast in the same direction, is decapitated in that virtual form by the abyssal shadow of the hole in the street. This figure seems to have followed a course along the pavement that could only have resulted in a gruesome street accident, and his shadow projects him back into a fall into the pit or grave. This accidental after-effect is

Figure on the tram beholding the abyss below the tracks, from *Berlin: The Symphony of the Big City*. Courtesy of the Deutsche Kinemathek, Berlin

also reprised in *Shadow Miracle* where the head of one of the figures is fully cut off by the bottom edge of the image and so only cast into sight as a shadow, a negative simulacrum of itself. The representation of the potentially lethal accident that 'would have been' according to the visual logic of *Uncanny Street* is also projected into a sense of what 'will have been' in all three images, the *vanitas* that shadows the life of the street, its lacunae and reparations. Molderings argues (1995: 95–103) that Umbo's perspective in these Berlin photographs is that of the *flâneur*, and this recalls the connection that Benjamin draws between that surveillant or voyeuristic perspective and the spectacle of urban crime and violence.[19] The apparently arbitrary image, taken from a window over the street, transforms it into a kind of crime scene under the close observation of a forensic gaze, seen darkly through the glass of the camera lens.

Coda – Living Dead

The figure that carries on walking beyond the grave can be understood as a version of the survivor of trauma in Freud's account, moving on from the scene of the accident or the crime apparently unharmed. But he is also understandable as an undead phantom, tracking through this urban shadow-picture and representing the principle of return, the revisiting of psychical and motor symptoms, that interrupts post-traumatic experience. In this reading, this image of the body in an urban street would be an avatar of the old photographs in Benjamin's account, spectral figures caught in the motion of stepping forward. Umbo's uncanny or mysterious street scenes suggest a sequence of stills from a motion picture of Weimar Berlin that is also, in the manner of Moholy-Nagy's film of Berlin, a still life. Like Ruttmann's symphony to Berlin, this motion picture in freeze-frames is cast between the social realism of the street caught unawares and a more abstracted aesthetic of light and shadow. Human life and activity are cast here in minimised and mortified shapes. The quotidian topography of Berlin is seen to harbour more mysterious, uncanny and always potentially traumatic shadow-sites and sights. From the high-speed phantom ride that takes the disembodied viewer into the Berlin of Ruttmann's film, through the photographic gallery of the 'dead city' that unfolds there, or the mortuary images that interrupt Moholy-Nagy's dynamics of the metropolis, to the phantom walk of Umbo's *Uncanny Street*, we see the shadow-side of the modernity of Weimar Berlin, captured in transit.

NOTES

1 In his 'Berliner Chronik' ('A Berlin Chronicle'), Benjamin suggests an affinity between stations as representative entry-points to cities and photography, especially in its snapshot mode. He refers to Brecht's discussion of the photograph of the exterior of a factory, and suggests that film is better equipped, motorised as it were, to expose the functional structure of the urban (1997b: 298).

2 For a detailed discussion of this 'dead city' section and its traumatic basis, see my book *Berlin in the Twentieth Century: A Cultural Topography* (2008).

3 In his programmatic essay, 'Der neue Film', in the *Illustrierter Film-Kurier* brochure for the film, Ruttmann proclaims that *Berlin: The Symphony of the Big City* will be a 'film without plot' (1927: n.p.) and break definitively with the dependence of film upon theatre.

4 Moholy-Nagy glosses the 'FILMIC' as 'film which proceeds from the potentialities of the camera and the dynamics of motion' (1969: 122).

5 Readings of women on the street in the film have tended to focus on the scene where a woman sees and is seen by a man through a shop window on a street corner. This visualisation in a window, reflecting the commercial images of women in shop-window displays elsewhere in the film, has led critics to see this as an encounter between a prostitute and a prospective client. For a critical account of the sexual-political assumptions of such readings, see Gleber 1996.

6 The scene is introduced by the Lumière brothers and recapitulated many times in both documentary and fiction film in the following decades. Brecht would return to it when he collaborated on the film *Kuhle Wampe* in 1932. For an account of the ironic handling of the factory-gates topos for the out-of-work workers there, see Webber 2004: 130–44.

7 This new mode of seeing was concomitant with the new mode of construction ('neues Bauen') discussed by Thomas Elsaesser in chapter 6 of this volume.

8 He mobilises terms like 'Bogen' (sheet/page, arc, arch), 'Druck' (print, pressure) and 'Zug' (trait, draught, train) to figure a mechanics of transportation into a new form of 'Buchraum' or 'book-space', where the writer becomes a dynamic typographer, putting the text in its topographical place, and the printed page (as 'Bogen') arches into new spatio-temporal dimensions (Lissitzky-Küppers 1967: 356).

9 While the English edition calls this scenery 'eerie', the German edition uses the term 'unheimlich', meaning uncanny (S. Moholy-Nagy 1972: 72).

10 Dimendberg (2003: 121) suggests that Moholy-Nagy's city is universal, as evidenced by the compendium of images from various places. The reference in the text to the Potsdamer Platz and the photographic image of the Friedrichstraße seem to suggest that it is more akin to Ruttmann's film, taking Berlin as its *prima facie* location but also universalising it as archetype: *the* Symphony of *the* Big City.

11 A more appropriate translation would be: 'strange web of space and time: singular apparition of a distance, however close it may be'.

12 For an account of this double economy in films by Eisenstein and Vertov, see Webber 2004: 122–30, 144–56.

13 For details of his role in the film, see Goergen 1989: 114.

14 The image and name of the photographer do not appear in the version of the photomontage used for the *Illustrierter Film-Kurier*.

15 Benjamin cites the torso of the Belvedere Hercules, as read in an 'un-classical way' (1998: 176) by Winckelmann.

16 In the 'corpse as emblem' section of his *Origin of German Tragic Drama*, Benjamin argues that 'the allegorisation of the physis can only be carried through in all its vigour in respect of the corpse' (1998: 217).

17 For a discussion of these in the context of avant-garde urban representations, see Webber 2004: 244.

18 Benjamin describes the arcade as 'The street that runs through houses. Track of a ghost through the walls of houses' (1999: 827). In the original, the full stop between these sentences is an unpunctuated double space, giving a nice typo-topographical sense of the phantom track (see 1991: 993).

19 For Benjamin, the *flâneur* is both a detective figure (1999: 442) and a 'true suspect' (1999: 420).

WORKS CITED

Barthes, R. (2000) *Camera Lucida: Reflections on Photography*, trans. R. Howard. London: Vintage.

Benjamin, W. (1991) *Das Passagen-Werk. Gesammelte Schriften*, 5.2, ed. R. Tiedemann. Frankfurt am Main: Suhrkamp.

_____ (1997a [1931]) 'A Small History of Photography', in *One-Way Street and Other Writings*, trans. E. Jephcott and K. Shorter. London/New York: Verso, 240–57.

_____ (1997b [1932]) 'A Berlin Chronicle', in *One-Way Street and Other Writings*, trans. E. Jephcott and K. Shorter. London/New York: Verso, 293–346.

_____ (1998) *The Origin of German Tragic Drama*, trans. J. Osborne. London: Verso.

_____ (1999) *The Arcades Project*, trans. H. Eiland and K. McLaughlin. Cambridge, MA: Belknap Press.

Brecht, B. (2000) *Bertolt Brecht on Film and Radio*, ed. and trans. M. Silberman. London: Methuen.

Dimendberg, E. (2003) 'Transfiguring the Urban Gray: László Moholy-Nagy's Film Scenario "Dynamic of the Metropolis", in R. Allen and M. Turvey (eds) *Camera Obscura Camera Lucida: Essays in Honour of Annette Michelson*. Amsterdam: Amsterdam University Press, 109–26.

Freud, S. (1985) *The Origins of Religion: Totem and Taboo, Moses and Monotheism, and Other Works*, ed. and trans. J. Strachey. Harmondsworth: Penguin.

Gleber, A. (1996) 'The Woman and the Camera – Walking in Berlin: Observations on Walter Ruttmann, Verena Stefan, and Helke Sander', in B. Becker-Cantarino (ed.) *Berlin in Focus: Cultural Transformations in Germany*. Westport: Praeger, 105–24.

Goergen, J. (1989) *Walter Ruttmann: Eine Dokumentation*. Berlin: Freunde der deutschen Kinemathek.

Kracauer, S. (1927) 'Wir schaffens', *Frankfurter Zeitung*, 17 November, Abendblatt, 1.

Lissitzky-Küppers, S. (1967) *El Lissitzky: Maler, Architekt, Typograf, Fotograf*. Dresden: VEB Verlag der Kunst.

_____ (1967 [1923]) 'Topographie der Typographie', in *El Lissitzky: Maler, Architekt, Typograf, Fotograf*. Dresden: VEB Verlag der Kunst, 356.

Moholy-Nagy, L. (1969a) *Painting, Photography, Film*, trans. J. Seligman. Cambridge, MA: MIT Press.

_____ (1969b [1925]) 'Simultaneous or Poly-cinema', in *Painting, Photography, Film*, trans. J. Seligman. Cambridge, MA: MIT Press, 41–43.

_____ (1969c [1921–22]) 'Dynamik der Gross-stadt', in *Painting, Photography, Film*, trans. J. Seligman. Cambridge, MA: MIT Press, 124–37.

Moholy-Nagy, S. (1969) *Moholy-Nagy: Experiment in Totality*. Cambridge, MA: MIT Press.

Molderings, H. (1995) *Umbo: Otto Umbehr 1902–1980*. Düsseldorf: Richter.

Ruttmann, W. (1927) 'Der neue Film', *Illustrierter Film-Kurier*, 658.

Schobert, W. (1989) *The German Avant-Garde Film of the 1920s*. Munich: Goethe Institut.

Ward, J. (2002) *Weimar Surfaces: Urban Visual Culture in 1920s Germany*. Berkeley: University of California Press.

Webber, A. (2002) 'The Manipulation of Fantasy and Trauma in *Orlacs Hände*', in K. Kohl and R. Robertson (eds) *Words, Texts, Images*. Oxford: Lang, 153–74.

_____ (2004) *The European Avant-Garde: 1900–1940*. Cambridge: Polity Press.

_____ (2008) *Berlin in the Twentieth Century: A Cultural Topography*. Cambridge: Cambridge University Press.

5 MODERN LIFE IN *HIGH TREASON*: VISUAL AND NARRATIVE ANALYSIS OF A NEAR-FUTURE CINEMATIC CITY

Richard Koeck

Introduction and Plot Summary

A number of fiction films of the 1920s and 1930s, such as Fritz Lang's *Metropolis* (1926), David Butler's *Just Imagine* (1930) and William Cameron Menzies' *Things to Come* (1936), visualise urban life in the not-too-distant future. These movies, which share a set of common characteristics and which I have termed 'near-future' films, typically portray terrestrial life that is not more than one hundred years ahead in time (see Koeck 2005: 315, 316). One of the most fascinating British films of that period falling into this category is Maurice Elvey's work *High Treason* (1929). I will explore the hypothesis that the fictional representation of the near-future urban scenario takes part in a dialogue about actual political, social and technological events and in particular about key themes of architectural thought of the same period.

The plot of *High Treason* takes place in London in a fictional 1940; a time when the two great powers of the world, the Atlantic States and a United Europe, are on the brink of a military conflict. The mediating power during these uncertain times is the so-called Peace League, represented by Dr Seymour (Humberston Wright) and his daughter Evelyn (Benita Hume), who is in love with Major Michael Deane (Jameson Thomas), commander of the European air force. As both the city of London and its citizens are subjected to a series of mysterious terrorist attacks, the European flying squadrons are mobilised in order to mount a counter-attack on New York. Only the drastic interference of Dr Seymour and his daughter can prevent the escalation of this delicate political situation.

The story of *High Treason* is based on a rather unsuccessful play by inventor, designer, entrepreneur, politician and social reform activist Noel Pemberton-Billing which was later adapted into a screenplay by L'Estrange Fawcett (see Anon. 1929e: 6). At the time of the film's production, Pemberton-Billing looked back on an interesting professional and political career. As early as 1908, he founded the first British aerodrome and later published the first British aeronautical monthly journal as well as starting his own aviation company. In 1914 he joined the Royal Naval Air Service and served in World War One, where he had first-hand experiences of aerial combat (see Pemberton-Billing 1941: ix). In 1916, he published the book *Air War and How to Wage It: With Some Suggestions for the Defence of Great Cities* which laid out his concern about a sudden aerial attack and the vulnerability of London (see ibid: xvi). It is this concern for the necessity of defending Britain that is almost identically reflected in the film plot of *High Treason*.

Throughout his career, Pemberton-Billing feared for the future of Britain as a leading industrial nation and remained critical regarding the country's deficient aerial combat and defence capabilities. Pemberton-Billing was an Independent Member of Parliament for East Hertfordshire, and shared not only his aerial defence expertise in the House of Commons, but also increasingly his conservative, moralist and nationalistic worldviews (see Hoare 1997: 2).[1] In June 1917, Pemberton-Billing co-founded the Vigilante Society and shortly thereafter a journal called *The Imperialist*, later renamed *The Vigilante* (see Hoare 1997: 53). The journal was devoted to the 'promotion of purity in public life', which in the case of Pemberton-Billing and Henry Hamilton Beamish, co-founder and National Party member, meant that it propagandised extreme conservative and right-wing views, expressing nationalism, xenophobia, homophobia and anti-Semitism (see Hoare 1997: 2, 54).[2] Taking into account Pemberton-Billing's personality and his political views, it will be interesting to see whether, although the film was adapted by L'Estrange Fawcett, the portrayal of near-future London in *High Treason* is critically informed by his political and ideological beliefs.

With regard to the visual style of near-future London in *High Treason*, two men were particularly important. Firstly, the film director Maurice Elvey, who was already well-established at the time, and who was signed by the production company Gaumont-British. Elvey started his career in film around 1913 and worked, as Paul Rotha notes, on over fifty productions prior to *High Treason* (see Rotha 1949: 315), none of which, however, would become particularly known for its architectural quality or set design. And secondly, the film designer Andrew Louis Mazzei, who was responsible for the construction of the set design and the miniature work of near-future London.

The portrayal of the city in the film was one of Gaumont-British's key selling points to exhibitors and audiences; yet Rotha disapproved of the quality of the film and, even though Mazzei was trained as an architect, considered the décor in *High Treason* 'ill-designed' (1949: 314). Certainly, Mazzei's know-how in set design does not compare with – in the case of *Metropolis* – Erich Kettelhut's long-term expertise in the film industry; yet *High Treason* contains a number of very specific references to the British architectural debates of the late 1920s, which suggests a considerable level of inside knowledge. Plenty of articles in the British architectural journals of the time discuss and show drawings of, for instance, the planned construction of a Channel Tunnel, a new Charing Cross bridge and a new Charing Cross Railway Station. It is no coincidence that *High Treason* visualises precisely the same architectural projects. Mazzei was a trained and practising architect in his own right, who was certainly familiar with the aforementioned debates. This leads to the assumption that the 'seemingly daring forecasts' of the future portrayed in the film (Anon. 1929g: 40), were perhaps less fantastic than previously thought.

Enhanced Mobility as Threat or Benefit

The opening scene of the city in *High Treason* illustrates that London has grown to be a highly dynamic place, which employs a series of innovative modes of transportation. Surprisingly, Elvey's film does not show any pedestrians; instead, the city is one in which its citizens have many choices of transport at their disposal. The introductory extreme long shots show a vertical traffic pattern that stretches from the ground (cars) and the river (small ships and submarines), over elevated bridges (cars, trains), to the air (planes,

zeppelins). While on the surface such imagery suggests a society accepting mechanised urban transport (for instance, the use of a helicopter-like aircraft as a personal vehicle), interestingly, the film's narrative shifts the characterisation of inter-city mobility from social boon to potential hazard.

The narrative of the film explores the chances of keeping peace or entering war in the not-too-distant future. This peace/war theme is connected throughout to the question of how much society's enhanced mobility might harm the future of cities and civilisation. Among the many filmic characteristics that illustrate this theme, there are several instances in which novel means of inter-city mobility become a threat to the welfare of Londoners. The first of these scenes depicts a new travel connection from London to Paris via a Channel Tunnel. This innovative way to link Britain with France becomes a target for a group of agitators, who secretly plant a bomb in one of the trains and whose aim is to increase the tension between Europe and the Atlantic States.[3] While certain technical aspects of this terrorist operation – those surrounding a timing device – will be looked at in more detail later, the situation as such is epiphanic: with the expansion of Britain's train services come increased risks of loss of life. The Channel Tunnel, one of the main technological innovations of the filmic near-future, becomes an ominous threat to society.

The seemingly futuristic idea of the Channel Tunnel turned into reality as late as 1994; yet, one of the earliest accounts suggesting a Channel Tunnel between France and England goes back to a proposal by the French mining engineer Albert Mathieu-Favier in 1802. In the late 1920s, this utopian idea resurfaced in governmental as well as public debates and was much closer to reality than one might expect. At the time of *High Treason*'s production, the Channel Tunnel was widely seen as a national opportunity that would facilitate 'the interchange of social and economic life' (Anon. 1929a: 13) in Britain and went on to enjoy strong support from the business community (See Anon. 1929c: 10). The Channel Tunnel plans sparked ideas of London becoming the 'Gateway to the West' (Anon. 1929b: 10), giving rise to the hope that it would attract new visitors, who

would subsequently increase the city's revenue. In the film, however, perhaps reflecting Pemberton-Billing's own concerns, such views were countered by portraying the Channel Tunnel as a potential threat to Londoners.

Later in the film, under the cover of night, a group of agitators instigate the dropping of a bomb on the Peace League headquarters. In this scene, perceived by a film critic as particularly 'realistic' (Anon. 1929f: 35), the roof, Dr Seymour's office and the central hall collapse amidst the flames. Dr Seymour and his daughter survive the onslaught unhurt and immediately realise the political ramifi-

Shortly after the bombing of the Peace League building in *High Treason* (1929)

cations of this sudden air raid. If he is unable to stop a public declaration of war, the situation will escalate into transatlantic conflict. These dramatic events highlight the notion that rapid transportation technology, and in particular the aeroplane's capabilities for a sudden, long-range attack, can become a threat to world peace. In doing so, it precisely reflects Pemberton-Billing's warnings on the same subject matter described earlier.

Stephen Kern notes that: 'The airplane altered the significance of national bound-aries and traditional geographical barriers between peoples' (1983: 7). Kern's sugges-tion finds application in *High Treason*'s consideration of the aeroplane as a factor that dissolves established 'geographical barriers'. Following the attack on the Peace League building, the European Council decides to declare war on the Atlantic States. Immedi-ately, London mobilises its bombing forces which assemble in the Central Aerodrome. Here, Evelyn congregates with her fellow female Peace League members and pleads with them to prevent the planes from departing for a counter-attack on New York.[4] The male pi-lots of the air force try to gain access to the aeroplanes but are stopped by Evelyn and her colleagues. What follows is a carefully choreographed and gender-coded standoff scene, which willbe described in more detail later. These pictures distinctly highlight the centre of the argu-ment between the male and female members of so-ciety. Gaining command of the aeroplanes is at the crux of preventing or promoting transatlantic war.

In aerial technological terms, the most remark-able addition to London's transport system in *High Treason* is a flying vehicle, seemingly a mixture be-tween helicopter and plane, called the Autogiro. This vehicle is able to vertically take off from and land on flat rooftops, which is a concept that is interesting in the context of urban planning. It implies an un-

Autogiro, *High Treason*

precedented symbiosis between aircraft and buildings which, if implemented, would have great consequences for the appearance and function of cities in the future. In portraying the application of the autogiro in an urban context in the film, *High Treason* precedes an important debate of modern architectural aesthetics and function, which would enter mainstream British architectural circles in the 1930s. Yet, *High Treason*'s portrayal of flat-roofed buildings should not necessarily be understood as a declaration of pro-modernist aesthetics,[5] but be seen to expand on the discussion of multiple functions of rooftops, which was introduced in Britain at least two decades earlier. In 1910, French urban planner Eugène Hénard presented a quintessential text on the 'near future' at the RIBA:

> But a still more important function to be performed by these terraces is that in the near future they will be used as landing stages for aeroplanes. [...] We may, I think, imagine some form of light aeroplane, equipped with horizontal helices in addition to the vertical propeller, and capable of remaining stationary in the air. [...] every ter-race will become a stopping-place for these aerial automobiles. (1911: 364).[6]

What emerges from this text is that *High Treason* precisely portrays Hénard's 'landing plat-forms' and 'aerial automobiles', which means that it depicts a near-future London where architecture and aeroplanes have evolved to service one another. Such a notion, in turn, is in line with modern, continental-European architectural thought and one instantly recalls the design of a future city by Le Corbusier who famously placed a landing platform for aero-planes at the heart of his *Ville Contemporaine* (1922) (see Fishman 1982: 114–15).

The autogiro in the film, seemingly ahead of its time, is firmly rooted in the history of science and was in the 1920s far from being a futuristic, implausible technology. A

very similar vehicle was indeed built by Spanish engineer Juan de la Cierva, and first flew on 19 January 1923. Because of better research and refinement possibilities at the time, Cierva moved his company, the Cierva Autogiro Co., Ltd, to England in 1925 (see Johnson 1994: 16).

Three years later, the year of *High Treason*'s production, Cierva's Autogiro made the news by successfully completing a flight across the English Channel and a 3000-mile tour of Great Britain (see Anon. 1928b: 414, 441). Eugène Hénard's aforementioned visions of future cities indeed conform with Cierva's aspiration that the vehicle would be used in densely populated urban centres. In fact, the Autogiro was seriously considered for

civil aviation purposes by officials from the London Police and the Post Office, who contemplated the use of the Autogiro in the city centre in order to find ways of escaping London's ground traffic. One of a series of experiments took place on 3 September 1934, when the Autogiro hovered 100 to 200 feet over the flat roof of the Temple Press building in London (Anon. 1934: 273). A test pilot who flew the Autogiro reported that 'given one hour of practice [he] would willingly land in any open square in London' (Pontius 1934: 846). The image printed in the press showing such a test flight looks remarkably similar to the vertical landing manoeuvre in *High Treason*.

High Treason makes an important distinction between inner-city and inter-city mobility. Means of inner-city mobility (vertical takeoff and landing aircraft) seem to increase the comfort-level of citizens of London. However, the more important motif is *inter*-city mobility. The notion of transcontinental flight has national implications and ultimately presides over questions of peace and war in the plot.

Vertical landing manoeuvre, Temple Press building, London, *The Aeroplane*, 5 September 1934

Rapid means of transport facilitate terrorists and Peace League members alike. In other words, newly-gained mobility comes at a high price. On the one hand, new means of transport serve the comfort of inner-city travel but, on the other, falling into the wrong hands, rapid transportation technology has the power to harm the fabric of urban society in the near future.

Enhanced Communication: Means of Mobilisation

Perhaps the greatest social effect of radio-communication so far has been a political one: the restoration of direct contact between the leader and the group. Plato defined the limits of the size of a city as the number of people who could hear the voice of a single orator: today those limits do not define a city but a civilisation. Lewis Mumford notes that Plato suggested the determination of the size of a city based on the laws of acoustics (see 1934: 241). Accordingly, the radius of a city should be defined by the distance across which a single narrator could vocalise his concerns to the group. If one looks beyond the

spatial implications for the city raised by this reference to Plato, it can be seen that Mumford alluded to a fundamental truth regarding the inherent link between urban space and the flow of information. *High Treason* recognises this important relationship and treats communication technology as a central motif to describe the near future of urban life.

From the start of the film, *High Treason* portrays instantaneous communication technology as a significant personal, political and, as such, social instrument for near-future London. Following a border conflict between Europe and the Atlantic States, *High Treason* shows a short montage that is dedicated solely to instantaneous communication and its relationship to world political events. This sequence starts with a man sitting in front of what appears to be morse apparatus, followed by a low-angle perspective of a news speaker on the microphone. Next, the camera focuses on a close-up of transistors, which

is then followed by an upwards tilt, revealing a telegraph mast from whose top wireless signals radiate. The sequence continues with a short blackout, dissolving then to the speaker again and a series of world maps, highlighting the territorial conflict between Europe and the Atlantic States. These images are accompanied by corresponding intertitles: 'New York calling the world … This morning's outrage creates a desperate situation.' Such visual and textual information conveys a clear message to the audience: in the near future, instantaneous communication will play an extraordinary role and will shrink the physical distances between nations into a diminutive space of time.

Speaker on a microphone, *High Treason*

High Treason also illustrates the application of a visual text-messaging system, located on the receiving end inside the Peace League's communications centre. Such a system, first seen in Dr Seymour's and Evelyn's office, mounted onto the wall behind their desks, appears to be almost instantaneous. Shortly after information has been transmitted by wireless, Dr Seymour and Evelyn receive a text message, which is possibly conveyed by an

Text-messaging board, *High Treason*

internal communication system set up between the Peace League's New York and London offices. The crawling text message, appearing on the wall, consists of flickering light bulbs. As in the case of wireless audio transmission mentioned above, this text message technology is only used for political news of considerable urgency in the plot. Importantly, in *High Treason*, such news has relevance for the immediate future of London in terms of being an early-warning system for sudden aerial attacks.

The strongest political implication of all instantaneous communication devices comes from what is labelled in the film as the 'Government Broadcasting System'. Screens of these audiovisual devices, looking similar to today's televisions, are mounted throughout the city at various important locations (see Table 1). *High Treason* introduces these devices for the first time in the office of the European Ministry of Air. Like the text message system of the Peace League, this system provides information about political

Table 1	Government Broadcasting	One- or two-way televisors	Wall-mounted text-messaging	Morse apparatus & microphone	Audio door control
Office Peace League	X	X	X		X
Office European President	X	X			X
Office Major Deane	X	X			
Office Agitators, unknown location		X			
Dance Hall, Peace League	X		X		
Central Aerodrome	X				

events.[7] Although the on-screen images appear not to be live footage, they have an immediate impact on the perception of the political evaluation of the military headquarters in London.

Unlike the film *Things to Come*, written by H. G. Wells, *High Treason* does not show a central broadcast studio located somewhere in the city. Instead, it embeds this function into the office of the European President. Thus, like *Metropolis*, the seemingly most powerful man in the city and the country has unrestricted access to a device with which he can address large parts of the population at once. Given this important connection between communication technology and political leadership, it is perhaps unsurprising that the presidential office with its broadcast facility is the location for the film's most dramatic scene – the deadly dispute between Dr Seymour and the President:

Watching political events, *High Treason*

> *President:* We need all possible unity... won't you broadcast a message of encouragement to our peoples?
> *Dr Seymour:* One moment! Europe will, of course, follow you to war?
> *President:* Yes, though I've been anxious – knowing your great influence.
> *Dr Seymour:* And you could preserve peace – if you so desired?
> *Dr Seymour:* Answer me!
> *President:* Yes. [no intertitle, but readable from his lips]
> *Dr Seymour:* Then I will broadcast a message to the world.

In this pivotal moment, Dr Seymour realises the contrasting consequences of instantaneous communication technology: it can immediately mobilise the masses to either engage in war or peace. As the president tries to intervene in Dr Seymour's broadcasting of a peace message, he is shot by the Peace League president. Although this tragic incident damaged the mass-communication device, he can still use the audio transmission. In doing so, Dr Seymour averts the instant outbreak of war, which would have had serious consequences for the city of London and Europe as a whole.

Apart from the impact of wireless audio, text-messaging and broadcast systems, *High Treason* employs in its plot two-way, instantaneous audio-visual devices (from here on called televisors). This device is the only piece of instantaneous communication technology in *High Treason* that is not shown in a direct political context. Instead, it allows Major Deane and Evelyn to hold private conversations from opposite ends of the city.[8] The device itself is little more than a screen that sits on each participant's desktop. There is no conventional telephone attached; instead it has a built-in speaker and microphone. Evelyn's televisor has a further astonishing function: at the push of a button, and in line with the utilitarian approach to modern furniture, her screen can be sunk into the table after use. It might surprise some viewers of *High Treason* today that this technology was not thought up by creative minds of the film industry, but directly inspired by actual technology of the time.

From 1925 onwards, Scottish entrepreneur John Logie Baird developed an image scanning system which would allow the wireless transmission of

Dr Seymour fighting for the broadcast apparatus and killing the President, *High Treason*

Evelyn communicating with Major Deane, *High Treason*

moving images. On 27 January 1926 he held the first successful public demonstration of what he called the 'televisor' in London (Anon. 1926: 9). By 1928, the year *High Treason* was produced, Baird had improved the quality of the televised images, verified an image transmission across the Atlantic, founded his own company and sold televisors to the domestic public (see Anon. 1928a: 13; Winston 1998: 95–6). Considering the amount of press Baird's sensational experiments received, it is almost certain that Elvey and his production team knew of the televisor. A closer analysis of the film's apparatus reveals at least three distinct design features, which suggest a direct relationship between the film's televisor and Logie Baird's televisor Model B (Noah's Ark) built in 1928.

Firstly, Baird's early experiments in wireless image transmission consisted of shots of faces, which is precisely the application for which it is used in *High Treason*. His apparatus consisted of a revolving disc and shutter, lenses and light-sensitive cells, which divided the images into regular segments that were then projected on a glass screen. A close-up of *High Treason*'s apparatus reveals an orthogonal grid system behind a glass lens, suggesting a similar division of the image into segments, and as such a similar

Televisor, Model B, 1928. Copyright: National Media Museum

Wall-mounted loudspeaker, *High Treason*

process of electrical image transmission to Baird's technology. Secondly, the wooden casing of Baird's apparatus has a very noticeable 45-degree trimming at its edges; the same ostentatious design feature is used in *High Treason*'s collapsible device.[9] Thirdly, the loudspeaker in Baird's apparatus shows an emblem of a rising sun that is the same as in Elvey's wall-mounted loudspeakers.[10]

I will suggest later that the central hall of the Peace League is architecturally inspired by the New Hall of the Royal Horticultural Hall in Westminster; interestingly, Baird demonstrated at this location the functionality of 'gramophone records, which will give visual reproductions of performers' (Anon. 1927c: 11). This demonstration would have caused great interest in the British film industry, particularly because Baird believed it would 'also offer an alternative to the present phonofilm in cinematography' (quoted in ibid.). The possibility cannot be excluded that Elvey himself, or a representative from Gaumont-British, visited this demonstration and drew the inspiration for the televisor and the Peace League building at the same time.

High Treason's narrative turns instantaneous communication technology into an instrument that has existential influence on tomorrow's quality of urban life. The ability to instantaneously unite people behind one cause goes along with Plato's concept of the acoustically determined size of the city. The fact that the physical size of London is much greater than Plato had suggested seems to stem from the logical consequence of technology's enhanced abilities to communicate in greater circles.

Urban Hygiene: Near-Future Lifestyle

In the second part of the nineteenth and at the beginning of the twentieth century, industrialised cities in Britain and elsewhere faced a series of severe problems. Large numbers of people, attracted by industry and the possibility of employment, moved from the countryside to urban areas, where they expected a more prosperous life. This led to the rapid expansion and densification of cities, a lack of housing and the associated spread of hygiene and health problems, such as tuberculosis.[11]

High Treason's narrative, supported by the use of futuristic domestic gadgetry, demonstrates that matters of personal hygiene play an important part in urban life in the near future. In one scene, Evelyn Seymour and her father discuss upcoming political events in their joint office, when she is being visited by Major Michael Deane. Before going out with him, Evelyn begins a series of tasks that demonstrate the significance of hygiene in her lifestyle. The camera follows Evelyn into a private section of her office, which contains a dressing room and shower cabin. Her activities are photographed strictly from

one camera set-up, somewhat evoking an association with the workflow of a Fordist production line. She turns on the radio, takes a shower, uses a heated blow dryer, changes her clothes, puts on her new shoes, switches off the radio and leaves the room again. This rational succession of tasks apparently saves Evelyn valuable time in her rationally organised lifestyle, placing matters of domestic hygiene high on her list of priorities. Seen in context with the difficult state of the housing situation of London in the late 1920s, the portrayal of having a private shower cleverly underlines the notion that the plot is set in the future.

Evelyn's clean appearance in *High Treason* can be seen as part of a gender and ideological colour code running throughout the film. Her white dress becomes a metaphor for her pacifist attitude in life and her belief in the good of humanity, which directly opposes that of her male counterpart, Major Deane, who wears dark clothes during most of the film. Evelyn returns from the changing room with an even brighter, sparkling silver evening gown, portraying her as a modern, emancipated woman with an immaculate appearance. More than that, in the case of Evelyn, the cinematic celebration of hygiene not only highlights her beauty, but also reveals her inner approach to political policy. Being the filmic and ideological counterpart to Major Deane, she personifies the peace movement in near-future London.

Evelyn in shower, *High Treason*

Evelyn in sparkling evening dress, *High Treason*

Chronological Precision: Geometrical and Social Regularity

High Treason shows a great number of clocks in various locations, suggesting that time is an important constituent of the near-future urban fabric (see Table 2). The following section argues that matters of time (symbolised by the recurring image of clocks) are significant visual and narrative motifs for the portrayal of order and regularity in society. In the first example, it is not only the clock itself, but also its spatial context that reveals the character of urban life. About 18 minutes into the film, Major Deane enters the Peace League headquarters' operational centre, a grand hall where predominantly women work on the calculation of numbers. The scene begins with a close-up of one of the hall's wall-mounted clocks and then tilts down to the entrance door through which Major Deane enters. After a short conversation with a Peace League member he proceeds down the centre aisle, where the scene cuts to a row of female typists sitting at their desks. In the next shot, cinematographer Percy Strong employs a moving-camera shot, stimulating the spectators' perception of motion, order, regularity and rhythm. Strong frames this shot very tightly, focusing on the typists only, which eliminates almost any spatial context. This shot creates a rhythmic passage, in which the photography of the women recalls the operations of a Ford-style production line. The film then makes a drastic cut to a wide-shot, revealing the full longitude

Table 2	wall-mounted clocks	clock for bomb
Peace League entrance	x	
Peace League central hall	x	
Peace League office Dr Seymour	x	
Channel Tunnel		x
Federated States Council Europe	x	
Women's Mobilisation Centre	x	

Moving-camera shot, *High Treason*

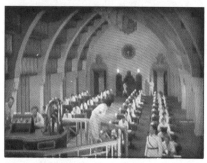

Central hall, *High Treason*

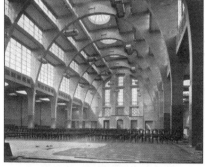

Royal Horticultural Hall. *The Architect's Journal*, 18 November 1931

of the dome-shaped hall, whose architectural characteristics bring to mind the then recently-completed New Hall (also known as Lawrence Hall) of the Royal Horticultural Hall in Westminster (1928): both structures ostentatiously employ the same concrete parabolic arches and stepwise, perpendicular glass infills. The evident contrast of these two shots (one of which is a medium close-up, the other a wide-shot) accentuates the spatial grandeur of the hall and as such heightens the spatial expressiveness of the scene. Because the typists sit lined up in precise rows, they form somewhat human vanishing lines, which emphasise the perspective depth of the shot and correspond with the structure of the building. Photographed from a high angle, following the laws of perspective, architectural structure and female staff share one *order* and merge into one *body*. These elevated wide-shots emphasise the exposed skeleton construction, which appears to be made of reinforced concrete filled with lightweight glass elements. Such architectural vocabulary would fit into the jargon of modern architecture; however, the design for this central space also compares to earlier forerunners of architectural modernism, for instance, Hendrik Berlage, whose work, including the Amsterdam Stock Exchange, was well recognised in Britain.[12]

Although Berlage's interior is significantly larger in scale than the Peace League building's central hall and despite the fact that their choice of material differs, both spaces resemble one another visually. Both interiors have a wall-mounted clock located conspicuously at almost exactly the same position, which in the case of the Peace League building becomes a visual reminder that the typists

work under the rule of time. In terms of function, it could be argued that the central hall in *High Treason* and Berlage's Stock Exchange both serve the same primary objective, which is essentially the management of numbers. While one is for the purpose of counting the rise in Peace League members, the other's purpose is trading. Thus, both buildings represent formally as well as symbolically a high degree of organisation, regularity, rhythm and, indeed, time itself – an image that stands in stark contrast to the chaos of war by which the city is threatened later. Considering the last two scenes (the moving-camera shot and the wide-shot of the hall), *High Treason*'s near future is one in which society at large appears to have accepted an ideology of scientific rationality. The portrayal of the female workforce's *rhythmic work*, and the Peace League's central hall *geometric regularity* foretell that this highly regulated society is organised with Taylorist precision.

High Treason returns to the clock motif in more literal terms later in the film, when it shows the execution of the terrorist attack mentioned earlier. Inside a Channel Tunnel train, a group of agitators prepare a time bomb to which a pocket watch is attached. They then throw the bomb out of the moving train, planning that the bomb will explode precisely at the moment when the next train passes the same place. The bomb explodes and causes great damage to the next train and its passengers. In contrast to the aforementioned scene, here the film exemplifies the fact that modern man's ability to time or control his actions can have disastrous consequences for events in the near future.

Time bomb with watch, *High Treason*

Time again becomes a critical factor for the narrative in a scene in the European President's office, from which the declaration of war is about to be broadcast. The shot begins with a close-up of a large wall-mounted clock, which metaphorically shows only a few minutes to twelve. Talking to a broadcast technician, Dr Seymour makes a cynical remark about the meaning of time: 'Yes ... if you kill a man at one minute to twelve, you'll be a murderer ... But, if you kill him at one minute after, you'll be a hero.' Dr Seymour questions the arbitrary power of time over the justice of human life. Thus, the film conveys the message that in the near future righteousness can depend on the way humankind times its actions, which is a credo that Dr Seymour believes will legitimise his murdering of the President in one of the following scenes. While accurate

A few minutes before 12:00, *High Treason*

timing in the aforementioned train scene causes disorder in society, here Dr Seymour's precisely-timed broadcast preserves peace and social order.

Towards the end of the film, in the stand-off scene between Major Deane (the leader of the male soldiers) and Evelyn (the leader of the female Peace League members), the clock motif becomes apparent once again. Located in the Aerodrome, both parties argue over the justice of the mobilisation of military troops as retaliation for the terrorist attacks. Percy Strong frames and lights this scene in such a dramatic way that a wall-mounted clock

in the background becomes an outstanding element of the *mise-en-scène*. The scene is shot in a dark environment from a high-angle position, whereby the Peace League members, wearing white clothes, build the base of this light composition. Above the female crowd are two open doors on either side, through which light enters from the rear into the room. The crowning point of this picture is marked by the wall-mounted clock, which is prominently lit by a spotlight. Seen together, the female League members, the doors and

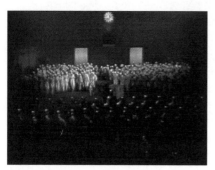

Stand-off in Aerodrome, *High Treason*

the clock formulate a triangular visual configuration placed in the centre of the image, which recalls the preoccupation with similar composition techniques and crowd scenes in High Renaissance paintings. Such optical geometry, elevating the clock as the major motif into the upper centre of the frame, creates a visual tension that corresponds to the narrative tension of the scene.

High Treason pays much attention to the continuity of the precise time of each clock in the film. As such, the clock reads the order of the narrative: the European Council 23:30 (vote on the declaration of war), the Aerodrome first 23:40 and then 23:45 (receiving access to the airplanes), before the President's office 23:50 (shooting of the President) and finally again in the Aerodrome 24:00 (broadcasting of the peace message). This underscores the fact that *High Treason*'s clocks are elements of the *mise-en-scène* that deliberately contribute to the narrative of the film. The repeated and demonstrative use of the clock motif in the film in important locations leaves the impression that time will be an important factor of near-future urban living. Most importantly, the precise timing of events can decide the future of society itself, such as its engagement in war or in peace.

Conclusion

This analysis has sought to demonstrate that the representation of near-future London in *High Treason* takes part in a dialogue about real political, social, architectural and technological events of the same period. Particularly striking is the film's notion that in the future transport and communication will become an even more important matter of modern life. Slightly less pronounced are suggestions that the future of London will be one in which the city is a more rationalised, ordered and healthy place to live, which draws to a considerable extent on the hopes of the cultural commentators, architects and planners of the time.

The plot, politically charged in the sense that it forecasts a war, and in particular the fear of an imminent aerial attack, appears to be inspired by Noel Pemberton-Billing's own eccentric views. *High Treason* shows a paradoxical relationship with the United States. On the one hand, the near-future cityscape clearly follows some of the principles of an emerging Americanised high-rise city. On the other, it speculates about the possibility of the outbreak of war between Europe and the Atlantic States. It is perhaps unsurprising that, because of this provocative portrayal of Anglo-American relations, *High Treason* was banned by the censors in some American states, which caused a considerable setback for the international market strategy of Gaumont-British. Nevertheless, or perhaps even

because of such a tension between filmic and real peculiarities of an emerging modern world, *High Treason* remains a fascinating historical filmic text. Despite Rotha's critical remarks at the time and viewed from today's perspective, like no other British film document of this period, it visualises a reasonable technological and architectural near-future, which is clearly informed by such thinkers as Mathieu-Favier, Hénard, Logie Baird, Cierva, Henry Ford and others. In doing so, it creates a unique cinematic experience of modern life in the near future – a utopian urban vision that deserves to be mentioned alongside Lang's *Metropolis*.

NOTES

1 Hoare also describes a libel suit which involved the allegedly immoral and lesbian performance of dancer Maud Allan in Oscar Wilde's controversial play *Salome*. The scandal is better known through Pemberton-Billing's provocative article in *The Vigilante* under the title 'The Cult of the Clitoris', February 16, 1918. For more on homosexuality in Britain of that time see also Cohler 2007: 68–94 and McLaren 1999: 9–22.

2 Pemberton-Billing published a gigantic conspiracy theory, involving the existence of a Black Book, on 26 January 1918. At the centre of the conspiracy were 47,000 allegedly homosexual members of the cultural and political elite of Britain, who were supposedly blackmailed by decadent foreign forces.

3 The agitators intend to gain financially from war through their affiliation with an arms manufacturer.

4 Charles Lindberg completed a solo transatlantic flight on May 20, 1927. It is likely that this event was still in the minds of the audience and might have fuelled their imagination regarding possible military applications when seeing *High Treason* two years later.

5 The debate on modern architecture became more important in Britain in the 1930s, when a number of modern architects found exile in Britain from the National Socialists in Germany.

6 The conference was held at the Royal Institute of British Architects, London, 10–15 October 1910. For more on Eugène Hénard see also Wolf 1968.

7 Apart from clear political, informative usage, the device also seems to have some secondary entertainment value. A short scene on the Governmental Broadcasting System shows girls on the beach in bathing suits.

8 There is no evidence that this device reaches beyond the limits of the city.

9 Some of the early American television sets show similar wooden casings.

10 *High Treason*'s wall-mounted speaker is also similar to the Pye portable loudspeaker.

11 More on the social history of tuberculosis see Bates 1992.

12 In 1932 Berlage received the Gold Medal from the Royal Institute of British Architects.

WORKS CITED

Anon. (1926) 'The "Televisor": Successful Test of New Apparatus', *The Times*, 28 January, 9.
____ (1927a) 'Office London: Electric Railways', *The Architect and Building News*, 6 May, 773.
____ (1927b) 'The Towers of Babel', *The Architect and Building News*, 22 July, 127–8.

_____ (1927c) 'Television By Gramophone: Mr. J. L. Baird's Prophecy', _The Times_, 22 September, 11.

_____ (1928a) 'Television Sets For Sale', _The Times_, 21 February, 13.

_____ (1928b) 'The Autogiro', _The Aeroplane_, 5 September, 414, 441.

_____ (1929a) 'Tunnel or Bridge', _The Times_, 3 January, 13.

_____ (1929b) 'The Channel Tunnel would make London the Gateway to the West', _The Times_, 12 January, 10.

_____ (1929c) 'What some Leading Business Men Think About the Channel Tunnel', _The Times_, 14 January, 10.

_____ (1929d) 'A London Opportunity', _The Architect and Building News_, 26 April, 542.

_____ (1929e) '_High Treason_', _The Daily Film Renter_, 9 August, 6.

_____ (1929f) '_High Treason_', _The Bioscope_, 14 August, 35.

_____ (1929g) '_High Treason_: Political Forecast in Gaumont "Talkie"', _To-Day's Cinema_, 31 August, 4.

_____ (1934) 'A Dangerous Experiment', _The Aeroplane_, 5 September, 273.

Bates, B. (1992) _Bargaining for Life: A Social History of Tuberculosis, 1876–1938, Studies in Health, Illness, and Caregiving in America_. Philadelphia: University of Pennsylvania Press.

Cohler, D. (2007) 'Sapphism and Sedition: Producing Female Homosexuality in Great War Britain', _Journal of the History of Sexuality_, 16, 1, 68–94.

Dennison, B. (1931), 'Concrete', _The Architect's Journal_, 661–2.

Edwards, T. A. (1929) 'Skyscrapers', _The Architect and Building News_, 9 August, 163–6.

Fishman, R. (1982) _Urban Utopias in the Twentieth Century: Ebenezer Howard, Frank Lloyd Wright, and Le Corbusier_. Cambridge, MA: MIT Press.

Hénard, E. (1911) 'The Cities of the Future', _Journal of the Royal Institute of British Architects, Transactions_. London: 345–67.

Hoare, P. (1997) _Wilde's Last Stand: Decadence, Conspiracy and the First World War_. London: Duckworth.

Johnson, W. (1994) _Helicopter Theory_. New York: Courier Dover Publications.

Jones, C. H. (1928) 'Westminster Abbey', _The Architects' Journal_, 4 January, 25.

Kern, S. (1983) _The Culture of Time and Space 1880–1918_. London: Weidenfeld and Nicolson.

Koeck, R. (2005) _The Cinematic Representation of the Near-Future City, 1926–1936_. University of Cambridge: unpublished PhD dissertation.

Lees, A. (1985) _Cities Perceived: Urban Society in European and American Thought, 1820–1940, The Columbia history of urban life_. New York: Columbia University Press.

McLaren, A. (1999) _Twentieth-Century Sexuality: A History_. Malden, Mass.: Blackwell.

Mumford, L. (1934) _Technics and Civilisation_. London: George Routledge & Sons.

Pemberton-Billing, N. (1916) _Air War: How to Wage it: With Some Suggestions for the Defence of Great Cities_. Aldershot and Portsmouth: Gale & Polden.

_____ (1941) _Defence Against the Night Bomber_. London: Robert Hale.

Pontius (1934) 'The Pilot's Point of View (New Series) XIV The C.30 Autogiro', _The Autogiro_, 23 May, 845–6.

Robertson, H. (1927) 'A City of Towers', _The Architect and Building News_, 21 October, 639–43.

_____ (1928) 'Towers of Manhattan Island: The Problem of the Skyscraper and New York's Attempt to Solve it', _The Architect and Building News_, 12 October, 473–5.

Rotha, P. (1949) _The Film Till Now_. London: Spring Books.

Stern, R. A. M., T. Gilmartin and T. Mellins (1994) *New York 1930: Architecture and Urbanism Between the Two World Wars*. New York: Rizzoli International Publications.

Winston, B. (1998) *Media Technology and Society: A History: From the Telegraph to the Internet*. London: Routledge.

Wolf, P. M. (1968) *Eugène Hénard and the Beginning of Urbanism in Paris, 1900–1914*. Paris: The Hague, International Federation for Housing and Planning.

6 CITY OF LIGHT, GARDENS OF DELIGHT
Thomas Elsaesser

Modernism – Modernisation – Modernity

This chapter attempts to intervene in the modernism/modernisation/modernity debate, as it impinges on the discourses of the city in general and the cinematic city in particular. The first two terms of this triad are often seen as antagonistic. Modernism designates the high-culture critique and ultimate rejection of what modernisation stood for: techno-logically-driven, capitalist modes of consumption and leisure, responsible for creating a mass culture whose outwardly most striking sign was the cinema, with its immense and near-universal popularity, at least since the end of World War One. The introduction of a third term – that of 'modernity' – signalled the moment when modernism and modernisa-tion seemed ready for a truce of sorts, prepared to leave behind not the questions, but some of the answers that these two terms were once meant to provide.

Although 'modernism' and 'modernisation' are semantic fields that refer to Euro-pean cultural life roughly between the 1870s and the end of World War Two, it seems fairly clear that the debate that pits them against each other belongs to the postwar period; for, if not invented, then they were certainly promoted and put in circulation inside and outside the academy only after 1945. Modernity, on the other hand, is a creation of the 1970s and 1980s, emerging chiefly through the 'rediscovery' of the writings, first of Walter Benjamin, and then of other, mainly German, intellectuals of the pre-World War One and interwar periods. The time from the 1970s onwards could thus be regarded as one where postmodernism constructed for itself a new genealogy – that of 'modernity' – which thus came to replace both modernism and modernisation. It bridged the antagonism while not effacing the conflicts and issues that had given rise to them. In particular, the emphasis on sight (where modernity equals visuality within a given field), combined with the loca-tion of the city (modernity equals mobility within a given space), seemed to provide an alternative strategy for articulating also the political tensions between elite and mass cul-ture, capitalism and socialism, the artist and the engineer, craft skills and *techné* versus industrial technology and mass production.

Modernity, it seems, was able to have this mediating or even transcending role, because the term encompasses the now familiar associations of the city with a whole range of characteristics, including those typical of cinema. The metropolis quickly came to stand for more than an accumulation of people in an urban settlement serving as a centre of commerce and trade. Thanks to Benjamin's fragments, essays and aphorisms about Baudelaire and Paris, but also to certain essays by Georg Simmel and Siegfried Kracauer, the conjunction 'modernity/metropolis' includes epoch-defining changes in consciousness and mental life, shifts in perception and sensory attention, which in

turn have broken up ideas of linearity by even foreshadowing such 'digital' concepts as random access. Or rather, the complex 'modernity/metropolis' has helped validate the emergence of different sight-lines of orientation, different horizons and organising principles, requiring new perceptual skills that demand the sort of reflexes of impermanence and improvisation which register positively as 'the urban experience', and negatively as 'urban anomie'. Modernity in this context is associated with the primacy of the eye, with vision as the modern master-sense, across the various scopic regimes of modernity, and shadowed among philosophers by the various anti-Cartesian critiques of ocular-centrism, so painstakingly analysed by Martin Jay in his *Downcast Eyes* (1993), across the central perspective projection from Alberti to Descartes, the topographical models in Dutch art, the embedded/embodied eye of the Baroque and the kinds of somatic perception which, according to Jonathan Crary, surfaced in the nineteenth century across the different 'techniques of the observer' (see Crary 1990). At the same time, the semantic clusters around visuality and the city also inspired major revaluations of the historical avant-gardes, especially surrealism (such as in Hal Foster's *Convulsive Beauty* (1993) and the work of Rosalind Krauss on the 'optical unconscious' (1994)), but also of futurism, and – in the German context – Berlin Dada.

The Rise of the Cinematic City

It was within this field of inquiry and the concept of the modern metropolis, that the paradigm of the cinematic city found successive historical grounds (Paris 1900, New York 1910s, Berlin 1920s, London 1920s and, once again, Paris 1930s) as well as its richest metaphorical tissue of references. Thanks again to Benjamin's phenomenological observations of his Berlin childhood, his affinity with both surrealism and futurism, and his more philosophical-materialist 'Passagen' project on Paris in the nineteenth century, these references tended to group themselves around such archetypal figures as the *flâneur*, the prostitute, the gambler and the rag-picker. The backdrop was provided by the new department stores, like La Samaritaine, and the emergent mass consumption encouraged by window-shopping, by chance encounters on streets and boulevards, especially those created in the wake of the 'Haussmannisation' of central Paris. For the twentieth century and its revolutionary urbanist designs, the key concepts outlined a space of tension and dynamic interaction, of God's-eye skyscraper view versus ground-level strolling. They pitted the geometrical grid of Le Corbusier against the gritty concrete jungle of the movies and their gangster or crime film cycles. They opposed order and planning versus gambling and risk, culminating in the polarities of social elevation and ethnic (or neighbourhood) sedimentation, as we find it around the urbanism of New York, in Jane Jacobs' diatribes against large-scale developers such as Robert Moses (see Jacobs 1964 and Berman 1982). Similar issues confronted urbanists at the end of the century, and led to locutions such as 'the space of flows' of the network society (see Castells 1996) and 'the non-spaces' of supermodernity (see Augé 1995).

My sense is that this focus on the city as the central conceptual metaphor of modernity in the last twenty years or so has not only had a very profound impact on how we have come to view the interrelation between the arts and modern life. In the case of film studies, it has also substantially shifted the terms of a debate that once concentrated on 'cinema and society', 'cinema and politics', 'cinema and subjectivity'. Yet the rise of what is now

generally called the cinematic city did not only displace these various discourses internal to the discipline. It also finally cancelled the kind of residual debt that film studies still owed to literary models and art historical assumptions about authors, works, movements, genres, influence – just as surely as it modified high modernist notions of medium specificity, anti-illusionism and formalism. Perhaps the debt now even flows the other way.

More generally, the cinematic city marked a turn to history, indeed to historicism, while carefully avoiding the sterile methodological debates around historical method, whether positivist-empirical or neo-Hegelian, while keeping clear of sociology, quantification and statistics. Instead, it approached such traditional film studies questions regarding audiences and spectatorship across new paradigms of ethnography and neighbourhood demographics. What came to be known as the New Film History also dealt differently with questions of genre; it conducted a kind of archaeology of the cinema as a popular medium across institutions such as vaudeville and music halls, across event-scenarios such as World Fairs and Hale's Tours, panoramas, dioramas and stereoscopy. It tracked the projected image into temperance leagues lectures and magic lantern shows, and it conducted a kind of anthropology of leisure pursuits across the various classes and genders. Much of this activity saw itself in the service of better understanding that core aspect of modernity, the 'urban experience' and its intertwining with the various kinds of image cultures, gendered spaces and visual displays, mostly based on photographic, projected, printed, but above all moving images.[1]

Metropolis and *Kuhle Wampe*: Polar Opposites or Unlikely Allies?

The question I want to pursue concerns my sense – after teaching the cinematic city for a decade to undergraduates, across its discourses of modernity/visuality and postmodernity/spectacle – that this paradigm, despite its richly metaphoric and historiographic yield, can also be a rather problematic way of understanding modernity, and within it the role of the cinema and the moving image. I hope to illustrate some of these difficulties by way of a case study, which asks what happens to the boundaries separating certain films we are used to classifying as opposites – 'modernist/avant-garde' versus 'modernising/reactionary' – when the cinematic city (of modernity/visuality) is introduced to confront these canonical films with each other. In other words, my question is: how can we understand the conceptual shift from 'modernism' to 'modernity' when the terms and their implied attributes are historicised, that is, when specific historical discourses and political debates are factored back into the emergence and reception of these films? In a second move, I want to show how this reframing, while it may give a more satisfying account of the films' plural semantics, does in turn leave certain questions unanswered. The historicisation may, for instance, produce a surplus of meaning apparently not preserved by the various afterlives that the films have in the culture, or they may acquire a different kind of 'modernity' not primarily referenced to visuality, and thus hinting at processes that wear visual modernity as a sort of mask, a foil or skin that could be shed, or thrown off like a disguise.

The two films of this case study are both canonical, but at opposite extremes, as it were, in the conventional definitions of modernism. While Fritz Lang's *Metropolis* (1926) is frequently seen as an anti-modernist film, because of its dystopian vision of the future, its nostalgia for the Gothic middle ages and a strictly hierarchical society, Slatan Dudov's

Kuhle Wampe (1932) by contrast, figures as a modernist work of the political avant-garde. Confident that the world can be changed through struggle, it ends on the rousing chorus of 'Vorwärts und nicht vergessen ... die Solidarität' ('forward, and let's not forget ... solidarity') and as such proposes the very opposite to the sentimental slogan 'between the hand and the head, the heart must mediate' which ends *Metropolis*. *Metropolis* is furthermore often regarded as a 'nationalist' film, indeed a national-fascist film, with its class-collaborationist message of the unity of the 'Volk', in contrast to *Kuhle Wampe's* declared internationalism, with the working class of all countries asked to join in the same fight against exploitation. Finally, the films are in opposite camps aesthetically and economically: *Metropolis* is a big, studio-based special effects extravaganza dedicated to cinematic illusionism, while *Kuhle Wampe* is a critical-realist film, with documentary qualities and ambitions, constructed according to formalised montage principles of anti-illusionism, counterpoint and dialectical juxtaposition. *Metropolis* was an ostentatiously commercial project, and produced in order to sell in the United States; *Kuhle Wampe* was made by and for Berlin Communists, to militate and agitate within youth groups and party organisations against the rising threat of fascism.

If *Metropolis*, which is said to have failed to recoup its huge financial investment, is therefore in the history books as an emblem of Teutonic hubris – the studio Ufa's hubris foreshadowing symbolically the even greater German hubris that was to follow after 1933 – then *Kuhle Wampe* stands as the monument to an alternative German filmmaking and film culture that was never given a fighting chance. The firm Prometheus, which produced the film, is the plucky David to Ufa's Goliath, earning its money first by distributing Eisenstein and Pudovkin's new montage films in Germany (known there as 'Russenfilme'), before venturing also into film production, and gathering for its efforts some of the best left-wing talents of the latter days of the Weimar Republic: besides Bertolt Brecht, Hanns Eisler and Slatan Dudov, there was Ernst Busch, Erwin Piscator and Helene Weigel (who, incidentally, played a bit part in *Metropolis*).

During the 1970s *Kuhle Wampe* helped revive interest in the possibility of a Brechtian aesthetics becoming productive for film theory, not so much because of its impeccable left-wing credentials, but because it seemed to deconstruct the classical Weimar father/son conflict, by giving the viewer a political and economic perspective on the patriarchal, bourgeois and petit-bourgeois family (see *Screen* 1974). *Metropolis*, on the other hand, is a classically Oedipal tale of fathers and sons, with rebellion finally quelled through a double act of auto-castration: that of the son in front of his father, that of the working classes in front of the boss. It is with such self-abnegation that *Kuhle Wampe* opens: probably the best-known scene is the young worker's suicide, after his unsuccessful quest for work and the row with his father over dinner. The second part follows the young man's sister, as she enlists her boyfriend for help when the family is evicted.[2]

Also well known is the final part, the ride back to the city in the commuter train home, where the nature of international capitalism (that is, 'globalisation') is being discussed, sparked off by a news item in the paper regarding hundreds of tons of Brazilian coffee having been burnt in Sao Paolo, in order to prop up coffee prices on the world market. Everyone has his/her own kind of outrage and solution, but the young people insist that only those will change the world who do not like it the way it is, while Hanns Eisler's solidarity song, 'Vorwärts und nicht vergessen', guides them to this hopeful goal, as the image shows a dark urban underpass.

Metropolis is remembered not only for its naïve social message of the head needing the heart to unite itself with the hand, a motto savaged in a famous review by H. G. Wells who called it 'quite the silliest film I have ever seen' (1927: 4), but also for Siegfried Kracauer's famous indictment of the 'mass-ornament'. For him, Lang's film provided the clearest example of Nazi aesthetics in the all-too-successful organisation of the masses for visual display, the blueprint for Leni Riefenstahl's *Triumph des Willens* (*Triumph of the Will*, 1935) and thus, for our purposes, a key political moment in the visuality/modernity trope. In *From Caligari to Hitler*, Kracauer called *Metropolis* 'cinematically an incomparable achievement, from the human point of view a shocking failure' (1947: 149–50), concisely summing up one of the sustaining ambiguities also about the cinematic city, especially in respect to the issue of social exclusion, the homeless, the underprivileged.[3] However, if Kracauer was critical of *Metropolis*, he was hardly kinder about *Kuhle Wampe*. In his article of 5 April 1932 in the *Frankfurter Zeitung*, one finds the following:

> The gravest blunder committed in *Kuhle Wampe* is its gross attack against the petit-bourgeois mentality of the old workers – an attack obviously designed to stigmatise social democratic behaviour. At a time when the menace of Nazi domination [is] felt throughout Germany, it would have been a better strategy to emphasise the solidarity of the working masses instead of criticising a large portion of them. In addition, this criticism is spiteful rather than solicitous. Like any reactionary film, *Kuhle Wampe* in its depiction of the engagement party goes so far as to ridicule the bad table manners of the older generation ... *Kuhle Wampe* is not free from glorifying youth as such, and to some extent its youthful revolutionaries resemble those youthful rebels who in numerous German films of the opposite camp [i.e. National Socialist youths] are finally ready to submit or enforce submission. This resemblance is by no means accidental ... anguished young unemployed would be swayed by a Communist spokesman [one evening] and the next succumb to a Nazi agitator's harangue. (Reprinted in Kracauer 1947: 246–7)

Kracauer's political critiques bypass the modernist/anti-modernist divide. They hint at a historical ground that both films share but which film history has largely written out of their reception: the question of class, and the apparent cynicisms that both *Metropolis* and *Kuhle Wampe* display *vis-à-vis* the moderate working class of the Weimar Republic. This shared ground opens the view to a number of areas of conflict and debate encapsulated in these films, for which again neither the modernist/anti-modernist nor the left/right divide can fully account, but which is, I think, illuminated by the cinematic city paradigm.

Cities of (Questionable) Delight

I want to focus here on one scene from each film. The scene from *Metropolis* is the early one set in the pleasure gardens of the rich, as Freder and a number of scantily-clad society beauties frolic around a fountain. Just at the moment that Freder is about to kiss the one who allows herself to be caught, the huge doors open and there stands Maria, an angelic-maternal figure, surrounded by a crowd of children, saying: 'Look – these are your brothers and sisters.' It is the ultimate 'chance encounter', not in the street, as in Baudelaire, but due to a very modern invention: the skyscraper elevator. The scene from

Kuhle Wampe is that of the engagement party, found so objectionable by Kracauer, where the young couple invite the neighbours and friends to a quite different garden of delight in the allotment colony, to celebrate the couple's less than passionate love match. The guests are visibly enjoying themselves, and are getting progressively more inebriated on the beer the hapless fiancé sullenly carts into the tent, until Uncle Otto drunkenly staggers out to relieve himself, shouting 'at least my body is my own'!

What is striking is the iconicity of the sites that the two scenes privilege. In the case of *Metropolis*, the Eternal Gardens of Delight, high up on the top of the tallest building, the New Tower of Babel, are the very symbol of the Ideal City, but also allude to *La Ville radieuse* of High Modernist architects such as Le Corbusier: at any rate, their siting reflects the 1920s fashion for skyscrapers, or 'tower houses' as they were first known in Germany. In the case of *Kuhle Wampe*, the contested site or social space is named in the title itself, about which all kinds of speculations have been made, down to the French title for the film, 'ventres glacés', as the supposedly literal translation of Kuhle Wampe, 'cold bellies'. But Kuhle is the German for a (sand-) pit. Wampe, on the other hand, is indeed Berlin slang for 'belly', especially when it refers to food, as in the phrase 'sich die Wampe vollschlagen' meaning 'to stuff or gorge oneself'.

The social space that Kuhle Wampe actually names is a 'Laubenkolonie', or tent colony, a not-so-distant relative of the more famous Schreber-Garten, or allotment garden. These allotments sprang up all over German cities after World War One, as ways of allowing the working class population to supply itself and their families and relatives with home-grown foodstuffs. In this respect, *Kuhle Wampe* put forward a controversial and probably already unpopular position: namely that such forms of self-help for supplying the urban working class with food and shelter, promoted mainly by social democrats, was no solution at all. On the contrary, the film argues, by showing the drunken excesses of the engagement party, these are counter-revolutionary initiatives.

In order to understand the polemical position taken by the filmmakers, one has to remind oneself of a hotly debated discursive terrain, namely post-World War One housing policy, urban planning and the new prominence given to domestic architecture (see Miller Lane 1968). Both films implicitly and explicitly engage with a number of concerns that are as much urbanist-political as they were film-political: above all, the discourse around the idea of the new 'metropolis' built on the American model as an agglomeration of high-rise buildings and skyscrapers. A second set of arguments refers to the widely discussed ideas of combating housing shortage through new urban planning and purpose-built housing estates (see Pommer & Otto 1991). In Frankfurt the debate was launched with the slogan 'Die Wohnung für das Existenzminimum' ('housing for the less well-off').[4] Then there is the discourse of the single-family home with its own garden, developed from the late nineteenth-century utopian schemes of garden cities, by utopian thinkers such as Charles Fourier, or reformers like Ebenezer Howard (see Hall 1996). Finally, there is the discourse of self-sufficiency or the world market, the local or the global, as the films are trying to define and redefine the relation of the individual not only to the family and community, but to the modern city.

Central to the iconography of *Metropolis*, for instance, is the contemporary debate around the function of skyscrapers, better known in German as 'der Schrei nach dem Turmhaus' ('the cry for the tower-block'). Lang claimed to have had the inspiration for the film from a visit to New York with Erich Pommer in 1924 (see Gehler & Kasten 1990:

29). But this mythic tale of origins ignores the fact that there had already been a lively discussion about skyscrapers in Germany, which went beyond words. In 1921, a much-publicised architectural competition took place, to design Berlin's first skyscraper opposite the Friedrichstrasse railway station. The competition is today best-remembered for Mies van der Rohe's design (ignored by the judges, as was his plan for the Chicago Tribune building), but reproduced in countless architectural history books, because now considered the birth of the modern all-glass, curtain-wall high-rise.[5]

The intellectual flavour of the competition and subsequent debate is well conveyed in the architectural writings of Siegfried Kracauer (see Volk 1997). There, a number of fundamental positions can be found, notably whether the new high-rise buildings should serve as nerve centres for the advancing white-collar society of civic administration, whether they should be conceived as a city's representative symbols (for which the name of *Stadtkrone*, civic crown, was coined by Bruno Taut), or whether high-rises should take on the function of a new type of habitat, and if so, for what class of inhabitants. Thus, around the designs and sketches for *Metropolis* one can recognise the new urban ideal of *Stadtkrone*, which one could translate as landmark buildings. They signal a modernist break, where architectural landmarks are no longer symbols of spiritual or dynastic power, such as cathedrals or monuments to Kings (for example, the Brandenburg Gate) and Emperors (such as the Kaiser-Wilhelm-Gedächtnis-Kirche, a typical example of historicism, even in its name), or to The German People (such as the Reichstag). Rather, they refer to industrial buildings (Walter Gropius' Fagus works), factories (Peter Behrens' AEG Turbine works), radio towers (Heinrich Straumer's Berlin radio tower), or to symbols of the proletarian revolution, like Tatlin's tower, taking over from an earlier generation of representative symbols such as exhibition towers (most famously, the Eiffel Tower in Paris).

In this context, an explicitly utopian ideal comes to the fore, namely the high-rise building as a city in itself. We can recognise in it the union of engineer and politician in those dreams of the 'city state', so dear to Italian Futurists and reflected in the designs of Sant'Elia, as well as in the writings of the young Le Corbusier, set out in *La Ville radieuse* (1933) or in his essay of 1924, *Formation de l'optique moderne*. Le Corbusier could only try out his city ideas after World War Two, for instance, in his famous Unité d'habitation, built in Marseille in 1947, and still considered one of the most important buildings of architectural modernism.[6]

If one goes back to some of the other designs presented in 1921 for the Friedrichstrasse competition, one is particularly striking, in that it seems explicitly to sketch something we are nowadays very familiar with, namely the skyscraper as an integrated unit consisting of office building, shopping centre, railway terminal or traffic intersection and entertainment and leisure complex. This is the design called *Lichthof* (atrium), where we can note cinemas, shops, dance-halls, underground car parks, pedestrian walkways. Like all other designs from the 1921 competition, this one, too, was not built, so that the historical paradigm for such an ensemble remains the Radio City in New York, dating from the 1930s, and starring, next to Coney Island, in Rem Koolhaas' *Delirious New York* (1978).

Kracauer, as indicated, had his doubts as to whether the high-rise as total environment could become a viable model for modern housing. This scepticism was in fact in line with the movement of urban renewal and expansion known as *Das Neue Bauen* (New

Building), of which the Britz housing complex in Berlin (architects Bruno Taut and Martin Wagner),[7] the Weissenhofsiedlung in Stuttgart (German and international architects) and – most importantly – several projects in Frankfurt (such as Praunheim, Römerstadt and Bruchfeld) have remained the prototypes.

Gardens of Light (Air and Sun)

My suggestion is that *Metropolis* and *Kuhle Wampe* can be better understood if one imagines them not as the binary opposites that film history has remembered them, but as two sides of a triangle (of an altogether different discursive history, precisely that of the cinematic city). The third side is Weimar Germany's urbanist modernity, among which the housing schemes of *Das Neue Bauen* and, in particular, their highly politicised, militant and polemical articulation in Frankfurt is the most exposed exemplar. While *Metropolis* keeps a tension between unacceptable tenement blocks and Le Corbusier-type *ville radieuse* pleasure-domes, and *Kuhle Wampe* is prepared to keep the tenements as the price for keeping the working class militant and on the streets, the promoters of *Das Neue Bauen* saw the city as a whole. In this sense they tried to renew it with civic landmark buildings for modern offices, administration and commerce, while implementing a housing policy that was at once radically modern in design, while radically social in its economic and emancipatory calculus, with its call for cheap, affordable social housing based on contemporary ergonomic and heliotropic principles, under the slogan *Licht, Luft und Sonne* ('light, air and sun').

The Frankfurt experiments were commented on all over Europe, not least thanks to a range of publications, conferences and model shows, culminating in Frankfurt hosting in 1929 the Second International Conference of the Association of Modern Architects (CIAM). The special issue of the journal *Das Neue Frankfurt*, published for the occasion, sported a title page which typically combined the graphic principles of constructivism with an outspoken political concept, explicitly quoting the film *Mutter Krausens Fahrt ins Glück* (*Mother Krause's Journey to Happiness*, 1929) and the famous line from Heinrich Zille (quoted in the film itself): 'You can kill a person with bad housing just as surely as with an axe.' A polemically-contested point at the time was whether the new housing units designed and built in Frankfurt were really benefiting the lowest income groups, or whether both in their style of living and in the rentals they were more attractive and suitable for the new white-collar population (see Kuhn 1998: 364). Especially known were the ergonomic studies of interior planning, and the then revolutionary concept of fitted kitchens, as designed by the architect Grete Schütte-Lihotzky and her so-called 'Frankfurter Küche' (see Kramer 1986; Schump 1972). Other types of kitchen designs were also extensively discussed (see Stahl 1977), and women were encouraged to wear white lab coats while doing their cooking chores (see von Saldern 1990).

If we now turn to the other corner of our triangle, *Kuhle Wampe*, the summer datcha and the allotment garden, we find that a problematic class position is also typical for the discourse 'house and garden' in the garden city. As indicated, one of the slogans of *Das Neue Bauen* was the call for 'Licht, Luft und Sonne', meaning that the housing estates not only were built with a controversial 'flat roof' which could serve as roof garden and sun-terrace, but that besides balconies and garden terraces there were also, behind the rows of houses, allotment gardens which formed a green belt and a natural vista for the eyes.

The Weimar Left and *Das Neue Bauen*

Modern architecture was viewed by the revolutionary left with often undisguised suspicion, not least because its leading representatives (Walter Gropius, Mies van der Rohe) seemed ideologically unreliable. The most 'unreliable' of all was, of course, Le Corbusier, who more than once justified his innovative housing concepts and building designs with the words: 'make architecture, not revolution', that is, he believed the best way to forestall an impending revolution was to give the working people modern, decently designed, utilitarian housing. Such pronouncements must have seemed to the left even more counter-revolutionary than the rather innocuous *Metropolis* slogan of the heart needing to mediate between head and hand. And there are, indeed, passages in Bertolt Brecht's and Ernst Bloch's writing strongly condemning the idea of satellite towns and garden cities because they de-politicised the proletariat. The left feared this de-politicisation that came from suburban living, hence the attempt to re-politicise the workers via sports events in *Kuhle Wampe*. But this combination of sports and outdoor activity was equally popular on the right, as Kracauer pointedly remarked and as one can, from today's perspective, only confirm, seeing the politics of sports, media and nationalism (ironically most reprehensible in the former GDR, the state that claimed to be the legitimate heir to *Kuhle Wampe*'s communist ideals).

However, the ambivalent politics of the most famous international modernists can only in part explain the suspicions of the communist left towards both International Modernist architecture in general and *Das Neue Bauen* in particular. The other part was distrust in the petit-bourgeois or middle-class ambitions of the working class itself, nurtured most conspicuously and most damagingly, of course, by the cinema. In the logic of the cinematic city, the avant-garde modernism of *Kuhle Wampe* is not only opposed to the apparent anti-modernism of *Metropolis*; it also disagrees with the autocratic high modernism of both Le Corbusier and the social-democratic modernism of *Das Neue Bauen*, the contradictory energies of which, by contrast, *Metropolis* celebrates. *Kuhle Wampe* clashes head-on with the cinema: as institution, as ideal city and as social utopia. Embodying the 'hidden hand' of capitalist modernity, the cinema – politically speaking – is perceived as anti-modernist and counter-revolutionary. In other words, if one central 'ground' on which the two films talk to each other, when interrogated through the modernity/visuality cinematic city paradigm, is certain architectural debates and urbanist dilemmas of Weimar Germany, then the terms by which they do so involve a historical-political deadlock that both *Metropolis* and *Kuhle Wampe* are caught up in. Somewhat foreshortened, one might say that as films they may be modernist or anti-modernist, but as part of the cinema they belong to 'modernity' only insofar as they help disguise as well as stage its contradictions: one of the central functions of the cinema, I want to argue, in the processes identified above with 'modernisation'.

A Blonde's Dream

The extent to which the cinema actively played this role of social moderniser, staging and disguising some of the tensions between modernising urbanism and political modernism, is illustrated by another German film from the early 1930s. Paul Martin's *Ein Blonder Traum* (*A Blonde's Dream*, 1932) is a star vehicle with Lilian Harvey, Willy Forst and Willy

Fritsch, made the same year as *Kuhle Wampe*. As if to fill the gap, or point out an alternative, it celebrates the very petit-bourgeois ambitions that Brecht and *Das Neue Bauen*, for all their differences, were both so sceptical about. Released in the middle of the same post-Wall Street Crash Depression, *Ein Blonder Traum*, too, is a film about unemployment, about housing shortage and about three young people – two men and a woman – choosing as their solution to move to a 'Laubenkolonie'. The male heroes are two happy-go-lucky window cleaners on their bikes, abducting a would-be actress to their allotment garden where they live with a tramp, a duck and a chicken in a disused railway carriage. In this operetta-derived, Warner Bros-inspired musical, the ambitions of the young people are as split between the global and the local as in *Kuhle Wampe*, but the global now has a different name from the world capitalism symbolised either by Brazilian coffee or the dystopian city-machine of *Metropolis*. The name of internationalism in *Ein Blonder Traum* is unambiguously 'Hollywood', for the narrative intrigue is provided by an impostor who makes himself out to be a dream-factory casting agent who has come to Berlin to hire fresh talent. One scene – a whole brigade of window cleaners with their ladders and bikes careering through Berlin – could be viewed as a comment on or even a parody of one of the most impressive scenes of *Kuhle Wampe*, the bicycle ride montage of the unemployed workers which opens the film. Emblematically, *Ein Blonder Traum* enacts one of the origins of the cinematic city paradigm: in a sort of inverted 'solidarity song' of the window cleaners, the shop windows that the young men have to clean and the movies in which the young woman wants to star are symmetrically joined, as the two sides of the same 'dream' of glamour and consumption. Lifestyle values and sophisticated erotic banter are taking over in the minds of the young from the class-consciousness of the returning sports fans in *Kuhle Wampe*, and while *Ein Blonder Traum* gives itself a clearly apolitical good conscience, its aspirational idyll includes a (suburban) home with a garden, halfway between Bohemian creative chaos (the tramp) and petit-bourgeois order (the railway carriage interior, with chequered tablecloth and flowerpots).

Speaking from the film-political perspective of *Ein Blonder Traum*, blockbusters like *Metropolis* were, by 1932, as obsolete as *Kuhle Wampe*, which was dismissed for its Communist Party propaganda. Erich Pommer, the same producer who went with Lang to New York, was behind *Ein Blonder Traum* and other highly popular Ufa musicals, successful in Germany, but no less so abroad. Whether set in the city or in the country, in Ruritania or at the Congress of Vienna, such films were not beholden to modernism, but nonetheless constituted a crucial step in the cinema's active role in the dialectic of 'modernisation'. They competed with Hollywood in their use of ultra-modern technology – in this case, optical sound – and, like Hollywood, were in the vanguard of modern mass entertainment, advocating international lifestyle and consumption habits, even as audiences were mostly too poor to be able to afford them.

What had happened? One of the more perceptive critiques of *Metropolis* in the United States noted that the film was unconvincingly and tendentiously communist in its depiction of the workers' slavish degradation, because, as everyone knew, since Henry Ford introduced the Model-T Ford Automobile workers had to have a share in the profits of mechanisation and automation in order to be able to buy the goods that mass-production was making available. If industrialisation was to function efficiently and if technology was to be profitable (or, as the propagandists of the new order would say 'of benefit to mankind'), the working class needed to become consumers. In one sense, this was the voice

of 'modernisation' in its clearest accents. Whether in political terms it was bourgeois-liberal or national-socialist is a moot point, since words to this effect – or at any rate measures to this end – were also adopted in Hitler's Germany, where in the years from 1933 to 1938 (carrying on a process that had been building up in right-of-centre social democratic Weimar since 1928) the Nazis did expand the production of modern domestic appliances and consumer goods dramatically. In fact, the Nazi formula for tackling the problem of housing (and thus for 'resolving' the problems posed by both *Metropolis* and *Kuhle Wampe*) – namely the redistribution of wealth to secure biological and social repro-duction – was not the building of better designed dwellings but the *Volksempfänger* (an affordable radio set), the *Volkswagen* and the *Autobahn*. These are moves typical of the dialectics of modernisation, anticipated by neither of the films considered here.

The private motor car and the public mass media effectively signal the primacy of consumption over production, but also the primacy of transportation and circulation over habitation – key elements of modernisation across the political divides. It puts one in mind of the remark supposedly overheard in the early 1950s in the American Midwest, after a screening of *Ladri di biciclette* (*Bicycle Thieves*, 1948): 'Great movie, there's only one thing I don't understand: why didn't he just take the car to work?'

From Habitation to Transportation

What I wanted to suggest is that the paradigm of the cinematic city not only reflects the shift from production to consumption made possible by industrialisation and technology, disguised and hidden in the exhibitionist charm of the commodity, it also entails a shift from habitation to transportation, whose logic may not altogether be encompassed by the ocular master sense of sight, however much the eye still partakes in it, having become mobile in its various 'static vehicles'.[8] My point is that some of the most important so-cial technologies of the twentieth century have not been those centred on vision, but on transport and mobility, as well as on time-shifting and simultaneity. In this respect, too, the moving image – modernising agent *par excellence* – has participated in their promo-tion, which is to say, their investment with subjectivity and fantasy.[9]

But such a 'city' is one of trans-port and trans-mission, of simultaneity and tele-presence as much as it is one of sights and ocular delights. The image of the children of *Metropolis* safe, high above in the New Tower of Babel, could be the film's alternative ending, its ending for today: their journey from the workers' city to the eternal gardens may once have seemed an allegory of class-collaboration, an illusory journey of social rise, but this would mean granting the topography of 'up' and 'down', of 'high' and 'low' metaphoric significance only in the register of the visual. Why not see their journey as a time-shifting, place-changing modality of transportation and co-presence, in which sight is only one sensory marker of embedded but also disembodied presence? After all, has the chance encounter in the office elevator not taken over from the fleeting eye contact of the *flâneur* with 'une passante' as our own century's most erotic 'lift'?

This brings me, finally, to contemporary surveillance culture, and its increasingly im-portant role in any concept of the cinematic city today. Marked by many an ambiguity about its invasiveness, balanced by the exhibitionist pleasures it also gratifies, surveil-lance perfectly captures the modernising – and what I termed opportunist – role of the

cinema. For one source of the ambiguity is that we tend to look at surveillance from the vantage point of the 'City of Light', the modernist fear or modernist fantasy of total transparency inherited, as Foucault so often reminded us, from the Enlightenment and the French Revolution, following the Cartesian logic of the disembodied, all-seeing eye, its obsession with the 'unimpeded empire of the gaze' (1979: 206). Yet modern surveillance, at least as figured in popular culture and the cinema, does not seem to be part of the Cartesian scopic regime, where the observer controls the picture. Rather, often enough it stages a Garden of Delight, where the observer is always already *inside* the picture. In which case, the pleasure that powers today's surveillance culture would be the fantasy of being in several places at once: embedded, but dis-embodied, embodied but dis-placed: from trans-port to trance-port. The *flâneur* of the cinematic city would have made his peace with the God of the City of Light, but only because Bishop Berkeley's God ('to be is to be perceived') has made his peace with Nicolas de Cusa's God ('to be at the centre of the world and yet at every point of its circumference'). After modernism's dialectic of top-down versus bottom-up, this would give us a more contemporary definition for modernisation, which come to think of it, is not such a bad definition also for the cinema: a global mobilisation machine that nonetheless keeps everyone perfectly 'in place'.

NOTES

1 The essays collected by Charney & Schwartz 1995, are a useful compendium. For the postmodern in architecture, see Venturi, Izenour & Brown 1972, which celebrates the urban environment as theme-park and the city as spectacle.

2 An unexpected pregnancy leads to an engagement, but the young woman calls it off when she realises her boyfriend has been pressurised into promising marriage by his male friend. She tries to get an (illegal) abortion, by borrowing money, but the couple get together again at a Communist Party sports rally.

3 The issue of gender is significant. Among the many readings since, Andreas Huyssen's has been the most influential. His 1986 essay 'The Vamp and the Machine' presents a Klaus Theweleit-inspired argument about the gendering of machines during the first industrial revolution, and the displacement of anxiety about mechanisation onto the terms of a culturally older and more familiarly pathological-patriarchal anxiety about all-devouring female sexuality.

4 See Mohr and Müller 1984, and Steinmann 1979. Berlin's working-class housing in the 1910s was notorious, and *Metropolis* contains some shockingly drastic depictions of the misery of living in the typical Berlin tenement block, with its dark and dank inner courtyards, its lack of light and air. No one at the time could mistake the workers' underground city for anything other than the housing bunkers of Kreuzberg or Moabit.

5 See Zimmermann 1988 where Mies van der Rohe's design is discussed in detail.

6 At this point, one could fast-forward to Fredric Jameson's description of James Portman's Bonaventure Hotel in Los Angeles. As in the Unité d'habitation, there is a belated realisation also of crucial features of *Metropolis*: the gardens, the racetrack, the shops, the totally designed environment. The idea of total design in *Metropolis* was denounced by Siegfried Kracauer as the 'mass ornament' of Fascism. By contrast, Jameson makes an

analogy between the Bonaventure Hotel and Hitchcock's *Psycho* (1960): the all-reflecting skin of the building reminds him of the reflective sunglasses of the highway patrolman interrogating Janet Leigh (see 1984: 81).

7 'Despite the dominance of ribbon development, other ambitious attempts at original arrangement of the exterior spaces through the manipulation of mass also existed. This can be seen in the Horseshoe estate in Berlin Britz' (Gympel 1996: 90).

8 On the cultural impact of the motorcar before 1945, see Moser 2003.

9 If one were to return to *Metropolis*, one might say that at the end of the film the children have indeed been saved from the flood and have found shelter in the Eternal Gardens – away from their parents, but also from housing problems and allotment gardens. They are at home in the entertainment architecture of the modern city.

WORKS CITED

Augé, M. (1995) *Non-places: Introduction to an Anthropology of Supermodernity*. London: Verso.

Berman, M. (1982) *All That is Solid Melts Into Air: The Experience of Modernity*. New York: Penguin.

Charney, L. and V. R. Schwartz (eds) (1995) *Cinema and the Invention of Modern Life*. Berkeley: University of California Press.

Crary, J. (1990) *Techniques of the Observer: On Vision and Modernity in the Nineteenth Century*. Cambridge, MA: MIT Press.

Foster, H. (1993) *Compulsive Beauty*. Cambridge, MA: MIT Press.

Foucault, M. (1979) *Discipline and Punish: The Birth of the Prison*, trans. A. Sheridan. New York: Random House.

Gehler, F. and U. Kasten (eds) (1990) *Fritz Lang – Die Stimme von Metropolis*. Berlin: Henschel.

Gympel, J. (1996) *The Story of Architecture*. Köln: Könemann.

Hall, P. (1996) *Cities of Tomorrow*. Oxford: Blackwell.

Huyssen, A. (1986) 'The Vamp and the Machine', in A. Huyssen, *After the Great Divide: Modernism, Mass Culture, Postmodernism*. Bloomington: Indiana University Press, 65–81.

Jacobs, J. (1964) *The Death and Life of Great American Cities*. London: Penguin.

Jameson, F. (1984) 'Postmodernism, of the Cultural logic of Late Capitalism', *New Left Review*, 1, 146, July–August, 59–92.

Jay, M. (1993) *Downcast Eyes: The Denigration of Vision in Twentieth-Century French Thought*. Berkeley: University of California Press.

Koolhaas, R. (1978) *Delirious New York: A Retroactive Manifesto for Manhattan*. New York: Oxford University Press.

Kracauer, S. (1947) *From Caligari to Hitler*. Princeton: Princeton University Press.

Kramer, L. (1986) 'Rationalisierung des Haushalts und Frauenfrage: die Frankfurter Küche und zeitgenössische Kritik', in R. Höpfner and V. Fischer (eds) *Ernst May und das Neue Frankfurt*. Berlin: Ernst, 74–87.

Krauss, R. E. (1994) *The Optical Unconscious*. Cambridge, MA: MIT Press.

Kuhn, G. (1998) *Wohnkultur und kommunale Wohnungspolitik in Frankfurt am Main, 1880 bis 1930*. Bonn: Dietz.

Le Corbusier (1933) *La Ville radieuse*. Boulogne: Architecture d'Aujourd'Hui.

Miller Lane, B. (1968) *Architecture and Politics in Germany 1918–1945*. Cambridge, MA: Harvard University Press.

Mohr, C. and M. Müller (1984) *Funktionalität und Moderne*. Cologne: Fricke.

Moser, K. (2003) 'The dark side of "automobilism", 1900–30: Violence, war and the motor car', *The Journal of Transport History*, 24, 2, September, 238–58.

Ozenfant, A and C.-E. Jeanneret [Le Corbusier] (1924) 'Formation de l'optique moderne', *L'Esprit nouveau* 21, March.

Pommer, R. and C. F. Otto (1991) *Weissenhofsiedlung and the Modern Movement in Architecture*. Chicago: University of Chicago Press.

von Saldern, A. (1990) 'The Workers' Movement and Cultural Patterns on Urban Housing Estates', *Social History*, 15, 333–54.

Schump, M. (1972) *Stadtbau-Utopien und Gesellschaft*. Gütersloh: Bertelsmann.

Screen (Summer 1974) Special Issue: 'Brecht and a Revolutionary Cinema', with essays by S. Heath, B. Brewster, C. MacCabe and J. Pettifer, 15, 2.

Stahl, G. (1977) 'Von der Hauswirtschaft zum Haushalt', in *Wem gehört die Welt: Kunst und Gesellschaft in der Weimarer Republik*. Berlin: Neue Gesellschaft für bildende Kunst, 102–6.

Steinmann, M. (ed.) (1979) *CIAM Dokumente 1928–1939*. Basel: Birkhauser.

Venturi, R., S. Izenour and D. Brown (1972) *Learning from Las Vegas: The Forgotten Symbolism of Architectural Form*. Cambridge, MA: MIT Press.

Volk, A. (ed.) (1997) *Siegfried Kracauer: Frankfurter Turmhäuser: ausgewählte Feuilletons 1906–30*. Zürich: Edition Epoca.

Wells, H. G. (1927) '*Metropolis*', New York Times, 17 April, 4.

Zimmermann, F. (ed.) (1988) *Der Schrei nach dem Turmhaus. Der Ideenwettbewerb am Bahnhof Friedrichstrasse Berlin, 1921/22*. Berlin: Argon.

7 IMAG(IN)ING THE CITY: SIMONIDES TO THE SIMS

William Uricchio

In her wonderful book *The Art of Memory* (1966), Frances Yates charts the rise and fall of the memory palace, the classical era's architecture of information and the means to its retention and retrieval. Yates' book charts a relationship between certain mental processes – in this case, remembering – and spatial configurations that at once enjoy the flexibility of individual configuration and the taken-for-grantedness of a well-practised spatialised routine. The success of a memory palace relied upon three uses of space: visual ornament, with interior décor, sculpture and painting as holders of data; the configuration of (imaginary) three-dimensional space, with related ideas clustered in particular rooms; and movement through space, enabling the user to depart from the linearity of memorised word sequences and to shift quickly from concept to detail or from one unrelated idea room to another. Particularly with regard to these latter affordances, this virtual architecture for memory resonates with 'As We May Think', Vannevar Bush's 1945 description of Memex (a proto-hypertext computing system, or 'memory-extender') and the notion of hypertext that followed in its wake.

More concept or visual metaphor than medium in the familiar sense, the memory palace nevertheless provided both a technology (even if subjective and non-material) for memory storage, and a social protocol for users' organisation, maintenance and retrieval of those memories. Turning on space (which, while most often limited to a single architectural structure, could be expanded to a city for more ambitious tasks), movement, information and the organisation of perception, the memory palace stands as a constellation of elements and practices not so different from those that concern the contemporary media scene. Along with many other 'old' media, it offers a position from which we can reflect on more recent turns in media technologies and their social protocols, allowing a broader range of trends and implications to stand out in relief. This is the position taken up by this chapter. I would like briefly to consider a series of representational trends in the moving image depiction of the city, of urban space and event. This endeavour should yield insight not just into *what* is stored in the various image systems under consideration, but into *how* that information is structured. It should also demonstrate *how*, just as with the memory palace, cultural trends in urban representation can lead to insights into the broader encounters between historical subjects and their self-fashioned environment, whether constructed as memory, imagination or lived experience. The stylistic affinities of historically coherent groupings of city films (and other time-based media) might allow us to make some claims regarding the framing of the medium, and as with the memory palace, yield some insights into the medium as both metaphor and tool.

In particular, I would like to consider three moments in the relationship between the city and the moving image. Firstly, I would like to look at non-fiction city films and filmed panoramas through the first decade of the twentieth century, moving images that served as the culmination of nineteenth-century representational practices. Secondly, I will consider the so-called city symphonies of the 1920s and 1930s, films that embraced the aesthetic of the 'camera eye' and sought to depict the city in a self-referential manner as an experiential kaleidoscope. And finally, I will discuss time-based city images from the end of the twentieth century and the start of the twenty-first, as manifest in computer-based simulations of urban space and event. Although I will argue for distinct conventions or 'regimes' of representation throughout, I do so fully aware of the coexistence of multiple representational traditions within such a relatively short time period; by underscoring what I see as dominant trends, I do not in any way want to deny the rich complexity that characterises our representational environment.

Memory Palaces

> What I have spoken of as being done in a house, can equally well be done in connexion with public buildings, a long journey, the ramparts of city, or even pictures. Or we may even imagine such places to ourselves. We require, therefore, places, real or imaginary, and images or symbols, which we must, of course, invent for ourselves. By images I mean the words by which we distinguish the things which we have to learn by heart; in fact, as Cicero says, we use 'places like wax tablets and symbols in lieu of letters'. (Quintilian 1969: 223)

The memory palace has a long and rich history, rooted in the story of the poet, Simonides, whose memory of the spatial position of guests at an ill-fated party enabled him to name those buried in the subsequently collapsed building. The idea of visually associating both physical details and sequence with a remembered or imagined architectural space found a place in the art of rhetoric, with Cicero in *De Oratore* – among others – drawing upon the classic treatise on the topic, *Ad Herennium*. Still well-trodden by the likes of Aquinas and Augustine, the memory palace fell out of favour by the sixteenth century, effectively replaced by the printed word.

My point is not to offer an exegesis on the memory palace – for that, see Yates – but rather to recover a figure or system that has been marginalised in media-historical discussion, and see how it might resonate with the moving image media. Beyond its utility for parlour tricks and long orations, the memory palace offers three aspects that I would like to position and draw upon.

(i) It seems to have functioned for the ancients as well as for contemporary writers as a metaphor for memory, a way of giving form to and spatialising a set of processes that are by nature ephemeral. Like any metaphor, this one selectively articulates aspects of the concept it references, shaping our understanding and access in the process.

(ii) The memory palace is a tool for remembering, a storage system of near infinite capacity and detail. Like any tool, it does some things better than others, holding certain kinds of knowledge and shaping access in particular kinds of ways. In this sense,

it is bound by the media that it references – architecture, sculpture and painting. It cannot, by contrast, do things that other media – the printed word, for example – do well, such as accessing information through indexing.

(iii) Extending from this, the memory palace offers evidence of a particular way of *seeing* or being in the world. In this case, operating with the so-called method of *loci*, of location or placement in space, it is profoundly visual in its reference. Rather than simply being a storage system, the memory palace stands as a visual and perceptual order. One senses a certain media logic evident in the interaction of its virtual technology and strictly defined social protocols, in the process opening the way for certain affordances and relations to the external world.

This chapter considers the city film and other time-based city representations as something of a contemporary memory palace. Far more than a (mere) repository of urban images and thus an unwritten history of the urban encounter, we also have a shifting set of metaphors, visual organising instruments, as well as evidence of a perceptual order based on the logics of spatial articulation. The issue is not so much the documentation of *what* visual data the films hold (although that is certainly both considerable and valuable), but rather evidence of *how* the films' makers and viewers related to the larger world. What might we find if we step back and view the distinctive patterns of moving image representation and use? If we take 'city films' as a coherent body of moving image endeavours charged with representing historically and geographically specific spaces, events and processes, can we gain insight into the various representational turns – and possibly even epistemic contours – of our own recent history? Following in the footsteps of others such as Stephen Kern, Donald Lowe, Jonathan Crary and Wolfgang Schivelbusch, I think the answer is yes, with, of course, the rather large proviso that the period in question – the nineteenth to early twenty-first centuries – includes competing representation systems and modes of deployment. But even here, there is some evidence to suggest that parallels exist in the (written) descriptive work of such diverse representational domains as physics and sociology.

Mapping the City: Spatial and Temporal Continuities

'Panorama' and 'panoramic views' by title constitute the single largest entry among films copyrighted in the United States between 1896 and 1912, with the preponderance of titles referring to films registered before 1906. These films offer boat-mounted views of waterfronts; carriage-drawn shots of passing storefronts, pedestrians and traffic; street-level tilting shots of skyscrapers, emulating a tourist's gaze; and lateral documentation of the city skyline from the tops of those same skyscrapers, as the camera pivots from a single, fixed point, covering up to 360 degrees. For some, these films attest to the 'naïve' fascination with movement of any kind that allegedly graced the film medium's first years. For others, they stand as evidence of the early entrepreneurial organisation of production, with itinerant cameramen trading in views and catering to audiences in search of sensation and an expanded view of the world. And for still others, they suggest continuities with precedent still photographic practice, replicating the vantage points and even catalogue descriptions of the postcards and views so popular at the end of the nineteenth

century. Taking this last position a step further, it can be argued that these films can be seen as the fulfilment of a project mapped out in earlier, mass-deployed, non-moving image systems such as the panorama and the stereoscope. Rather than the naïve first steps of a new medium, these films represent the culmination of a much longer representational tradition, and a translation into coherent slices of time and space of that which could only previously be suggested through static compositional conceits.

Although painted panoramas almost always portrayed horizontal expanses, as just suggested, panoramic films explored space in many different ways – horizontally, vertically and by tracking shots that penetrated the depths of Albertian-perspective. Moreover, they charted the texture of movement itself, in the process offering new pleasures and presences not available to the painted or photographed static panorama. Filmed panoramas – horizontal or vertical or forward tracking – usually maintained time and space relations in a rigorously continuous manner. Where fragmentation exists (it seems to occur more frequently in lateral tracks), it seems additive rather than analytic, as if the camera was turned on and off when passing points of interest entered into the frame. Nevertheless, it suggested a rather important conceptual difference between the continuities of penetration and horizontal and vertical camera swivels, where the issue of fixity and continuity of the viewing position was central.

The use of near-seamless expanses of time and space in forward tracking shots, tilts and lateral panoramas seems to speak to the spirit, although not the letter, of the traditional panorama. The emphasis on the act of seeing, on the unfolding of space in a manner that encourages the viewer to feel really 'on the spot' links these films with Robert Barker's initial appeal in his 1787 patent for a 360-degree painting, originally entitled 'la nature à coup d'oeil' or 'nature at a glance' (see Barker 1787). Despite the name, however, the circular format by definition precluded any all-encompassing glance, requiring instead a series of glances and a mobilised spectator. Perhaps for this reason, the term apparently failed to catch the public's imagination. By 1791 Barker's unfinished, large, semi-circular view of London (this time indeed visible at a glance) opened with the new name 'panorama'.

Rather than simply presenting a wide expanse as had sixteenth- and seventeenth-century city portraitists, Barker's invention stressed the construction of a particular way of seeing. Said Barker, 'the idea is entirely new, and the effect, produced by fair perspective, a proper point of view, and unlimiting the bounds of the Art of Painting' (1787: n.p.). Like some of today's amusements in London's Trocadero or Los Angeles' Disneyland, or indeed in George Hale's chain of cinemas in the first decade of the twentieth century (Hale's Tours of the World), Barker conceived of elaborate strategies to lure the viewer into seeing in a particular way. As Barker put it, the goal was to make the viewer 'feel as if really on the spot' (ibid.).

The expiration of Barker's patent in 1801 opened the way for a host of other entrepreneurs to explore the 'panopticon of nature'. Although far removed from the original 'nature at a glance', the continued deployment of the term 'panorama' retained an insistence on the act of seeing linking it to the *quality* and not the *object* of what is seen. Our contemporary usage has tended to dull this connection with the act of seeing, instead shifting attention to the graphic parameters of representation, as the latest panoramic format snapshots attest. But from a historical perspective, the panorama has an equivalent claim to the act of seeing as that celebrated with Jeremy Bentham's panopticon.[1] One

mark of its association with the perceptual act rather than the parameters of representation may be seen in the quick adaptation of the term by other (non-visual) media. Within a decade of Barker's introduction of the term panorama, it was being used in book titles to refer to comprehensive coverage – for example, *The Political Panorama* (1801), *The Panorama of Youth* (1806) and *Literary Panorama* (1806).[2]

The notion of the panorama as a mode of vision rather than a sight seen can be found in a number of different technological manifestations that immediately preceded and even coincided with the moving picture. Offering a magic-lantern version of Raoul Grimoin-Sanson's Cineorama, Charles A. Close projected images over a 360-degree surface with his Electronic Cyclorama at the 1893 Chicago World's Fair. At roughly the same time, Thomas Barber's Electrorama cashed in on the mania for things electric and showed images some forty feet high and 400 feet in circumference; and by 1901, the Lumière brothers were busy with their circular projection system for still images, the Photorama. Film was quick to embrace the panorama. Pathé's 1900 catalogue, covering the period 1896–1900, includes 'vues panoramiques' as one of the nine production categories. Within a year, Pathé's catalogue fine-tuned its categories, maintaining nine of them but distinguishing between 'scènes panoramiques et de plein air' and 'vues panoramiques circulaires', described as utilising optics especially developed to capture the grandeur of the 1900 Exposition Universelle.[3]

One might wonder why films constituted largely by forward tracking shots were included within the same conceptual realm as traditional panoramas, since one of the fundamental characteristics of the painted panorama (360-degree or moving) regards the image's fixed distance from the spectator. The forward track, moving towards the vanishing point, would seem to shift the *extensive* relations mapped out by the traditional panorama to a set of *intensive* relations – an ever-closer inspection of spaces first seen at a distance. I suggest that such films were consistent with Barker's original use of the term, and that, moreover, this underscores the notion of the continuity of space that underlies the filmed panorama's deployment.

But perhaps more to the point, the films also seem to have served as explorations of the space mapped out by another late nineteenth-century rage – the stereoscope. The illusory third dimension evoked in the stereoscope and responsible for its status as one of the most important elements of pre-cinematic mass visual culture, is entered and probed by these films. Three-dimensional illusionism is supplanted by the illusion of motion, and thus the fourth dimension as a fluid process of movement through space fulfilling the stereoscope's promise (or displacing its visual limits). These films occupy a cross-point between the two very different experiences of spatial continuity mapped out by the panorama and the stereograph; in so doing, they are consistent with a larger understanding of time, space and the world that had not changed much since Newton's pronouncements. The same grand ordering principles served as the point of reference for all of these technologies, so it is not surprising that their projects were fundamentally related. Correlations might even be drawn to the grand narratives so characteristic of nineteenth-century sociological representations of the city: consider the unified explanatory paradigms of Henry Sumner Maine (law); Adna Weber (location); Fustel de Coulanges (religion); and Karl Marx (production). Like the stereograph, panorama or panoramic film, they privilege particular parameters of representation, charting the world viewed through that lens in a systematic and expansive manner. While the notion that panoramic city

films resonate with the city's great structuralist thinkers goes beyond the bounds of this essay, the two domains partake equally in Barker's notion of the importance of the quality of seeing in a particular manner.

City Symphonies: Fragmentation and Evocation

Even as the film medium took form, and throughout the years when the mapping strategies just described dominated film production, change was afoot in the larger world. The scientific domain of physics, and with it the understanding of how the world worked and the inexorably linked project of how the world was represented, was in a growing state of crisis (consider the work of Mach, Heisenberg and Einstein); in sociology, grand narratives gave way to the interaction-based, multi-variable models of Simmel, Weber and the Chicago School (Park, McKenzie and Wirth); and in painting, the tradition of realism was under siege by impressionists (Cézanne, Monet), cubo-futurists (Archipenko, Malevich) and expressionists (Beckmann, Dix), all exploring new ways of giving form to their experience.

In sharp contrast to the previous films and their concern with mapping, with tracing spatio-temporal continuities, with their intertwined notions of the city as a space and the medium as a window on the world, a new generation of moving images shattered that window and reassembled the pieces in order to give form to their notion of the city as experience and film as a medium to evoke it. Skewed perspective and violent changes in scale, simultaneous perception of different sites and objects, multiple points of view of surging masses and buildings, the imposition of rhythms and accentuation of formal elements, all served as the vocabulary that artists, photographers and filmmakers drew upon for their evocation of a new experience.

More radical than even the painterly tradition of the Cubists or Italian Futurists, the efforts of Dada *photomonteurs* such as Hanna Höch, John Heartfield, Paul Citroen and Raoul Hausmann literally fragmented the photographic surface, and with it any claims the medium might have had to a coherent epistemology, recomposing the shards into new compositions, and freely mixing scraps of time, space and perspective (Citroen's 1923 montage, *Metropolis I*, is emblematic in this regard). Powerful assumptions regarding the photographic image's indexicality (an assumption apparently taken for granted, given the medium's use for identity purposes and its status as legal evidence) were confronted, subverted and, in the process, newly constructed images foregrounded their own mediality in powerful ways unavailable to painters.

City films begin to pick up on this strategy with Paul Strand and Charles Sheeler's *Manhatta* (1921), a film constructed around radical shifts in angle and perspective, explicitly informed by the compositional conceits of the cubo-futurists, with whom Sheeler shared extensive roots. Strand and Sheeler, like artists of the painting tradition that inspired them, did not fragment and reassemble the photographic image in the manner of the *photomonteurs*. Rather, they worked across time, joining shots together in ways that enhanced the shifts in perspective and contradictions in scale between shots, jolting the viewer and mapping out a very different urban film practice than had the panoramic tradition. While *Manhatta*'s editing could hardly be called radical in the sense of exploiting tempo and rhythm, it nevertheless offered something of a cinematic nod to photomontage, breaking with the long tradition of coherence and continuity so characteristic of non-fiction urban representation in film.

László Moholy-Nagy's *Dynamik der Gross-stadt* (*Dynamic of the Metropolis*), written in 1921–22 and published in 1925 (*Bauhausbücher* 8), served as a manifesto for a more far-reaching vision of the experiential articulation of the city than *Manhatta*. Although never realised as a film, Moholy-Nagy's project envisioned a city film explicitly through the lens of photomontage – sustaining over time the temporal contradictions, compressions and juxtapositions suggested in photomontage. Moholy-Nagy packed his 'sketch' with all the elements that would reappear several years later in the city symphonies: sharply contrasting compositions (of the sort Eisenstein would later systematise into his notion of conflict-based montage), the explicit invocation of musical markings (tempo, fortissimo) and an embrace of the notion of *Gesamtkunstwerk*. Also, since the sketch was never filmed but only appeared in printed form, he also pressed the medium of print into his vision of urban experience through the use of creative typography.

But the *locus classicus* of this new way of representing the city appeared in 1927 with Walter Ruttmann's *Berlin: Die Sinfonie der Grosstadt* (*Berlin: The Symphony of the Big City*, 1927). With roots in the post-expressionist realist art movement, *Neue Sachlichkeit* (New Objectivity), and informed by the work of *photomonteurs*, Ruttmann's film, like Moholy-Nagy's sketch before it, departed from traditional notions of narrative and instead relied on the structure of a day in the city. It is constructed around the tempos and rhythms that accompany urban life; its hierarchy of characters is reworked to give equivalence to humans, machines and animals; and the logic of its cutting and composition reflects elements such as time of day, or clusters of shots grouped around repeated themes (waking up, cleaning) or common directional movements. Slow, languid and compositionally similar shots of the city awakening give way to a series of increasingly frantic episodes built around contrasting directions and volumes as the day picks up tempo. The film evokes the city as a palimpsest of rhythms, experiences and scales, in the process rigorously excluding the vistas, monuments, skylines and axial perspective characteristic of the urban postcard trade, the stereographs and films that dominated Berlin's earlier representational tradition. One of the striking things that *Berlin: The Symphony of the Big City* reveals, and that Dziga Vertov was quick to pick up on in *Chelovek s kino-apparatom* (*Man with a Movie Camera*, 1929), was a sense of the acoustical. Although these, along with other city films sharing in the same basic project such as Wilfried Basse's *Markt am Wittenbergplatz* (*Market on Wittenbergplatz*, 1928) and Eugen Deslaw's *Les nuits eléctriques* (*Electric Night*, 1930) were silent films, they evoked sound as much through visual reference to specific sources (telephones, radios, bells, steam whistles, car horns), as through an awareness of the image's potential to engender a sense of synaesthesia in its viewers. Significantly, both Ruttmann and Vertov were early experimenters with radio, with Ruttmann's sound collage, *Weekend* (1930), serving as an acoustical counterpart to *Berlin: The Symphony of the Big City*. From this perspective, the nomenclature of city symphony captures both the reference and technique of the many usually silent films clustered at the end of the 1920s and start of the 1930s that understood the city in terms ranging from musical structure to cacophony. That this historical juncture also witnessed the introduction of sound into film and the mass acceptance of radio as a medium with its own distinct representational parameters, helps to situate this dramatic shift in the city's cinematic depiction.

The project of these non-fiction films has little to do with recording or documenting urban space, or with creating a sense of being 'on the spot', at least with regard to physi-

cal location. Instead, they offer an instrument for evoking the city as dynamic, and, like the modernist project generally, they offer insights into a perceptual order that embraced the materiality of the medium both as means and end. Experience of the city as the ebb and flow of competing forces and perspectives, as complexity and contradiction (to echo Robert Venturi's notion of the modern), emerges as its defining character. The visual landmarks of famous buildings or well-established vistas that distinguished Paris from Berlin from New York for an earlier generation of image-makers are here abandoned, and with them even the stability of orientation and representation provided by simple panoramas, tracking shots and tilts. The camera eye, seeing sights, assembling rhythms and making myriad juxtapositions, constructs a very different subjectivity from that bound up in the stable, single viewing position of the panoramic tradition. Indeed, it is an impossible viewing position, or at least a viewing position that is impossible to humanly embody or literalise as if being 'on the spot'. It evokes the richness of experience and the dynamic of the metropolis in ways that fundamentally redefine the notion of the city to be documented, in the process calling upon distinctively modernist deployments of the medium.

Simulation: The Shape of Things to Come

The digital turn has enabled a litany of well-rehearsed possibilities in the domain of representation, though it continues to surprise with its networked affordances and its blurring of the line between production and consumption. Terms such as 'virtual' and 'interactive' have acquired fresh meanings, and the logics of remediation have resulted in a tension between, on the one hand, a repurposing of the new in the framework of the old, and on the other, the exploration of new and as yet unformulated expressive capacities. If one accepts the repurposing argument, one can certainly find ample evidence of digital technologies being used to support all of the visions discussed in this chapter. The memory palace has become relevant once again as we seek ways to 'spatially' organise data and as we rely on social protocols to develop highly personalised virtual storage systems and data interfaces. The panorama, and with it the notion of a coherent block of time and space accessible from a unified subject position, can be found anywhere from online 360-degree views of existing cities that the viewer can control, to game spaces such as *Grand Theft Auto* where one's character inhabits a seamless imaginary urban environment. The notion of a reflexive and evocative experience representing multiple and conflicting points of view (the city symphony approach) can be found in the rhizomatic structures of the Internet, where hundreds of thousands of competing visual perspectives of a given city link together through social tagging and compete for our attention in domains such as Flickr or Yellow Arrow.

These deployments might be read as retro-fitting new technologies to serve the purposes once provided for by the old, but the fit by no means offers a one-to-one correspondence with earlier textual instantiations. Significant differences in agency, for example, reposition apparent similarities in concept and graphic form; and the weight of history bears heavily upon the accrued meanings of a particular application or expressive tradition. While the panoramic webcam or tracking shot-structured racing game might seem the formal equivalents of a one hundred year old cinematic practice, such fundamental contextual repositioning renders these examples perhaps referential, but ultimately quite distinct in meaning and implication. The alternative to the repurposing scenario, the ex-

ploration of new and as yet unformulated expressive capacities, offers a more promising approach. It seems capable of drawing upon and activating previous representational traditions, rather than simply claiming radical novelty. I would like briefly to exemplify two very different directions that these (moving image) technologies can take, both regarding the city and its (possible) memory. Berlin-based new media and architecture firm Art + Com's *The Invisible Shape of Things Past* offers an exploration of the representation of time in virtual space and the navigation through time in virtual reality (see Art + Com 1995). The project enables users to transform historical film sequences (time-based information) into interactive, seemingly three-dimensional virtual objects. These objects, in turn, are positioned on flat maps representing a particular space and time (say, Berlin, 1920). One can immediately see the various films made of the city over a certain period of time as a set of spatialised objects occupying an otherwise flat map.

The transformation of cinematic images into virtual objects is based on the visual parameters of a particular film sequence (movement, perspective, focal length): the individual frames of the film are lined up along the path of the camera as it is transferred to virtual space. The angle of the individual frames in relation to the virtual camera-path depends on the perspective of the actual camera. The outer pixel rows of the frames define the skin of the film object, thus rendering a simple tracking shot into something like a shoebox with a photographic image (the opening frame) on one end. Navigating into the image, the tracking shot begins, running its course until the viewer is deposited on the other side of the 'box'. A fixed-point 360-degree panoramic film in this system would look more like a wheel of cheese. A mapping protocol is available that permits the user to stack the accumulated images produced year by year over any period of time and chart patterns of interest and intersection. Comparing, say, a map from 1920 with one from 1940 shows the persistence of Unter den Linden as a site of interest, allows users to compare and contrast both physical points of view and the impact of historical developments on the street and its buildings, and serves as a robust tool for assessing cultural trends and archival holdings. Meanwhile, a virtual information architecture is also available that permits us to step inside the image box, and to see inside the walls of filmed objects, experiencing space and representation in heretofore unimaginable ways. The implications of this latter tool for notions of point of view are intriguing.

The meta-view of a city's film history afforded by *The Invisible Shape of Things Past* both draws upon past signifying practices, indeed, literally re-calling them, and at the same time re-casts them and their significance. Like the earlier shift from coherent swaths of panoramic time and space and a fixed notion of the subject, to the symphonic evocation of the city as a fragmented and multiply embodied experience, this latest turn in representational conventions offers a new metaphoric vocabulary through which to order our memories and perceptions, and new tools through which we can variously manipulate and understand an accreted visual history and evolving present. This latest turn attests to a new way of seeing, at once unarticulated by previous deployments of the moving image and consistent with the larger shift in cultural perception, as argued by the likes of Gilles Deleuze, Paul Virilio and Jean Baudrillard (to mention but one line of assessment).

Of course other approaches abound, each in their own way making use of the new technologies' affordances and charting out new possibilities. *SimCity 3000: Universal Edition* (2000), for example, offers historical moments in four 'real' cities as a simulation laboratory for the user to construct and manipulate conditions, playing God as the crude

contours of a historical moment are replayed, this time with new variables. Thus, *SimCity Berlin* puts the viewer in the unenviable position of being a kind of Helmut Kohl: will the wall come down? Will it stay down? Will peace and prosperity reign? The ability to inhabit a city space in the subjunctive, to explore the implications of various choices and interventions, again offers a new tool through which to explore and, in a sense, to test various urban scenarios.

My point is not to outline the myriad new directions that are now emerging, but rather to point to the present as another key moment of change in representational contours and norms. Although the present situation is in part supported by new technologies, we have seen that media technologies are not determining. So, for example, the shift from the panoramic city film to the city symphony was largely based on the same silent 35mm film technology; just as saliently, as the early work of Baudrillard, Deleuze, *et al.* demonstrates, key components of the current representational change were already in play well before the public appearance of digital affordances. Instead, I have tried to point to the distinctive temporalities, spatialities and notions of experience and event that can be found in the last hundred or so years of non-fiction moving image representations of the city. Although the sites seen in New York, Paris or Berlin certainly differ, the accreted modes of seeing, of representing and fixing experience, have much in common within each of these clusters.

Representation offers a way to trace the fundamental concepts underlying and informing a specifically historical manner of being in the world. Donald Lowe's *A History of Bourgeois Perception* (1982) comes to mind, though Lowe's scope is obviously far more ambitious and his insights wider ranging. In each of the cases that I have briefly sketched, we have seen clusters of representational strategies that differ in their notions of viewing position (from unified, to multiple, to a kind of super-agency); their deployments of media (from 'being there,' to experiential evocation, to direct manipulation); their notions of time and space (coherent, fractured and relative, virtual); and even their aesthetic assumptions (from the contemplative and sublime, to the reflexive and modernist, to what for the moment might be summarised as post-structuralist, though this is a contentious stance). This approach admittedly risks missing or over-writing the specificity of individual texts, a task taken up by many other chapters in this book; but it has the advantage of encouraging us to reflect upon a body of representation in terms of its metaphoric capacities. It calls attention to the larger ordering strategies that give public memory its contours. And it offers a way to move beyond what is seen in order to consider a way of seeing or being in the world.

NOTES

1 Bentham's use of the term 'panopticon' has been redeployed by critics such as Michel Foucault (1979) and Jonathan Crary (1990) to define the regime of visual control characteristic of the modern era. It was developed at the same moment that Barker's panorama was introduced to London. The panorama and the panopticon shared similar architectural forms and conceptual goals, with the key difference that the former fixed nature within its controlling gaze and the latter fixed human behaviour, a key issue in assessing the continued development of media apparatus (see Foucault 1979: 317).

2 This is not to deny that the term panorama also referred to the object seen. In 1842, the *Illustrated London News* began to market in print form the kinds of images of nature, exotic locations and epic events that for the previous fifty years had been institutionalised in the panorama. Shortly after its start, the *Illustrated London News* published an etched, two-page version of Antoine Claudet's 'colosseum view' photograph of London (7 January 1843). But while image was marketed as a collector's item, the metaphoric dimensions of the shift from one site of seeing (the panorama) to another (the illustrated press) remain striking.

3 I wish to thank Frank Kessler for bringing this to my attention. The terms translate as 'panoramic and open-air scenes' and 'circular panoramic views'.

WORKS CITED

Art + Com. (1995) *The Invisible Shape of Things Past*. Online. Available at: http://www.artcom.de/index.php?option=com_acprojects&page=6&id=26&Itemid=144&details=0&lang=de (accessed 6 August 2006).

Barker, R. (1787) *Panorama patent*. Online. Available at: http://www.edvec.ed.ac.uk/html/projects/panorama/barker.html (accessed 1 August 2006).

Bosquet, H. and R. Redi (1988) *Pathé Frères. Les films de la production Pathé 1896–1914*, Quaderni di Cinema 37.

Bush, V. (1945) 'As We May Think', *The Atlantic Monthly*, 176, 1, 101–8.

Crary, J. (1990) *Techniques of the Observer: On Vision and Modernity in the Nineteenth Century*. Cambridge, MA: MIT Press.

Foucault, M. (1979) *Discipline and Punish: The Birth of the Prison*. New York: Vintage Books.

Lowe, D. (1982) *A History of Bourgeois Perception*. Chicago: The University of Chicago Press.

Moholy-Nagy, L. (1925) *Bauhausbücher No. 8: Malerei, Fotografie, Film*. Munich: Albert Langen.

_____ (1969 [1921–22]) 'Dynamik der Gross-stadt', in *Painting, Photography, Film*, trans. J. Seligman. Cambridge, MA: MIT Press, 124–37.

Quintilian (1969) *Institutio Oratoria*, 4, trans. H. E. Butler. London: Heinemann.

Wilcox, S. B. (1988) 'Unlimiting the Bounds of Painting', in R. Hyde (ed.) *Panoramania: The Art and Entertainment of the 'All-Embracing' View*. London: Trefoil Publications, 13–42.

Yates, F. (1966) *The Art of Memory*. Chicago: University of Chicago Press.

8 TIME AND THE CITY: CHRIS MARKER

Sarah Cooper

We are such stuff
As dreams are made on; and our little life
Is rounded with a sleep.

– WILLIAM SHAKESPEARE, *THE TEMPEST*

In the beginning was a city and this city was Paris: decimated, rebuilt and suspended in an infinitely accessible past. Chris Marker's cult film *La Jetée* (*The Pier*, 1962) thus inaugurated a loosely-bound trilogy: the jetty projects forwards in time to its own displacement in *Sans Soleil* (*Sunless*, 1982) and to its remake in *Level 5* (1996), both of which de-centre, if they do not entirely dissolve, the initial Parisian focus. To tell a different opening narrative: in the beginning was a relation to the face – not only the mother's face, as psychoanalysis may have it, but also the post-phenomenological kind, the Levinasian '*visage*' of pre-reflective subjectivity through encounter with which the other calls me to responsibility and into question from the very outset. In this chapter, it will be a matter of working together film, psychoanalysis and Levinasian philosophy, as I consider the question of how to approach other times, places and people through film, and Marker's specific style of documentary in particular.

Marker's *Sans Soleil*, the centrepiece of his triptych, will be my own focal point, through which the city will be subject to drift: temporal, spatial and conceptual. Replacing the Levinasian 'Other' with the city in my title (one of his earliest works, from 1947, is *Le Temps et l'autre* (*Time and the Other*)), my aim is not, however, to lose sight of the human in so doing. My reading of *Sans Soleil* as the filming of a city differs from the way in which it has already been written about within scholarship on cinema and the city:[1] precisely what the 'city' and 'film' mean in the context of this chapter will be left open to question. Indeed, in quasi-Levinasian mode Giorgio Agamben ruminates on what this chapter works better to understand when he states: 'The face is at once the irreparable being-exposed of humans and the very opening in which they hide and stay hidden. The face is the only location of community, the only possible city' (Agamben n.d.)[2] The city, then, is seen as less that of concrete, steel and neon, than of people coming together. The cityscape as such never vanishes from Marker's global vision as he charts the post-industrialised world along with the desert in his travels. Extremes meet, just as memory and forgetting, reality and dreams, life and death, the animate and inanimate are also turned inside out to reveal each opposition to be reverse sides of the same material.

Marker's experiments with the materiality of film may invite comparison with Laura Marks' (2000) theorisation of the skin of the film in her book of the same name. The filming of the city in *Sans Soleil*, I will argue, becomes the fabrication of a second skin,

through which the spreading of a fine enveloping and impressionable membrane over the city lends it a surface akin to that of a living being. Yet Marker's concern with impermanence and the immaterial leads me to privilege the post-phenomenological thinking of Levinas when accounting for the filmmaker's fascination with what lies beyond the material realm of appearance and experience, and to couple this with a turn to the discourse of psychoanalysis. Didier Anzieu's notion of the skin ego (1989), along with his pellicular theory of dreams, permits us to explore, through tactile contact, the ethereal realm of sleep from which Marker's images – these 'Dreams of the Human Race' – are thought to emerge, and to which they necessarily return in the end.

Sans Soleil is a dazzling film to watch. It washes over and readily slips the grasp of its spectators who, on first viewing at least, are hard pressed to take in everything that is seen and heard. The difficulty inheres in the speed and density of the commentary and the swift succession of diverse images. Most of the filming has been done, we are told, by the imaginary cameraman, Sandor Krasna. He has written a series of letters on his travels to a female narrator – Florence Delay (in the French-language version) and Alexandra Stewart (in the English-language version). She reads the letters out by way of a commentary, which reflects both obliquely and directly on the images we see. The innovation that André Bazin termed horizontal montage with reference to Marker's *Lettre de Sibérie* (*Letter from Siberia*, 1958) (1983: 180) serves here also to move from ear to eye rather than strictly from image to image, at times jarring with what is shown, at others glossing it more simply. Neither actress is given an assumed name, a tactic which establishes the voice as that of documentary commentator even though her gender and the letter-based style breaks up the expository, authoritative aspects of this somewhat. Extracts of other filmmakers' work feature throughout (Alfred Hitchcock, Danièle Tessier, Haroun Tazieff), along with Krasna's images altered synthetically by a Japanese friend of his, Hayao Yamaneko. In addition to the commentary, diegetic and non-diegetic sound contribute to the contrapuntal texture, through radio and television broadcasts, recorded music, unaccompanied voices and music altered synthetically. The film comprises footage from Japan, Okinawa, Africa (namely Guinea-Bissau), the Cape Verde Islands, Iceland, San Francisco and France from the 1960s through to the 1980s. Fascinated by islands along with mainland coastal areas, one of the only landlocked places in the film is the Ile-de-France (the Island of France), the departmental area that includes and surrounds Paris. With no land-based geographical links to other countries, the watery shores isolate these lands of the limit; but a filmic continuum indebted to Sergei Eisenstein and Lev Kuleshov, and a series of graphic matches, along with other visual and aural correspondences, creates a sense of continuity across the globe. Marker's editing in *Sans Soleil* functions as a bridge joining one land to another – a jetty would fall too short. It is with the infinite insistence of waves on a shore, to cite Jacques Derrida's description of Levinas's style (1967: 124), that we turn and return to the ethics of how difference and distance emerge from the continuities established between the people and places of Marker's filmic world.

Just as the early work of Levinas – in the essay 'La Réalité et son ombre' ('Reality and its Shadow', 1948) – has us doubt any positive possibility of thinking his ethics in relation to the aesthetic dimension, his thought more generally reveals an anti-ocular tendency that makes his appearance in the filmic context odd to say the least.[3] His work has consistently questioned what he understands as the ontological reduction of alterity to the self-same in Western philosophy, founded, as he sees it, on a reflective logic in which we

only see ourselves wherever we may look. It is with a view to seeing more than this that the *visage* or face is theorised on the limits of the phenomenological world of appearance. The face names the interface of an encounter between me and what lies beyond my sphere of comprehension and my senses, vision and touch being totalising modes of contact with others that the Levinasian ethical encounter throws into question. In the first instance, Levinas describes the way in which one encounters others through the face in terms that defy reduction to an image: 'The face of the Other at each moment destroys and overflows the plastic image it leaves me' (1969: 50–1). An iconoclastic thrust that does not, however, aim at the complete obliteration of an image is evident at this point and it is the fragile sense of a trace of alterity never to be fully known that is important. When we step over Levinas's threshold – for his is an ethics of hospitality – we withdraw from the threshold of the visible world, to borrow the title of Kaja Silverman's (1996) psychoanalytically-inspired ethics of the field of vision. We move away from a relation to the other based on identification in the full analytic sense of this term: 'The transformation that takes place in the subject when he assumes an image' (Lacan 1977: 2). Contrary to Jacques Lacan, the image of the other can never be assumed in a Levinasian sense. Taking this into the filmic arena through the Lacanian-inspired psychoanalytic semiotics of Christian Metz, Levinas's work also stands in a questioning relation to Metz's theory of primary and secondary identification, through which viewing positions are constructed. The Levinasian face – as interface – is not the mirror of Lacanian psychoanalysis or of Metz's apparatus theory, then. But nor is it the window of phenomenological film theory which explores cinema and individual films for what they allow us to see beyond them: a transcendent space, whether this be the ontological essence of the real (André Bazin) or a divine realm (Henri Agel and Amédée Ayfre).[4] While an encounter with the face accesses what lies forever beyond my sphere, the asymmetry of such a relation is one that we can find within film – an immanent approach to transcendence through the image, distance accessed through proximity.

To come back to Marker: in an overly literal sense, one that deliberately moves away from the non-phenomenological definition of the Levinasian face, if only for a moment, faces abound in *Sans Soleil*. In Japan, in Guinea-Bissau, in Cape Verde, Krasna films people's faces, particularly those of women, looking back at him or attempting to avoid his gaze. In the first place, our cameraman is a voyeur, an uninvited observer who steals images, passing over the surface of the people he encounters without even attempting to know them in any more detail. This is not a painstaking ethnography and one could argue that acknowledging the limits beyond which one fails to know the other is an entirely self-centred matter here: this is about Krasna, his journeys, his memories. On a superficial level, this is his film and no one else's. Similarly, a fascination with the exotic and the erotic makes him just another belated Orientalist, unapologetic about his desiring gaze, the origins of which he otherwise wishes to disguise. The legacy of Euro-American domination is inscribed in his own cultural markers but he refuses to explore his position, geopolitical or otherwise, beyond this.

In view of this, I find Krasna's position less generous to those he films than, for example, Kaja Silverman when she argues that *Sans Soleil* is penetrated by other people's memories to the extent that it remembers in the voice of the other and encourages spectators to do the same (1996: 186–93). Yet the way in which images are spoken about in relation to Krasna's memory is significant to the ethics of vision that I see at work in this

film nonetheless. This is based not on an openness to the other but the displacement of the self, the Western male self at that, a displacement that occurs in spite of himself. If the film is about the time of life in the varied continents it visits, it is also about the time of death, using its journeys to reflect on the final journey, the end beyond which neither we nor Krasna can see from the same position. It is at this point that we can invoke the Levinasian face. In the asymmetry between Krasna's position and ours we move beyond identification with an image or looking through the image to a space beyond it; we focus, rather, on the space for alterity as inscribed in the very form of the film itself – beyond the surface appearance of the image. This film that flicks from face to face also moves from place to place with alacrity, as the landscapes and cityscapes are subjected to the same fleeting but inexorable turns and returns. No man is an island – or a desert or a city for that matter – but Krasna relates to and connects the human and the non-human in the same way. Consequently, the main literal cityscape of the film, Tokyo (although San Francisco also features at some length at a late point as Krasna makes a pilgrimage to the locations of Alfred Hitchcock's *Vertigo* (1958), present in still images), is brought to life.

Tokyo constitutes the principal place of return for the traveller who confesses to having never known the simple joys of going home to a country or a family. He relates that the twelve million inhabitants provide him with this on one of his journeys to the city. He delights in getting lost in translation as not understanding what he sees around him or on television heightens his enjoyment. As a space of adopted homecoming and anonymous encounter, the foreign – or perhaps not so foreign – city furnishes a home, then, but one that actually turns out to be illusory. The cityscape is fleshed out before becoming a stage for the fabrication of memories and dreams, a place of life and substance, and also the locus of access to the insubstantial.

Krasna's return to Tokyo is narrated over images of the city's motorways, which in terms of visuals and the accompanying electronic sound effects, hark back to Andrei Tarkovsky's filming of this city in *Solaris* (1972). The title of Tarkovsky's film, in contrast to Marker's, focuses on the presence, rather than the absence, of the sun. Further on in the same sequence in *Sans Soleil*, Tokyo is described as being criss-crossed by trains, tied together with electric wires and showing her veins. The formal grammatical convention by which pronouns referring to the city gender as feminine is made more substantial here (in the English version as well as in the French), as the trains and wires that circulate become the blood stream of a woman's body. A different *Solaris* is also relevant to this discussion, however: that of Steven Soderbergh, from 2002, who makes the love story between Chris Kelvin and Rheya (not Hari, as in the Tarkovsky original) the modified sole focus of the film. Rheya's non-human reincarnation recalls the memories of her lifetime double, now dead, but she is unable to remember the experiences that generated them. Her body did not live the past that her head remembers and which she sees in her mind's eye in flashback. This visual contact with a memory cut off from its point of origin in experience is something that links to Krasna, since images, for him, take the form of his memories, which come to matter through celluloid and its myriad distortions.

In one of the less obvious city sequences of the film, one that moves from the Island of Sal (part of the Cape Verde group) spliced with images from a city (Tokyo?), to the Island of France, to Tokyo, we move almost imperceptibly between desolate, arid, desert-like landscape, lush green watery undergrowth and densely populated city spaces. This is an indicator of the formal moves by which one area is connected to another throughout

the film, but what interests me is the way in which these images are described by the commentary with reference to Krasna's memory. Time dilates and space is diminished as we are directed back to the place where Krasna is at the time of writing this particular letter. In straightforward terms he is on the Island of Sal, listening to radio Hong Kong, thinking back to when he was in Tokyo in winter, subject to these and other images that return unbidden via association with his present. We are beyond distanced contemplation of images that may or may not have been filmed by him, but we are also beyond flashback, neither seeing through his mind's eye nor seeing images as testimony to his memory but, rather, we are told that the images *are* his memory. Time is more important than place, movement than stagnation, in this film that spirals vertiginously down memory's path, with concentric memories growing face on face, like a series of tree rings. Later on, indeed, *Sans Soleil* features a still from *Vertigo*, which shows the sequoia cut in Muir Woods, and then films the similar cut in the Jardin des Plantes in Paris, which figures in *La Jetée*. As in *La Jetée* we see here an impossible memory, the only difference being the introduction of motion to the pictures we see and the fact that Krasna does not feature within these images to be looked at as the protagonist of *La Jetée* does. These memory images may well function to point back to Krasna's location at the time of writing but this position is constructed in the film as a visual and aural absence. Krasna's memory, fashioned by film in every sense, opens out beyond himself in the absence of his physical presence.

The montage and/or voice-over works to take us back to things that have already been mentioned or seen. This forms a self-reflexive enclosure that identifies the spectator with a point of view that actually ends up being as distant from Krasna's experience as it is from the spectator's own. Consequently, a lack of parity emerges in which each position is divided from itself as well as being out of joint with each other. Not only did Krasna not film many of the images of *Sans Soleil*, but even the ones that could be labelled his take on a life of their own, referring back now to other filmic images, rather than a pre-existing historical or psychical reality. This is precisely what enables us to speak of a less self-centred perspective at this point. The move beyond the filming self does not take place through an ostensible openness to the manifold subjects he films, as Silverman has it. Rather, this occurs from within the very perspective of the images, not what they show us, or how they are put together. This film that flashes over those people and places it encounters, getting to know no one in particular, no others in their singularity, also creates a space in which people and places are positioned beyond the viewing self's perspective rather than being contained within it from the outset. As such, what is documented here is a reworking of documentary's relation to the real, and to experience, through the profound calling into question of the viewing self. This different relation to the real is founded in an altered connection to indexicality and time, which passes through a dream space before it enters the 'Zone', this latter space marking a return to Tarkovsky, but this time to a later film, *Stalker* (1979). We have observed how Levinasian ethics, particularly his theorisation of the face, are compatible with the positioning of Krasna in relation to those he films. The altered real that we perceive in this film thus registers a post-phenomenological challenge to the centrality of vision. By questioning ocular-centrism in this way, the film engages more than the sense of sight, opening on to questions of tactility. Although Levinas too theorises an ethics in which a totalising sense of touch, as well as sight, is destabilised in relating to the other, it is to the psychoana-

lytic theory of Didier Anzieu that I wish to turn, since he enables us to approach Marker's dream space in terms that bring us into contact with a texture, a second skin. Anzieu offers us a theorisation of the relationship between skin and film from a position that Laura Marks deems incompatible with materiality. It is the rapport between body and psyche when thinking about film, skin, memory and dreams that I wish to re-view.

In her haptic theory of film Marks distances herself from psychoanalysis in the following way:

> It can be argued that psychoanalytic explanations ultimately found meaning linguistically, rather than in the body, thus translating sensuous meaning into verbal meaning. I concentrate here on the bodily and sensuous responses to cinema that are meaningful as such, since meaning is produced at the very level of our sensuous perception. (2000: 249)

Such a view of psychoanalysis is both illuminating and risky. It draws attention implicitly to the dominant Lacanian paradigm within Film Studies, since the mid-twentieth century, which rethought Freud through the lens of Saussurean linguistics and which enabled semiotic positions such as those of Metz to be rooted in fundamental psychical structures. It also harks back to Freud's sense of a talking cure through which bodily traumas in particular need to be articulated linguistically, the conversion from embodied experience to linguistic expression being fundamental to finding meaning and a cure. However, it sets up a potential opposition between psychoanalysis and the phenomenology of haptics by suggesting that the latter is more interested in the body and embodiment in cinema, and this is not necessarily the case. From Freud's infamous description of the ego as first and foremost a bodily ego, bodies, albeit fragmented and de-essentialised in our post-structuralist era, are central to psychoanalysis (even though Lacanianism accentuates the tendency to take into account only what passes through language, and nothing else, within the analytic relationship). Furthermore, Marks' work unavoidably performs a similar translation from bodily to verbal meaning in order to express the very sensuous experiences she locates in cinematic encounters. Anzieu offers a way of reintroducing the body through psychoanalytic debate[5] – relevant here because of the place of dreams in his work – and of showing how questions of touch, both literal and metaphorical, are important to thinking about psychical contact in embodied terms. Beyond the dream screen of cinema, theorised by the likes of Jean-Louis Baudry (see, for example, 1978), whose apparatus theory parallels that of Metz showing how film takes us back to earlier states of our psychic life, here is a dream theory that is about touch, and acquiring a second skin as we sleep/view, rather than solely about seeing in the dark of the mind/auditorium.

Anzieu's most famous text, comprising his theory of the skin ego, *Le Moi-Peau*, was first published in 1985. The skin ego is a vast metaphor before becoming a concept. For Anzieu, the first contact one has with others is tactile, and this is transferred metaphorically in time to other sensory organs and domains. Anzieu would, no doubt, wish to qualify my opening narrative of the first contact being with sight of the mother's face within psychoanalysis, since for him, touch is the first sense. A common skin unites mother and child, which needs to be broken for individuation. The skin is experienced as a protective surface and understood as a system that shields our individuality as well as being the instrument and the place of an exchange with others. In this text he speaks about the

skin in relation to thought, experience and pleasure/displeasure on many levels. He also, importantly for my purposes here, roots his theory in relation to the dream work, which is relevant to *Sans Soleil*.

For Anzieu, the dream is a 'pellicule' (film) in the sense that it is a fine membrane, which envelops and protects certain parts of organisms, yet it is also like photographic film, which supports the sensitive layer that will be marked during sleep. He writes: 'The film may be defective, the reel may get stuck or let in light and the dream is erased. If everything goes well, we can on waking develop the film, view it, re-edit it or even project it in the form of a narrative told to another person' (1989: 211). The film of the dream is open to internal and external stimuli and could break at any moment. Dreams spin or weave a psychical skin that repairs what the day has done to the skin ego, but this could always also be destructive in relation to the ego. The dream is given materiality through analogy with, and expression in terms of, film, which works well with reference to the kind of film that is impressed upon indexically, celluloid and not digital technology. The psychical life takes on a consistency here, through a skin or membrane that is also a photographic film: it comes to matter and be tangible through dreams. In *Sans Soleil* this has material resonance, as Krasna's impossible and illusory celluloid memories also become the film – in both senses of the term, following Anzieu – of dreams.

Tokyo's cityscape passes through analogy with the comic strip (the walls of buildings are drawn over with images, which are described as 'voyeurising the voyeur') before becoming a dreamscape, as Krasna asks whether he is dreaming all of this or whether he is part of a dream of which the images he sees are just a projection. Indeed, corroborating this and sharing in its belief, Marker's gloss on the film in English is 'The Dreams of the Human Race'. Cinema, the factory of dreams, in its exploration of the boundaries between the imaginary and the real, is presenting us here with the light of Krasna's mind, melancholic and sunless, imaginary and real, yet we feel and touch as well as see in the darkness. Having removed the black sun that Gérard de Nerval and latterly Julia Kristeva (see 1987) use to figure melancholia, Marker turns to music – that of a Mussorgsky song cycle – for his title. The land of the rising sun that features principally in this documentary is ridded of its very defining object enabling us better to understand the dreamscape in which one never sees the sun even though what one may dream of is flooded with light. The impossible dream of this film is that it wants to escape the things that make its very being possible: the image and time. It has to fail in this, of course, but in failing it achieves a move beyond the constraints of an ontological and ethnocentric vision, stepping into eternity through an electronic fabric woven from the contact Krasna has had with other places, people and times. Anzieu once again suggests how this impossible dream might materialise.

Anzieu's *L'Épiderme Nomade* (*The Nomadic Skin*), first published in 1990, is a fascinating text that works through many of his theoretical ideas in a fictional format. The protagonist's dreams recounted in the narrative suggest the origin of his future vocation. He used to imagine that he would take off his skin to go to bed, and that this was essential to his getting a good night's sleep, since his flesh could then expand without meeting any resistance. He dreamt one night that a phantom stole his skin. This fantasy was then sexualised when he dreamt that he took off his penis to go to sleep. The amicable version of this was that a friend did the same, putting his own in its place. The more nightmarish scenario was that the intruder left a prosthetic penis that did not fit the gap that his

own penis had left. These two dreams get confused and the skin becomes an unbearable screen between him and his friend, so each takes off their own protective layer and gets into that of the other. Anzieu's erotic fantasy is expressed in filmic terms when he states: 'I had filmed the interior life of my friend and he had known me better than if we had had an intimate conversation or carnal relations' (1999: 13).[6] When he reaches puberty his curiosity for the female body leads him to an intimacy that does not, however, result in sexual penetration but in stepping into the other's skin: 'I am dressed in all the sensations that she feels and which weave across my male skin a second female skin' (1999: 16). In later life he takes up the profession of skin transplantation, but soon realises that his desire to bring people closer together through this is not improving human relations. He conserves the pieces of skin, however, taken harmlessly from others, and makes himself tapestries, which allow him to dream of what a tactile form of art might be like. His ultimate move into eternity is secured through his fabrication of a shroud made of pieces of the skin of all those he has known: 'For my shroud it will suffice for me to have on my mortal skin, the second incorruptible skin taken from the multitude of people that I have known and who will then accompany me forever' (1999: 26). The fact that Anzieu's narrator speaks about filming the interior life of his friend, and that dreams are described in filmic terms, suggests that this skin is also a film, a permeable layer through which one enters into epidermal contact with the other's desire, and wears it, along with one's own. It is this final move into a timeless dimension that concerns me here, though, narrated as the tactile experience of carrying the skin of others with us into eternity.

The manner in which *Sans Soleil* expresses Krasna's visions verbally is clearly a conversion of experience into language. Yet rather than relate this experience in solely linguistic terms, the points of reference are rendered material: forgetting is described as the lining of memory, and, as we have already observed, Tokyo shows her veins, memories become celluloid images and the indexical mark on the reel of film is transformed into an unreal dreamscape. Such verbal imagery has its counterpart in what we see (even though the commentary does not always match the actual images before us) and in the manipulation the images themselves undergo. Krasna, albeit differently from Anzieu, uses this peculiar contact with others through these images to enter eternity. Krasna's 'memories' (the memory bank of films that he has seen merge with the images that have since become cut off from his experience) become subject to material distortion: montage is assured through straight cuts but also in dissolves or fades; stills are used (notably from *Vertigo*); black leader is inserted between shots, as with the children from Iceland at the very beginning; the television is filmed, and images from Japanese television are also stilled, before being shown frame by frame in a manner akin to slide projection; and, finally, images are passed through an electronic synthesiser, as is the soundtrack at times. This ultimate passage through an electronic synthesiser, credited to Hayao Yamaneko, which emerges early on in the film but to which it returns in the end, is an entry into the Tarkovsky-inspired 'Zone'. The images within this realm that also flag up their status as non-images are described as having the only texture that can convey sentiment, memory and imagination and as the only eternity we have left. Krasna wears these images – without incorporating them, and beyond their mental presence in his mind's eye – as a second skin, and he is thus fashioned by film in every sense.

To film other people, places and times, is, for Krasna, to be impressed upon by the experience, and to wear this as the skin of his and others' memories, fabricated through

celluloid as the impossible dream of stepping outside of time. Although the cityscape is one space among many in *Sans Soleil*, to return to one of my own points of departure, and to yoke Levinas to Agamben, perhaps an asymmetrical encounter with the human and the non-human is our only city, the occasion and setting for such contact on the world stage being facilitated here by connections between travel, telecommunication and the rich resonance that the term 'film' acquires. As with Anzieu's dream skin, Krasna's move into eternity involves mind and matter. The relation with others that fashions both Anzieu's protagonist and Krasna serves as the multivalent film of consolation for losing touch with the conscious world, through the sleep that, as Shakespeare has it, rounds our lives.

NOTES

1 See, for example, Barber 2002, whose eloquent reading focuses on film as urban landscape. See especially pages 113–19 for a discussion on *Sans Soleil*.
2 I am indebted to Paul Julian Smith for bringing this quotation to my attention.
3 I discuss the relationship between Levinas and documentary film at greater length in Cooper 2006.
4 For a discussion of this phenomenological film theory, see Andrew 1976.
5 Precursors that Anzieu cites to his thinking are Freud and Paul Federn. Freud's earliest description of the ego corresponds to the skin ego: consciousness is an interface, containing but also serving as a point of contact with the outside world. Federn was influential because of his interest in transitional states (between waking and dreaming and what happens to the body at these times) and his concern with interfaces: what comes from the outside and what comes from the inside. Anzieu also acknowledges Mahmoud Sami-Ali (1972), as a signal figure who is not the first who privileges the body within psychoanalytic debate. I am grateful to Mary Jacobus for first bringing Anzieu's work to my attention.
6 All translations from the French are my own.

WORKS CITED

Agamben, G (n.d.) *Page on The European Graduate School: Media & Communications*. Available at: http://www.egs.edu/faculty/agamben-resources.html (accessed 1 May 2006).
Andrew, J. D. (1976) *The Major Film Theories: An Introduction*. Oxford: Oxford University Press.
Anzieu, D. (1989) *The Skin Ego*, trans. C. Turner. New Haven: Yale University Press.
_____ (1999) *L'Épiderme Nomade et la peau psychique*. Paris: Les Éditions du Collège de psychanalyse groupale et familiale.
Barber, S. (2002) 'Japan: the image of a city', in *Projected Cities: Cinema and Urban Space*. London: Reaktion, 107–54.
Baudry, J.-L. (1978) 'Le Dispositif: approches métapsychologiques de l'impression de réalité', in J.-L. Baudry, *L'Effet-Cinéma*. Paris: Éditions Albatros, 27–49.
Bazin, A. (1983) *Le Cinéma français de la libération à la nouvelle vague (1945–1958)*. Paris: Cahiers du Cinéma – Éditions de l'Étoile.
Cooper, S. (2006) *Selfless Cinema?: Ethics and French Documentary*. Oxford: Legenda.
Derrida, J. (1967) *L'Écriture et la différence*. Paris: Seuil.

Kristeva, J. (1987) *Soleil noir: dépression et mélancolie*. Paris: Gallimard.

Lacan, J. (1977 [1966]) 'The mirror stage as formative of the function of the I as revealed in psychoanalytic experience', in *Écrits: A Selection*, trans. A. Sheridan. London: Tavistock, 1–7.

Levinas, E. (1948) 'La Réalité et son ombre', in *Les Temps Modernes*, 38, 771–89.

_____ (1969) *Totality and Infinity: An Essay on Exteriority*, trans. A. Lingis. Pittsburgh: Duquesne University Press.

_____ (1979) *Le Temps et l'autre*. Montpellier: Fata Morgana.

Marks, L. (2000) *The Skin of the Film: Intercultural Cinema, Embodiment, and the Senses*. Durham: Duke University Press.

Sami-Ali, M. (1972) *Corps réel, corps imaginaire*. Paris: Dunod.

Silverman, K. (1996) *The Threshold of the Visible World*. New York: Routledge.

9 FROM TOPOGRAPHICAL COHERENCE TO CREATIVE GEOGRAPHY: ROHMER'S *THE AVIATOR'S WIFE* AND RIVETTE'S *PONT DU NORD*

François Penz

As film history recalls it, Lev Kuleshov staged a number of experiments in March 1921.[1] One of them would become known as the creative geography experiment and was described as 'the arbitrary combination of various scenes of action into a single composition – 13 metres [of films]' (Yampolsky 1994: 45). Kuleshov carried on with his experiments and in 1929 he made a short film in which two people meet on a city street, shake hands and ascend the steps of a large building.[2] Although viewers saw an event taking place in a single environment, the film was actually created by combining shots from widely disparate locations. From this the audience infer that the four locations in this short film belong to the same diegetic space, although composed from an imaginary geography. In the 1920s other filmmakers were experimenting, Dziga Vertov in particular. *Chelovek s kino-apparatom* (*Man with a Movie Camera*, 1929), was filmed in three cities (Moscow, Kiev and Odessa) and therefore Vertov made extensive use of the creative geography notion. This was done through montage, juxtaposing different parts of the city organised thematically, as can be seen with a series of empty streets, followed by series of people waking up and so on. In other words, in the city symphony tradition the creative geography notion is essential to montage by visual analogy. However, it is a creative geography associated with montage while the original Kuleshov experiments belong to the continuity editing tradition, where the filmmaker creates an illusion of continuous action even though both time and space are being condensed on the screen. For the purposes of this chapter we will not consider further the creative geography notion as used in city symphonies, but will concentrate on its use in the continuity editing tradition conventionally associated with fiction films.

Prior to working on the Kuleshov creative geography experiments, cognitive psychologists Daniel Levin and Daniel Simons had shown in their research an audience's difficulty in detecting continuity errors in films, coining the term 'change blindness' (Simons & Levin 1997: 261). This is pertinent to this chapter as it shows how complicated it is to notice simple changes in uncomplicated scenes, anticipating the issues posed by the creative geography experiment. In one of their first experiments Levin and Simons made a short video of two women having lunch, intentionally inserting a number of continuity errors: 'This test film presents a virtual circus of discontinuity in which objects spontaneously appear, disappear, change colours, and move between shots. Not only do observers fail to detect these changes, but the event itself seems natural and continuous' (Levin & Simons 2000: 358). This first experiment seems to confirm observations made

by André Bazin regarding the décor of Jean Gabin's room in Marcel Carné's *Le Jour se Lève* (*Daybreak*, 1939). Bazin recorded in his notes on the film the experiments which he carried out with audiences over the course of twenty public presentations (totalling between 1,000 and 1,500 people) (1998: 113). Although clearly not as rigorous as the work of Levin and Simons, Bazin made a comprehensive list of the results obtained from the questionnaires he had gathered and analysed regarding what the public was likely to remember, as well as what they would be unlikely to recall. Bazin's list of unnoticed items includes some large pieces of furniture such as a commode with a marble top, the sink and the bedside table, totalling about thirty per cent of the furniture in the room (1998: 87). This sounds surprising given that it is a 90-minute film where around thirty per cent of the action takes place in Gabin's bedsit, but not to Bazin who explains that the forgotten items have in fact no dramatic functions and therefore go unnoticed.[3]

This is probably one of the clues to Levin and Simons' first video experiment where, in a very short movie with little or no dramatic action, the objects in the décor have no real function and therefore there is no particular reason to notice them. However, in a second video experiment, Levin and Simons went further and 'changed one person into another with no lapse in time to cover the inconsistency' (2000: 372).[4] Despite the switch, 66 per cent of the participants did not notice the change, although one would expect the audience to concentrate on the only character in the scene and notice that, across a cut to the next shot, it is a different person. Levin and Simons concluded that 'these experiments suggest that film viewers have only minimal commitment to the particular details that inhabit filmic space' (2000: 366). This is not entirely surprising according to a large body of empirical work in spatial and visual cognition which points to our inability 'to retain visual details from one fixation to the next' (ibid.).[5] However, we know from an equally large body of research that from early childhood we are good at following actions, both on the screen and in real life. As long as the narrative, the fiction, appears to be consistent, our human brain does not detect seemingly anodyne continuity anomalies. It would appear that the key element which overrides all other information is the spatio-temporal dimension, leading to 'the inference of continuity despite other information inconsistent with that conclusion' (ibid.). So, in the case of the experiment regarding the switch of character, the failure by the majority of participants to detect any anomalies is due to our understanding and experience of the continuity editing tradition of screen language convention. Both time and space are being condensed, maintaining the illusion of continuous action despite a change of character across the cut, thus reinforcing our expectation of spatio-temporality.

In this light, Levin and Simons give Kuleshov's creative geography the following interpretation: 'For example, in the creative geography experiments, perhaps the first shot of A showed one set of buildings in the background and the shot of B showed another. If other factors such as the direction of the sunlight were consistent, then there is nothing to contradict other information suggesting the actors' proximity ... In this circumstance, where no perceptual information contradicts generally reliable cues of gaze and gesture, it is not surprising that we infer that the shots collectively show a single space' (2000: 363). As spectators we therefore infer a diegetic space despite the fact that the locations are miles apart.[6]

Significantly, this highlights the fact that these perceptual gaps are applicable to the real world:

> In the real world we experience a rich array of sensations and have control over what we see. In film, on the other hand, we see only the bits of experience that filmmakers have chopped up and recombined for us. Therefore it might not be surprising that a few discontinuities go unnoticed ... Change-detection failures reveal a deep similarity between film viewing and real-world perception. (Levin & Simons 2000: 358)

Key to their observation is the belief that 'motion picture perception certainly involves quite a bit of perceptual inference and extrapolation from limited information, but that does not make film viewing fundamentally different from real-world perception. In fact, people make large inferences about the continuity of real-world events; we all make the assumption that objects in the world continue to exist in an unchanged state if they momentarily disappear from view. This assumption can even override dramatic information to the contrary' (2000: 361). They then proceed to demonstrate through a third experiment that there are similar change-detection failures in real life and reproduce the character switching experiment, but this time in a real street situation with a surprising high number of participants (thirty to fifty per cent) not noticing the change (2000: 374). At that point they conclude that 'the real world experience is diegetic in many ways ... the difference between diegesis in film and the real world is not qualitative but rather a matter of degree' (ibid.). In other words, the same type of inferences we make when watching films may, to a certain extent, apply to the real world. This is a significant result and pertinent to Kevin Lynch's research on the real city.

In his book *The Image of the City*, Lynch concentrates on 'the identity and structure of city images' (1960: 9). He studied Boston, New Jersey and Los Angeles by conducting a series of interviews with city residents to 'evoke their own images of their physical environment', asking them for 'sketches and for the performance of imaginary trips' (1960: 15). Lynch was looking for 'physical qualities which relate to the attributes of identity and structure in the mental image ... This leads to the definition of what might be called imageability ... It might also be called legibility or perhaps visibility' (1960: 9). Lynch's work on the imageability and legibility of the city gathered momentum and is still very current, judging by the Bristol Legible Conference in 2002, and is one of the foundations, in its modern incarnation, of the notion of 'city branding'.

Of interest to us in this chapter, his study reveals – among other findings – that there are 'gaps' in people's perception of the city, in a way not too dissimilar to Levin and Simon's conclusions. For example, in Boston the analysis of the maps drawn by the participants revealed that 'one of the most interesting districts is one that isn't there: the triangular region between the Back Bay and the South End. This was a blank on the map for every person interviewed, even the one who was born and raised there' (1960: 20). This ability to block out parts of the city was confirmed in Los Angeles where 'in almost all the interviews where the subjects were describing the trip they took from home to work, there was a progressive decrease in the vividness of impression as they approached downtown' (1960: 41). This might have been caused by the 'blandness' of the downtown area of the American city, something which Lynch noted with New Jersey, a place with a low imageability; it may only come to life through visual imagery of shops as recalled by an interviewee: 'On your right, before you cross the street, there's a place where they sell households appliances and then 1st Street there's a butcher shop, a meat market on the left' (1960: 30).

Lynch's ultimate purpose was to improve the design of future cities, making them more legible and less confusing. But what we can gather from his analysis is that there might be gaps in our memory of the city, even of familiar surroundings, though recollections tend to get worse as we move away from known locations towards more anonymous settings. Since Levin and Simons demonstrated that there are striking similarities between film viewing and real-world perception, we could therefore infer that some of Lynch's findings could also apply to audience interpretation of city films. Although it might make depressing reading for those caring for the correct restitution of the city on the screen, it is indeed unlikely that the average viewer would be capable of drawing with some accuracy a plan of part of a city depicted in a film, as Lynch asked of his subjects. This is clearly a speculation at this stage as no such data appear to be available. Nevertheless, it is with those general considerations in mind that we will examine further the notions of creative geography and topographical coherence.

Topographical Coherence

In the history of filmmaking there seems to be no equivalent to the Kuleshov creative geography experiments in terms of topographical coherence. The literature is equally scarce, and one needs to turn to Bazin's reference to Robert Flaherty's film *Nanouk of the North* (1922) for remarks on spatial coherence:

> It would be inconceivable, in the famous hunting of the seal scene, not to show in the same shot, the hunter, the hole and then the seal. But it is of no importance if the rest of the scene is cut at the directors' will. The spatial unity of the event is only required to be respected at the point when disrupting it would transform reality in its simple imaginary representation. (2002: 59)

He adds that often for a scene to work 'our imagination needs to have on the screen the spatial density of the real' (2002: 56). This is clearly the case in anthropological films where the notion of truth and realism is essential, but it could potentially be equally important to historians aiming to understand how a filmmaker has (re-)constructed fragments of urban reality as expressed by Nicholas Bullock: 'However compelling the film, we must remember as we surrender to its enjoyment that the world of cinema is ultimately not one of neutral recording, but of artifice, one wonders indeed how architectural and urban historians will see those films in 30 to 50 years from now!' (2003: 397).

If for historians topographical coherence is crucial, then the yardstick against which all other films must be measured is Agnès Varda's *Cléo de 5 à 7* (*Cléo From 5 to 7*, 1961). In Varda's work, the idea of topographical coherence partly stems from an eminently sensible consideration 'because it is practical or perhaps because I am lazy, I often use the locations around my house' (Varda 2003: 3). *Cléo de 5 à 7* captures with confounding accuracy the geography of the area which was drawn by Varda on a map (see fig. 1). Furthermore, it is in 'real time', as the film is ninety minutes long with the action taking place precisely between 5pm and 6.30pm on 21 June 1961. The combination of precise topographical coherence with temporal accuracy confers upon *Cléo de 5 à 7* the special quality of a cinema which 'validates memory' (Audiard 2006: 22).[7]

Topographical Coherence: The Case of Eric Rohmer's *La Femme de l'aviateur* (*The Aviator's Wife*)

Eric Rohmer has always been fascinated by architecture, space and the city and once said that 'if I hadn't become a film director, I would have been an architect' (quoted in Binh 2005: 156). Between his first article, entitled 'Cinéma, art de l'espace' (1948), and *Rendez-vous de Paris* (1995), he achieved an impressive 'city oeuvre' on the screen, mainly about Paris, including many documentaries on cities.[8] It is, therefore, not surprising that as a filmmaker it falls to him to be the best advocate of topographical coherence. Before considering *La Femme de l'aviateur* (*The Aviator's Wife*, 1980), there are three films worth mentioning in relation to his attitude to filming the city.

In his first film, *Le Signe du Lion* (*The Sign of Leo*, 1959), Rohmer already showed the unusual interest in the city which was to become his trademark. He recalled that 'for *Le Signe du Lion* I spent every Sunday over a whole year location scouting along the Seine' (quoted in Jousse & Paquot 2005: 21). Similarly, for *Place de l'Étoile*, one of six short films in *Paris vu par...* (1965), Rohmer remarked that 'the subject is taken from the geographical

Fig. 1. Varda's map of the locations from the film *Cléo de 5 à 7 (1961)*

structure of the Place de l'Étoile' (quoted in Douchet & Nadeau 1987: 193). This meticulous research of locations prior to filming came into early fruition with *La Boulangère de Monceau* (*The Baker of Monceau*, 1962), the first of six *contes moraux* or moral tales. It starts with a visual montage of the physical geography of the film's principal location reinforced by a voice-over commentary: 'Paris, the Carrefour Villiers. On the East the Boulevard des Batignolles. To the North, the rue Levis and its market. The café, the Dôme de Villiers. To its left is the Avenue Villiers. The métro Villiers. To the West the Boulevard de Courcelles.' As spectators, we are also kept fully informed of the main character's whereabouts as he ventures outside the Carrefour Villiers and its immediate surroundings towards the *boulangerie*. He tells us where he goes via the voice-over and this is further reinforced by the street signs, very similar to Varda's strategy in *Cléo de 5 à 7* (see fig. 2).

There are no car or public transport scenes, as the main character (and narrator) walks everywhere; as he states, 'I opted for walking and *flânerie*.' Furthermore, the *boulangerie*, which he visits every day, is only two streets away, north of the Carrefour Villiers. As a result it is almost as if we are following him in real time. It is topographically one of the most coherent films ever made, which is due in particular to the constant walks and the small area covered. This minimalist narrative device of the walk allows us not only to understand the topography of a quarter of Paris but also its markets, cafés, shops, texture and scale, as well as its people. The black and white cinematography consists essentially of long takes and wide angles with good depth of field, allowing the audience plenty of time and space to discover this part of Paris.

The Aviator's Wife, the most Parisian of Rohmer's series *Comédies et Proverbes*, offers his more complex and complete example of urban topographical coherence, which, unlike *La Boulangère de Monceau*, is spread over several areas of Paris, the largest part taking place in and around Les Buttes Chaumont in the 19th *arrondissement*. Of this film Rohmer stated that

> what interests us now in 1980 is not just to film in the street in documentary fashion ... what was a goal at the time [of the *Nouvelle Vague*] is now just a means but we have to introduce a rigour, different from the studio, but in the street, a discipline of filming in a documentary fashion ... I have tried to use the street décor as if I was in a studio ... to evolve in the street as freely as in a studio ... and I chose Les Buttes Chaumont as I was equally at ease there as on a theatre stage ... it is a location which has been used a lot in films, it is banal in a way but that did not stop me ... Paris has been shown a thousand times but it isn't a reason for not trying to show it in a new light. (Quoted in Douchet & Nadeau 1987: 195).

Fig. 2. Street signs and plan of the 17th *arrondissement* in *La Boulangère de Monceau* (1962)

Fig. 3. Map of locations from *La Femme de l'aviateur* (1980)

Rohmer had already made the short film *Nadja à Paris* (1967) in Les Buttes Chaumont and was therefore familiar with the location.[9] As such, that part of the filming inside the park of Les Buttes Chaumont is not of particular interest since it is devoid of city content; more notable here is how the whole film is carefully woven to always make sense in relation to the topography – for example, how we arrive at Les Buttes Chaumont and how we leave it. If we take the time to look carefully at the city across the whole film, across its different areas and journeys, one finds a complete coherence, not just in relation to one small area of Paris as in *La Boulangère de Monceau* or for the part in and around Les Buttes Chaumont, but a coherence which runs in depth across all the different parts of the city. Rohmer is always topographically correct and there are never any unexplained jumps across the city. He always leaves enough clues for us to determine where we are and where the characters are going. It is therefore easy to construct a complete map of the film's locations as shown here (see fig. 3). It counts five main locations and represents a day in the life of the characters, from early morning to late at night.

In this respect the opening scene is very telling: right from the first dialogue, François (Philippe Marlaud), the main character, indicates in the conversation that he is about to go and drop a note at his girlfriend's flat, number 56 rue Rennequin (17th *arrondissement*). He then proceeds to take the métro and re-emerges at the Peireire station on the Place du Maréchal Juin, which is indeed the closest station to the rue Rennequin. After a short walk he turns into the rue Rennequin (we can make out the street sign on the corner) and enters number 56. It is with absolute precision that Rohmer shows us within the first few minutes of the film where François works – the sorting office at the Gare de l'Est – and where his girlfriend Anne (Marie Rivière) lives, as well as the journey between the two as we see François going down into the métro as well as inside it.

Let us consider two further examples which involve two consecutive trajectories within Paris, leading to Les Buttes Chaumont. The first involves the street where Anne and François have an argument. Just prior to that, Anne and a friend have gone to a restaurant

during Anne's lunch break. We have so far no information on where she works. However, Rohmer gives brightly coloured visual clues as the friends pass by two cafés looking for space. The two cafés are called Marceau and Chaillot. We are at the corner of the Boulevard Marceau and rue de Chaillot (see fig. 4) and we can therefore identify the area where Anne works (on the Eastern edge of the 16th *arrondissement*). After lunch, François follows her and we see them going up the rue Jean Giraudoux, the street which is situated between the two cafés (Marceau and Chaillot). As they argue in the street we follow them in shot/reverse shot fashion and we can recognise shops in the distance,[10] a *brasserie* and a brightly coloured butcher's shop in particular. These act as local landmarks, not unlike the New Jersey example of the resident interviewed by Kevin Lynch who could not remember much about the particular neighbourhood bar or the local shops. As François and Anne continue their journey, we can just about make out the name of the street at right angles, the rue de Bassano. As they part, François tells her that he will go on to take the métro Étoile (Place de l'Étoile) and again we can verify on the map that as he goes up the rue Jean Giraudoux it will lead straight (via Avenue d'Iéna) to this station.

The second example involves the journey which leads François to Les Buttes Chaumont. Having emerged in the Gare de L'Est from his métro journey from Place de l'Étoile, he stumbles upon Anne's former lover, Christian (Mathieu Carrière). In case we had not picked up previous clues, the camera lets us see 'Gare-Est' written on the kiosk behind François where he sits in the café. François decides to follow Christian and the blonde woman who accompanies him when they leave the Gare de L'Est. We next see the couple walk along a street with François at a distance. Behind them we discern the large shape of the Gare de L'Est (see fig. 5). It is very much a landmark clue, as described by Lynch, except that in this case it is orientating the audience as opposed to the people in the city. They turn the corner and take a bus, clearly labelled No. 26 (see fig. 5); if we consult a map of the area we would find that from Gare de l'Est they have gone north along the rue d'Alsace and turned the corner onto the rue La Fayette to catch the No. 26 bus at the La Fayette-Dunkerque bus stop which in turn leads them in seven stops to Les Buttes Chaumont on the East of Paris. The journey from Gare de l'Est to Les Buttes Chaumont is therefore absolutely topographically correct and can easily be followed on a map thanks to identifiable landmark clues in terms of buildings and bus routes.

What we learn from these two examples is that Rohmer pays enormous attention to making sure that the city is correctly described and fully identifiable. Indeed, in the rue d'Alsace example he could have simply had a different camera angle, the reverse shot,

Fig. 4. The two cafés at the intersection of Boulevard Marceau and rue de Chaillot

CITIES IN TRANSITION

Fig. 5. Gare de l'Est and N° 26 bus stop

which would have given us no Gare de l'Est landmark at the back. We could well be on a bus without knowledge of the route number, depriving the audience of potentially iden-tifying the topography.

In many ways we could wonder about the reason for doing this. He himself must wonder when he says of restituting the topography, 'I hope the spectators are moved although they may not notice' (quoted in Jousse & Paquot 2005: 27). Rohmer must be aware that indeed the audience in its vast majority will not follow, as I did here, the tra-jectory of the characters across Paris. Indeed, after consulting Lynch as well as Levin and Simons' studies we know that the audience is most unlikely to pick up on clues and landmarks. The answer probably lies in the fact that it is Rohmer himself who is acutely aware of spatial issues in architecture and the city, and finds himself completely inca-pable of cheating the city, or even playing with it. He is therefore compelled to be true to the topography. Furthermore, he has worked in that way since his very first film and it constitutes a methodology at the heart of his work, giving him reassuring 'landmarks' for his script, something he readily acknowledges: 'If the script is written ahead of time or if one starts with a novel, one needs to find a location to suit the story while I find much more exciting to write a script starting from a place' (quoted in Jousse & Paquot 2005: 23). He takes from the city and therefore feels he needs to give something back, even if it goes unnoticed. Rohmer films the everydayness of the city, not the glorious nineteenth-century architecture as Jean-Pierre Jeunet does with the Gare du Nord in *Amélie* (2001). Rohmer's Gare de l'Est is indeed very ordinary – he is at pains to make us understand the in-between scenes, the dotted lines across a city, the trajectories, not unlike having a bird's-eye view of a city while following the characters on the ground.

Creative Geography

At the start of this section it is worth mentioning two intriguing early examples of the use of creative geography. The first can be found in Buster Keaton's *Sherlock Jnr* (1923) where we see Keaton on the cinema screen diving from a rock in the middle of the sea but land-ing in the snow (see fig. 6, left), followed by an 'accidental' fall which starts in the forest and finishes in a walled garden. The unity of time has been respected but not the spatial coherence which in this sequence is the object of Keaton's humour, as, for example, the cause of the fall is due to new geography (the tree against which Keaton was leaning is not there in the change of scenery). He plays with the notion of creative geography,

Fig. 6. Keaton's (left) and Deren's (right) use of creative geography

most likely unwittingly, and we cannot fail to notice the changes in the scenery since they become the centre of our attention. It is in a way a caricature of the creative geography notion. The second example is to be found in some of Maya Deren's films, in particular *A Study in Choreography for Camera* (1948) as well as her previous film, *Meshes of the Afternoon* (1943). In *A Study in Choreography for Camera*, Deren plays with the temporal continuity of the choreography played out against its spatial discontinuity. The dancer leaps in the air as the camera captures his leg unfolding against different backgrounds, from a forest to an interior in one sweep of a movement.

Both of these examples are explicit experiments with the creative geography notion and focus the audience's attention on it. However, mainstream fiction films have long played with this idea with varying degree of success. Beyond its sporadic use in silent cinema and avant-garde films, the device of creative geography was used widely in particular in the 1950s when filmmakers started to film again in real cities. David Bass (1997) defines two broad families of approaches to the geography of the city: the outsider's view (the case of filmmakers unfamiliar with a city) and the insider's vision. It is often the misuse of the geography of a city which is noted and Bass refers to the outsider's view of Rome – mainly American movies of the 1950s such as *Roman Holiday* (1952) and *Three Coins in the Fountain* (1955) – as 'film cartolina':

> ...shows the tourist what to see ... As well as denying Rome's topography the film cartolina alters its historical and cultural contexts ... The city of attractions is a lazy tourist's dream: a collection of desirable wonders, visitable without hot slogs through potentially boring, dangerous, 'non-places' in between ... remaking it, destroying the parts folded away in the interstices of its montage, and suppressing fragments or aspects that do not conform to its overview. (1997: 86–7)

This vision is echoed by Sidney Lumet who, when talking about New York, states that 'if a director comes in from California and doesn't know the city at all, he picks the Empire State Building and all the postcards shots – and that, of course, isn't the city' (quoted in Clark 2006: 7). Similarly Thierry Jousse, referring to 'Paris étranger' (2005: 535), chastises some of the Hollywood productions that 'make of Paris a village for tourists'(ibid.). Far from concluding that all filmmakers foreign to a city are unable to make good use of its geography, it is more a matter of recognising that local directors have a decisive advantage, as John Clark notes regarding Spike Lee who 'continues to make movies that display an intimate knowledge of New York' (2006: 7).

Similarly, Patricia Kruth states that 'Martin Scorsese and Woody Allen come out as the auteurs of a real New York work', whilst acknowledging different approaches in filming the city: 'Scorsese's construction of a screen metropolis owes no doubt a great debt to Kuleshov's creative geography. What Scorsese aims at is to capture not the letter but

the spirit of a place; this is done through meticulous and increasingly obsessive attention to details ... Whereas Woody Allen's New York can be taken at face value, Scorsese's city is a movie town'. (1997: 70–1).

Creative Geographies: Jacques Rivette's *Le Pont du Nord*

Le Pont du Nord by Jacques Rivette was shot in October and November 1980 and released at the end of 1981. It was Rivette's ninth film, all of them staged in Paris apart from two, *Noroît* (1976) and *Merry-go-round* (1978). His first film, *Paris nous appartient* (*Paris Belongs to Us*, 1958), subtitled '*Paris n'appartient à personne*' (Paris belongs to nobody), a quote from Charles Péguy, has retrospectively been seen as prophetic, despite being the first commercial failure of the *Nouvelle Vague*. It contains Rivette's blueprint for the future: enigmatic and unresolved paranoid fictions, part of a cosmic plot haunted by the ever-present Paris from which each film is constituted, never as a simple décor but as a character.

The post-May 1968 era of the 1970s saw the end of the utopia with many of the *Nouvelle Vague* filmmakers finding it difficult to get their second wind. Rivette was in that position, and following a difficult period with the two commercial failures of *Noirot* and *Merry-go-round*, *Le Pont du Nord* acted as a new departure: '*Le Pont du Nord* is a watershed film symbolising Rivette's return to Paris after several years of retreat, the film being first and foremost a reportage on the changes in Paris during the intervening period' (Frappat 2005: 789). The film is the convergence of two main ideas, a snapshot of France in 1980,[11] and a walk in different parts of Paris with two female characters, Marie (Bulle Ogier) and Baptiste (Pascale Ogier). The project was about the desire to mix, within the Paris of autumn 1980, the memory of the heroes and situations of Miguel de Cervantes' *Don Quixote* (1605). An itinerary of both landmarks and tests, it is the confrontation of two characters with a different logic, for one a paranoid fiction and for the other the desire for peace and rest. The narrative device of the walk across Paris is much more than a *flânerie*, it is a four-day *dérive*. Guy Debord defines the *dérive* as follows:

> One or two people embarking on a *dérive* give up temporarily ... jobs and leisure, to experience the opportunities offered by the terrain and people they may encounter. From the point of view of the *dérive* there is a psychogeography of the city, with constant currents, landmarks, and swirls which may render difficult the access or exit from certain zones. (1958: 19)

Jacques Rivette does not explicitly mention the situationist movement but rather claims that the lack of funds dictated 'the walk as the narrative device. We could not afford any interiors or studio' (quoted in Daney & Narboni 1981: 10). Significantly, some funds came from L'Année du Patrimoine, a heritage organisation, which meant that in parallel to *Le Pont du Nord*, Rivette made a documentary, *Paris s'en va* (*Paris Disappears*, 1980). It partly justifies the use of the creative geography notion, as the documentary brief demanded the recording of very disparate locations in the city.

His two previous films, *Noroit* and *Merry-go-round*, were shot outside Paris and Rivette's delight to be back in the capital is palpable: 'I thought a few years ago that it wasn't possible to make films in Paris but I was wrong. Paris is changing all the time ... we can

still make 500 or 5000 films there' (quoted in Daney & Narboni 1981: 11). The film takes place over four days using in total around thirty different locations unevenly distributed across the journey: 13 locations on day one against nine on day two, six on day three and only two on the last day. Fortunately, and similarly to Rohmer, Rivette worked with a small and mobile team which allowed him to cross Paris swiftly from one location to another. On day one the use of creative geography is frantic whilst on the last day, as the denouement approaches, the characters slow down, as if becoming reconciled with their environment. As Marie's life gradually unravels towards its tragic end, the environment around her becomes more and more marginal, desolate and derelict. Marie is just out of prison and this long march is a form of redemption, the journey a quest to be reunited with her ex-boyfriend, Julien (Pierre Clémenti), who at the end takes her life. As such the spatially organised narrative takes us from the centre of Paris, from conventional quarters such as Place Denfert-Rochereau, where the film starts, through some quite touristic areas (for example, the Arc de Triomphe) and progressively moves away from the centre towards the periphery and the northern edge of Paris. The monuments and landmarks are associated with meeting points, such as the Arc de Triomphe, when Marie is reunited with Julien for the first time on day one, but after day two their rendezvous take place in increasingly seedy locations. The *dérives* between meetings are devoted to Marie and Baptiste's discovery of each other, a terrain for talking and walking, whimsically, poetically and philosophically.

It is during those moments that Rivette makes best use of the creative geography notion. He employs the device in two different ways, the first being the 'classic Kuleshov experiment', as we observe the characters accomplishing great leaps across the city regardless of the topography within a very tight time frame. This is most noticeable on day one:

Fig. 7. Day one across Paris, *Le Pont du Nord* (1981)

at the start of the film the Place Denfert-Rochereau (14th *arrondissement*, South of La Seine) is clearly identified as, unusually, the street sign is caught on camera.[12] Within a few hours, Marie and Baptiste will have – amongst other unidentified locations in between – travelled north across the Seine to the 9th *arrondissement* (Place Toudouze, identified by its Wallace fountain), and then south to the Arc de Triomphe before going back north again to walk up some steep stairs around Montmartre – quite a day (see fig. 7).

A particularly telling example is when Marie and Baptiste are seen walking in the middle of a street and Marie declares, pointing forward (see fig. 8),[13] 'L'étoile is there, in front', referring to the Place de l'Étoile where the Arc de Triomphe is situated, and where they find themselves, after the cut. Looking at the map, it is geographically implausible, as the Place de l'Étoile is surrounded by a concentric array of large and busy avenues. In this case it is possible to notice it because it involves a landmark such as the Arc de Triomphe, but at other times it is almost impossible to detect as Rivette weaves together a Paris made of small and anonymous streets, taking great pleasure in creating a new and very believable topography without 'destroying the parts [of the city] folded away in the interstices of its montage', following Bass's remark about 'film cartolina'. The new topography

Fig. 8. 'Classic Kuleshov experiment' around L'Arc de Triomphe – on the left frame before the cut and on the right after the cut

is almost seamless as 'a long series of events ties the two appearances together, giving a strong cognitive counterweight to whatever visual discontinuity viewers may have registered' (Levin & Simons 2000: 371).

However, in some instances Rivette adds an extra dimension to the original creative geography notion, where the sound was absent, and offers a refinement which involves the characters' dialogue. He organises the cut over a new geography, in the middle of a dialogue (differently from the shots identified in figure 8 where the dialogue stops just before the cut). In that way we have a continuity of action and dialogue over a new topography. We know from the work of Levin and Simons that if the shots contain no mutually contradictory perceptual information, such as the direction or the intensity of the light, the audience will read a single coherent space, a diegetic space. A good example of this technique is on day one when Marie and Baptiste start their first personal conversation just above Place Toudouze. Marie asks Baptiste 'and you, what's your name?', to which Baptiste replies: 'I am called Baptiste', after the cut and over the new location. The new location is evidently miles away, as it is a bridge, possibly a pedestrian bridge over the Seine or a canal. There are no such features close to the Place Toudouze. Yet the cut is well disguised for two reasons: firstly, the light is very similar on each side of the cut, soft autumnal afternoon sunlight, both in its intensity and direction. Furthermore, to shoot this scene Rivette used a Steadicam, framing the faces of the characters quite tightly, therefore minimising the impact of the background (see fig. 9).

It should be noted in figure 9 that Rivette avoids having a straightforward cut whereby Marie and Baptiste would continue to talk in the same position. This would potentially create a jump cut. But by switching Marie and Baptiste across the cut he avoids the issue

Fig. 9. A refinement to the classic Kuleshov experiment, as the dialogue is cut across a change of location – on the left the frame before the cut (Place Toudouze) and on the right just after the cut.

from topographical coherence to creative geography

while maintaining the illusion of the continuous action through the dialogue.[14] He uses a similar technique in a sequence where Marie and Baptiste talk non-stop while walking up a series of unconnected stairs and in order to avoid the jump cut, shots of statues of lions are interspersed between locations. It is interesting to note that the theme of creative geographies runs deep into the film, and there is even an invented location in a dialogue: Max (Jean-François Stévenin) – a small-time gangster – conveys Marie to a meeting at the 'corner of the rue de Nuit and rue du Port de Bercy', an address which does not exist.

So why does he do this? There are probably several layers of explanation to Rivette's fascination with the creative geography notion. Firstly, at the origin of the project, he wanted to create a snapshot of the disappearing Paris in 1980, the final act of the 1970s. For that he needed to film a wide range of locations, ideally suited to the creative geography strategy. Secondly, he recognises the immense difficulty associated with topographical coherence:

> There is something that one learns when doing films which is that when we try through film to give the feeling of what a place is really like, that's the most difficult thing to do … it's extremely difficult to describe a location, to give the spectator an idea of the proportions and layout, especially if it is a complex plan, even the layout of a flat … even more so with location shooting in the city. You learn quickly that sometimes it is useful and sometimes it is useless … and one starts to try again … cinema needs to constantly reinvent and explore this relationship to space and place. (Daney & Narboni 1981: 12)

Fig. 10. 'Le Jeu de l'Oie' over the map of Paris

Since he does not feel compelled by the tyranny of the city's geography, unlike Rohmer, Rivette engages with the city in a game-like fashion in which he maps out on a Jeu de l'Oie diagram the different squares aimed to guide Marie and Baptiste,[15] and possibly also the audience, since the game is symbolically drawn over a map of Paris (see fig. 10).

But, crucially, Rivette raises here a broader issue when he talks about the extreme difficulty in describing a place, and in order to understand his point we need to consider briefly the relationship between diegetic space and creative geographies. Heath refers to space as the 'superior unity' (1981: 40) that binds the spectator within the film. This 'superior unity' can be constituted of many spaces: rooms in a house, rooms in more than one house, houses and streets, and indeed many other spaces in a city, as in Le Pont du Nord. As Jean Mitry puts it: 'shots are like cells, distinct spaces the succession of which, however, reconstitutes a homogenous space but a space unlike that from which these elements came originally' (1965: 10). Therefore the notion of creative geographies whereby one extracts different 'cells' from a city to create a new homogenous space, can be construed as another way of achieving Heath's 'superior unity'. Furthermore, this spatial unity is achieved, in the continuity editing tradition, by the binding mechanisms of screen language, of which the 180-degree rule, or 'crossing the line' rule, is one of the most important when it comes to spatial coherence. Indeed, any misjudgement of the camera set-up can lead to an in-

fringement of this rule, by inverting the relative positions of people and objects in space and potentially leading the audience to be momentarily disorientated. Even in the simple layout of the ramp scene in *Architectures d'Aujourd'hui* (1931), we know that a temporary sense of disorientation can be experienced by viewers as Pierre Chenal's camera crosses the line, despite this being only a thirty second 'promenade architecturale' involving just one character (see Penz 2006).[16] Could it therefore be that many geographies would make the spatial coherence issue more complex and threaten the spatial unity of the diegetic space? Not so, answers Rivette, on the contrary. It is making coherent the domestic interior of a flat which presents him with a challenge, while the employment of the creative geographies is liberating. Rivette's use of the temporal continuity of the bodies in space, played out against the spatial discontinuity of the city, presents little risk of spatial incoherence as the locations change most frequently from one cut to another. In some ways it is a world where the 180-degree convention ceases to rule.[17] As Rivette complies with the temporal continuity dictated by the narrative, the 'superior unity' of the diegetic space is respected and the illusion of a continuous piece of action maintained.

Conclusions

One of the reasons for choosing to compare these two films was that they were shot within six months of each other. Therefore, one could imagine comparing the effect that the two different strategies would have on the 'legibility' of Paris. The fact that they were using different parts of the city makes the comparison more difficult; however, there are general considerations worthy of note. With reference to Lynch's definition, Rohmer uses everyday landmarks, such as the Gare de L'Est, or the café signs and shop awnings, to validate the topography of the city as well as orientate the spectator. Rivette, on the other hand, chooses some more touristic landmarks, in particular the Arc de Triomphe, not as an orientation point, but more as an observation point from which to gaze at the 'Paris ocean' (as Marie describes the lovely view from the cliff). Rohmer's city strategy, in its accurate portrayal of everydayness, is steeped in Bazin's 'spatial density of the real', while Rivette's characters engage in a *dérive* dictated by a surreal psychogeography where, echoing words from *Moby Dick*: 'true places never are in any map' (1977: 150). But more striking is the fact that the 'disappearing Paris', which looms large in *Le Pont du Nord*, does not figure in Rohmer's film. Undeniably Rivette's film contains images of genuine historical importance, thus, to paraphrase Bass, preserving on the screen the parts of Paris which are being folded away in the interstices of a new, emerging map of the city.

Another reason for concentrating on those two films is the fact that Rivette and Rohmer are seen by the new group of French filmmakers emerging at the beginning of the twenty-first century as the 'godfathers of their new generation' (Guerin 2006: 12), partly due to the way they film Paris. Marie Anne Guerin observes that 'the cinema of Sophie Fillières with *Aïe* (2000) and *Gentille* (2005) takes place in a Paris invented bit by bit as in Rohmer', always allowing 'the identification of the location'; and acknowledges that 'Laurence Ferreira Barbosa with *J'ai Horreur de l'Amour* (1996) proposes a desolate Paris inspired by Rivette' (ibid.). Guerin also points out that in this new generation the tendency when filming in Paris is 'towards a reduction of the city to a very small perimeter' (ibid.). Might Rohmer's strategy get the upper hand, despite the fact that, in Rohmer's own

words, the 'spectators may not notice' (quoted in Jousse & Paquot 2005: 27)? Intriguingly, the debate on creative geography versus topographical coherence is now raging amongst specialists of computer games and virtual environments where traditionally real-time rendered virtual spaces (RT 3D VEs) have precisely defined spaces not unlike real architectural spaces. However, thanks to the concept of 'teleporting', the virtual equivalent of the Kuleshov creative geography notion, new horizons open up for game players, as pointed out by Michael Nitsche and Maureen Thomas: 'when teleporting a user-avatar to another location, the camera cuts to a new view of this avatar, hiding the spatial teleport effect. In this way, cinematic techniques can enhance the spatial coherence of RT 3D VEs and edit the fragmented space into one perceived entity using continuity editing techniques that reinforce spatial orientation', before adding: 'these spaces lead to perceptual problems … They disorientate and destabilise the audience as the spatial connections are broken' (2003: 91). Since the debate has now permeated the virtual world, no doubt it will go on for some time.

NOTES

1 Kuleshov is better known for the 'Kuleshov effect' where he explores the meaning conveyed by different montages of images, combined with the neutral expression of the actor Mozhukhin.

2 The first actor, Alexandra Khoklova, is seen walking in a Moscow street. The second actor, Leonid Obolensky, is seen walking in the other direction as he greets Khoklova. Although the greeting suggests that Obolensky is within a block or so of Khoklova, the actual shot was taken in a different part of the city, many miles from Khoklova's location. In a third shot, filmed in yet another area, the two meet in front of a statue. They then look off-screen and a cutaway shows the White House in Washington DC.

3 He then adds a footnote (1998: 113) where he recalls a time when he only showed three reels as the others were missing. On that occasion the audience had seen the commode, which surprised him, but there was a simple explanation: they had not yet been gripped by the action or by the dramatic function of the décor. Indeed, after the third reel one would still notice the commode because there was no reason not to.

4 This experiment was inspired by Luis Buñuel's *Cet obscur objet du désir* (*That Obscure Object of Desire*, 1977), where Conchita is played in some scenes by Angela Molina and in others by Carole Bouquet.

5 Our eyes move from one fixation to the next in quick jumps, referred to as *saccades*.

6 We believe in it because the fiction dictates it, as suggested by Étienne Souriau in his definition of diegesis (see Aumont & Marie 2002: 52).

7 In the words of Jacques Audiard: 'When I see a film of Gilles Grangier shot in Paris in the 50s, I am taken by the streets and the cars … suddenly that lorry in front of my eyes has existed. It is as if cinema validates' (2006: 22).

8 In particular, Rohmer directed *Le Béton dans la ville* (1969) with Paul Virilio and four documentaries on the new towns, *Villes nouvelles* (1974) with Jean-Paul Pigeat.

9 Given that it is a vast public park, it tends to be quiet (with no traffic), and that was to be crucial, as it was to be Rohmer's first film where he experimented with direct sound with radio microphones (RFH).

10　The argument between the two characters is as an excellent example of what Rohmer calls 'using the street décor as if I was in a studio', as they are followed by a fluid hand-held camera, with passers-by occasionally looking on.

11　Originally Rivette had intended to do a remake of *Out One* (1970), a film looking at the 1960s.

12　The lion in the centre of the Place Denfert-Rochereau is also very present and would constitute an identifiable landmark.

13　Marie's pointing forward is the equivalent of a cut on the gaze.

14　Since the sound was recorded live it could have been a major issue across cuts due to the different locations. However, in the film it is not noticeable, possibly because it was cleaned up in post-production.

15　A type of 'snakes and ladders' game.

16　Situated in Le Corbusier's Villa Savoye.

17　The only other example when the 180-degree convention does not apply is through the device of the long take sequence shot, such as in Alfred Hitchcock's *Rope* (1948) or Jean Rouch's *Gare du Nord* (1965), which resembles the first-person point of view of the computer games.

WORKS CITED

Audiard , J. (2006) 'Les Gens du cinéma', *Le Monde*, numéro special, 6 May, 18–25.

Aumont, J. and M. Marie (2002) *Dictionnaire Théorique et Critique du Cinéma*. Paris: Nathan.

Bass, D. (1997) 'Insiders and Outsiders: latent urban thinking in movies of modern Rome', in F. Penz and M. Thomas (eds) *Cinema and Architecture*. London: British Film Institute, 84–99.

Bazin, A. (1998) 'Marcel Carné – *Le Jour se Lève*', in J. Narboni (ed.) *Le Cinéma Francais de la Libération à la Nouvelle Vague 1945–1958*. Paris: Cahiers du Cinéma, 76–113.

____ (2002) 'Montage Interdit', in *Qu'est-ce que le Cinéma?* Paris: Les Éditions du Cerf, 49–61.

Binh, N.T. (2005) *Paris au Cinéma: la vie révée de la Capitale de Méliès à Amélie Poulain*. Paris: Parigramme.

Bullock, N. (2003) 'Two cinematic readings of the Parisian suburbs', in *City: analysis of urban trends, culture, theory, policy, action*. Abingdon: Taylor and Francis, 386–99.

Clark, J. (2006) 'As New York turns chic, its essence on film fades. *Le Monde*', *The New York Times Supplement*, 13 May, 7.

Daney, S. and J. Narboni (1981) *Entretien avec Jacques Rivette*. Paris: Cahiers du Cinéma 327, 8–21.

Debord, G.-E. (1958) 'Théorie de la Dérive', *Internationale Situationniste*, 2, December, 19.

Douchet, J. and G. Nadeau (1987) *Paris Cinéma*. Paris: Éditions du May.

Frappat, H. (2005) 'Jacques Rivette', in T. Jousse and T. Paquot (eds) *La Ville au Cinéma*. Paris: Cahiers du Cinéma, 786–89.

Guerin, M. A. (2006) *Paris leur appartient*. Paris: Forum des Images des Halles, Le Guide 3, March/April, 12.

Heath, S. (1981) *Questions of Cinema*. Bloomington: Indiana University Press.

Jousse, T. (2005) 'Paris étranger', in T. Jousse and T. Paquot (eds) *La Ville au Cinéma*. Paris: Cahiers du Cinéma, 535–9.

Jousse, T. and T. Paquot (2005) 'Un cinéaste dans la ville - entretien avec Éric Rohmer', in T. Jousse and T. Paquot (eds) *La Ville au Cinéma*. Paris: Cahiers du Cinéma, 19–27.

Kruth, P. (1997) 'The Color of New York: Places and Spaces in the films of Martin Scorsese and Woody Allen', in F. Penz and M. Thomas (eds) *Cinema and Architecture*. London: British Film Institute, 70–83.

Kuleshov, L. (1974) *Kuleshov on film*, ed. R. Levaco. Berkeley: University of California Press.

Levin, D. T. and D. J. Simons (2000) 'Perceiving stability in a changing world: Combining shots and integrating views in motion pictures and the real world', *Media Psychology*, 2, 357–80.

Lynch, K. (1960) *The Image of the City*. Cambridge, MA: MIT Press.

Melville, H. (1977) *Moby Dick*. Harmondsworth: Penguin.

Mitry, J (1965) *Esthétique et Psychologie du Cinéma, vol. 2*. Paris: Éditions Universitaires.

Nitsche, M. and M. Thomas (2003) 'Stories in Space: The Concept of the Story Map', in O. Balet, G. Subsol and P. Torquet (eds) *Proceedings of the Second Conference on Virtual Storytelling ICVS '03*. Berlin: Springer, 85–94.

Penz, F. (2006) 'Notes and Observations regarding Pierre Chenal and Le Corbusier's Collaboration on *Architectures d'Aujourd'hui* (1931)', in U. Belkıs, E. Ayhan and A. Vatansever (eds) *Design and Cinema – Form Follows Film*. Cambridge: Cambridge Scholars Press, 164–84.

Rohmer, É. (1948) *Cinéma, Art de l'Espace*. Paris: La Revue du Cinéma 14, 3–13.

Simons, D. J. & D. T. Levin (1997) 'Change Blindness', *Trends in Cognitive Science* 1, 261–7.

Varda, A. (2003) 'Untitled article', *Libération Un été 2003 – CinéVilles*, 22 August, 2–3.

Yampolsky, M. (1994) 'Kuleshov's Experiments and the New Anthropology of the Actor', in R. Taylor and I. Christie (eds) *Inside the Film Factory*. London: Routledge, 31–50.

10 CONTROLLED SPACE: THE BUILT ENVIRONMENT OF MARGARETHE VON TROTTA'S *THE GERMAN SISTERS*

Charity Scribner

It is dark and bleak today,
the paths and lanes slumber on,
and it almost seems to me
as if it were a leaden time.
– HÖLDERLIN, 'THE PATH INTO THE COUNTRY'[1]

For eight months from 1972 to 1973 Ulrike Meinhof, a leader of the left-wing militant group the Red Army Faction (RAF), was held in solitary confinement in the Women's Psychiatric Section of Köln-Ossendorf prison. While incarcerated she kept a notebook of letters, one of which described with poetic fragmentation her reduced life in the '*toten Trakt*', or dead section, of the prison:

Wardens, visitors, the courtyards seem as if they were made of celluloid –
Headaches –
Flashes ...
The feeling that time and space are interlocked,
that you move in a time loop. (1976: 152–4)

Meinhof's incarceration put on pause her volatile engagement in armed struggle and in-clined her to the anomie of endless repetition. Constantly exposed to fluorescent light, separated from other inmates in a soundproofed cell, she lost her sense of location and began to detach from the material world. As Margrit Schiller, another RAF member, re-counted in her 1999 memoir *It Was a Real Struggle to Remember: A Report from the RAF*, the voids of the dead section depleted prisoners' abilities to 'distinguish internal percep-tions from external reality' (1999: 138–9). The austerity of internment delivered Meinhof into an altered state: the silence, the stillness seemed to cordon off a space outside of history. Beside herself with anguish, Meinhof began to see the leaden weight of her cell dissolve into a surreal figment. Memories flashed up onto the walls, some false, some true, taking her to a place apart, to another time. As her skewed perceptions transubstan-tiated the prison architecture, reducing cubic space to two dimensions, her life shifted down to the horizontal and vertical of a celluloid filmstrip, then slowed to a still frame.

Margarethe von Trotta's feature film *Die bleierne Zeit* (*The German Sisters*, 1981) transposes the fundamental yet paradoxical conditions that Meinhof conveys in her

notes – the concrete constraints of the prison complex and the psychological strictures of enforced isolation. It navigates the controlled space at the intersection of these two conditions, surveying the texture of the prison grounds and illuminating the surfaces of its enclosures. Although the film draws elements from the biographies of several RAF militants, *The German Sisters* most closely follows the life, incarceration and death of Gudrun Ensslin, a notorious RAF *engagée*, who, like Meinhof, died in prison.[2] Von Trotta's composite character is called Marianne; we see her rise and fall chronicled by her sister, Juliane. In a series of flashbacks, von Trotta develops a cinematic *Bildungsroman* of the fictional sisters: born in the bomb raids of World War Two, they come of age in the somber caesura of the 1950s (the so-called '*bleierne Zeit*' or leaden times), then are startled into social action by the turbulence of 1968. By the late 1970s, when the film reaches its climax, Juliane has become a grassroots activist and editor of a feminist magazine. Marianne has been imprisoned as a terrorist in a modern, maximum security facility modelled after Stammheim, the jail that held Meinhof and Ensslin when they died and that has become a key term in the lexicon of postwar militancy.

The German Sisters climaxes in the season of discontent that Germans call the 'hot autumn' of 1977, the months when the RAF first escalated their threats against the German state with a series of kidnappings and hijackings and then came to suicidal crisis. This spell of time serves as both flashpoint and prism; von Trotta dramatises the moment when postwar German democracy met its greatest challenge and refracts Germany's ongoing process of *Vergangenheitsbewältigung*, or coming-to-terms with the past. She structures her narrative with carefully composed images of the built environment. Using wide pans, von Trotta connects different sites and temporal moments – a technique that lays bare several links between penitentiary and urban space. Her direction discloses the poetics of the hot autumn: the RAF stands as a metaphor for the marginalised and insurgent forces of the oppressed; Stammheim, meanwhile, functions as a metonymy of the West German police state.[3] Together these tropes convey the introspective, melancholy temper of 1977.

Many cinema scholars have written about *The German Sisters*: the first waves of reception focused on the gender dynamics of the film; critics have only just begun to consider the film from other angles.[4] Recently Karen Beckman (2002) brought the film to bear on an article about the design of the World Trade Center in New York, but instead of elaborating a spatial analysis of *The German Sisters*, it concentrates on the parallel dualisms between the two sisters and the two towers. It remains to be considered how von Trotta's concern with the built environment engineers her narrative about German militancy.

Gate of the old prison

The film's framing of architectural enclosures presents the prison as a vital organ of the city.[5] We could draw upon the conceptual arsenal of Michel Foucault's *Discipline and Punish* and Jeremy Bentham's panopticon to work out a particular reading of *The German Sisters*. But this would leave unaddressed another important element of von Trotta's urban imagination. For it is not just her shots of penal enclosures that frame the film; her attention to the smaller objects of city life also guides her narrative. Delineating the fullest dimensions of metro-

CITIES IN TRANSITION

politan life, von Trotta extends her scope to include both the massive prisons and hous-
ing blocks and the more ephemeral constructions of the built environment – particularly
those comprised of textiles. She exploits the constraints of the tight shot in her sequences
of domestic and carceral confinement and trains a close focus on the light, mobile struc-
tures that furnish and clad these worlds.

Engaging with the architecturally-inflected cinema studies of Giuliana Bruno and
Thomas Elsaesser can lead us to another analysis of *The German Sisters*, one at variance
with a Foucauldian critique. Bruno has argued that film as such is a product of the metro-
politan era, for it enables a perceptual mode that shifts continuously between the interior
and the exterior (1993: 53, 54).[6] Her study of Elvira Notari's films maps out a landscape
of Naples as it traces the parallels between *flânerie* and cinema – their shared juxtaposi-
tions of space and time, their privileging of montage (1993: 48). If Notari's work highlights
the traffic of men and women through Naples, their flow in and out of its cinemas and
arcades, *The German Sisters* seeks out the deadlocks of the city, its moments of stasis,
most specifically those of the prison.

Thomas Elsaesser, in an article on the representation of the RAF in the film *Deutsch-
land im Herbst* (*Germany in Autumn*, 1978) and the ARD television docudrama *Todesspiel*
(*Death Game*, 1997), has considered the appearance of the 'urban guerrilla' in the Ger-
man public sphere. Although he touches only obliquely on von Trotta's filmmaking, his
observations on the dynamics between militancy, media and surveillance open up an
important critique of *The German Sisters*. His essential question turns around a shift in
German society from an elite culture focused on the theatre stage and an elite govern-
ment of the parliament towards the dispersed and disseminated politics of the media
spectacle (see 1999: 292). Elsaesser presents the RAF and the cultural response to it as
an optic for our current historical moment – that in which space is activated as a political
category. Germany's rebellious youth, and the police dispatched to control them, did not
only operate within an urban fabric of escalating visual surveillance (see Elsaesser 1999:
285), they also provoked and disclosed this very transformation. With the medium of
cinema, directors like von Trotta put this condition into even starker relief.

The German Sisters persists as a residue of the German Autumn, yet certain aspects
of the film point beyond the ideological horizons of the leftist consensus with which von
Trotta affiliated herself; indeed they take the critical viewer to a destination that she might
not have intended. Von Trotta's attention to the surfaces and structures of authority pow-
erfully conveys the literal and figurative confinement of radicals like Meinhof and Ensslin.
Yet aspects of *The German Sisters* cede to the RAF's desperation, particularly as Meinhof
expressed it in her prison notebooks. Von Trotta dissolves the multiple surfaces of her
film – walls and windows – into a homogenous screen: a screen that cannot adequately
differentiate the context of the hot autumn from the deeper trauma of the Holocaust.
Making Stammheim into a symbol of German authoritarianism, von Trotta, like her hero-
ines, blurs the margins between police state and nation state. More than this, she also
risks equating the RAF prisoners with Holocaust victims. *The German Sisters* invites such
scrutiny through its ambiguous incorporation of selected sequences from Alain Resnais'
Nuit et brouillard (*Night and Fog*, 1955) that document concentration camp architecture.
At the same time, however, von Trotta's attention to smaller objects of the built environ-
ment ultimately resists such a relativising account. Her film indicates a new way to think
about visual culture in the context of German history.

The Stammheim Complex

Incarceration at Stammheim both shaped the RAF identity and brought about the movement's demise. The prison's deployment of restraints and its disenfranchisement of civil liberties confirmed the RAF's belief that the Federal Republic of Germany (FRG) was a state of social control and fuelled their revolutionary commitment. The architecture and technologies of the German penal system provided the substrate, medium and traction against which the RAF took full shape. At the same time, however, the RAF's resistance – its violence and its insurgent rhetoric – prompted the Bundestag to tighten its grip on civil society.[7] If, in their first years of engagement, activists like Meinhof and Ensslin sought to address social inequality and imperialism, the RAF's subsequent campaign to exonerate the Stammheim inmates introverted the group's energies. Meinhof was one of the first to see Stammheim as a trope for the repression of German administered society. In her words, the 'anti-imperialist struggle is really about liberation from prison – from the prison that the system always already is for the exploited and oppressed ... from the prison of total alienation and self-estrangement' (Rote Armee Fraktion 1978b: 74). Although Meinhof never rigorously substantiated this comparison, the RAF's broader allegations of direct abuse at Stammheim cannot be fully discounted. As the group's advocates initially attested, and some historians have since affirmed, wardens used unconventional means – including the confiscation of clocks and watches, bodily restraints and feeding by intubation – to control the militants. Sceptics, meanwhile, have detailed the unusual privileges accorded to RAF inmates, such as the right to communicate within the prison and to accumulate large collections of books and recordings in their cells.[8] Indeed, if Baader, Ensslin and Jan-Carl Raspe, another RAF leader, actually committed suicide at Stammheim, they probably relied on several modes of communication to seal their pact, some of which their lawyers could have enabled.[9]

The German Sisters dramatises the conditions of the RAF's imprisonment, activating questions about human rights and criminal punishment that have only intensified in the last thirty years. Von Trotta's view of prison systems illuminates continuities that link institutions like Stammheim with the new order that has arisen in the FRG's young democracy. She locates other associations as well, such as those that link personal choices with political tendencies, particularly within the sexualised field of vision. As a result, *The German Sisters* situates itself at the political intersection of two discourses: the cinematic and the architectural. Thomas Elsaesser has described the emphatically urban conditions of the RAF. He situates the direct actions of the Baader-Meinhof group within the culture of the site-specific aesthetic movements that both animated and unnerved European metropolises in the 1960s and 1970s: the Fluxus happenings of Frankfurt and Berlin, and the Situationists' Parisian *derives* (see 1999: 284, 292). What becomes evident in both the proliferation of RAF documents and the subsequent accounts of the group's history – *The German Sisters* certainly being one of them – is that the cityscape was both the medium and material support of the German militants. The structures of streets, municipal buildings, department stores, medians and underpasses generated the syntax of the RAF idiom.

Although *The German Sisters* was shot mostly in and around Berlin, the cast and crew also worked in suburban parts of the Federal Republic, as well as the former Czechoslovakia and several locations in Italy and Tunisia. But *The German Sisters* strays far from the

genre of the travelogue, the city as modernist matrix, the film as scenic *Überblick*. While von Trotta's film tracks broad swaths of the urban environment, it also directs our gaze inward to the private lives lived within the ever-smaller precincts of domestic and penitentiary space. Cinema scholars were quick to emphasise the 'personal-is-the-political' premise that structures von Trotta's feminist vision, but another aspect of *The German Sisters* – the movement across the threshold of the public and private spheres – is central both to the film and, to a great extent, the rhetorics of urban surveillance.[10]

Landscape with prison

Von Trotta's repeated focus on windows, particularly barred windows, reminds the viewer of the control systems that define both urban life and social relations.[11] The film's first shot is framed through a mullioned window in Juliane's study onto the desolate courtyard or *Innenhof* of her apartment complex. Von Trotta returns again and again to this perspective, using parallel shots of other windows – generic school windows, prison windows girded with metal grillwork or otherwise obscured – to lend a consistent vision to the entire film. The return to these apertures both reinscribes von Trotta's elaboration of the personal/political axis and registers key moments in the sisters' relationship.

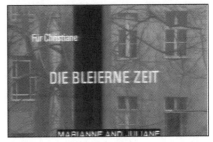

Title shot

When Juliane first visits Marianne in prison, one shot shows her looking out of a waiting-room window. The window is made of opaque milkglass, but Juliane finds a small spot that has been rubbed clear. She leans close and looks into the empty prison courtyard; all she can see are brick walls and barred windows. As the camera pans, the shot segues into a view of another residential courtyard, this time that of Marianne and Juliane's childhood home, circa 1947. Here von Trotta suggests a continuum between prison architecture and the design of the traditional German home; she also establishes a link between the season of discontent that beset the German left in the 1970s and the first postwar years.

Marianne before window

Marianne in waiting room

This same transposition structures a subsequent flashback in the film, one that recalls a divergence in the sisters' sensibilities and, simultaneously, reiterates the architectural motifs that subtend the story. As is the case in the earlier flash-

Brick wall with windows

back, von Trotta does not use a dissolve or fade. Rather, she makes hard cuts to move from time to time and from place to place. When Juliane returns to the prison, the camera follows her gaze upon the building's windows, perhaps in search of the one leading to Marianne's cell. This image segues to a shot of another brick wall: the exterior of the school where the sisters, together in the same class in 1955, are studying Rainer Maria Rilke. Marianne recites Rilke's poem 'Herbsttag' ('Autumn Day', 1902), which Juliane derides as '*kitschig*', or kitschy, prompting her dismissal from the class. Here we get a sense that it was Juliane who first scouted out the path towards rebellion. At the same stroke, von Trotta plays on Rilke's autumnal melancholy – the solitary lull when those who have not yet built their houses will not find the time to do so before winter sets in:

> Who doesn't have a house won't build one now.
> Who is now alone will long remain so,
> Will stay up, read, write long letters,
> And will walk restlessly along the promenades
> When the leaves drift down. (1935: 42)

One reason, perhaps, why the architectural motifs of *The German Sisters* resonate so deeply today is because they were reiterated in Gerhard Richter's much-debated photopainting series *18. Oktober 1977*, which he produced in 1988. Consider *Erhängte* (*Hanged*, 1988), part of the project. Based on a forensic photograph widely publicised in television and mainstream media, the painting shows Gudrun Ensslin's corpse hanging from a window casement in her cell. Richter's blur technique emphasises three elements of the image: Ensslin's hyperextended body, her strangely tilted head and the gridded window from which she hangs. The result has become an icon of contemporary art, one that we can work into a broader constellation of German culture that includes not only Richter's contemporary, Margarethe von Trotta, but also the literature of Friedrich Hölderlin and Rilke, and, as we shall see, the architectural ideas of Gottfried Semper and Adolf Loos.

Police photo

Hanged (Gerhard Richter, 1988)

The deeper meanings of *The German Sisters* develop within this matrix and according to the architectural constraints that von Trotta establishes in the film. Her study of the cityscape includes smaller structures, especially articles of clothing – the mobile 'architecture' that has been conventionally designed and fabricated by women. Von Trotta shapes several key scenes by staging Marianne and Juliane's clothing; their slips and pullovers establish links between the sisters' shared past and their divided present. When Juliane makes her first prison visit, von Trotta offers a detailed account of the surveillance procedure. The camera remains fixed on Juliane and the female warden, who searches her

clothing for weapons and contraband. Juliane does not resist the warden's commands until she is asked to remove her pullover. When told that this is standard procedure, she hesitates, then lifts the garment up over her head, revealing her naked body beneath. During their next visitation, Marianne recalls the slips or bodices (*Leibchen*) that the sisters wore as girls: 'Do you remember our slips?' she asks. 'The ones that closed only from the back? No matter how cross we were with one another, we'd button each other up.' They recall how the stocking straps of the white, cotton slips were either too long or too short, how the fabric itched. But Marianne quickly changes the subject, turning her focus to the plight of the other jailed comrades and sparking Juliane's fury.

This recollection of their shared past precipitates a brief but explosive quarrel about their political differences. Within a few expository lines, the viewer grasps the sisters' conflict. Although both are committed to social change, Juliane has chosen to work in the public sphere, where second-wave feminism aimed to transform German law and media; she sees Marianne's decision to join the RAF as a miscarriage of radical politics. At Juliane's next visit, Marianne relates an extended monologue about her penal isolation and lends a different rhythm to their conversation. The clock strikes the end of the visiting hour just as Juliane begins to comprehend her sister's circumstances. At their farewell embrace Marianne asks Juliane to give her the pullover she is wearing. To the wardens' astonishment, the sisters quickly undress and re-dress in each other's pullover, in a single, fluid gesture. Reiterating the control and exposure that marked Juliane's first visit – for a moment they face each other with bodies exposed, woollen forms held briefly overhead – the sisters refunction the movement into a defiant double manoeuvre. Then the guards forcefully separate the women and escort them to separate exits.

Leibchen

Marianne and Juliane undress

Juliane discovers the purpose of the pullover exchange in the next scene, when she finds a note in the pocket. Marianne had written: 'Talk to friends. Intellectuals, liberals, important people. They should damn well do something for us this time.' In this sequence and in several scenes that follow, fabric objects continue to function as both medium and message at once. The news of Marianne's death, a purported suicide by hanging, devastates Juliane: suffering a nervous collapse, she grieves her sister's loss and recalls, again, the shared ritual of buttoning their slips.

Wall, Dress, Screen

It might seem strange to speak of fabric and clothing as part of the city, but von Trotta's alertness to small-scale and mobile structures has a historical context, one that is distinctively Germanic. Indeed, *The German Sisters* makes several points of contact with the

early modern architectural theses of Gottfried Semper and Adolf Loos. Semper's 1860 study *Der Stil in den technischen und tektonischen Künsten* (*Style in the Technical and Tectonic Arts*) locates the crux of architecture in the textile, disclosing the tight knot that binds the fabrication of architecture with the clothing of the human body. In his 'Prinzip der Bekleidung' ('Principle of Cladding' or 'Principle of Dressing'), Semper extends his analogy between walls and dressing (*Wände* and *Gewände*) to maintain that architecture's truth consists not in its internal structure but rather in its covering layer (2004: 242–55). Taking Semper's lead, Loos published his own 'Prinzip der Bekleidung' in 1898, a manifesto that argues at once for a minimalist aesthetic and for an architecture that emphasises the 'outer layer' of a building (1982: 67). Even though it dissimulates the structure it covers, this layer of cladding mediates our perception of the building.

For Semper, building originated with the use of woven fabrics. Textiles were not simply placed within an enclosure to define a certain interiority, he argues. Rather, they enabled the production of space itself, introducing the idea and practice of occupation. As Mark Wigley explains, Semper saw weaving both 'as a means to make the "home", the inner life separated from the outer life' and to formalise and define places out of spaces. (1995: 11). Ornament produces the house as well as social structure.[12] The interior is not defined by a continuous enclosure of walls but by the folds, twists and turns in an often discontinuous decorative surface.

Von Trotta's interest in textiles and fabrics both looks back to Semper and Loos and anticipates the most recent tendencies of design. The staging of objects in *The German Sisters* turns our attention towards the possibilities of new architecture, such as the tensile structures of Günter Behnisch and Frei Otto's stadium for the 1972 Olympic Games

in Munich. Suspended from steel pylons, the stadium's perspex tents created a seemingly ethereal contrast to Albert Speer's colossal arenas for the Berlin games in 1936. Against the fascist ideal of a static *Heimat*, this variable architecture participates in a nomadic culture of transit and contest. What seems mobile or portable in the Munich structure is more fully realised in the subsequent 'wearable shelters' of several designers: Peter Cook's provisional projects for the firm Archigram, the couture of Hussein Chalayan and the armoured garments recently produced by engineers at the MIT Media Lab. This clothing dresses the body for subterfuge, escape and duress. Von Trotta's mobilisation of cloth objects in *The German Sisters* approaches

Munich Olympic Stadium (Günter Behnisch, architect and Frei Otto, structural engineer, 1972)

the horizons envisioned by these designers. It privileges the portable and mutable; it gestures towards non-standard and even transgressive designs.

After introducing the vests and pullovers into *The German Sisters*, von Trotta enters a third material object into the narrative, bringing it to a close. Juliane splits with her partner Wolfgang, an architect, moves to her own apartment and devotes herself to investigating the cause of Marianne's death. She reads books about knots, marking the pages that show nooses. She requisitions the belongings her sister kept when incarcerated and works out a whole calculus of figures – her sister's weight, the height of the window grill,

CITIES IN TRANSITION

the maximum load any of the collected materials could bear – all in an attempt to assess whether Marianne could have committed suicide in the controlled space of the prison cell. In one scene, von Trotta films Juliane consumed with the task of fashioning from fabric a life-sized model – Marianne's body double – cut from cloth, each limb tacked and sewn, filled with sand and finally assembled into a doll. Juliane ties a rope to her own window casement and hangs the doll from it. It dangles for a few seconds as she looks on in horror, crouched in the corner. Then, suddenly, the cable breaks, letting the doll drop and corroborating her conviction that Juliane must have been murdered.

Marianne reads the knot book

Semper's analogy between *Wände* and *Gewände* finds its third term in the *Leinwand*, or cinema screen, of *The German Sisters*. Von Trotta emphasises the structural essence of this screen in her framing of walls and windows, particularly towards the end of the film, when Marianne is transferred from her dungeon-like quarters in an old jail to a modern facility that closely resembles Stammheim. The sisters have their last visit under the surveillance of armed guards, stenographers and closed-circuit television. A wall of mesh-reinforced glass separates them, forcing the women to communicate via an intercom system. As Juliane's voice-over notes, there are no more iron grates on the windows in the modern prison, only blinds and screens. Seated to face each other directly, their individual reflections on the glass obscure the sisters' view of each other. Von Trotta shows Marianne's face superimposed onto the reflection of Juliane's, creating a blurred montage. This image connotes the distorted ego boundaries of the two sisters – as Marianne's prospects for exoneration dim, Juliane's identification with her grows more desperate. The prison window also illuminates the alienating effects of the federal discipline that seized Germany in that moment of crisis.

Dummy at window

He with no house will never build one.
He who is alone will remain so

Old prison, exterior

This seizure occurs in both the spatial and temporal dimension in *The German Sisters*. Marianne describes her confinement as disorienting and dehumanising. Isolated from any sound, constantly exposed to light, she loses all sense of time and, ultimately, her sense of self in the 'dead stillness'

She was transferred to a modern block. No bars, but with special glass

Modern prison, exterior

Of course I visited her again

Glass partition

Marianne and Juliane montage

1945. The camps filled up

Watching *Night and Fog* (1955)

of her cell. Here we see the blocking of time used as a technique of control. But this achronicity also inheres in the ostensibly benign digital media that, more and more, organise urban experience and register public movement in the perpetual present of the video archive. We might not want to go as far as Andreas Huyssen, who in *Twilight Memories* (1995) sets the data banks of virtual space in opposition to authentic, human memory. But we might still acknowledge the possible forfeitures that could attend the increased mediatisation of city life, whether it be through iris-scanning security systems, the atomising influence of the Internet, or HDTV and home entertainment's eclipse of the collective moment of watching film in public cinemas.

The total recall of closed-circuit technologies finds its parallel in the impasse of solitary confinement; both conditions signal if not the end of collective memory, then its ends, its limits. This condition subtends the German portrait that von Trotta depicts in *The German Sisters*. The sequences from 1947, 1955, 1968, 1977 and the late 1970s interlink and seem dead set to fix our attention on the defining historical moment of the concentration camp. The continuity that von Trotta establishes between the home and the prison recurs in the relationship between different historical moments. *The German Sisters* maintains an intertextual relationship to Resnais' *Night and Fog*, particularly the final segment depicting Auschwitz and Majdanek after liberation. Indeed, von Trotta's investigation of Marianne's enigmatic death echoes Hitler's order by which arrested resisters would be made to disappear 'in the fog of the night' (*Nacht und Nebel*), such that even their deaths in camps and prisons would not be divulged. The commentator in Resnais' film describes the concentration camp as 'an abandoned town' set into a landscape 'pregnant with death'. The deadlocks and prisons of *The German Sisters* are projected over this same terrain – a zone from which, von Trotta suggests, no German can escape.

In her efforts to illuminate the associations between domestic, penitentiary and concentrationary space, von Trotta runs a great risk: of reducing Germany's entire twentieth century to the Holocaust; of depleting other moments of their historical specificity. The indeterminate incorporation of *Night and Fog* prompts a crucial question: might *The German Sisters* enable viewers, especially RAF sympathisers, to falsely identify with the real victims of German authoritarianism, the Jews, above all, but also the communists, Slavs and other targets of Nazism? Ceding to the impressions of Meinhof's prison notebooks and Ensslin's testimonies, von Trotta nearly elides Stammheim with Auschwitz.

As historians and critics have argued, the RAF long deluded themselves that their plight was akin to that of the Third Reich's victims. Legal advocates who defended Meinhof, Ensslin and others also posited an association between Stammheim (and other maximum security facilities) and the death camps that Germans administered across Central and Eastern Europe. In her prison notebooks, Meinhof remarked that her understanding of Auschwitz and its effects became clearer while serving her sentence; in her words, the 'political conception of the Cologne prison's dead section ... is the gas chamber' (quoted in Aust 1987: 253).[13] To a large extent, the RAF and their sympathisers shared the German New Left's conviction that many of Hitler's structures of domination extended into the foundations of the *Bundesrepublik*.

Meinhof and Ensslin exploited the confines of their prison cells and the courtroom to accomplish two goals: to establish a conceptual link between Stammheim and Auschwitz and to amplify the RAF message. Paradoxically, physical restraint worked to mediate the militants' communiqués. Kept under close watch, Meinhof and Ensslin reoriented their critique and recast the terms of the RAF according to the constraints of incarceration. Transcripts of their testimony record the RAF's shift in strategy from an active, international struggle to an interiorised politics of discontent. Under the sway of a psychological 'Stammheim complex', RAF sympathisers saw the prison as a metonymy of the police state – its architecture of repression, its systems of surveillance. Since the penal institutions served as the locus of state violence, the RAF could revolt from within. The inmates' resistance was perceived to spark a revolution that would take the nation and the spread onto the international plane.

As the RAF's views contracted to Stammheim's pinpoint perspective, they collapsed the array of social, political and economic conflicts into their own singular plight. Testimony and self-published documents from the time present the RAF as a metaphor for themselves, as Jeremy Varon argues (see 2004: 225). Facing nearly absolute isolation, Meinhof and Ensslin articulated a reactionary rhetoric that united the destinies of RAF and other oppositional movements and projected illusory bonds of solidarity and shared purpose. Despair amplified this projection, blinding the RAF to the actuality of their predicament: extended penitentiary confinement had ruptured the group's external affiliation and cauterised its powers. The RAF was becoming a cipher, an empty signifier lacking any referent to the transformations taking place outside the prison walls, whether in Germany or elsewhere.

Modes of Redress

It is not only the long perspective of the thirty years intervening between our current moment and the German Autumn of 1977 that discloses the failures of the RAF's armed struggle to effect democratic change; already in the 1970s critics doubted the group's agency. In an interview in *Der Spiegel*, when a reporter spoke frankly about the RAF's 'lack of influence on the masses and connection to a base', they responded with a telling reply. Within the FRG, they noted, there endured 'a trace of RAF politics' (Rote Armee Fraktion 1978c: 249). This account acknowledges a degree of defeat, but it also points us towards new avenues of inquiry. Where did the RAF's political trace appear when Meinhof and Ensslin sat for years in solitary confinement, or when they were at the hour of their deaths? Where has it become manifest in the decades that have followed? The incarceration of

the RAF's upper echelon of power channelled the movement into a series of final, desperate acts; after armed struggle came implosion and a degree of anomie that emptied out the RAF's political purpose. But if the RAF lost its status as Europe's anti-imperialist vanguard, it gained a new currency in its half-life. The cinema, literature and art that have emerged in the wake of the RAF deaths persist as cultural residues. *The German Sisters* is a key element of this political fallout. In its production and at its release, the film still carried palpable traces of Meinhof's and Ensslin's lives, the compromises and choices they made – particularly as women – to resist domination with political violence. Von Trotta's portrait makes a feminist intervention at the levels of the political as well as the cultural. It captures the postwar moment when women aimed to transform German society through all available means, from media communications to covert operations. *The German Sisters* conveys the dynamics of collaboration and dissonance among women that attended this moment.

To Giuliana Bruno's modernist insight that 'film spectatorship incarnates the metropolitan body' (1993: 56), von Trotta might counter that penal complexes and the techniques of visual surveillance function to control it, to still it. But *The German Sisters* also grants us a purchase on the transgressive potentials of the small-scale structures of the built environment, particularly its fabric objects. Marianne and Juliane's subversive play with clothing and things made of cloth contravene the dictates of the police state. Their acts also gesture towards a new horizon of design, where variably fashioned structures might enable autonomous challenges to tradition and authority.

A growing consensus among Germans asserts that the most enduring effect of the autumn of 1977 has been the disenfranchisement of civil liberties and the entrenchment of state repression. As Thomas Elsaesser suggests, the RAF's violent agendas could only accelerate this counter-democratic tendency. Yet *The German Sisters*, perhaps despite von Trotta's intentions, indicates that the state's grip on German culture is not so total. Her film still attracts a wide audience. It engages cinematic means to further a critical inquiry into recent German history, one which, to varying effects, a number of directors are currently reanimating.[14] If *The German Sisters* discloses the structures and systems that control the state's objects of suspicion, it also shows us how those objects might return that gaze – how the object might look back.

NOTES

1 Unless otherwise indicated, all translations are mine.
2 Ulrike Meinhof and Gudrun Ensslin died in Stammheim prison in 1976 and 1977, respectively. Although some critics suspect the women were murdered, many historians have concluded that they committed suicide by hanging. Several works investigate the RAF deaths on 18 October 1977, such as Weidenhammer 1988.
3 Jeremy Varon was the first to theorise the semantics of the RAF. He establishes that 'the RAF sought to compensate for its chief political failure: the absence of a sociopolitical referent beyond itself' (2004: 225). My elaborations of the RAF's cultural significations are indebted to his insights.
4 Important analyses of von Trotta's film include Delorme 1982, Elsaesser 1993, Kaplan 1983 and Kaplan 1985.

5 The prison also serves as a stage in von Trotta's *Rosa Luxemburg* (1986) (see Lant 1996).

6 Drawing on a series of French thinkers – Baudelaire, de Certeau, Debord and Lefebvre – Edward Dimendberg (2004) makes an apposite point about the urban condition of *film noir*.

7 By the mid-1970s the RAF and the FRG had locked into a relationship in which each agent's action was met with a reaction from the other side. Armed struggle invited martial clampdown which, in turn, provoked the RAF's deathgame of kidnapping the industrial executive and former SS Officer Hanns-Martin Schleyer and collaborating in the hijacking of a Lufthansa plane. In September 1977, two days after the RAF took Schleyer hostage, the Bundestag banned contact between the 72 political prisoners of German jails (most of whom were RAF associates) and all visitors, including their lawyers. Overriding the critics who doubted the constitutionality of this intervention, the Bundestag soon thereafter passed the Contact Ban Law (*Kontaktsperregesetz*), which legalised the isolation of public enemies in a state of emergency.

8 Stefan Aust (1997), Pieter Bakker-Schut (1997) and Gerd Conradt (2001) have established that the RAF's counsellors facilitated illegal contacts among the Stammheim inmates.

9 If we dismiss the conjecture that prison staff killed the RAF leaders, then we should also acknowledge that the incarcerated militants received treatment in accordance with federal conventions on prison conditions. For a fuller consideration of the conditions at Stammheim, see Teuns 1987 and Oesterle 2003. Works of *Stammheim-Zeitgeschichte* continue to proliferate, even after the dissolution of the RAF. One recent example is Koenen 2003.

10 Von Trotta (1988) has written about the '*weibliche Ästhetik*' of film. For a consideration of the personal/political dynamic in the film, see Seiter 1986. In an interview with Raimund Hoghe for *Die Zeit*, von Trotta noted that *The German Sisters* functions as a synthesis of two of her previous films. Whereas *Das zweite Erwachen der Christa Klages* (*The Second Awakening of Christa Klages*, 1978) studies the dynamics of the Bundesrepublik, *Schwestern oder Die Balance des Glücks* (*Sisters, or The Balance of Happiness*, 1979) focuses on private relationships. *The German Sisters*, she explains, is meant to function on both levels, looking outward and inward at once.

11 Von Trotta's focus on windows extends into *Rosa Luxemburg*, in which Barbara Sukowa, Marianne in *The German Sisters*, stars. Several key prison scenes frame the action through window casements, behind grillwork or within the confines of the jailhouse courtyard.

12 Mark Wigley (1995: 10) traces Semper's influence over Adolf Loos.

13 In a 1972 statement, Ulrike Meinhof drew a parallel between fascism and imperialism, claiming that that 'National Socialism was only the political and military precursor to the imperialist system of multinational corporations' (Rote Armee Fraktion 1978d: 434–5; also cited in Varon 2004: 245).

14 For example Johan Grimonprez with *Dial H-I-S-T-O-R-Y* (1997), Gerd Konrad's *Starbuck: Holger Meins* (2002), based on the book of the same title from 2001; and Stefan Aust and Helmar Büchel's television programmes *Der Krief der Bürgerkinder* and *Der Herbst des Terrors* (2007).

WORKS CITED

Aust, S. (1987) *The Baader-Meinhof Group: The Inside Story of a Phenomenon*, trans. A. Bell. London: Bodley Head.

_____ (1997) *Der Baader-Meinhof Komplex*. Hamburg: Hoffman und Campe.

Bakker-Schut, P. (1997) *Stammheim: Der Prozeß gegen die Rote Armee Fraktion. Die Notwendige Korrektur der herschenden Meinung*. Cologne: Pahl Rugenstein.

Beckman, K. (2002) 'Terrorism, Feminism, Sisters, and Twins: Building Relations in the Wake of the World Trade Center Attacks', *Grey Room*, 7 (Spring), 24–39.

Bruno, G. (1993) *Streetwalking on a Ruined Map: Cultural Theory and the City films of Elvira Notari*. Princeton: Princeton University Press.

Conradt, G. (2001) *Starbuck: Holger Meins*. Berlin: Espresso.

Delorme, C. (1982) 'Zum Film, *Die bleierne Zeit* von Margarethe von Trotta', *Frauen und Film*, 31, 52–5.

Dimendberg, E. (2004) *Film Noir and the Spaces of Modernity*. Cambridge, MA: Harvard University Press.

Elsaesser, T. (1993) 'Margarethe von Trotta: German Sisters – Divided Daughters', in *New German Cinema: A History*. New Brunswick: Rutgers University Press, 232–38.

_____ (1999) 'Antigone Agonistes: Urban Guerilla or Guerilla Urbanism? The RAF, *Germany in Autumn* and *Death Game*', in M. Sorkin and J. Copjec (eds) *Giving Ground: The Politics of Propinquity*. New York: Verso, 267–302.

Foucault, M. (1979) *Discipline and Punish: The Birth of the Prison*. New York: Vintage Books.

Hoghe, R. (1981) 'Begegnung mit der Filmemacherin Margarethe von Trotta', in H.-J. Weber (ed.) *Die bleierne Zeit: Ein Film von Margarethe von Trotta*. Frankfurt: Fischer, 77–81.

Hölderlin, F. (1951) *Sämtliche Werke*, ed. F. Beissner. Stuttgart: Cotta.

Huyssen, A. (1995) *Twilight Memories: Marking Time in a Culture of Amnesia*. New York: Routledge.

Kaplan, E. (1983) 'Female Politics in the Symbolic Realm: Von Trotta's *Marianne and Juliane* (*The German Sisters*)', in *Women and Film: Both Sides of the Camera*. London: Methuen, 104–12.

_____ (1985) 'Discourses of Terrorism, Feminism, and the Family in von Trotta's *Marianne and Juliane*', *Persistence of Vision*, 1, 2, 61–8.

Koenen, G. (2003) *Vesper, Ensslin, Baader: Urszenen des deutschen Terrorismus*. Cologne: Kiepenheuer & Witsch.

Lant, A. (1996) 'Incarcerated Space: The Repression of History in von Trotta's *Rosa Luxemburg*', in T. Ginsberg and K. Thompson (eds) *Perspectives on German Cinema*. New York: Prentice Hall, 361–77.

Loos, A. (1982) 'The Principle of Cladding', in *Spoken into the Void: Collected Essays 1897–1900*, trans. J. O. Newman and J. H. Smith. Cambridge: MIT Press, 66–9.

Meinhof, U. (1976) 'Brief einer Gefangenen aus dem toten Trakt', in P. Brückner (ed.) *Ulrike Marie Meinhof und die deutschen Verhältnisse*. Berlin: Wagenbach, 152–4.

Oesterle, K. (2003) *Stammheim: Die Geschichte des Vollzugsbeamten Horst Bubeck*. Tübingen: Klöpfer und Meyer.

Rilke, R.M. (1935) *Das Buch der Bilder*. Leipzig: Insel.

Rote Armee Fraktion [RAF]. (1978a) *texte: der RAF*. Malmö: Bo Cavefors.

_____ (1978b) 'rede von ulrike zu der befreiung von andreas, moabit 13. september', in *texte: der RAF*. Malmö: Bo Cavefors, 62–74.

_____ (1978c) 'spiegelinterview', in *texte: der RAF*. Malmö: Bo Cavefors, 241–61.

_____ (1978d) 'den antiimperialistischen kampf führen!', in *texte: der RAF*. Malmö: Bo Cavefors, 411–47.

Schiller, M. (1999) *'Es war ein harter Kampf um meine Erinnerung'*. Hamburg: Konkret.

Seiter, E. (1986) 'The Political is Personal: Margarethe von Trotta's *Marianne und Juliane'*, in C. Brundson (ed.) *Films for Women*. London: British Film Institute, 109–16.

Semper, G. (2004) 'The Principle of Dressing Has Greatly Influenced Style in Architecture and in Other Arts at All Times and Among All Peoples', in *Style in the Technical and Tectonic Arts, or, Practical Aesthetics*, trans. H. F. Mallgrave and M. Robinson. Los Angeles: Getty Research Institute, 242–55.

Teuns, S. (1987) 'Isolation/Sensorische Deprivation: Die programmierte Folter', in *Ausgewählte Dokumente der Zeitgeschichte: BRD–RAF*. Cologne: GNN Verlagsgesellschaft Politische Berichte, 118–26.

Varon, J. (2004) *Bringing the War Home: The Weather Underground, the Red Army Faction, and Revolutionary Violence in the Sixties and Seventies*. Berkeley: University of California Press.

von Trotta, M. (1988) 'Female Film Aesthetics', in E. Rentschler (ed.) *West German Filmmakers on: Visions and Voices*. New York: Holmes and Meier, 89–90.

Weidenhammer, K. H. (1988) *Selbstmord oder Mord? Das Todesermittlungsverfahren, Baader/ Ensslin/Raspe*. Kiel: Neuer Malik.

Wigley, M. (1995) 'The Emperor's New Paint', in *White Walls, Designer Dresses: The Fashioning of Modern Architecture*. Cambridge, MA: MIT Press, 1–34.

11 TEMPORAL GEOGRAPHIES: COMIC STRIP AND CINEMA IN 1980s MADRID

Paul Julian Smith

Urban Time-Space

Scholarly assessments of the Spanish transition to democracy (1975–82) have tended to be negative, focusing on the persistence of mourning for and melancholia over the recently lost dictatorship (see Vilarós 1998; Medina Domínguez 2001; Moreiras Menor 2002). I suggest in this chapter that we adopt a more sympathetic attitude to the period. Attention would then shift from mourning and melancholia to the less fashionable themes of life, liberty and the pursuit of pleasure, if not happiness. One way to do so is to change and extend the corpus or object of study beyond literature and cinema by examining lesser-known primary sources of the period, such as comic strips or graphic novels. Another way is to shift methodology to the fragile and flexible practices of everyday life. Arguably, the latter are more central to the success of democratic citizenship than formal institutions. To this end I propose a theoretical move from psychoanalysis to cultural geography and, more precisely, to urbanism and the much discussed notion of time-space.

Mutatis mutandis, the return of the Labour Party to power in the UK in 1997 presents some structural parallels with the triumph of the Socialists in Spain in 1982. Just as the city would prove central to the transition, so an urban renaissance was held to be key to social and cultural change in Britain. Geographers in the UK were spurred to contribute to this debate on at least three levels: practical proposals for policy change; more general accounts of 'spatial formations' in cities; and theoretical versions of 'temporalised space' or rhythm as played out in the urban site. Although they are clearly interconnected, for the purposes of exposition I take these three areas in turn.

Reacting to the report by the prestigious architect (Lord) Richard Rogers ('Towards an Urban Renaissance' of 1999), three British geographers offer some pointers towards *Cities for the Many, Not for the Few*. Noting the new Labour government has no 'overall conception of "urban citizenship"' (Amin, Massey & Thrift 2000: vi), they stress that in a still centralised state, where devolution was only now being contemplated, cities were both 'seedbeds of the local' and, in their hybridity, inherently 'conflictual' (ibid.). While they welcome the 'enthusiasm' of the Rogers Report for the potential of cities (rare in a country with a long history of anti-urbanism) and the shift from the sprawling congestion of the US to 'thriving European cities' as a model for sustainability and human scale (2000: 1), they suggest two inadequacies. The first is that the Report is 'overly design-led' and subscribes to 'environmental determinism' (2000: 3). Just as local governments in the 1960s trusted to concrete tower blocks to solve social problems and private corpora-

tions of the 1980s put their faith in glass towers, so this new urban renaissance relies too heavily on the quality of building design. The second inadequacy is the 'presupposition of attainable urban harmony':

> The new compact city will strike a balance between nature, built environment, and society, between private, public, and community, between work, travel, home, shopping, and play. This harmony is based on a rose-tinted evocation of the centres of selected European cities – their historical architecture, busy markets, small shops, cafes and squares, mixed buildings and residential blocks and proud citizens. (2000: 4)

Unfortunately, this utopia is characteristic neither of British metropolises nor of the outer areas of European cities. Moreover, the urban 'vibrancy' held to be typical of mainland Europe is founded on 'diversity in close proximity' (ibid.), which is itself ambivalent in its effects. While it can lead to 'creative intermingling, cultural mixture, and exploratory potential', it also results in 'a desperate search for privacy, sanctuary, and anonymity' (ibid.).

How, then, are we to imagine cities in ways helpful for public policy? The first general principle is that cities are not things but processes or interactions whose ends cannot be predicted. The second is that the interaction in cities is peculiarly intense, once more with unpredictable results (see 2000: 8). For example, a specialised area (for example, a 'gay village') may prove to be exclusive in both positive and negative senses, manifesting either 'exclusivity' or 'exclusion' (2000: 9). A third principle is that 'cities are essentially dynamic' (2000: 10). However, as open and interconnected spatial phenomena, they are also highly 'varied', and must be studied for their 'individualities' (see 2000: 11–14). One vital aspect here is 'recognition for the increasing centrality of the social/civic economy centred around not for profit activities ... as an alternative to the formal economy' (2000: 28).

This urban imagining gives rise to 'rights to the city'. Social expression and participation often offer 'non-instrumental gains' (2000: 32), such as public access to open spaces. The authors propose 'hedonism without consumerism' (2000: 36) as the 'driving force of a new politics of transformation' (2000: 37). Their 'interest in pleasure [is] not gratuitous [and] not a prioritisation of individual rights over social obligations [but rather a way to] inculcate civic values' (ibid.). Through pleasure, individuals can be offered 'the possibility of becoming something/someone else' beyond 'the traditional politics of prescription and elite designation' (2000: 38). Cities, they say, are already 'replete' with this unfocused energy, full as they are of 'creativity and innovation' (2000: 38). To sum up:

> We need to recognise the role of cities as places of socialisation and sociability beyond riverside cafes, shopping mall atria, and bijou restaurants ... acknowledge and encourage the vast network of everyday associations of sociability which already exists ... beyond the life of firms and work, melancholy and alienation, state and other institutions of governance ... We need to recognise spaces of democracy that lie beyond democratic state and representative politics ... Cities are massive reservoirs of institutionalised activity, around which urban democracy can be built and extended. (2000: 42)

Beyond these particular policy proposals, many of which are as relevant for high-density Spain as they are for suburban Britain, general accounts of spatial formations are also important. Qualifying the 'spatial turn', or even 'spatial imperialism' of recent theory (May & Thrift 2001: 1, 2), some of the same scholars call for 'geographies of temporality'. Four kinds of time intersect dynamically with urban space: the rhythms of the natural world; those of social discipline (both religious and secular); instruments and devices (such as the VCR); and texts, which serve as 'vehicles of translation' for time (see 2001: 3–4). The authors argue that 'social time is made and remade according to social practices operating within and across each of these domains' (2001: 5). Time-space is thus by no means dualistic or dichotomous. Rather it serves as 'the essential unit of geography' (ibid.). Adapting Karl Marx, Nigel Thrift writes: 'The frozen circumstances of space only come alive when the melody of time is played' (1996: 1).

In 'Rhythms of the City: Temporalised Space and Motion' (2001), Mike Crang goes further. For Crang the 'intersection of lived time, time as represented, and urban space' (2001: 187) is typical of everyday practice. Multiple temporalities collide: dominant forms of linearity or even simultaneity overlay 'quieter cycles on daily, weekly, annual rhythms that continue to structure the everyday' (2001: 189). The urban place or site is actually composed through 'patterns of these multiple beats' (2001: 190). Its plural rhythms include not only the trend towards acceleration so often cited by theorists, but other phenomena, such as the 'colonisation of the night – the steady movement of social life into the dark' (2001: 191). Again the much discussed 'non-stop city' may break down 'family time' ('the demise of "meal times"') (ibid.). But it also allows 'new rhythmic groupings [to] emerge ... transient, episodic affinities and comings together [in] neo-tribes' (ibid.). The latter rework old collective temporalities without 'locking into the solidarities of tradition' (ibid.). The rhythms of the city lead inevitably to both the formation of collective groups and their 'dissolution, fragmentation, and reformation' (ibid.). Urban living is thus both a 'rhythmic composition' and a 'realm of shattered, fragmented times' (ibid.). Finally, the 'polychronic city' is not just a question of 'routes, routines, and paths' (2001: 192) but also one of 'velocities, directions, turnings, detours, exits, and entries' (2001: 206). If urban space is to dance, then, it must be 'temporalised' (2001: 200).

Rodrigo's *Manuel*: the Pleasures of Urban Apprenticeship

La Luna begins with a smile. The first issue of the quintessential magazine of the *movida*, the cultural explosion of the transition (November 1983), features a typically stylish *trompe l'oeil* by well-known photographer Ouka Lele: a hand tears back a strip of wrapping paper behind which we see a woman's lipsticked mouth and exposed teeth. With its large format (36 x 27cm) and extended length (72 pages), *La Luna* is a substantial document of the period, and remained so for the twenty issues which were edited by Borja Casani. Aesthetically it is difficult to place. The art design is distinctive: the famous logo is based on 1960s-style space-age lettering and the layout features semi-vorticist diagonal placing of text and image. With its poor paper quality and limited colour (restricted to accents in tangerine, lime and pink in the first three issues), *La Luna* positions itself between the well-established glossies and the grubby Xeroxes of the new fanzines (*Penetración*, a carbon copy of UK punk originals, also began publication in 1983). Compared to its most obvious foreign precedents and equivalents, *La Luna* is less enamoured of celebrity

than New York's *Interview* (1969–present) which carried full-colour star portraits by Andy Warhol on its cover, and less devoted to cutting-edge design than London's *The Face* (1980–2004).

The smile is significant. *La Luna* shows little sign of mourning, melancholia or *desencanto* (the 'disenchantment' that allegedly followed hard on the heels of the arrival of Spanish democracy). Indeed, the magazine is at once fascinated by the outside world and free and uninhibited in its egotism. The personification of this optimism is its most famous and enduring feature: Patti Diphusa, the chronicles of a gloriously hedonistic porno star, authored by Pedro Almodóvar and impersonated by Fabio McNamara in a series of outrageous photo portraits by Pablo Pérez Mínguez. Patti is a creature of the present. She exclaims to the editor that she loves *La Luna* already, even though he confesses that the first issue has yet to appear. As she explains, when she likes something, she likes it right away. *La Luna*'s secret, then, is this absolute contemporaneity: from the very beginning it sought to bring together in a magic circle of distinction the best and brightest in the multiple media of music, fashion, visual arts and literature.

The self-conscious creation of a community is clear even in the pastime section: new readers are invited to identify the faces of thirty figures of the *movida*. A 'self-portrait' feature also allows luminaries to present their own public image to the emerging audience (the first is photographer Pérez Mínguez). But this process is inseparable from the city. Future competitions will feature unidentified gates and clocks ('The Time of Madrid'), testing and schooling readers in the built environment of Madrid (see no. 3, January 1984; no. 7, May 1984). Even when Pérez Mínguez shows himself bathing in the Mediterranean, far from the capital, he wears, playfully and ironically, a Madrid T-shirt, complete with iconic bear and tree.

Perhaps the most unusual and explicit example of urban apprenticeship is the appearance in each issue of minutely detailed drawings of individual buildings, which readers are encouraged to cut out and keep. Beginning with central sites such as the Plaza del Callao the section will soon light out for less familiar locations (the muddled intersection of Cuatro Caminos, the distant and undistinguished office buildings of the Plaza de Castilla). This is not just an example of the inculcation of civic pride (of renewed pleasure in the detail of familiar locations). It is also an investigation of urban function and history: the pseudonymous commentator ('Mieldeluna' or 'Honeymoon') lists both the multiple uses of often insignificant buildings (housing, rented offices, small shops and cafes) and the aesthetic influences of their precisely dated construction (Parisian Beaux Arts, Chicago School modern, Castilian vernacular). Even the massive and ungainly Torre de Madrid, the product of untamed Francoist speculation, can be made 'loveable' ('entrañable'), when subjected to this affectionate makeover (see no. 12, November 1984).

A seed-bed of the local (like the city itself) *La Luna* also serves to temporalise space. An extreme instance here is the agenda which takes up two pages of each issue and is first printed on a shadowy background of that most recognisable of monuments, the Puerta de Alcalá. The days remain empty, ready to be filled. Just as readers are invited to appropriate even the grandest of city spaces, rendered small and accessible when cut out and kept, so they are helped to structure their time: 'léete la revista y búscate la vida' ('read the magazine and get yourself a life'). *La Luna* understands that space will dance only to the music of time; hence its double role as geographical guide and chronicle of urban life. It is thus a key text for the translation of social time into social practice.

Magazines are both word and image; and one exemplary text of the first issue is the opening installment of a wordless graphic novel called 'Manuel' by the little known artist called simply 'Rodrigo'. 'Manuel', which ran over six full pages until issue 16, is an enigmatic and suggestive story of love between bearded men (the physical type is very precise). The unnamed protagonist falls for the taller, darker and even hairier Manuel, an apparently heterosexual man. Countering the acceleration of city life, Rodrigo boldly postpones a narrative whose readers are already constrained by the regular, but infrequent, monthly rhythm: it is not until issue 15 that the two men make love and even then it is only perhaps in fantasy.

Unlike his better-known counterparts, the lyrical Ceesepe and the mock-naïve Mariscal, also founding contributors to *La Luna*, Rodrigo is a technically perfect draftsman, having trained as an architect. He is also highly innovative, constantly playing with the grid format of the comic. Most significant, however, is his focus on the spatial formations of everyday life in the city. Opening with a wholly black image, the first page continues with an extreme close-up of a hand lighting a match and a candle. We then pull back to see a contented protagonist (the spitting image of the artist himself) lying back on his pillow, flanked – like a secular saint – by serried ranks of candles. The format changes to elongated rectangles, mimicking the shape of a mirror, as he playfully tries on costumes, discarding check shirts and polka dot ties for less showy plain shirt and trousers. Making his way to the Noviciado Metro entrance (a meticulously detailed portrait of the street façades), he goes down to the train (shown in an illustrated lateral cutaway). His destination is the swimming pool. In the final full-page image, his face, emerging from the water, is seen from between the muscular legs of the otherwise invisible Manuel, who is standing by the pool. Looking longingly up out of frame, the protagonist is a new Sebastian, torso pierced by arrows from the perfect Art Nouveau cherubs entwined around the new beloved's name.

Rodrigo testifies, obliquely (even mutely), to the democratic citizenship that *La Luna*'s editors so proudly announced. He and his character exercise without fear their right to the city (their right to social expression and participation), taking advantage of access to public spaces (streets, stations and swimming pools) to stage a touching gay romance. The geography of the city extends, however, beyond the public sphere (diverse in its close proximity) into private space: the character's basement apartment is almost literally his sanctuary, illuminated as it is by church candles. 'Manuel' celebrates the pleasures of city solitude as it does those, better known perhaps, of the chance urban encounter. And its hedonism is untainted by consumerism. In interview with *La Luna* (no. 7, May 1984) Rodrigo confessed what was transparently obvious from his work: that he took intense delight in walking the city streets and in the details of built environment, most especially the incongruously rich ornaments of the 'theatrical' buildings of the Gran Vía. But this is no environmental determinism; Rodrigo's urban spaces are not frozen fetishes, but are rather made to dance to temporal rhythms, both natural and social. As the couple talk by the pool in the second installment the evening shadow falls over them in successive images; colonising the night, the two men move social life into the dark when they go from pool to discotheque. In the episodes that follow, where chronology and geography are often willfully fluid and confused, Rodrigo overlays the multiple fragmented beats of urban time on to the relatively regular rhythmic composition of the monthly magazine.

Even if we can no longer experience the excitement of the first subscribers, the accumulated effect of the magazine remains temporal. Month by month, issue by issue, *La Luna* drew on a reservoir of urban creativity and innovation that at once acknowledged and encouraged a network of everyday associations of sociability. If that space-time complex sometimes seemed exclusive, then it offered readers the fantasy at least of joining the magic circle: if you could recognise the gates and clocks of Madrid, then surely one day your picture would appear amongst those of the *modernos* shown socialising at the famous picnics and parties meticulously organised and faithfully documented by the magazine. While such neo-tribes would prove transient, their routes and paths were infinite. Certainly, *La Luna* provided ample evidence of the possibility of becoming something or someone else in the city.

Almodóvar's *Laberinto de pasiones* (*Labyrinth of Passion*): Urban Rhythms on Film

I would like to compare Rodrigo's protocinematic graphic novel (with its creative exploration of framing and point of view) with a more familiar text, Almodóvar's second feature film *Laberinto de pasiones* (*Labyrinth of Passion*), which appeared in 1982 just one year before the comic strip. The film is Almodóvar's craziest and most chaotic farce, and it is fair to say that it has not been much liked by critics. While it can hardly be read as a manifesto for urban policy change, it gives a surprisingly thorough account of spatial formations in the newly fashionable city of Madrid and, more precisely, of temporalised spaces or rhythms played out in the urban site.

Shot entirely on location on a tiny budget, *Labyrinth of Passion* (the supposed story of nymphomaniac Sexilia (Cecilia Roth) and gay heir to the throne of Tiran, Riza Niro (Imanol Arias)) is actually an encyclopedic collation of urban spaces: hotels, boutiques, furniture shops and dry-cleaners. Moreover, many of these locations are connected to transport, the definitive site of intersection for time and space: characters stroll pointedly in the street, wait dejectedly at bus stops, take the metro in inappropriate attire, and try out taxis and airports, locations Almodóvar would later explore more expertly in glossier hymns to Madrid, such as *Mujeres al borde de un ataque de nervios* (*Women on the Verge of a Nervous Breakdown*, 1988). The film is quite literally structured around urban rhythm, featuring as it does music performed by Almodóvar himself, in his then day job as pop musician.

With its many coincidences and encounters, *Labyrinth* clearly exploits the extreme density of Madrid, the vibrancy that comes from diversity in close proximity. But, aggressively local, it also remains actively hostile to the cults of both design and tradition emphasised by some brands of urbanism. There are neither sleek new buildings nor historic architecture here. If Almodóvar focuses on markets and cafes it is in the spirit not of civic pride, but rather of the celebration of urban squalor.

Let us examine the opening sequence. Where Rodrigo focused on the ritual-like preparation of a gay man on setting out from a womb-like home, Almodóvar plunges straight into the social and sexual encounter itself, made possible by the unpredictable interaction that is characteristic of high urban density. Beginning with a high-angle establishing shot of Madrid's weekly flea market, the famous Rastro, Almodóvar cuts to a medium tracking shot of Sexilia cruising the crowds amongst the stalls. An extreme

close-up shows sunglasses in which the image of Riza Niro is repeatedly reflected. We now cross-cut between the two faces and their points of view: close-ups of anonymous male crotches and buttocks. Almodóvar then cuts to a street café where Riza is reading (we are given point of view cutaways to his newspaper). At another table Fabio McNamara (as Patti Difusa) feeds his multiple addictions (alcohol, tobacco, nail varnish). Eye-line matches establish that Patti is ogling Riza: he sends over an extravagantly worded pick-up note in which he puns on the Spanish for 'happy' and a superannuated Hollywood star ('fe-liz (Taylor)').

As the urban geographers recommended, this is hedonism without consumerism. Patti's pleasures are free or illegal and his invitation to Riza strictly not for profit. The extravagant costumes the characters sport are home-made or from thrift shops. While family time has been degraded (the only traditional father in the film rapes his daughter with numbing regularity), transient coming together is clearly thriving. And if the *movida*'s exclusivity can be socially exclusive (characters such as the fat Argentine psychoanalyst in the following sequence are mere figures of fun), then urban sociability is still insepa-rable from socialisation: the refugee Riza is seduced into companionship by his acclima-tisation to Madrid mores. The very genre of farce with its constant exits and entries can be read as analogous to, or coextensive with, the rhythmic composition of urban living, with its accelerated velocities, turnings and detours.

To conclude, *Labyrinth of Passion* remains aggressively rooted in the local and spe-cific: Fabio's macaronic mixture of languages (for instance, '¡Qué overdose!') resists any attempt at translation and indeed defeats the subtitlers throughout the film. The hedo-nism of both Rodrigo and Almodóvar, a long forgotten graphic artist and a famous cin-easte, is thus no laughing matter. Rather it testifies not only to the temporal geographies of city life in general, but also to the vital pleasures of democratic citizenship perilously and provisionally achieved in Madrid after the death of the dictator.

WORKS CITED

Amin, A., D. Massey and N. Thrift (2000) *Cities for the Many, Not for the Few*. Bristol: Policy.

Crang, M. (2001) 'Rhythms of the City: Temporalised Space and Motion', in J. May and N. Thrift (eds) *TimeSpace: Geographies of Temporality*. London: Routledge, 187–207.

La Luna de Madrid 1–26 (November 1983–March 1986).

May, J. and N. Thrift (eds) (2001) *TimeSpace: Geographies of Temporality*. London: Routledge.

Medina Domínguez, A. (2001) *Exorcismos de la memoria: políticas y poéticas de la melancolía en la España de la transición*. Madrid: Libertarias.

Moreiras Menor, C. (2002) *Cultura herida: literatura y cine en la España democrática*. Madrid: Libertarias.

Thrift, N. (1996) *Spatial Formations*. London: Sage.

Vilarós, T. (1998) *El mono del desencanto: una crítica cultural de la transición española (1973–93)*. Madrid: Siglo XXI.

12 LOLA/LOLO: FILMING GENDER AND VIOLENCE IN THE MEXICAN CITY

Geoffrey Kantaris

This chapter looks at the intersection of representations of gender and violence in Mexican urban cinema of the 1990s, specifically the way in which gender and violence are used as grids of recognition for the stabilisation of the discursive field, even as they apparently signal subversion, destabilisation and the transgression of frontiers within urban and para-urban spaces. To illustrate these processes, I shall discuss three films from the last decade of the twentieth century: *Lola* (1989) by Mexico's première woman cineaste, María Novaro; *Lolo* (1991) by Francisco Athié; and *Hasta morir* (*Till Death*, 1993) directed by Fernando Sariñana, a film which could be considered something of a 'prequel' to Alejandro González Iñárritu's *Amores perros* (*Love's a Bitch*, 2000) and whose scriptwriter is a woman, Marcela Fuentes-Berain.

What is the valence of gender and violence – their mutual interactions and their relationship to new spatial processes – in urban films of the periphery? In what way is gender connected to the representation of urban space in general and urban violence in particular? If gender and violence can be understood – like the production of space – as representational categories in their own right, how does film appeal to these representational categories in its framing of urban space and social interaction? Are new configurations of gender and gender relations produced by urban processes, or does gender provide a powerful and stereotypical grid of recognition through which films can stabilise, fix and represent the flow, dislocations and transfusions of the megalopolis? Is violence the expression at street level of those dislocations which may have their origin in abstract and violent global transactions, or is it a representational practice aimed at re-inhabiting the emptied out spaces of the megapolitan periphery? These are the kinds of questions raised by end-of-millennium urban cinema in Mexico, which has now emerged as something of a genre with its own stock discourses and procedures, of which the hugely successful *Amores perros* is only the tip of a large and growing iceberg.

Gender and Violence as Representational Categories

The familiar concept of gender as a representational category – as a set of available discourses to be combined and performed, enforced or declined – needs no particular elaboration. How gender intersects with ways of inhabiting urban space has been less explicitly theorised in film studies, although it is certainly the object of urban feminism as a political force in Mexico.[1] Nevertheless, a number of the more internationally successful Latin American urban films of recent years tend to pander to a stereotypical conflation of hypermasculinity and violence, of which *Amores perros* and *Cidade de Deus* (*City of God*, 2002) are the best-known examples. Clever though they are in their brilliant manipula-

tion of film form, neither film could be said to engage in much more than a conventional take on machismo and the city, not to mention a highly stereotypical alignment of women with a set of bourgeois values which each film is at pains to problematise (because their stability is rendered critical through violent urban and global processes).

Many contemporary urban films contain in one form or another a projection of urban space through more or less stereotypical representations of a highly performative masculinity whose outward appearance is aggression and violence and whose culture is often represented as a demonic version of rock or punk. The interstitial spaces occupied by urban criminal gangs, a corrupt police force, voyeurs, stalkers and female prostitutes are all deeply libidinalised, and often do little more than mirror the social libidinalisation of urban space reinforced generally through the mass media. One recent film, *Perfume de violetas* (*Violet Perfume*, 2001), aligns itself with such mass-media generated insecurity by projecting its opening credits over newsprint reports and government studies of urban violence, particularly sexual violence against women: kidnapping, rape and murder. This film provides a very interesting reading of adolescent femininity and of the social fears surrounding the feminine body and sexuality which may restrict women's self-realisation and agency. But it does so at the expense of reproducing stereotyped representations of masculinity amongst the urban poor and marginal populations, representations which are expressed purely in terms of sexual predation and are bolstered by a hard rock soundtrack which encourages the spectator to reject and condemn instead of understanding and engaging with marginal urban culture. It is thus curious that representations of masculinity in one sense prove to be fixed, almost iconic, in such films (and we could include *Amores perros* here) whose themes nevertheless involve the destabilisation of identities along many other axes. It is as if spectacular performances of exaggerated versions of gender identities become compensatory fictions in some films, screens which substitute for a loss of place, fictions which lay claim to what is lost in 'the space of flows' (see Castells 1996: 376–428).

As suggested above, media representations of urban violence are complicit in the creation of reactionary fundamentalisms – stabilising fictions, retrenched identities, even defensive residential patterns. From within the gated condominium of the typical Latin American megalopolis, petty urban violence has a powerful imaginary dimension – much more powerful than its real impact – which, through a fantasy of transgression and dissolution of boundaries, creates and reinforces violent social distinctions. As with representations of gender in many urban films, the effects of filmic violence are difficult to separate from reactionary fantasies of otherness which are apt to trigger a defensive posture in the spectator. The Colombian theorist Jesús Martín-Barbero has theorised the dependency between the media ('los medios') and social fear ('los miedos') (2001: 134, 247), with the bourgeois urban imaginary in Latin America caught in a deadly serious game of complicity between seeing and being seen. Moreover, portrayals of criminal violence and the violence of social exclusion can easily become the smokescreen which conceals and naturalises the employment of violent social and urban practices by the rich. This leads to the paradox that the violence of the socially invisible is rendered visible in order to conceal the violence of social exclusion practised by those who have full access to public visibility. It is very hard for film to deal sensitively with these kinds of paradoxes without falling back on Hollywood-style fetishisation of violence, that is, the displacement of social misery onto criminal violence.

Nevertheless, several Mexican films prior to the boom initiated by *Amores perros* show an often subtle reflection on the intersection of gender, violence and urban space, seeming to experiment with different ways of analysing the valence of these phenomena. The three films I am looking at here can be characterised briefly with the following typology, which could be applied to a number of other Latin American urban films: (i) feminist analysis of non-conventional family structures such as single-mother families; (ii) *Bildungsroman* accounts of masculinity in the city, in particular the effects of poverty and violence on masculinity; and (iii) analysis of the mimetic and performative dimensions of masculinity and violence in a fractured and globalised urban space.

Feminist Film and Urban Imaginaries

Uniquely in Mexico, there is within the now very strong tradition of urban filmmaking, a recognisable subgenre of feminist urban film made by a new wave of women directors, producers and scriptwriters who began to emerge from two film schools in the 1980s. As pointed out by David R. Maciel and Joanne Hershfield (1999: 250), by the end of the 1980s the majority of students in the film schools in Mexico were women, and the films that emerged began to question definitively the icons of femininity which had been established in the Golden Age of Mexican Cinema of the 1940s and 1950s – the innocent virgin, the seduced and abandoned woman, the sexual miscreant and the stoical mother. The most well known of these filmmakers is María Novaro, whose first feature-length film, *Lola*, appeared in 1989, to be followed by the internationally successful *Danzón* (1991). The script for *Lola* was co-written by Novaro and her sister Beatriz Novaro.

For our purposes, *Lola* is of particular interest because it combines its re-evaluation of one of the most powerful and problematic of feminine roles – motherhood – with a deliberately non-cosmetic view of Mexico City (see Espinasa 1992) a mere four years after the devastating earthquake of 1985 which left twenty thousand people dead and many buildings in ruins. Set mostly in the impoverished working-class district of Colonia Obrera, and in some streets of the Colonia Roma in the historic heart of Mexico City (see Cuéllar 1991), the film nevertheless refuses iconisations of all kinds. Its protagonist Lola (Leticia Huijara) is a young single mother and street seller with a five-year-old daughter. Lola is an all-too-human and imperfect mother, frustrated in her aspirations, disappointed in love, sometimes unable to cope with the demands placed on her, frequently resorting to alcohol and one-night-stands. Novaro states that with this film she wished to 'demystify maternity, to speak about it frankly, exactly as it is, with all its confusion, desires and headaches … without glamour, without a sense of duty' (quoted in Ayala Blanco 1989: n.p.). The film engages with very indirect forms of violence, and as such is different to many recent Latin American urban films: violence here is that of the police who confiscate the merchandise of the street sellers, or poverty which leads Lola to shoplift and then prostitute herself to avoid charges when she is caught, or else it comes in the form of constant sexual harassment, to which she responds ambiguously, but ultimately violently when she smashes an empty bottle over the head of her harasser. These examples suggest that violence, which forms such an important part of the typical urban imaginary, is here analysed and diffused through a feminine perspective. In fact, it is characteristic of the two films made by women mentioned here (*Lola* and *Perfume de violetas*) that violence is related almost exclusively to gender and sexuality, whereas the two films which

concentrate on the problematics of masculinity appear to have more direct access to an urban imaginary of criminal violence.

The narrative of *Lola* is deliberately non-dramatic, focusing on broken relationships, the everyday difficulties of making ends meet, and the city experienced as a carceral space. What is particularly interesting in the film is the way urban areas are portrayed, or rather the way the film constructs a feminine urban imaginary. For a start, many of the city locations are those that might be frequented more regularly by women or mothers than by men: school patios, children's playgrounds, sewing-machine sweatshops. Ways of inhabiting and traversing space are subtly – and sometimes overtly – marked by gender in this film, as when Lola goes in search of her one-night-stand, and finds him in an all-male gym: as Lola gazes provocatively at him we see that she is standing next to a sign reading 'women are not admitted'; or when we see her getting drunk at the foot of a statue after having left her daughter with her own mother in desperation, and the camera tilts upwards to reveal that the statue is an official monument to motherhood portraying a Madonna-like mother and child. In both of these sequences, and characteristically throughout the film, the gaze that is constructed for the cinema spectator is not even implicitly Lola's own gaze: as she strolls through a dirty and sometimes derelict city, we look at the decaying buildings, but Lola does not; we hear the ironic overlay of Vivaldi's *Stabat Mater Dolorosa*, but Lola does not. Her body in the cityscape thus becomes an object of representation, both of the film in an obvious sense, and of the urban environment itself in a less obvious one, but which the film's mode of filming impels us to read as such.

The photography in this film often (but not always) treats exteriors as if they were interiors, and sometimes treats interiors as if they were exteriors. That a children's playground should be treated visually as if it were a bedroom or a kitchen, shot with close confined angles, with pans focusing tightly on walls and corners and a preponderance of close and medium shots, and that, conversely, a sitting room should be treated as if it were a landscape, with the camera panning across the stereotypical Hawaiian beach scene of Lola's wallpaper as if it were a real beach, accentuates a sense of confinement within the interstices of urban space. But it also suggests a strong imaginary dimension to Lola's own experience of space, or rather the imaginary becomes her means of escape. Two interesting sequences emphasise this tension between real and imaginary dimensions while at the same time suggesting a complex relationship between the body, clothes, movement and urban space.

The first takes place immediately after an open-air primary school performance to celebrate Mothers' Day in which Lola's daughter Ana (Alejandra Vargas) has taken part. The girls are dressed in Hawaiian-style costumes and dance with little enthusiasm for an audience composed mostly of mothers. After the show, Ana's grandmother (Lola's mother, Chelo (Martha Navarro)) criticises Lola for not taking enough care in the preparation of the costume, since 'it wasn't the same as the other girls' costumes'. The grandmother's criticism of Ana's costume for not conforming to type causes Ana to look away in disappointment, and we follow her gaze to a point of view of a huge earthquake-damaged building being demolished laboriously by hand. This view then hard-cuts to a close-up of a cotton-reel in a clothes factory that manufactures cheap local copies of fashionable designs which Lola is taking to sell on the streets. With the exception of one foreman, the factory is another all-female environment, revealed to us through a slow tracking shot

which shows rows of women sitting at the sewing machines, making the space highly suggestive of the *maquiladoras* which employ a low-paid, casual and mostly female workforce. The hard-cut, or montage collision, powerfully suggests that we should read the factory in terms of urban processes: invisible female labour in the sweatshops is compared explicitly with visible masculine physical labour in the open air, once again confounding exteriors and interiors. Moreover, female urban labour is producing the clothes which women buy precisely in order to make their bodies conform to 'exclusive' reference types, designs, fashions, to enable them to inhabit public urban spaces and control their image within them, but which also control and restrict movement, image and behaviour, as seen in the grandmother's disparaging comments. The foreman in this sequence tells Lola that he will have to discount ten per cent of the cost of some soiled clothes which she is returning, and while he is talking Lola smiles to herself with her eyes half closed. In the foreground, we note the wind from a fan playing across her face while the fan's sound is amplified on the audio track, creating the impression that Lola is inhabiting an entirely imaginary spatial dimension.

The second sequence takes place in a playground near Lola and Ana's apartment. Ana wants Lola to play ballerinas with her, and they both start to dance with rhythmic movements. Lola, however, does an 'exotic' dance and tells her daughter that she is a Hawaiian ballerina. Ana rejects the dance – perhaps because of the disappointment which the grandmother's comments had caused her previously – and moves off to sit on the swings in a huff while Lola continues dancing, unaware of anything around her. The camera frames Lola against a background of walls (those of the park) and buildings, swaying to her own internal rhythm in an imaginary reconfiguration of space. In both sequences, then, there is a slow transition from restrictive urban settings to the imaginary spaces which Lola slips into, signalled in each case by the technique of taking an element of diegetic sound, amplifying it and adding an echo. Here, the rusty squeak of Ana's swing, indicative of the marginal space of a poor, dusty park in a working-class district, effects a transmutation of space through amplification and distortion, transforming a stereotypical and stylised 'feminine' dance into pure bodily movement fused with a powerful imaginary dimension. This amalgam of the real, the stereotypical and the imaginary produces a very different reading of the (female) body's relationship to urban space, its mode of inhabiting and moving through that space, to that which we find in most of the other films under discussion here.

(Un)learning Masculinity in Edge City

Nearly three years after *Lola* – at the end of 1991 – there appeared another *opera prima*, Francisco Athié's *Lolo*. Although the gender change in the title would suggest that the latter work is a reading of the former, there is little to suggest that it is in direct dialogue with it except the use of the same male actor, Roberto Sosa, who plays a besotted friend of Lola's in the former film, and the lead character in *Lolo*. Instead, Athié declares in interviews that his work is in dialogue cinematically with Luis Buñuel's pioneering films of the 1950s set in Mexico City, *Los olvidados* (*The Young and the Damned*, 1950) and *El bruto* (*The Brute*, 1952), and textually with Fyodor Dostoevsky's *Crime and Punishment* (1866) (see Anon. 1993; Rabell 1992). While the reference to Dostoevsky has generally been seen by critics as a slightly pretentious claim, the links to Buñuel's neorealist-inspired

mode of filmmaking are more obvious, despite the fact that *Lolo* does not use any non-professional actors. *Lolo* concerns a young foundry worker, Dolores Chimal, nicknamed Lolo, who loses his job for 'unjustified absence' after being mugged in the street on pay-day and having had to spend several days in hospital. The real motivation for the sacking is that he had been complaining to the other workers about the poor rates of pay, but even his mother insinuates that he is at fault – or more precisely, that his masculinity is at fault – for having let himself be mugged. Lolo falls in love with Sonia (Esperanza Mozo), a girl who has recently moved to the neighbourhood, but he is sucked into the world of crime when a chance discovery leads him to undertake what he believes will be an easy robbery, and he carries out the unpremeditated but brutal murder of an elderly woman who discovers him committing the crime. A friend of his is arrested, but his cousin – a corrupt policeman – seems to know that Lolo committed the murder, and Lolo finds himself trapped in an ever-widening nightmare of corruption, crime and betrayal.

The fact that Lolo's full name is Dolores, a gender-ambiguous name that is more comfortably feminine than masculine in Spanish, already suggests that the meaning of masculinity is to be examined in this film. In particular, *Lolo*, uniquely among the films discussed here, questions the equation of violence and masculinity. Or, more properly, it questions the idea that violence is an attribute and defining element of urban working-class masculinity. Lolo is presented as weak, unassuming and frightened throughout most of the film, often ill, often lying in bed with fever, not accepted within the band of dropout youths, easily bullied, sensitive and tender – the very qualities which make him attractive to his girlfriend Sonia. It is hard to think of another example of such a singularly un-macho man in contemporary Mexican urban cinema, and his character seems designed to unravel one of the standard gender alignments by which crime is fetishised in film. This is not to say that the film does not indulge in a certain libidinalisation of urban space which addresses a bourgeois spectatorship, with edge city filmed as dark and dangerous, inhabited by 'los chicos vampiros' (vampire kids), dropout youths whose culture is, in varying degrees, the 'no future' of punk and hard rock and the nihilism of Goth.

Punk reached Latin America as a marginal urban youth movement in the mid-1980s and persisted through to the mid-1990s. The Colombian urban theorist Armando Silva, in his book *Imaginarios urbanos*, describes Latin American punk as a cultural practice designed to 'make visible so as to make believe in your aggressivity' (1992: 124).[2] It is, he maintains, bound up with a postmodern culture of visual effect and simulacra, but it is also, in its Latin American form, a discourse of cultural interactions and symbolic mixtures, being appropriated from British dropout culture of the 1970s. Martín-Barbero theorises rock as a culture of stridency which in the 1990s subsumes punk and opens itself much more to televisual cultures, becoming the perfect expression of the fragmented culture of the megalopolis:

> In the sonorous stridency of rock, the sounds of our cities are hybridised with the sonorities and rhythms of indigenous and black music; the aesthetics of obsolescence with the fragile utopias which emerge from moral unease; the vertigo and empathy of audiovisual culture with a technological culture in whose stories and images, fragments and velocities, young people of all social classes seem to have found a common rhythm and language. (2001: 123)

I have no space to analyse here the fascinating ramifications of punk, hard rock and Goth as transnational urban discourses of marginality – the far-reaching transformations of the social imaginary which such appropriations signal in Latin America – although we shall return to the theme of musical hybridisation in the analysis of *Hasta morir* below. In any case, *Lolo* does not engage particularly seriously with punk, using it merely as an image of urban aggressivity and as a foil for Lolo's own failure to wield these simulacra of aggression.[3] Where punk is interesting in this film is in its relation to gender, since it is Lolo's dropout older sister, Olympia (Artemisa Flores), who acts as the leader of a Gothic band of marginal criminal youths who dress in black and vampire costumes and from whose earnings Lolo's family indirectly benefits.

Our first encounter with the band of 'vampire kids' clearly suggests a reading of punk and Goth in terms of a mortal game of visibility and invisibility in a new amalgam of urban space, performance and velocity. This comes in a sequence near the beginning of the film portraying a raid on a neighbourhood pharmacy. The sequence begins with a tracking shot, accompanied by chords on an electric guitar, revealing one by one the faces of the youths, some made up with painted fangs, stylised hair and black clothes, sitting with their backs to a wall and looking bored, until Olympia suggests that they go and get some 'chocolates'. There then begins a rapid montage of various shots which elliptically depict the raid on the pharmacy in a highly stylised manner, with rhythmic background music suggestive of a typical action film. The montage sequence ends when the chemist manages to grab a pistol and kills one of the group, 'el Pelón', as they are running away: there is an extremely quick cross-cut from the medium shot of the chemist aiming his gun, to a shot apparently out of temporal sequence showing the chemist's foot kicking the supine body of Pelón in the street, returning immediately to a shot of the chemist holding the gun he has just fired. The jump-cut effect occurs here both in time and in space and takes the form of a metacommentary on the new urban spatialities and temporalities as they relate to the self-same visual culture to which the stylised mode of representation in this sequence seems to allude. These Mexican darks or Goths manipulate the codes of spectacle, using violence almost as a visual practice. The deathly nature of the game of visibility in this urban imaginary is revealed when the vector of violence is inverted and the corpse of el Pelón, still spewing out blood, is turned into a spectacle for the crowd who gather round to gaze at him. The film thus offers us the filmic *mise-en-abyme* of our own gaze as spectators – of the fetishisation of violence as spectacle within our urban imaginary – and underlines it with a dramatic crane shot which, starting from a high-angle shot of the corpse, pulls us away from street level and over the rooftops while the camera tilts towards the horizon and lays before us the entire cityscape of the Valley of Mexico. Mundane street violence thus becomes a terrifying allegory of the complicity of urban processes with the violence of vision.

Another sequence emphasises the links between spectacle and the analysis of gender in the film. After Lolo has committed his crime, his policeman cousin Marcelino (Damián Alcázar) takes him for a ride in his police car. A point of view shot from Marcelino's perspective shows us two punks walking along the street with spiky multicoloured hair and carrying a stereo. Comfortably installed in the 'space of flows' described by Manuel Castells, the policeman interprets the visual spectacle of the street in the way that we might interpret a film, projected onto the windscreen of the car, reading punk as a failed representation of masculinity, an unconvincing masquerade of gender inadequacy:

Marcelino: I don't get it with these kids. They get all dressed up like they're real tough. But then you find out they've got stupid little girls' voices and they wear coloured trainers. They even look like poofters, don't you think cuz? Green, lilac, blue. I bet some of them even have red ones, eh?

Alluding to the red trainers which Lolo was wearing when he committed the crime, Marcelino interprets street violence in terms of a sexual masquerade, and so quite literally polices the boundaries of masculinity via the fantasmatic yet ever-present threat of homosexuality. Similarly, in another sequence, the merest hint of masculine sensitivity evokes homosexuality for Sonia's mother (Lorena Caballero) ('Er, he's not a poof is he?'). Sonia herself describes the wounded Lolo, beaten up after a fight which takes place (self-reflexively) in a cinema, as 'abierto' (open), the word which Octavio Paz famously uses to describe the machista view that Mexican men are alleged to have of women, in his famous work of 1950, *El laberinto de la soledad* (*The Labyrinth of Solitude*; see 1981: 69–92).

Finally, the ironically-named Olympia, who – unlike Sonia – rebels against established patterns of femininity, and so is far from being a version of the automaton *femme fatale* which E. T. A. Hoffmann describes in *Der Sandmann* (*The Sandman*, 1816), nevertheless refers us, as does Hoffmann's tale, to the intersection of gender with the visual and spatial culture of the city. The subtle analysis undertaken in this film points to the radical changes which modernity, and now postmodernity – whether technological or urban – have brought about in the social modes of representing and understanding gender.

Performing Masculinity and Violence

The film *Hasta morir*, which finished post-production at the end of 1993 and began to appear in festivals during 1994, has, in retrospect, striking similarities with *Amores perros*. These similarities are not just in that it shares one actress, Vanessa Bauche, has a penchant for dog fetishism and is set in a megapolitan space of flows rather than in any citational filmic city, but also in its focus on masculinity and violence. However, *Hasta morir* is more interested in the performative dimension of both masculinity and violence, in what we might call their mimesis and their semiosis within a simulated, hybridised and transnational urban culture, yet one which retains, unlike in *Amores perros*, strong connections to the hybrid Mexican identities of the *cholo* and the *pachuco*.

Cholo is a term used in Mexico and throughout Latin America for people of mixed race, but in Mexico the term is used to designate hybrid cultural identities more than *mestizaje* or racial intermixing. More specifically, *cholos* are aggressive, showy youths in cities on the border with the United States, such as Tijuana and Ciudad Juárez. They have a very specific borderlands culture, and are the inheritors of the loud and brash dress styles of the earlier *pachucos*, Mexicans living in the US in the 1940s and 1950s whose hybrid identities are examined by Octavio Paz (see 1981: 11–28), and who are referred to in this film. The film's scriptwriter, in her prologue, explains thus the significance of the *cholo* and her reasons for having chosen this figure as a symbol of the mimesis and intermixing of cultures:

When I had to choose an archetype, something which would inspire the desire for mimesis, I immediately thought about the *cholos* on the Mexican side of the border.

Belonging to an important youth movement of the 1970s which has now lost much of its political strength, the *cholos* and their aesthetic crossed the frontier in both directions, and they have still not lost their relevance in urban cultures which are as different as Los Ángeles and Tijuana ... The *cholos* are excessively bodily: the men, with their competitions of conquest; the women, with their dance; all of them, through what they try to express with their tattoos ... They are nearly all Catholic and they hold in high esteem the Virgin of Guadalupe. *Cholos* and *cholas* have a very particular relationship to death, pain and guilt. (Fuentes-Berain 1995: 13–14)

This film is less of an auteurist production than the others examined here, and the intelligent and gender-sensitive script by Marcela Fuentes-Berain goes a long way towards accounting for the analysis of masculinity in its performative dimensions; however, it should be said that the portrayal of femininity in this film is for the most part stereotypical, even that of the punky urban females who, like the bourgeois chick that one of the *cholos* prefers, are all portrayed as hooked on heterosexual romance. Fuentes-Berain laments the fact that in the film 'there did not appear a single female *chola*' (1995: 14), because had the film respected the script in this detail, it would have introduced a certain complexity in its representation of feminine identity. The film concerns a *cholo*, Mauricio or Mau (Damián Bichir), and a *chilango* (working-class inhabitant of Mexico City), Juan Carlos, known as El Boy (Juan Manuel Bernal), who were blood friends, *carnales*, in childhood and adolescence. Mau went to live in Tijuana or Tijuas – *cholo* country – on the border with the US, and at the beginning of the film he returns to Mexico City and teaches Boy what he has learnt about the customs of the *cholos*, about crime, honour and knifefighting. They engage in petty but violent urban crime together, with Boy trying but failing to imitate the superior corporeal control and sense of purpose which Mau has. The interest in the film comes from the focus on Boy's mimesis of Mau, and the reversal of this in the second half when Boy has to go into hiding and Mau takes over his identity: he pretends to be him and seduces his estranged and very conventional bourgeois cousin Victoria (Verónica Merchant) in order to dupe her out of a house which she should have inherited. Victoria does not know Boy, because both sides of the family were estranged, leading to a vertiginous interplay of masked and mimetic identities.

Apart from the representation of gender and violence, the other principal point of interest in this film is the innovative representation of urban space literally as a 'space of flows' typical of the new spatial formation that is the megalopolis. Castells characterises the megalopolis as 'globally connected and locally disconnected' (1996: 404), and gives as an example of this local disconnection the popular *colonias* (neighbourhoods) of Mexico City in which two thirds of the megapolitan population live, but which play no significant role in the functioning of the city as a globally connected financial centre (1996: 380–1). What is particularly noticeable in this film is the emptying out of any sense of locality; simultaneously there is the profound connection which all the spaces inhabited by the characters have with 'elsewhere', with frontiers, the crossing and mingling of cultures, and, of course, with the 'elsewhere' that the United States represents as an imaginary destination desired by almost all of the characters. Two sequences from the beginning of the film serve to illustrate this visual take on urban spaces, and confirm Castells' idea that we should conceive of megapolitan space in terms of processes and not of forms.

In the first sequence we see Mau and Boy in the North Terminal bus station, a location typical of this film: spaces which are transit points and not recognisable landmarks, frontiers and passages *between* places, as if all place had somehow been emptied of its materiality. A medium shot frames Boy, with pop-star-style long hair, anxious and restless, behind a large plate-glass screen, trying to recognise Mau amongst the passengers disembarking from the buses. The reflections in the glass confuse our sense of space even more, creating a superposition of spatial layers and making it hard for the spectator to 'place' Boy within his surroundings. We then see a close-up of a typical *cholo* getting out of a bus, with very short hair (almost shaved), obscure glasses, baseball cap with the visor pointing backwards and a checked shirt, his body held firm and straight: it is Mau, he recognises Boy, smiles, and they approach to greet each other. First they initiate an elaborate 'Soul Brother'-style handshake, and then they embrace, while on the soundtrack there pipes up a musical theme which could come straight out of any US road movie, introducing an important element in the film: the use of music to express the profound cultural hybridisation amongst the marginal urban and para-urban populations. There is a cut to a children's park, invaded by a gang of marginal youths. Its walls are covered in an overdetermined mixture of graffiti, that curious urban sign system which consists of appropriating the signification of space and re-writing it, obliging anonymous settings to signify and represent that which they resist rendering visible. However, the effect here is more that of an indecipherable palimpsest. We then cut to a night-time scene of urban apocalypse, representing a baroque and undifferentiated mix of subcultural styles – punk, heavy-metal, Goth – with youths dancing wildly around a bonfire in some generic para-urban wasteland, accompanied by a hard rock soundtrack. These are the hybrid, transnational – even globalised – cultures of the urban youths of the megalopolises which Fabio Giraldo and Hector López sum up very well in their analysis of the relationship between urban marginality and the flows of substances and images which characterise Latin America's insertion in 'late modernity':

> The marginal youths who live in the great urban centres and who in some of our cities have assumed the role of the *sicario* (contract assassin), are not only the result of underdevelopment, poverty or unemployment, the absence of the State and of a culture whose roots are anchored in Catholicism and political violence. They are also the reflection, maybe even more emphatically, of hedonism and consumption, of the culture of the image and of drug addiction, in a word, of the colonisation of the lifeworld by late modernity. (Giraldo and López 1991: 261)

The other sequence which gives particular emphasis to this new sense of para-urban space, and to the self-representation of a form of masculinity which seems to want to arrest the flows at the same time as it is shaped by their interstitial spaces, is the lads' first visit to a patch of abandoned wasteland in amongst some railway sidings (a form of transport already in the process of extinction in the 1990s in Mexico). This setting sums up perfectly the idea of the dematerialisation or emptying out of space, of the loss of locality, smeared along lines of transport and displacement, in the interstices of larger flows. It is no coincidence that the film should return several times to this almost iconic setting: a non-place, criss-crossed by railway lines, with abandoned wagons and a huge number of rusty axles piled up like scrap in great heaps. In this space, Mau teaches Boy to

discipline his body in order to perform the rite of knife-fighting, to hold himself straight, his buttocks taut. He wants him to represent a firm, hard and contained figure of masculinity, ready for combat, in contrast to the floppy, uncontrolled movement which characterises Boy throughout the film (and the mobility of the camera during this sequence seems to reproduce his perplexity). As Paz says of the *pachuco*, it is as if these abject spaces between frontiers and cultures were inciting an exaggerated, ritualised and highly performative representation of identity.

The film adopts an experimental visual style in some sequences, with the use of the jump-cut to indicate the passing of time, and with the imitation, in the sequence in which Mau is stalking Victoria through the city streets, of an MTV-style music video. This sequence of tracking shots and rack-focus shots, some using a telephoto lens, in which Victoria is visually identified with some naked tailors' dummies with which her figure is confused, has as its sole soundtrack a self-conscious made-for-the-film Mexican rap. In this way, both the visual style and the intensely hybrid music strongly suggest the superimposition of identities and cultures in megapolitan spaces, and at the same time imply that we can only approach these spaces and hybrid identities through the layers and filters of audiovisual culture and its transnational imaginaries. Flaunting the mediatised nature of urban *flânerie* at the end of the millennium, this sequence suggests that it is no longer possible to film the street: the camera can now only film the mediatisation and hybridisation of urban space.

Conclusion

In the films examined here, the interdependency between gender relations (in particular sexuality) and urban violence seems to suggest a continual oscillation between the staking out of territory and tribal identities, and the deterritorialising forces that empty urban space of its materiality and meanings. In his contribution to the conference on which this volume is based, Stephen Heath suggested that we should understand the verb 'to film' in the expression 'filming the city' in the same way as we understand the verb 'to paint', in the sense of coating bodies and cities with layers of film, layers of mediation and simulation. It is, then, impossible to decide whether the images of violence and representations of gender in these films are effects of the instabilities wreaked by urban processes or whether they are part of the process of mediating and mediatising the city. Indeed, it is no longer possible, in these end-of-millennium urban films, to separate representation from mediation.

I end with a fascinating sequence from the last of these films, *Hasta morir*, which sums up particularly well the complexities of the production of images of gender and violence which I have examined in this chapter. Boy and Mau are sitting in a tattoo parlour; Mau has just had a new tattoo and Boy wants the assistant to make him a copy of an old complicated tattoo which Mau had received in Tijuana, of a brash hypermasculine *pachuco*. The assistant says that it is far too complicated and that she does not know how to do it, and Mau adds 'anyway it was done to me by a *cholo*, and I earned it, you dickhead'. The assistant offers Boy some more conventional tattoos: 'Don Juan, or the flying mermaid, or the Virgin', but he rejects these and asks her instead to give him the one she has just done for Mau: 'You copycat!' she retorts. When she applies the needle to trace the outline, Boy flinches and she laughs, 'You're a real sissy, Boy!'

Film here becomes quite literally a sk(e)in-like surface, making literal the process of registering images on the surfaces of bodies and urban spaces which I have tried to emphasise here. Gender is fully revealed in its mimetic dimension – as a copycat culture – but Boy has not earned the right, through some violent rite of passage, to sport the tattoo of the hypermasculine yet hybrid *pachuco*, and has to make do with a mere simulacrum. Or rather, both masculinity and the violence which 'guarantees' it are revealed to be displacement fictions, compensating for and attempting to fix the flows and instabilities of the hybridising urban cultures of the megalopolis.

NOTES

1 A good example would be the demonstrations against sexual violence in Ciudad Juárez on the Mexican–US border in 2004, aimed at reclaiming the streets for women in the face of the violent femicide taking place in that city. Since 1993, some four hundred women have been murdered (often after having been sexually assaulted) in this unregulated 'free-trade' border city, and a further four hundred are reported missing.

2 All translations in this chapter are my own.

3 The film which most carefully approaches the world of punk in Latin American cinema, specifically amongst the marginal youths of Medellín, is *Rodrigo D. No futuro* (*Rodrigo D. No Future*, 1988) directed by Víctor Gaviria. See Kantaris 1998 for an analysis of punk as urban subculture in this film. See also my 'Cultures of Fear, Cultures of Resistance: Hard Rock, Punk and Rap in Latin American Urban Cinema' (published in Spanish, 2008, as 'Culturas del miedo, culturas de la resistencia: la representación del rock duro, punk y rap en el cine urbano latinoamericano').

WORKS CITED

Anon. (1993) 'La cinta *Lolo* no se trata de un análisis social o económico de México, dice Francisco Athié, en Cannes', unreferenced press cutting from the archives of the Cineteca Nacional, Mexico, 17 May.

Ayala Blanco, J. (1989) 'María Novaro y la dificultad de ser a la deriva'. *Cinemiércoles popular, El financiero*, unpaginated press cutting from the archives of the Cineteca Nacional, Mexico, 22 November.

Castells, M. (1996) *The Rise of the Network Society. The Information Age: Economy, Society and Culture, vol. 1*. Oxford: Blackwell.

Cuéllar, Ó. L. (1991) '*Lola*: retrato de mujeres con paisaje', *Siempre* (*Suplemento La Cultura en México*), 13 March, unpaginated press cutting from the archives of the Cineteca Nacional, Mexico.

Espinasa, J. M. (1992) 'Neorrealismos'. Unreferenced press cutting filed under *Lola* from the archives of the Cineteca Nacional, Mexico.

Fuentes-Berain, M. (1995) *Hasta morir* (film script). Mexico: Ediciones El Milagro/Instituto Mexicano de Cinematografía.

Giraldo, F. and H. F López (1991) 'La metamorfosis de la modernidad', in F. Viviescas and F. Giraldo (eds) *Colombia: el despertar de la modernidad*. Bogotá: Foro Nacional por Colombia, 248–310.

Hoffmann, E. T. A. (1988) *Der Sandmann*. Berlin: De Gruyter.

Kantaris, E. G. (1998) 'Allegorical Cities: Bodies and Visions in Colombian Urban Cinema', *Estudios interdisciplinarios de América Latina y el Caribe*, 9, 2, 55–73.

_____ (2008) 'Culturas del miedo, culturas de la resistencia: la representación del rock duro, punk y rap en el cine urbano latinoamericano', *Cuaderno CES* (Universidad Nacional de Colombia), 20, 2–17.

Maciel, D. R. and J. Hershfield (1999) 'Women and Gender Representation in the Contemporary Cinema of Mexico', in J. Hershfield and D. R. Maciel (eds) *Mexico's Cinema*. Wilmington, DE: Scholarly Resources, 249–65.

Martín-Barbero, J. (2001) *Al sur de la modernidad: comunicación, globalización y multiculturalidad* (Nuevo Siglo). Pittsburgh, PA: Instituto Internacional de Literatura Iberoamericana.

Novaro, B. and M. Novaro (1995) *Lola: guión cinematográfico*. Mexico: Plaza y Valdés.

Paz, O. (1981) *El laberinto de la soledad*. México: Fondo de Cultura Económica.

Rabell, M. (1992) '*Lolo*, estreno de una película mexicana', *El día*, 27 October, unpaginated press cutting from the archives of the Cineteca Nacional, Mexico.

Silva, A. (1997) *Imaginarios urbanos: cultura y comunicación urbana en América Latina*, third edition. Bogotá: Tercer Mundo Editores.

13 LOOKING AT THE CITY IN
THE MATRIX FRANCHISE

Henry Jenkins

In a scene from Andy and Larry Wachowski's *The Matrix: Reloaded* (2003), Neo (Keanu Reeves) looks out of the window at the city below him (fig. 1). His back is turned to us but his face is mirrored in the glass. The city itself glows – white light shining through many other windows as the city spreads out before him. Neo partakes of the panoramic vision that has long been a central feature of science fiction in film and literature.

Consider, for example, the opening of Edward Bellamy's novel from 1887, *Looking Backward* when the nineteenth-century man awakens to find himself in a new epoch. Only when he is shown the vista of the future Boston from the rooftops does he believe the transformations that have occurred:

Fig. 1

At my feet lay a great city ... Public buildings of a colossal size and an architectural grandeur unparalleled in my day raised their stately piles on every side. Surely I had never seen this city nor one comparable to it before. Raising my eyes at last towards the horizon, I looked westward. That blue ribbon winding away to the sunset, was it not the sinuous Charles? I looked East; Boston harbor stretched before me within its headlands, not one of its green islets missing. (1967: 115)

The Wachowskis return to a similar image near the end of *The Matrix: Revolutions*, when Neo first beholds the machine city, 01 (fig. 2). We can scarcely say he looks down upon it – since Neo has been blinded and now perceives only the code from which the city was built. In the first case, the image of the city is documentary: this is a real city (Sydney) rendered photographically, albeit a city removed from context, stripped of its recognisable features, so that it can stand in for every city in the Western world. Ironically, of course, within the film's terms, this city does not really exist. It is a digital construct – part of the illusionary world of *The Matrix*. In the second case, the image of the city is constructed digitally: this is

Fig. 2

a city unlike any we have ever seen before, a world created not for human inhabitation but for mechanical residents. As we look over Neo's shoulders, we have trouble parsing this landscape: we cannot understand the relationship of the parts to the whole; we cannot determine the function or identity of the structures that stand before us.

These two images reflect *The Matrix* series' fascination with urban spectacle as well as its tendency to generate multiple (contradictory and complimentary) images of the city. The panoramic shot is a key element of the visual iconography of contemporary science fiction cinema: science fiction artists put great effort into the production of imaginary worlds and then they lay them out before the spectator to observe and interpret. We hover over the city of tomorrow much like visitors at the 1939 World's Fair floated above and looked down upon Futurama.

From the very beginning, such vistas have been central to this genre which is frequently as interested in depicting a vividly realised and fully imagined alternative world as it is in developing a story. Often, the plot is a vehicle to justify our travel through conceptual and geographic space. We look past the characters to see what they see – change and continuity expressed through the details of a cluttered *mise-en-scène*. Writers have consistently criticised science fiction's lack of novelistic characters but this is to misunderstand the level on which this genre operates, often more interested in discussing societies, civilisations, worlds and galaxies, rather than individuals.

We are encouraged to read the urban landscape symptomatically – for signs of similarity to and difference from cities we encounter in our everyday lives. These imaginary cities, Annette Kuhn argues, 'are also constructed as spaces for the film's spectator to enter, to map, and to explore' (1999: 77). Finally, we are invited to read these cities as allusions, which reference and remediate earlier works in the genre. Some of the earliest science fiction films – Fritz Lang's *Metropolis* (1926) and William Cameron Menzies' *Things to Come* (1936) – offered such vivid images of the urban experience that filmmakers have returned again and again to a shared database – a matrix – of previous representations. Most of the early science fiction writers came from cities – and, more particularly, from ethnic enclaves within cities – translating the giddy excitement they felt looking down from skyscrapers or the confusion they experienced wandering through crowded, multicultural neighbourhoods into fantasies about other times and other worlds.

Indeed, *The Matrix* franchise is marked by a proliferation of different cities – the contemporary city within the Matrix, the underground city of Zion, the machine-built city of 01; the city ascendant and the city in ruins. Each of these can trace their roots back across

the history of science fiction film and literature: the cities of *The Matrix* are at once illusions (plausible immersive environments that provide a context for the story's events) and allusions (references outward to this larger generic tradition of imaginary cities). Much of what Giuliana Bruno says about the city depicted in Ridley Scott's *Blade Runner* (1982) also holds for the *Matrix* films:

> The city of *Blade Runner* is not the ultramodern, but the postmodern city ... The city is called Los Angeles, but it is an LA that looks very much like New York, Hong Kong, or Tokyo. We are not presented with a real geography, but an imaginary one: a synthesis of mental architectures, of topoi. Quoting from different real cities, postcards, advertising, movies ... *Blade Runner*'s space of narration bears, superimposed, different and previous orders of time and space. It incorporates them, exhibiting their transformations and deterioration. (1990: 184–5)

This chapter follows in Bruno's footsteps – examining the multiplicity of different urban images in a contemporary science fiction classic.

Consider this photo-essay an exploration of the image of the city within the *Matrix* franchise. I use the term 'image' here in a double sense: first, and most obviously, I want us to look at cinematic images of the city captured during a close reading of the films. Second, I mean to refer us to Kevin Lynch's notion of the 'image of the city' as a mental composite of previous impressions and memories.[1] As Lynch writes:

> At every instant, there is more than the eye can see, more than the ear can hear, a setting or a view waiting to be explored. Nothing is experienced by itself, but always in relation to its surroundings, the sequence of events leading up to it, the memory of past experiences ... Every citizen has had long associations with some part of his city, and his image is soaked in meanings and memories ... Most often, our perception of the city is not sustained, but rather partial, fragmentary, mixed with other concerns. Nearly every sense is in operation, and the image is the composite of them all. (1960: 1)

In Lynch's terms, our immediate perceptions give way to memories which in turn inform our more abstract concepts. Our understanding of the city in *The Matrix*, similarly, has been constructed and compiled across a range of compelling visual devices. With that in mind, my goal here is to show as much as it is to tell. I want to stop the flow of the narrative and focus on the individual images which constitute the *Matrix* text.[2] What follows are intended as a series of notes and speculations, not a fully realised interpretation of the films.

In an oft-cited passage, Michel de Certeau describes the experience of observing Manhattan from atop the World Trade Center. New York City transforms into geometric patterns devoid of human activity:

> Beneath the haze stirred up by the winds, the urban island, a sea in the middle of a sea, lifts up the skyscrapers over Wall Street, sinks down at Greenwich, then rises again to the crests of Midtown, quietly passes over Central Park and finally undulates off into the distance beyond Harlem. A wave of verticals. Its agitation is momentarily arrested by vision. The giant mass is immobilised before the eyes. (1974: 91)

De Certeau is fascinated with the false sense of totality ('seeing the whole') created by this panoramic perspective: 'To be lifted to the summit of the World Trade Center is to be lifted out of the city's grasp' (ibid.). Cinematically, this systemic perspective on the city is perhaps most powerfully expressed through extreme high-angle shots, which, as in de Certeau's description, abstract the city (fig. 3).

Note how similar the aerial photograph of the city is to the three-dimensional construction of data in the opening credits of *The Matrix: Revolutions*. What at first seem to be buildings turn out to be the film's iconic falling green kanji (fig. 4). One could describe these images as a god's-eye view – though this is a film where architects and agents, keymakers and hackers, stand in for deities. Only in the trilogy's final moments do human figures occupy the divine perspective depicted in these earlier shots: here, agent Smith (Hugo Weaving) and Neo do battle high above the human city, the fate of the world resting in their hands (fig. 5).

Fig. 3

Fig. 4

Fig. 5

Fig. 6

Fig. 7

Fig. 8

Moving closer to earth and closer to a human vantage point, the film returns again and again to shots that either look straight up at skyscrapers looming above (fig. 6) or straight down from the rooftops on the human activity below (figs 7 and 8).

These shots pull us out of the action, distancing us from the human characters who look like ants, and inviting us to marvel at the verticality of the urban canyon. But the shots can also amplify the action, as in figure 6 where bullets rain down upon us in the midst of a helicopter battle or in figure 8 where Neo comes straight at us as he ascends skyward. These shots define limits only to allow the most dynamic characters to burst free.

As Scott Bukatman has suggested, the superhero tradition depends upon a tension between the grid (that is, the ways that human movements are patterned, constrained and restricted within urban space) and its negation (that is, the ways that a superhero asserts his or her own way of moving through space):

Superheroes negate the negation of the grid – they move through space in three dimensions, designing their own vehicles, choosing their own trajectories. To be a superhero, you've got to be able to move. Superhero narratives are sagas of propulsion, thrust, and movement through the city. (2003: 189)

The contrast between these two ways of travelling through the city is visible in the differences between figure 7 (where the human characters seem to be corralled) and figure 8 (where Neo escapes gravity). *The Matrix* makes explicit this urban logic – the tension between mobility and constraint, individuality and social conformity. The most estranged images of urban space are literally pedestrian – they pull us down to the ground, forcing us to walk within the nameless and faceless crowd, all walking in the same direction (fig. 9). Only Neo and Morpheus (Laurence Fishburne) walk against the foot traffic, banging into the indifferent masses. Morpheus characterises the 'businessmen, teachers, lawyers, carpenters' as at once the minds they are trying to liberate from machine-control and as 'hopelessly dependent on the system' they seek to destroy.

Interior space is similarly indifferent to human agency (see figs 10 and 11): stripped of any distinguishing features, drained of colour, sterile and symmetrical.

Deep focus cinematography exaggerates long hallways; shots are framed so as to emphasise the limits of the character's potential for movement – architectural details mask the edges of the frame. If the exterior shots emphasise verticality, interior shots emphasise horizontality (fig. 12), with both seen as restrictions on potential movement and individual choice.

Fig. 9

Fig. 10

Fig. 11

Fig. 12

By contrast, the film's protagonists are hackers. They assert their own designs, create their own routes. A hacker is more than simply someone who masters computer code. As writers like Sherry Turkle (2006) have documented, to hack has been part of techno-logical slang since at least the middle part of the century. To hack was to break and enter spaces under someone else's control, leaving some mark (often a practical joke of some kind) but doing no damage. Hacking culture reflected the apprentice engineer's growing technical mastery and the ability to solve problems. In the case of *The Matrix*, these two concepts of the hacker have fused – all the more so because the hackers see what mun-danes take to be physical space as a digital illusion. The protagonists go where they want. They can use telephones to port themselves directly to a desired location. When they are pursued, they will take any action necessary to avoid capture, including smashing through walls and scampering down crawl spaces (fig. 13), trampling through subways and sewers, swinging over fire escapes and leaping across rooftops. Their erratic move-ments map the city from above, below and all points in between. We soar over the city and we crawl under it. We see ethnic enclaves and elite high-rise apartments, low rent dives and corporate offices.

At places, the film taps contemporary images associated with Parkour, the French ex-treme sport that involves moving through urban space by the fastest means possible, and often requires highly gymnastic manoeuvers to bypass obstacles or exploit affordances. Trinity (Carrie-Anne Moss) (in the live action films) and Jae (in one of the animated shorts, *The Final Flight of the Osiris*, 2003 seem more like gibbons than human beings. The cam-era loves to watch their lithe feminine bodies in leather jumpsuits defy gravity as they leap through the air (fig. 14).

Fig. 13

Fig. 14

The films' Computer Generated Images push characters beyond hacking or Parkour – walking on ceilings, stepping across the air or running along the sides of walls, all stock images in the Hong Kong action films from which the filmmakers recruited their key fight choreographer, Yuen Woo-Ping. The protagonists master, but are not limited by, spatial features: they are mentally and physically free to do as they wish (fig. 15).

Film critics have often compared *The Matrix* to a contemporary video game: part of what they are responding to may be this particular construction of space. Some aspects of game space constrain movements, others facilitate it. Much as in Parkour, gamers scan their environment for otherwise hidden affordances. The Wachowskis worked closely with the designers of the *Enter the Matrix* game. As is often the case, the game was designed to look like the film but the opposite was also true: the film was designed to look like a game.

Fig. 15

Fig. 16

An experienced gamer can tell which game genre influenced specific scenes (as in the case of figure 16 which borrows core mechanics from both racing and shooter games).

Since *Blade Runner*, the visual iconography of *film noir* has more and more informed the construction of cities in science fiction cinema: as writers like Frederic Jameson have suggested, our future increasingly looks like the past (see 1980 and 1984). These *noir* borrowings are particularly strong in the first film, which opens with policemen bearing torches moving through a darkened interior, tracking down Trinity who is hurriedly typing information into a terminal. The retro-style of deadly serious, clinch-jawed Agent Smith makes him seem like a hard-boiled detective from a classic 1940s or 1950s movie. It is not simply that the story elements – cops, detectives, breaking and entering, late-night rendezvous, chases through rainy streets – follow the now familiar logic of *film noir*; the scenes are also shot with low-key lighting, canted angles, off-centered compositions (fig. 17), bold architectural lines (fig. 18), silhouettes and shadows, extreme close-ups and the heavy use of reflective surfaces, to cite just a few of the visual motifs associated with the genre (see Place & Peterson 1976). Opening the film with these *noir* borrowings provides a narrative and thematic context for what follows – the man on the run, sucked into an underground organisation by a seductive woman, forced to step further and further outside the law, and confronted with harsh truths that he is not initially prepared to accept. The *noir* iconography establishes the paranoia that pervades the films: nothing is what it seems and we do not initially know whom to trust.

This retro influence is even more dramatic in *A Detective Story* (2003) (fig. 19), one of the animated shorts, which features a private eye's search for the Red Queen. Here,

Fig. 17

Fig. 18

Fig. 19

the images evoke New York in the 1940s while the first-person narration provides a hard-boiled voice to match.

The Matrix franchise depicts a world where constant struggles between humans and robots have devastated the natural order: human cities above ground lie in ruins (fig. 20); the humans have darkened the sky to prevent the robots from having access to solar power and the robots have in turn harnessed human bodies as an alternative source of bioelectric energy. The city in ruins has become a key icon of post-apocalyptic science fiction cinema (see, for example, climactic moments in films like *The Planet of the Apes* (1968), *Soylent Green* (1973), *Logan's Run* (1976) or *Escape from New York* (1981)).

Those humans who do not live their lives within a digital illusion have burrowed deep into the ground and formed an alternative civilisation. The film emphasises the physical-ity and earthiness of Zion, this underground civilisation: their homes are like burrows; they gather together in vast caverns by torch and candle-light to celebrate Morpheus's return; they dance until their bodies glisten with sweat and their bare flesh pounds on the cave floors (fig. 21); they wear earth-coloured, open-weave clothing. The chaotic energy unleashed during the celebration scenes in Zion could not contrast more sharply with the regimented and ordered movements in the city above. These are the people of the earth and Zion is depicted initially as a safe haven and a sacred space.

One might also contrast the emphasis on stone and earth in the Zion sequences with the very different kinds of industrial materials featured in the pod city where humans are incubated (fig. 22). Designer Geoff Darrow trained under the French comic-book artist Moebius and was deeply informed by a Euro-comics tradition that has been fascinated with richly detailed representations of alien technologies and landscapes.

Fig. 20

Fig. 21

Fig. 22

Similarly, the warm auburn glow of the torchlight in Zion can be contrasted with the bright illumination of 01 (fig. 23), which taps deeply into a long tradition of depicting urban landscapes at night to emphasise the wonderland created by electronic light. Zion's more formal spaces, such as the Council Chamber (fig. 24), resemble cathedrals in their use of Gothic arches and windows.

It is a shape that extends even to seemingly natural openings formed by stalactites and stalagmites (fig. 25). Cultural Historian Rosalind Williams has described the underground worlds that ran through nineteenth-century works that precede the modern science fiction tradition: 'Subterranean surroundings, rather real or imaginary, furnish a model of an artificial environment from which nature has been effectively banished. Human beings who live underground must use mechanical devices to provide the necessities of life: food, life, even air. Nature provides only space' (1990: 4). This is a world that is both natural and man-made.

Fig. 23

Fig. 24

Fig. 25

The Head of the Zion Council (Anthony Zerbe) takes Neo for a walk down to the engineering level and speaks with him about the interconnectedness of humans and machines (fig. 26):

> The city survives because of these machines. These machines are keeping us alive while other machines are coming to kill us. The power to give life and the power to end it ... If you wanted to you could smash them to bits – although if we did, we would have to consider what would happen to our light, our heat, our air.

Much as in *Metropolis*, social hierarchies (between machines, workers and the ruling elite) get mapped onto physical layers: the rulers live above the ground; the people live below and the factory is still further down. The films do take us from time to time to high-

Fig. 26

Fig. 27

rise pleasure gardens which suggest the decadence of elites separated from the realm of everyday life (see Desser 1999). Yet, within Zion, there are no signs of alienated labour. The machines, in effect, run themselves and the Council Chair makes clear that few humans give them any thought or understand how they work any more.

The Matrix series seems to evoke the hierarchical structures associated with *Metropolis* precisely to break them down, creating not the alienated society of the German Expressionist film, but returning some element of the utopian imagination to this representation of the underground city. The scenes of the labourers taking arms to defend their city against the machine invasion in *The Matrix: Revolutions* (2003) contrasts with our memories of the panic-stricken workers rioting, smashing machines and flooding their own homes in *Metropolis*. *The Matrix* trilogy pits the power of the community and the wisdom of crowds against *Metropolis*'s fear of a mob mentality.

The city as depicted in *The Matrix* series is ultimately not a physical place but rather a structure of information. Several times, we strip aside the façade and reveal the source code out of which this urban landscape has been constructed (fig. 27). It is the City of Bits that William Mitchell described as 'capital of the twenty-first century':

> This will be a city unrooted to any definite spot on the surface of the earth, shaped by connectivity and bandwidth constraints rather than by accessibility and land values, largely asynchronous in its operation, and inhabited by disembodied and fragmented subjects who exist as collections of aliases and agents. Its places will be constructed virtually by software instead of physically from stones and timbers, and they will be connected by logical linkages rather than by doors, passageways, and streets. (1995: 4)

Fig. 28

Fig. 29

Similar images of the digital city surface across science fiction of the period in writers such as Bruce Sterling, William Gibson, Rudy Rucker, Pat Cadigan and Greg Egan, who imagined the long-term implications of networked communications.

So many of the film's spaces having been emptied of clutter or visual confusion, it is striking how often we see signs of the human effort to map, decipher or comprehend the structure of the city. There are photographs of cities on the walls of the office building where Neo works at the opening of the film; we see a wide array of maps, charts and graphs scattered on table tops or pasted to the walls; we see the city on a television monitor (fig. 28) when Morpheus tries to explain to Neo that everything he has known so far is simply a digital hallucination.

Such images carry over into the animated films as well, with *A Detective Story* (fig. 29), for example, including a number of shots of archaic and retro-information technologies as part of how it establishes its setting.

In the final moments of *The Matrix: Reloaded* (fig. 30), Neo finds his way into the control room and stares face to face with the Architect (Helmut Bakaitis), the one agent who might be able to provide him with answers if the human was capable of comprehending them. Here, we see the image of the divine force of creation and destruction personified not as a clockmaker (as he might have been imagined in another century) but rather as an architect. And the Architect's power and knowledge is personified through a huge wall of television monitors that allow him to survey the full range of human experience, or to dig deep into Neo's conscious thoughts and unconscious responses.

At least as far back as *Things to Come*, television has been figured as a technology of power and authority: the Menzies film no doubt reflected the spirit of early prewar British

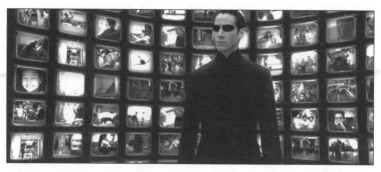

Fig. 30

Fig. 31

experiments with the medium. Here, television is depicted as one of the technological enhancements that brings man from the barbarian dark ages into a new era of enlightenment over which will preside the Engineers. By the time we get to George Orwell's *1984* (1949), television is more clearly associated with the power of the state – a medium of surveillance and propaganda. As we see Neo standing in front of the wall of video monitors, one cannot help recall as well the moment in Nicolas Roeg's *The Man Who Fell to Earth* (1976) when the alien played by David Bowie watches and comprehends dozens of television sets playing at once, sucking up information about us at an alarming rate.

Here, the camera is fascinated with the images within images displayed on all of those monitors, zooming into one screen, as if each new shot was embedded within the last. The characters, however, pay them almost no attention. The Architect is largely indifferent to what television might teach him about his human subjects who he has reduced to cold calculations and mathematical formulas. If this image bank constitutes a city of bytes, it is a ghost town.

The final shot of *The Matrix: Revolutions* (fig. 31) depicts a city skyline engulfed in a halo of bright light and surrounded by the vivid pastel colours of a sunrise. The DVD titles this last chapter 'Freedom and Sunlight', capturing both the emotional and physical quality of this image. Vivian Sobchack has talked about the 'nostalgic' quality carried by similar scenes of empty, open and natural spaces at the end of earlier science fiction films – especially the final moments of *Blade Runner* when Deckard (Harrison Ford) has escaped the crumbling city (see 1987: 267). The lush greens of the city park contrast sharply with the lurid greens of the digital characters that have opened the film, suggesting a return from the synthetic into the natural. The painted skies and the sunlight contrast with the

darkened skies and the glistening glass buildings, which in turn contrast with earlier shots of the city in ruins. In comparison with the enclosed spaces we saw earlier in the film, the space is open, allowing complete freedom of movement. Humans are at last at liberty to rebuild their society on their own terms, working in harmony with the machines, rather than struggling for control over the planet. Lest we miss the message, the scene is viewed through the eyes of the young South Asian girl (Tanveer K. Atwal) and the ageing Oracle (Mary Alice), both reflecting in different ways the future of human civilisation, even though neither of them is themselves human.

In the end, the fragments of this chapter are contradictory, evoking competing yet contrasting myths of the city that run through the science fiction tradition. *The Matrix* raids and then jams our memory banks – inviting us to Look Backwards at Things to Come. As I have suggested elsewhere, the film was designed to be dismantled and reassembled by its fans, each with their own blueprint or curriculum within which these pieces make sense. It is less a text designed to be read and more a work designed to be deciphered.

NOTES

1 For further discussion of the relevance of Lynch's concept of the 'image of the city' to the analysis of media representations, see Jenkins 2001.

2 See also my discussion of the *Matrix* franchise as a transmedia narrative in Jenkins 2006.

WORKS CITED

Bellamy, E. (1967) *Looking Backward*. Cambridge, MA: Belknap Press.

Bruno, G. (1990) 'Ramble City: Postmodernism and *Blade Runner*', in A. Kuhn (ed.) *Alien Zone I: Cultural Theory and Contemporary Science Fiction*. London: Verso, 183–95.

Bukatman, S. (2003) *Matters of Gravity: Special Effects and Supermen in the 20th Century*. Durham: Duke University Press.

de Certeau, M. (1974) *The Practice of Everyday Life*. Berkeley: University of California Press.

Desser, D. (1999) 'Race, Space and Class: The Politics of Cityscapes in Science-Fiction Films', in A. Kuhn (ed.) *Alien Zones II: The Spaces of Science Fiction Cinema*. London: Verso, 80–96.

Jameson, F. (1980) 'SF Novels/SF Film', *Science Fiction Studies*, November, 319–22.

_____ (1984) 'Postmodernism, or the Cultural Logic of Late Capitalism', *New Left Review*, July–August, 53–94.

Jenkins, H. (2001) 'Tales of Manhattan: Mapping the Urban Imagination Through Hollywood Film', in L. Vale and S. Bass Warner (eds) *Imaging The City: Continuing Struggles and New Directions*. Center for Urban Policy Research, 179–212.

_____ (2006) *Convergence Culture: Where Old and New Media Collide*. New York: New York University Press.

Kuhn, A. (1999) 'City Spaces', in A. Kuhn (ed.), *Alien Zone II: The Spaces of Science Fiction Cinema*. London: Verso, 73–9.

Lynch, K. (1960) *The Image of the City*. Cambridge, MA: MIT Press.

Mitchell, W. (1995) *City of Bits: Space, Place and the Infobahn*. Cambridge, MA: MIT Press.

Place, J. A. and L. S. Peterson (1976), 'Some Visual Motifs of *Film Noir*,' in B. Nichols (ed.) *Movies and Methods Volume 1*. Berkeley: University of California Press, 325–38.

Sobchack, V. (1987) *Screening Space: The American Science Fiction Film*. New Brunswick: Rutgers University Press.

Turkle, S. (2006) *The Second Self: Computers and the Human Spirit*. Cambridge, MA: MIT Press.

Williams, R. (1990) *Notes on the Underground: An Essay on Technology, Society and the Imagination*. Cambridge, MA: MIT Press.

14 THE SOUND OF THE CITY: CHINESE FILMS OF THE 1990s AND URBAN NOISE

Elena Pollacchi

This chapter addresses the significance of the eruption of sound, in particular urban noise, in Chinese films of the 1990s.[1] The city space has played an increasing role in Chinese cinema since 1988–90 when a first set of city films was produced and, since privatisation of the national studio system began in 1994, most production companies have been based in Beijing and Shanghai.[2]

Since the mid-1990s, natural sound, as an alternative to or in combination with dubbed dialogues, has accompanied changes in film production structures, the newly permitted right to shoot on location and the introduction of digital technologies in Chinese filmmaking. Sound in films thus seems to articulate a crucial discourse on Chinese society, moving away from the controlled tradition of state studios while recalling the fascination of the film pioneers for urban space. Early sound cinema in Europe and elsewhere often associated city space with technological development and machines, so that noise and speed became two essential facets of the modern metropolis. In the fast-paced Chinese cities of the twenty-first century, the overwhelming and intertwined flow of images and noise – often echoing from public to private spaces, from mass scale (advertisements, street-signs and so forth) to individual scale (mobile phones, I-Pods and so on) – is necessarily captured by any sort of visual technology.

However, sound, as it is used in contemporary films, bears witness not only to the modernising efforts and the striking development of Chinese metropolises but also to some of the less glorious aspects of the process of modernisation, such as the demolition of traditional urban housing, the moving of entire residential quarters to suburban districts, the closing down of industrial areas and related labour issues. A significant example is provided by Wang Bing's documentary *Tiexi qu* (*West of Tracks*, 2001), in which the thrilling combination of images and natural sound portrays the collapse of the socialist core relationship between workers and the factory.

Furthermore, sound appears as a feature that strongly marks any representation of city space and is one of the key elements through which the complexity of the contemporary Chinese film scene can be approached. In addition to Wang Bing's work, a discussion of several fiction films of the 1990s will exemplify the evolution of the cinematic representation of urban space through its soundscape. In fact, since the 1990s the city has imposed itself on Chinese screens through the combined effect of images and sound, often conceived as elements of a dialectical relationship. This is in striking contrast with the previous tradition of state studio production that, since the nationalisation of the Chinese film industry in the early 1950s, left out any natural sound in order to emphasise, through dialogue and music, the ideological message.[3]

Whether bringing in the noise of an industrial area in the process of being demolished as in *Tiexi qu* or, in contrast, promoting sound in connection to the glamorous urban lifestyle,[4] contemporary Chinese films have displayed a variety of soundscapes together with equally significant visual landscapes. The analysis of sound, therefore, can address changes in film production and, moreover, point to significant issues like language and dialects, which further enhance the representation of urban life in contemporary China, as in Wang Guangli's film *Heng shu heng* (*Go for Broke*, 2001) discussed in the final section of this chapter.[5]

The Evolution of Urban Noise

Novels and films have described the modern city as the site *par excellence* of technologies and machines, and so as a place of growing noise, so that the modern urban landscape has been characterised not only by its visual but also by its sound elements.[6]

In Émile Zola's Rougon-Macquart cycle of novels, stations and trains, in *La Bête Humaine* (*The Human Beast*, 1890), as well as market places, in *Le Ventre de Paris* (*The Fat and the Thin*, 1873), epitomise the core of modern society. The first lines of *Le Ventre de Paris* anticipate the noise of the huge market of Les Halles that will feed the urban population at the awakening of the city:

> Amidst the deep silence and solitude prevailing in the avenue several market gardeners' carts were climbing the slope which led towards Paris, and the fronts of the houses, asleep behind the dim lines of elms on either side of the road, echoed back the rhythmical jolting of the wheels. At the Neuilly bridge a cart full of cabbages and another full of peas had joined the eight wagons of carrots and turnips coming down from Nanterre; and the horses, left to themselves, had continued plodding along with lowered heads, at a regular though lazy pace, which the ascent of the slope now slackened. The sleeping waggoners, wrapped in woollen cloaks, striped black and grey, and grasping the reins slackly in their closed hands, were stretched at full length on their stomachs atop of the piles of vegetables … And all along the road, and along the neighbouring roads, in front and behind, the distant rumbling of vehicles told of the presence of similar contingents of the great caravan which was travelling onward through the gloom and deep slumber of that matutinal hour, lulling the dark city to continued repose with its echoes of passing food. (2004: 10)[7]

At a different and more personal level, in Fernando Pessoa's *Livro do Desassossego por Bernardo Soares* (*The Book of Disquiet*, 1982), the first-person narrator perceives his existential *malaise* through the sound of his own body which echoes the ceaseless noise of Lisbon in the 1930s, at a time in which the city was undergoing huge changes in its social and urban structures:

> In what seems to me like a slumber
> There is always a sound of the end of all things
> The wind in the darkness, and, if I listen closely,
> The sound of my own lungs and heart. (2003: 242)[8]

The association between an increasing, often imposing, noise and the modern metropolis can also be found in many Chinese literary works in which noise is an overwhelming element in descriptions of modern urban life. Serial novels like *Shisheng* (*The Sound of the City*) by Ji Wen, published by the Commercial Press in 1908, and urban love stories of the Mandarin Ducks and Butterflies school of fiction (*yuanyang hudie pai*), in particular works by Zhou Shoujuan (*Liushengji pian/A Gramophone Record*, 1921),[9] highlighted the newness of urban sound as a feature of modernity. Later works by Mao Dun, such as *Ziye* (*Midnight*, 1933), which openly referred to Zola's naturalistic social analysis to discuss Shanghai urbanities inevitably deal with sound as an essential element of the cityscape (see Chung 2003: 405–10; Zhang 1996: 117–53; Zhang 1998: 173–87).

Yet, the importance of sound can be traced much earlier in history. Art historian and critic Wu Hung noted how architectural analysis rarely mentions sound, despite it being intrinsically connected to city life. The announcement of the time for closing the city gates, for example, is an action that affects access to the city and is one of the functions attributed to clock towers in European medieval towns, as well as to drum towers in Beijing. Not by chance, drum towers were the most visible buildings in the Yuan (1279–1368), Ming (1368–1644) and Qing (1644–1912) dynasties.[10]

In everyday life an image rarely comes to mind without being associated to sound and, since its invention, cinema has attempted to reproduce this common situation. Since Thomas Edison's phonograph of 1877, which used wax cylinders as sound support, the possibility of recording moving images aimed at a synchronised reproduction of sound. As is well known, silent films were usually accompanied by live music but, from the late 1920s, synchronised sound films took over the scene, first in the US and in Europe. In the early decades of the twentieth century a similar evolution took place in China, while the modernising city – in particular Beijing and Shanghai – became the centre of a critical debate and was discussed as a site of contrasting forces, of virtues and vices.[11] The film industry flourished in 1920s Shanghai, but only in 1931 were the first sound films released, among them Zhang Shichuan's *Genü Hongmudan* (*Sing-Song Girl Red Peony*, 1931).[12] Sue Tuohy discusses how, as early as the 1930s, commercialisation of film music had become part of the film industry in a way not dissimilar to today's merchandising of soundtracks (see 1999: 209–10). Although such technological developments at first had some negative implications (sound equipment became so cumbersome that actors' movements had to be limited, and acting consequently became less natural), the introduction of sound marked a point of no return in world film history and silent films inexorably declined everywhere.[13] Chinese films of the mid-1930s such as Cai Chusheng's *Xin nüxing* (*Modern Woman*, 1935), Shen Xiling's *Shizi jietou* (*Crossroads*, 1937) and Yuan Muzhi's *Malu tianshi* (*Street Angels*, 1937) among others, attempted to recreate the noise of the city (streets with trams and vehicles, whistles of factories, ships, and so on) to enhance the experience of the modern metropolis, demonstrating how sound vividly contributed to the representation of city life.[14]

This tendency in the use of sound underwent a dramatic reversal after 1949 because the nationalisation of the film industry forced cinema off the streets and into the premises of film studios and resulted in cinematic representations that lost contact with the actual city space. Shooting on location was discouraged as was the recording of natural sound, all in order to highlight the political message that film creation should promote.

Technical experimentation during the decades of state production had to struggle with overwhelming political pressures, of varying degrees of severity according to the period. Even in the later works by Zhang Yimou, Chen Kaige and the directors of the Fifth Generation, active since the end of the 1980s, a real challenge to this consolidated tradition of polished sound was limited to some experimentation in the use of music and silence, in particular in Chen Kaige's *Huang tudi* (*Yellow Earth*, 1984) and *Bianzou bianchang* (*Life on a String*, 1991) (see Zhang 1997; Silbergeld 1999). Only in the 1990s, thanks to the combined effect of the changes in the film industry, the upsurge of private companies, the accessibility of digital technologies and the introduction of new censorship regulations, the sound of the city has re-appeared as a striking feature in Chinese cinema, raising significant issues for analysis.

Soundscapes of Increasing Urban Noise

As early as 1996, Zhang Yingjin confirmed the importance of the city in Chinese modern culture by analysing the variety of urban explorations in literature and films. Zhang emphasised the importance of combining perceptual and personal experience of a city, often derived from some prior knowledge of it through a map or a guide book, with the 'frequent adjustment and correction' needed during the actual exploration (Zhang 1996: xv).[15] The variety of contemporary urban representations seems to respond to the artists' need to readjust their own experience in the light of the fluid space of Chinese contemporary metropolises (see Davis *et al* 1995; Chen *et al* 2001). A set of examples can better illustrate the process.

Xie Jin's *Mumaren* (*The Herdsman*, 1983), a well-known title produced five years into the reform era launched by Deng Xiaoping in 1978, anticipates the interest in urban space of later films but still uses sound in the tradition of state studio productions. *Mumaren* is set in Beijing and on the Mongolian plain. It evolves around a father/son relationship sundered by the Communist victory in 1949. The father was, in fact, a wealthy businessman who escaped to the US during the Civil War and there pursued his career and built a new family. As a consequence of his bad class background, the son was sent to Inner Mongolia during the Cultural Revolution (1966–76) and had to adapt to harsh rural life. After many difficulties, the son comes to perceive that the post-Mao policy of reform can bring the nation and the future of his family towards some positive goals. The father manages to come back to China and arranges to meet his son in Beijing, but the son refuses his invitation to follow him to the US since he has decided to participate in the Chinese reforms. The film obviously encourages the viewers to support Deng Xiaoping's policy.

Xie Jin's post-Cultural Revolution films, frequently referred to as 'political melodrama', combined political message with an interest in everyday life (see Xie 1998; Zhang 2002: 230), and *Mumaren* was no exception. But despite its ideological input, which fitted in with the Chinese Communist Party (CCP) agenda of the time, the film should not be addressed simplistically as a 'propaganda film', since, as in most of Xie Jin's works, clear-cut distinctions between 'positive' and 'negative' characters tend to be elusive. As for sound, *Mumaren* combines long dialogue sequences with music. A key-sequence is set in the father's hotel room with a wide window looking onto a Beijing avenue. The sequence starts with a subjective shot of the father who is looking down from the window at the few cars driving along the big road. The background noise of the traffic is clearly

perceived until the first cut in the sequence takes the action back to the room. Then the father comments on the changes undergone by the capital while he was abroad; as he looks outside in thought, the background noise of the city vanishes, disappearing for the rest of the sequence in order to guarantee full attention to the words pronounced in the room. Interestingly, the conversation between father and son is not spoken but mediated through a written letter which the son is writing in the hotel room as the father is looking at the city out of the window. The son's statements are uttered by a voice-over that makes the switch between background noise and spoken words even more abrupt. Despite the fact that the change between different treatments of sound would be unacceptable to a contemporary viewer, Xie Jin's films of the 1980s laid the basis for later developments, and their portrayals of aspects of daily life constitute a first attempt to bring Chinese cinema back to life after the breakdown of film production during the decade of the Cultural Revolution.

Among the world-famous directors of the Fifth Generation, Zhang Yimou provided one of the most vivid visual and sound representations of contemporary Beijing. After his first titles set in the countryside and in an unspecified past (*Hong gaoliang/Red Sorghum*, 1987; *Ju Dou*, 1989; *Da hong denglong gaogao gua/Raise the Red Lanterns*, 1991), *You hua haohao shuo (Keep Cool*, 1996) captures the frenetic pace of the Chinese capital. The roaring sound of an engine struggling to switch off anticipates the first images of the film. Nothing more than sounds, voices and noise introduce the location, then a loudspeaker announcement prompts the viewer to think that the film is going to open on a bus. From its first shots, *You hua haohao shuo* features fast-paced editing, bright colours, music and plenty of noise. The hand-held camera follows the female protagonist who is trying to avoid meeting her former boyfriend. The latter chases the girl on the bus, then rushes on a stolen bicycle, passing the gate of the Forbidden City, and follows her until she reaches her flat in one of the high apartment buildings which used to dominate the Beijing cityscape before the new skyscrapers took over the skyline. The background noise of the city of the first sequence leaves space for a Chinese song by rock star Cui Jian, which will only fade out when the chase sequence ends. Finally, at the doorstep of the apartment building, the protagonist hires a peddler (played by Zhang Yimou himself) to cry out the girl's name. Such a kaleidoscopic set of images and sounds establishes the central motif of the film: a fast-paced Beijing narrated through an unstable love relationship and a difficult working life, both emblematic issues of human relations in a metropolis increasingly preoccupied with professional competition and the search for wealth. *You hua haohao shuo* achieves a sonic and visual impact by mixing the daily noise of the metropolis with popular music. Such a complexity of flashy images and sound was obtained by careful post-production work, indicative of improved sound technologies and strong financial support.

Li Yu's *Fish and Elephant (Jinnian xiatian*, 2001) presents an equally rich soundscape, although achieved within a much smaller production structure. The film is shot in 16mm and depicts the difficult relationship between two girls in Beijing. Here, natural sound enhances the realism of scenes of daily life and is related to the location shooting. The film opens with one of the two girls engaged in a conversation on a public phone. Only with the help of subtitles can the conversation be understood, since the girl's voice is almost inaudible, covered as it is by the traffic noise. Similar events occur in the film when scenes were shot in public places regardless of official permission and censorship

regulations, mostly with real people acting as themselves. Due to budget limitations, post-production work could not be as refined as in Zhang Yimou's film, so that natural sound and background noise often cover the film's dialogue, resulting in a disorienting effect. At the same time, the film achieves a proximity to the narrative subject and the location, which allows the filmmaker and the viewer to engage with the actual situation in which the shooting takes place. Like Li Yu, many young filmmakers active since the late 1990s have pushed the representation of Chinese cities close to the actual experience of a visitor who first enters the metropolitan space. In such productions, details of everyday life slip into the shots: dress codes, youth slang or local dialect, and real people on the street become part of a cinematic concept that encompasses vision and sound.[16]

Soundscapes and Social Change: the Documentary *Tiexi qu* (*West of Tracks*)

The nine-hour long documentary *Tiexi qu* offers one of the most compelling examples of interaction between digital cinema and the changes underway in a shooting location. In this instance, the setting is the Tiexi district near Shenyang, Liaoning province, long a major Chinese industrial centre, with a population of around one million workers at the beginning of the 1980s. Under the Japanese occupation, heavy industry was strongly developed in the region. In 1934, as part of the Manchukuo state, the area began producing armaments for the Japanese Imperial Army. Tiexi district factories were converted to civilian use after 1949 and became crucial centres for the production of steel and other materials. In the 1950s the factories received Soviet equipment, mostly confiscated from Germany at the end of the war, and the place hosted Soviet-financed industrial projects. It experienced a first decline with the breakdown of Sino-Soviet relations in 1964, when many factories were relocated to internal spaces although more than one hundred plants remained in operation. At the end of the Cultural Revolution, when the workers sent to the countryside returned to urban sites, over a million were employed in Tiexi. Only in the 1990s did the place begin to falter, with production becoming unprofitable, and at the end of the decade many factories were shut down and progressively dismantled. The de-commissioning of the area was announced in 1999 and completed in 2002. Wang Bing's work documents this three-year long process.[17]

Each of the three sections opens with an introductory title providing basic information on the area. An off-screen industrial noise accompanies the opening texts. Such noise provides the *continuum* against which the whole work unfolds, thus creating a sort of natural intradiegetic soundtrack, whose notes change according to the progressive de-commissioning of the area. As soon as the opening titles disappear, the viewer is introduced to the Tiexi district by the freight train's whistle. Wang Bing's camera manages to address contemporary social issues very poignantly while recalling a sort of modernist drive towards exploration of technical devices and faraway realities. The exploration of the industrial space pushes the viewer to engage with workers' lives while the railway journey opening the film is used as a narrative motif throughout the three parts of the documentary. Each section is dominated by a distinct typology of sound: the noise of the freight railway and the factory machinery in the first, *Rust*; the sounds of the public gatherings in *Remnants*; and the noise of trains in the last part, *Rails*; but all three parts end in silence, marking the success of the dismantling process.

The sound of *Tiexi qu*, recorded live and rarely reworked in post-production, evolves through the three parts and contributes to the entire cinematic process of creating a social and historical memory. However, the soundtrack is never simply juxtaposed with the images as a fictional and emotional device but is part and parcel of the evolution of the context the filmmaker interacts with, a context in which several factors (economy, urban architecture, social life and so forth) play significant roles.

Thanks to the potential of digital technology, which allows longer takes in comparison to traditional techniques, and imposes fewer requirements in terms of space and lighting, the final result is an unusual viewing experience. Moreover, the use of digital cameras allowed Wang Bing to record such a long process with limited costs, an enterprise that would have been unaffordable if undertaken with traditional 35mm or 16mm film techniques. It also granted the director the possibility of a closer and less intrusive participation in the daily life of the people of Tiexi district, while the absence of a voice-over and the presence of the author restrained to the off-screen space, help the viewer to engage with the cinematic experience.

Wang Bing challenges the general assumption that documentary cinema is just a 'representational form', a recording of events, and involves his process of filmmaking with an articulation of time and space which encompasses documentary and fiction and in which natural sound plays an essential function.

Urban Soundscape and Language Issues: *Heng shu heng* (*Go for Broke*)

Heng shu heng combines documentary and fiction, while taking advantage of the aesthetic implications of shooting on location. Privately produced by the company Eastline Film Studio with a minor contribution from the Shanghai Film Studio, *Heng shu heng* is set in Shanghai and was shot in only twelve days in 1999, with a limited budget of 90,000 USD.[18] In his second feature, director Wang Guangli develops a personal style in which the use of cinematic devices such as jump-cuts,[19] combined with a documentary style and the shooting on external location, create an original portrait of contemporary Shanghainese life. Dialects and live-recorded sound are used to point up the social issue of laid-off workers. Moreover, a subtle irony underlies the narrative so as to encourage a sympathetic attitude towards the protagonists, played by real people who first experienced the events narrated in the film between 1994–98.

The film opens in daylight, as the hand-held camera enters a brand new apartment, still unfurnished. Only thanks to the introductory captions and credits do we understand that the location is Shanghai: were it not for that, the empty interior could be located in any other city of the world. Off-screen dialogue confirms that the story is set in China but the language heard is not the conventional *putonghua*, the official language spoken in most films produced since 1949, but Shanghainese dialect. A young man and his girlfriend are talking loudly between rooms; they are arguing about a lottery ticket left in the pocket of the trousers the girl has just washed. The following sequence then introduces the protagonist of the film while the opening credits unfold. The first shot is located in a factory space, followed by a shower area where a worker is seen getting ready to exit his workplace. While the pre-credits sequence aimed at setting the authenticity of the situation by explicitly informing the viewers that what they were going to see was based

on real events, the series of jump-cuts on the worker's actions highlights the fictional aspect of the film. What *Heng shu heng* announces from its early sequences is a sort of 'life re-enacted', calling in the fictional and reproductive device of cinema to re-tell the story its protagonists have experienced in life. As the worker comes out of the factory, the camera looks onto the shipyard in the Shanghai harbour. A subtitle, of the type used in documentary films, provides the viewer with the basic data related to the protagonist Zhang Baozhong, a worker laid off from the Jinan Factory, who has just completed his last day of work there. His secure state employment is now over.

From these first sequences sound emerges as a striking and essential feature of the film. The disturbing, loud noise of the factory decreases as Zhang Baozhong leaves the workplace and walks out into the harbour, where a song is heard from the loudspeakers. It is a political song of the early 1990s and praises the policies of leader Deng Xiaoping and former PRC President Jiang Zemin in creating 'a bright future of prosperity for everybody', as the song's lyrics recite. In the film, music is often intradiegetic, produced from sound sources in the scene, thus forming an integral part of the narrative, rather than being used as an external commentary. Such a use of intradiegetic music ironically recalls the days when masses of workers used to sing well-known songs in support of the Communist Party, and not by chance the songs' lyrics refer to Wang Ping's *Dongfang hong* (*The East is Red*, 1965), a large-scale epic of music and performances praising the CCP, completed just before the launch of the Cultural Revolution. This same song re-appears towards the end of the film, once the protagonist has undergone several twists and turns in his new career as a self-employed businessman. Two elderly ladies in a retirement house sing the song, thus suggesting that the concept of prosperity encouraged in the lyrics was never actually experienced by most Chinese state-employed workers.

After the protagonist Zhang Baozhong, five more laid-off workers enter the scene. They will all be part of Zhang Baozhong's new project: the Jinxing Company, an interior decoration company whose head office and shop are soon to be established as a response to the lack of state employment. Obviously, the new enterprise faces the challenges and the risks of the private market so that a providential gain at the lottery would solve all difficulties.

Interestingly, both *Heng shu heng* and *Tiexi qu* refer to the welfare lottery as a crucial event: a state business first launched in 1998 in Shanghai and then widely encouraged by the government nationwide through public fairs, shows and dedicated television programmes. The third part of *Tiexi qu* opens in one of the public fairs related to the lottery in the northern area of Liaoning, whereas *Heng shu heng* entirely revolves around the lottery craze. The film's epilogue brings back the young couple first seen discussing lottery tickets in the opening sequence. The man, who is by now recognised as one of Zhang Baozhong's workers, finds out that his ticket is a winning one. He shouts the news aloud to his girlfriend as she is performing a restrained strip-tease show at an improvised entertainment venue. With an ironic approach towards life and society, *Heng shu heng* highlights how traditional concepts of teamwork and mutual support have now been adapted to market needs.

The 'model labourer' portrayed by many films of the 1950s and 1960s is now only part of a historical memory, and the interest in social issues variously shown by Wang Bing's documentary and Wang Guangli's docu-drama is also part of a marginal discourse within contemporary filmmaking. The evolution in the use of sound and the different

kinds of soundscapes discussed in this chapter contribute, in particular, to the addressing of social issues and to engagement with the historical and social context. However, the development of shooting and post-production technologies is rapidly allowing accuracy in sound recording, regardless of the kind of production structure and financial support filmmakers can rely on. Yet, the combination of sound and images opens up a wide range of possibilities to relate to the transformation of Chinese urban space, often associating contrasting values to contemporary life, a life dominated by the ceaseless noise of the metropolis.

NOTES

1 All films quoted in the text are indicated with their official or conventional English title, with the original Chinese title according to the *pinyin* transcription.
2 A set of titles is frequently quoted as evidence of the booming of city films in 1988–90: Sun Zhou's *Gei kafei jia dian tang* (*Add a Little Sugar to the Coffee*, 1988); Tian Zhuangzhuang's *Yaogun qingnian* (*Rock Kids*, 1989); Zhou Xiaowen's *Fengkuang de daijia* (*Price of Madness*, 1988) (see Kuoshu 2002: 277–82). *Taiyang yu Sunny Rain* (*Sunny Rain*, 1988) by Zhang Zemin, is set in Guangzhou, not by coincidence a Special Economic Zone and one of the richest and more advanced cities. Moreover, all titles adapted from Wang Shuo's urban stories (see Wang 1995; Noble 2003) were quite successful in the same years: Mi Jiashan's *Wanzhu* (*Masters of Mischief*, 1988); Huang Jianxin's *Lunhui* (*Samsara*, 1988); Xia Gang's *Yiban shi haishui, yiban shi huoyan* (*Half Brine, Half Flame*, 1989) (see Wang & Barlow 2002: 44–6).
3 The sparkling Chinese film scene of the 1930s, with Shanghai at its core, was brought to a halt by the Japanese attack on Shanghai in 1932 and later saw an increasing politicisation that culminated in the victory of the Chinese Communist Party (CCP) in 1949. The CCP prompted a nationalisation of the film industry and labelled as bourgeois and capitalist-oriented most of the films produced in Shanghai so that the city almost disappeared from Chinese screens for several decades (see Pollacchi 2001).
4 Two titles, not analysed in detail in this chapter, exemplify a possible use of sound in commercially oriented film production focused on city lifestyle. In Feng Xiaogang's *Shouji* (*Cell Phone*, 2004), a range of ring-tones constitutes an important motif in the film. This is also related to the growing phenomenon of product-placement in Chinese cinema, since Motorola used the film to launch a range of mobile phones. In Zhang Yuan's *Lücha* (*Green Tea*, 2003), hotel lobby music is also a significant sound element. The film is adapted from a short story by Jin Renshun, *Shuibian de Adilina* (*Adilina by the River*, 2002), whose title refers to the popular piano piece *Ballade pour Adilina* by Richard Claydermann, very often played as background music in Chinese hotel lobbies (from a personal communication with Zhang Yuan in Beijing, January 2005).
5 Sheldon Lu and Cui Shuqin addressed the language issue at the symposium 'From Past to Future: 100 Years of Chinese Cinema' (College of Staten Island, 24–25 October 2005) with specific reference to the cinema of Jia Zhangke.
6 For a discussion on the modern city in film and literature in the West, see Lehan 1998 and Rohdie 2001.
7 The quotation is taken from the English translation.

8 The quotation is taken from the English translation.

9 Zhou Shoujuan was also one of the editors of the Shanghai popular magazine *Libailiu* (*Saturday*), contributing to the Shanghai star-system of the 1920s and 1930s. For an analysis of the Mandarin Ducks and Butterfly school of fiction see Link 1981.

10 During the seminar 'Public Criticism and Visual Culture' (Hong Kong University, 3–14 June 2002), Wu Hong discussed the relationship between sound and representations of the city. On the same topic, see Landes 1983: 15–52 and Wu 1997.

11 For a cross-cultural analysis of the complex discourse on modernity in the West and in China see Hockx and Lee, both 1999. In this article the expression 'modern metropolis' is used to address the context in which the Chinese film industry developed in the 1920s and 1930s.

12 *Sing-Song Girl Red Peony* is usually discussed as the first Chinese sound film, however the film was synchronised by means of a Phonograph (see Zhang & Xiao 1998: 17, 305–06; Tuohy 1999: 203–5).

13 For the evolution of sound recording see Hayward (2000: 332–5). Among film studies, Altman 1992 and Chion 1990 are specific to sound analysis. For Chinese film studies see Hu & Li 1997; Yao & Sun 2002.

14 *A Modern Woman* presents a special case. The negative of the film was restored in 2005 as part of the Italian project, 'The Secret History of Chinese Cinema', developed by La Biennale di Venezia and Prada Foundation, in which I collaborated. The curator of the restoration, Nicola Mazzanti, suggested that the available soundtrack, full of urban noise and dialogue, might not be the original but a dubbed one, probably added in later decades. The film in its original state was likely to have had a combination of songs and sounds that could be played during the screening, as was common practice in the transition from silent to sound films. Whatever the case, the film strongly relies on urban views and city images, so that one can speculate that urban sounds might also have predominated in the original sound components.

15 Zhang (1996) analyses the evolution of the representation of the city along Chinese cultural history from the early decades of the twentieth century to the films of the Fifth Generation produced in the late 1980s. Zhang (1999) more specifically discusses the relationship between Shanghai urban space and pre-revolutionary cinema (1922–43).

16 For a discussion of Li Yu's *Fish and Elephant*, digital and independent Chinese films of the 1990s, see Cui 2002 and 2005.

17 For a more in-depth analysis of Wang Bing's *Tiexi qu*, see Pollacchi 2005. See also Burdeau 2004 and, on the documentary movement in China, Lü 2003.

18 From a personal communication with director Wang Guangli and producer Cory Vietor (Beijing, December 2003).

19 The use of jump-cuts (edited shots within an angle shorter than 30°) was widely explored by the French *Nouvelle Vague* in the 1960s and opposed the cinematic rule of 'transparency', thus emphasising not only the fictional situation, but also the camerawork.

WORKS CITED

Altman, R. (1992) *Sound Theory, Sound Practice*. New York: Routledge.

Burdeau, E. (2004) 'Eloge de *Tiexi qu*' ('In praise of *Tiexi qu*'), *Cahiers du Cinéma* 586, 34–6.

Chen, N. N., C. D. Clark, S. Z. Gottschang and L. Jeffery (eds) (2001) *China Urban: Ethnographies of Contemporary Culture*. Durham: Duke University Press.

Chion, M. (1990) *L'Audio Vision*. Parigi: Editions Nathan.

Chung, H. (2003) 'Mao Dun, the Modern Novel, and the Representation of Women', in J. S. Mostow (ed.) *The Columbia Companion to Modern East Asian Literature*. New York: Columbia University Press, 405–10.

Cui, Z. (2002) *Diyi guanzhong (The First Audience)*. Beijing: Xiandai chubanshe.

____ (2005) 'Il cinema digitale: le prime immagini libere' ('Digital cinema: the first free images'), in M. Müller and E. Pollacchi (eds) *Ombre Elettriche: Cento anni di cinema cinese 1905–2005*. Milano: Electa, 168–75.

Davis, D. S., R. Kraus, B. Naughton and E. J. Perry (eds) (1995) *Urban Spaces in Contemporary China*. Cambridge and New York: Woodrow Wilson Center Press and Cambridge University Press.

Hayward, S. (2000) *Cinema Studies: The Key Concepts*. London: Routledge.

Hockx, M. (ed.) (1999) *The Literary Field of the Twentieth-Century China*. Richmond: Curzon Press.

Hu, J. and X. Li (1997) *Zhongguo wusheng dianying (Chinese Silent Cinema)*. Beijing: Zhongguo dianying chubanshe.

Kuoshu, H. H. (2002) *Celluloid China: Cinematic Encounters with Culture and Society*. Carbondale, Il: Southern Illinois University Press.

Landes, D. (1983) *Revolution in Time*. Cambridge, MA: Harvard University Press.

Lee, L. O. (1999) *Shanghai Modern: The Flowering of a New Urban Culture in China, 1930–1945*. Cambridge, MA: Harvard University Press.

Lehan, R. (1998) *The City in Literature: An Intellectual and Cultural History*. Berkeley: University of California Press.

Link, P. (1981) *Mandarin Ducks and Butterflies: Popular Fiction in Early Twentieth-Century Chinese Cities*, Berkeley: University of California Press.

Lü, X. (2003) *Jilu Zhongguo: Dangdai Zhongguo xin jilupian yundong* (Recording China: Contemporary Chinese New Documentary Movement). Beijing: Shenghuo dushu xinzhi sanlian shudian.

Noble, J. (2003) 'Wang Shuo and the Commercialization of Literature', in J. S. Mostow (ed.) *The Columbia Companion to Modern East Asian Literature*. New York: Columbia University Press, 598–603.

Pessoa, F. (1982 [1932]) *Livro do Desassossego por Bernardo Soares*. Lisboa: Ática.

____ (2003) *The Book of Disquiet*, trans. R. Zenith. London: Penguin.

Pollacchi, E. (2001) 'Paesaggi urbani: lo sguardo del cinema sulla città' ('Urban Landscapes. Cinema and the City'), in *QA: Quaderni dell'Amicizia*. Roma: Associazione Italia-Cina, 63–76.

____ (2005) '*Tiexi qu: West of Tracks*. Un'opera emblematica per un approccio interdisciplinare al cinema cinese contemporaneo' ('*Tiexi qu: West of Tracks*. A Multidisciplinary Approach to Contemporary Chinese Cinema'), in M. Scarpari and T. Lippiello (eds) *Caro Maestro ... Scritti in onore di Lionello Lanciotti per l'ottantesimo compleanno*. Festschrift. Venezia: Marsilio, 951–63.

Rohdie, S. (2001) *Promised Lands: Cinema, Geography, Modernism*. London: British Film Institute.

Silbergeld, J. (1999) *China into Frame: Frames of Reference in Contemporary Chinese Cinema*. London: Reaktion Books.

Tuohy, S. (1999) 'Metropolitan Sound: Chinese Film Music of the 1930s', in Y. Zhang (ed.) *Cinema and Urban Culture in Shanghai*. Stanford: Stanford University Press, 200–21.

Wang, J. and T. Barlow (eds) (2002) *Dai Jinhua. Cinema and Desire*. London: Verso.

Wang, S. (1995) *Wang Shuo wenji (Collected Works)*. Beijing: Huayi chubanshe.

Wu, H. (1997) 'The Hong Kong Clock – Public Time-Telling and Political Time/Space', *Public Culture*, 9, 329–54.

Xie, J. (1998) *Wo dui daoyan yishu de zhuiqiu (My Pursuit in Film Directing)*. Beijing: Beijing dianying chubanshe.

Zhang, X. (1997) *Chinese Modernism in the Era of Reforms: Cultural Fever, Avant-garde Fiction and the New Chinese Cinema*. Durham: Duke University Press.

Zhang, Y. (1996) *The City in Modern Chinese Literature and Film: Configurations of Space, Time and Gender*. Stanford: Stanford University Press.

_____ (1998) *China in a Polycentric World. Essays in Chinese Comparative Literature*. Stanford: Stanford University Press.

_____ (1999) (ed.) *Cinema and Urban Culture in Shanghai, 1922–1943*. Stanford: Stanford University Press.

_____ (2002) *Screening China: Critical Interventions, Cinematic Reconfigurations, and the Transnational Imaginary in Contemporary Chinese Cinema*. Ann Arbor: University of Michigan, Centre for Chinese Studies Publications.

Zhang, Y. and Z. Xiao (eds) (1998) *Encyclopedia of Chinese Film*. London: Routledge.

Zola, E. (1956) *La Bête Humaine*. Paris: Fasquelle.

_____ (1964) *Le Ventre de Paris*. Paris: Fasquelle.

_____ (1977) *The Human Beast*, trans. L. W. Tancock. London: Penguin Books.

_____ (2004) *The Fat and the Thin*, trans. E. A. Vizetelly. Whitefish: Kessinger Publishing.

15 TRANSITIONAL SPACES: MEDIA, MEMORY AND THE CITY IN CONTEMPORARY FRENCH FILM

Isabelle McNeill

Chris Marker's film *Level Five* (1996) opens with a visual and verbal layering that puts forward a complex set of comparisons between technology, cities and collective mental representations. The camera follows the circular motion of a hand moving a computer mouse. It then moves upwards to the monitor, zooming in on a video image of a city at night until it fills the screen and blurs out of focus, as though the city-image were drawing the spectator inwards to its virtual world. Almost immediately there is a cut to a mobile image where the camera travels noiselessly along a road between high-rise buildings, illuminated by the lights of a city at night-time. This forward tracking shot is superimposed over another, immobile image of the calm, blank face of a primitive statue. Already, in the sequence and superimposition of images, analogies are suggested between the digital motion of the Internet and the buzzing circuitry of the modern metropolis. The female voice-over on the soundtrack extends this parallel between cyberspace and the contemporary city, asking us to imagine a Neanderthal man (perhaps represented by the mask-like statue) catching sight of the endless traffic, towering buildings and neon lights of the cityscape at night:

> He doesn't know how to sort out all the images which land inside his head like birds
> ... Thoughts, memories, visions. For him, it all comes down to the same thing: a kind
> of hallucination that frightens him.[1]

As contemporary city-dwellers thrust into the information age, the voice-over suggests, we are like this primitive man catching sight of an inconceivable topography, trying to comprehend it by imposing upon it our existing visions, thoughts and memories: 'the Neanderthals that we are have begun to graft their own vision, thoughts, memories'. The narrator concludes, however, that, 'none of us knows what a city is'. The implication is that while the city – with its dense circuitry, its intense centres of interaction, its archiving and construction of knowledge, its ceaseless commerce – may provide us with a model for conceiving of cyber-topographies, it remains an ever-changing mystery itself. It is historically contingent and always in transition, not least because of its interdependence with ever-evolving technologies of communication.

Marker's film anticipated a post-millennial, digital culture in which virtual spaces increasingly impinge upon city spaces in our daily lives. It is not without significance, therefore, that he chose this frame of reference for a film investigating memory and in particular setting in motion a filmic remembering of the horrific 1945 battle of Okinawa: Marker reminds us that any engagement with the past is necessarily conditioned by its

contemporary framework of spatio-temporal experience. *Level Five*'s beginning is there-fore an appropriate opening for a discussion of media, memory and the city, since it raises the question of how moving images can engage with history in the context of the twenty-first century's mediated social spaces. Itself an art-form in transition, contemporary film is inevitably permeated by the influence of digital media and information technology, on a conceptual as well as a formal level. My aim in this chapter is to shed light on some of these conceptual possibilities by mapping ways in which the shifting terrains of media, memory and the city resonate and interact with one another. In so doing I hope to offer, through examples from recent French filmmaking, fresh critical approaches to films that evoke the past through the representation of urban space. Ultimately I wish to show how a concept of transitional space, drawn from a socio-psychological engagement with D. W. Winnicott's theories (see 1980) of transitional phenomena and potential space, may be useful in considering interconnections between physical and virtual spaces in our lives.

The City as Memory Zone

Place and memory have been linked in Western thought at least since Simonides of Ceos (556–469 BC), to whom Cicero attributes the invention of a mnemotechnics based on the mental location of ideas.[2] Chris Marker has shown how memory itself can be understood as spatial, using his CD-ROM *Immemory* (1998) to attempt a 'geographical' representation of memory, accounting for its fragmentary and fluid nature in terms of disparate locations and *terrae incognitae* rather than a linear development. But it can be argued that cities are spaces bearing a particularly powerful association with memory: like memory itself, they are formed through a continual process of preservation, destruction and reconstruc-tion. Moreover, they are dense, evolving places where, as French philosopher Paul Ricœur points out, various different temporal layers are visible: 'a city confronts different eras in the same space, offering up to the gaze sediments forming a history of cultural tastes and shapes' (2000: 187). To take this further still, it can be argued that these varying archi-tectures and juxtaposed historical forms are only the visible sediment – to use Ricœur's term – of myriad lives that have inscribed their habits into the city and have housed their memories there. Cities also constitute virtual mnemonic zones where a continual activity produces a collective mental life with its own histories. The inscription of everyday move-ments within urban spaces has been discussed by Michel de Certeau in his seminal writ-ings on city space in *The Practice of Everyday Life*. He opposes the messy accumulation of quotidian movements to the overarching, panoptic viewpoint of authorities who theorise the city as a space to be made clean, orderly and functional (see 1984: 93–5). This lat-ter viewpoint he terms *la ville-concept* (the Concept-city), a notion of 'city' with its own rhetoric, which is constantly being resisted by what he calls the semantic wanderings of the city's ordinary inhabitants (see 1984: 102).[3] Though he sees this in terms of a constant dispersal and rearrangement of narrative and therefore of the memorable, nevertheless traces (or sediments) do remain in what he calls 'legend', which one might also describe as the cultural memory of the city:

> Fragments of [memory] come out in legends. Objects and words also have hollow places in which the past sleeps, as in the everyday acts of walking, eating, going to bed, in which ancient revolutions slumber. (de Certeau 1984: 108)

What is particularly suggestive here for my argument is the connection between this no-tion of material containers of memory and the mobile habits of the collective body. It evokes a crucial link between the concrete spaces of the city and the virtual zones of memory and, by extension, media. Recalling the etymology of the word habit (from the Latin *habitus*, 'demeanour, appearance, dress', originally the past participle of *habere*, 'to have, to hold, to possess'), it suggests a dual movement by which inhabitants of a city 'clothe' the space in memory at the same time as the city 'clothes' or contains them as the receptacle of their memories and therefore of a shared zone of identity. For de Certeau this represents a kind of haunting. He quotes an inhabitant of the Croix-Rousse district of Lyon to show how the 'spirit' of a place is generated between personal and collective memories:

> Memories tie us to that place ... It's personal, not interesting to anyone else, but after all that's what gives a neighbourhood its character. There is no place that is not haunted by many different spirits hidden in silence, spirits one can 'invoke' or not. Haunted places are the only ones people can live in. (Ibid.)

As lived spaces, then, cities combine the visible, concrete signs of temporal change with more intangible, spectral traces, which may or may not be invoked and which may or may not remain dormant forever. The question that arises then is how, in the age of continual flows of information and images, something as relatively fixed as a film may account for these different kinds of memory traces? In his evocative dissection of film and the con-temporary city, Stephen Barber remarks upon the continued importance of film form in the multiplying visual spaces of what he terms 'the digital city': 'alongside its powerful web of media screens, the digital city is assembled from the delicate visual and emo-tional projections of its inhabitants, and that often hallucinatory apparition of the city is pre-eminently rendered and narrated in filmic style' (2002: 156). Following on from this, I want to suggest that filmic images continue to provide a powerful means of represent-ing both actual and virtual spheres of city life, combining as they do the ability to depict environments by suggesting spatial depth and movement through different planes, with the symbolic possibilities of juxtaposing images, or sounds and images.

French Contexts

In the early years of the twenty-first century a marginal (in relation to box office) but pow-erfully insistent theme in French cinema has seen filmed city space in precisely these terms: charged with memory, more or less explicitly haunted or marked by traces of the past. In *Les Glaneurs et la glaneuse* (2000), Agnès Varda's documentary on the activity of gleaning (picking up fragments of crops left behind after the harvest), the traditionally rural gesture of stooping to pick up what others have discarded is shown to be inscribed into the socio-economic landscape of contemporary urban living. Varda's film shows that this now primarily urban gesture contains within it a multitude of resonances that stretch back through time, forming a part of France's cultural memory that, like waste itself, is both marginal and constitutive.

Marker's *Chats Perchés* (*Perched Cats*, 2004) also films urban space as a scene for examining a collective past, though he focuses on a very recent past (for example the

tumultuous elections in 2002 when *Front National* leader Jean-Marie Le Pen received un-precedented popular support). Marker seeks out recurrent paintings of a striking and enigmatic graffiti cat among the roofs and alleyways of Paris and takes these apparitions as a starting point for a journey through the political landscape of the city at the start of the new millennium.

Jean-Luc Godard's work in this period has also looked at the city in terms of an archae-ology of changing socio-political frameworks, revealing the ways in which it is steeped in cultural history. The Parisian section of *Éloge de l'amour* (*In Praise of Love*, 2001) weaves together a cityscape of train depots and sumptuous *hotels particuliers*, abandoned fac-tories and historic monuments, neon signs and commemorative plaques, film posters and graffiti, in order to evoke France's relationship to its troubled national past, and in particular the ongoing collective obsession with the twin realities of resistance and col-laboration in World War Two. *Notre Musique* (*Our Music*, 2004) represents a broader ex-ploration of the impact of war and conflict on collective memories and spaces, but the primary site of this exploration remains an urban topography. Godard takes the Bosnian locations of Sarajevo, and, to a lesser extent, Mostar, as paradigmatic of riven and war-marked cities. Largely set in and around a literary conference in Sarajevo, *Notre Musique* looks to the future by imagining a series of dialogues between conflicted cultures, bridg-ing time, geography and generations. As a city marked by long histories of bitter conflict, Sarajevo is depicted as a place in the process of healing and coping with the rift between past and present. It is shown to be both physically scarred by the Bosnian war of 1992–95 and virtually haunted by discord and violence that stretches beyond these geographical and temporal confines.

The theme of the city as a zone haunted by past violence has even surfaced in somewhat more mainstream cinema, such as Austrian director Michael Haneke's *Ca-ché* (*Hidden*, 2005).[4] In *Caché*, a relationship between past and present is played out between two Parisian neighbourhoods – a comfortable, bourgeois area in the 13th *ar-rondissement* and a modest, working-class suburb. A post-colonial, socio-economic spectre of 'hidden' collective guilt is suggested in the film's narrative and embedded in the divided representation of city space. Georges Laurent (Daniel Auteuil), the presenter of a literary television talk show, starts receiving videotapes of his house and street, ac-companied by child-like drawings depicting violent scenes. As he begins to suspect that childhood acquaintance Majid is behind these mysterious and menacing deliveries, Georges is drawn to confront Majid, taking him into the latter's humble neighbourhood, home and apparently bleak life. Throughout, the spectre of the 1961 massacre of peace-ful Algerian demonstrators by French police (in which Majid's parents are supposed to have been killed) haunts Georges' personal – and aggressively resisted – excavation of guilt in relation to his own childhood mistreatment of the orphaned Majid. It is notable that televisual images play an important role in the film, pointing to the mediation of both city space and memory through contemporary visual media, from the menacing CCTV-like video images to the fake bourgeois/intellectual living room set of Georges' chat show.

Certain common elements can be discerned in these explorations of cities and mem-ories in early twenty-first century French filmmaking, three of which are of particular sig-nificance for my discussion here. The first is that, as discussed in the previous section, the city is subject to temporal change both as a physical, geographical place and as an

imaginary or virtual sphere. Secondly, this virtual sphere is mediated through cultural experience. Finally the city is figured as an intersubjective space where personal and shared experiences and memories interconnect.

I now turn to two films that warrant particular attention, not only for their explicit focus on questions of memory and place, but also for their subtle evocation of the intersections between individual and collective memory. *Pola à 27 ans* (2002), the first film by Natacha Samuel, is an hour-long documentary following Pola's return to her hometown Warsaw, and to the death camps of Auschwitz and Birkenau where she spent a year of her life. In Claire Simon's *Mimi* (2003) we are taken on a journey around Nice that is also a journey into Mimi's past. Though extremely different in their tone and historical lenses, both films illustrate the difficulty of coping with the transitional, unstable character of both places and memories. In the context of the present discussion, it is worth noting that these films' deployment of 'new media' is, unlike *Level Five*, limited to the digital cameras that facilitate their low-budget production and – more significantly perhaps – their ability to navigate urban and other spaces with relative freedom. However, the questions they raise about the shifting, intersubjective worlds of memory and city can be brought to bear productively upon questions posed by theorists in the context of our increasingly multi-media social experience. Moreover, they illustrate ways in which films continue to constitute a resource for negotiating and conceiving of the relation between memory, environment and self. A close look at these films, therefore, will ultimately lead to a broader theoretical discussion of intersubjectivity as it is mediated by cultural experience.

Cities in Transition: *Pola à 27 ans* and *Mimi*

Through the course of *Pola à 27 ans*, the film's subject, Pola, passes through three kinds of physical space: the domestic space of home and hotel room, the city space of Warsaw and the domain of the camps at Auschwitz and Birkenau. Each has its role to play in the film's rendering of Pola's memory, but it is specifically the urban scenes that I want to focus on here. It is significant that the first encounter of urban space in the film comes not upon arrival in Warsaw, but in a filmed experience of memory. Early in the film, as Pola speaks of her wartime memories to her granddaughter behind the camera, an extended shot of her silently remembering is followed by the explanation, 'I was in Warsaw'. In her memories she is transported there once again, she is *in* Warsaw. As spectators of the film, we watch a person in the process of remembering, and are thus invited to imagine her memory-images, as she re-inhabits the urban landscape of the past, mentally mapping happy memories onto the contours of the city.

When she arrives physically in Warsaw, however, Pola experiences a painful disjuncture between the perceived and remembered mapping of space, expressed via a close-up image of a map. In a haptic image – an image that makes the tactile visible – we trace the city space visually through Pola's fingers, as they seek out remembered places on a map of Warsaw. Her hands seem to know the city, and with a habitual sense of spatial outlines she confidently locates the street where she grew up, even though it is no longer on the map. We then cut to an image of Pola standing by a vast Warsaw highway, against a backdrop of skyscrapers and a crane that hints at the city's ongoing reconstruction. She looks around her, clearly unable to recognise this as the city she remembers. The gradual disintegration of Pola's mental map is revealed as we see her repeatedly asking

for directions to Marianska Street, an incoherent series of modern buildings and streets in the background ensuring that orientation is denied to the viewer as much as to Pola herself. We move from seeing Pola in the distance, dwarfed by the huge, concrete apartment blocks and the very audible roar of the traffic, to an extreme close-up view, where the hand-held camera spins giddily round her, accentuating the feeling of disorientation, with trams and cars moving rapidly behind her in the frame. The contradictory answers of those she asks for directions suggest, like the crane and diggers we have glimpsed in the background, a city of ever-changing contours, an Alice-in-Wonderland city where buildings, roads and streets shift and change shape. In a sense then, this is the archetypal city of forgetting, whose mnemonic map is constantly under erasure. However it also seems eternally locked into a specific moment of trauma in its past; viewed through Pola's disoriented perspective, it is as if the bombing and rebuilding has never stopped.

The sequence reaches a moving climax when Pola finally locates her childhood home, 3 Marianska Street: it has become a road, ironically a place of unending transit and motion. Pola's search for the stable architecture of her past has led to a blunt reminder of the ceaseless mobility of space and time. The more time she spends in Warsaw, the more her confidence in the stability of her memory's map crumbles. Her journey down memory lane has turned into a peculiar excavation, in which getting lost in a city repeatedly dug up and rebuilt comes to signify the pain of the past she has lost. This sense of both being lost and experiencing loss is emphasised later, in a heartrending scene where we again see Pola's fingers roving over the city map. 'What street are you looking for?', asks her granddaughter, and Pola replies, sadly, 'I don't know.' The scene plays on the difference between the image of a conventional city map and the mappings of memory. Both city and protagonist are suffering from disturbances of memory, and the close-up image of her fingers touching the map comes to signify the insufficiency of a flat, fixed image of the city to account for the fissures, both physical and emotional, that open up at sites of trauma.

Although postwar Warsaw represents an extreme instance of instability in the urban landscape, all cities exist in a state of constant flux, albeit slow-moving. For Freud this was reason enough to demolish the analogy between city and memory that he constructs at the beginning of *Civilisation and its Discontents*, where he evocatively imagines the psyche's retention of the past via the mental superimposition of all the past incarnations of the city of Rome. He rejects the comparison on the grounds that, 'even the most peaceful urban development entails the demolition and replacement of buildings, and so for this reason no city can properly be compared with a psychical organism' (2004: 10). But Freud here appears to envision cities purely in terms of bricks and stone, forgetting the human element of cities that constantly scrawls its 'semantic wanderings' over the cityscape, leaving ghostly trails to haunt the space in the form of memories and urban narratives, like the tracings on Freud's own mystic writing pad model of memory (1991: 11). As inhabited places, cities live as much as they are lived in; as with the psyche there is no demolition without a trace. City maps may seem to refuse this shifting urban fluidity, but they are of course periodically required to take account of it. Looking at different maps of one city throughout the ages reveals the secret temporal movement at the heart of all mapping – a mobility I will return to in the next section. De Certeau comments on this changing nature of cities, locating the very essence of *place* in its 'moving layers':

It is striking here that the places people live in are like the presences of diverse absences. What can be seen designates what is no longer there: 'you see, here there used to be ...' but it can no longer be seen. Demonstratives indicate the invisible identities of the visible: it is the very definition of a place, in fact, that it is composed by these series of displacements and effects among the fragmented strata that form it and that it plays on these moving layers. (1984: 108)

In *Mimi*, too, we are aware of the presence of absences in the mapping of city space. As the film's subject, Mimi Chiola, moves around Nice she recounts her own memories – called forth from architecture, pathways and landscapes – to the camera, and by extension to the spectator. But her memories draw in the memories of absent others, through the familial and social frameworks that have been a part of her life. Through Mimi's stories, the absences of her father and mother, of her brother and of past lovers, come to haunt the images of present-day inhabited city space gleaned by Simon's camera. But there are other means by which the film evokes the inscription of Mimi's memories into a virtual, collective memory of the city. The film's images and soundtrack open up a gap between perceived and remembered places. Since the filmmaker, Claire Simon, chooses the locations, there is rarely a simple equivocation between a place and memory of it, rather a more complex circuit of remembering which passes through the fragmented and moving strata of the city. For example, a new sports centre that Mimi has not seen before triggers her memories of the class divide that once denied such leisure activities to all but a few. And though steam trains have disappeared, transforming the railway bridge beyond recognition, a chance encounter with an eccentric trainspotter allows Mimi to relive the experience of crossing the bridge with her mother, as she listens with him to a tape recording of a steam train passing. It is thus through the *changing* shape of the city, its collective and transitional quality, that Mimi negotiates her past.

The opening panorama that frames the credit sequence is accompanied by the unmistakable rhythmic, mechanical creaking of a crane, again suggesting the continual rebuilding of the city even as it establishes Nice as the mnemonic home of Mimi's identity.[5] Perhaps most emblematically, near the beginning of the film, a fixed-camera shot shows Mimi leading her friend Diego over a motorway bridge in the neon-tinged light of dusk, pointing out roads below: 'The collinettes pathway, St. Philippe's bridge – which wasn't like that – Châteauneuf Avenue'. Having traced with her hands the familiar streets and signalled their temporal transformation, she then asks Diego to sing 'her song' outside, near where her house *used to be* (she points to a spot outside the frame): 'I would like you to sing my song outside ... my house, actually, which was over there'. In the next scene we see Diego playing the guitar and singing to Mimi, as she has requested. The song is called 'Il Ragazzo della Via Gluck', released by Adriano Celentano in 1966. It was made famous in France by Françoise Hardy's popular recording of 1966, which translated it into French as 'La Maison où j'ai grandi'. The lyrics tell the story of a young man who leaves for the city but who never forgets his childhood home, now absorbed by the tar and cement of the city. It speaks, that is to say, of places, streets and houses known and lost, of memory, departure and return.

It is not clear whether, like Pola, Mimi has lost her childhood home under a concrete strip of road, or whether it has become absorbed by the breeze-block buildings across

which the camera also pans during the song. In any case, the rhythmic rushing noise as each of the constant stream of cars goes past becomes a part of the song. The noise intrudes, overlaying the words and harmonies of the song. But in doing so it mirrors the way that in the song's own story the city covers what used to be grass, 'but where the grass once was there is now a city'. The song becomes a commemorative moment, shared between the two friends and the filmmaker, but it is – crucially – a transient and transitory monument-in-motion that expresses the mnemonic and physical movement of urban space. It can be seen then that the filmic remembering in *Mimi* is an intersubjective process on three levels: it arises between Mimi and filmmaker Simon (who chooses the route through Nice); between Mimi and her family history; and more broadly between Mimi and the collective past of the city, suggested in the diverse encounters with strangers and musicians incorporated into the film.

Although 'moving layers' may be an essential feature of both cities and memory, in Pola's case the shifting strata are marked with such a powerfully traumatic sense of loss that the kinds of creative commemorative interaction we see in *Mimi* seem foreclosed. When she finds the road that covers the absence of her childhood home there is no song to mediate between past and present and the inevitable losses entailed by the passage of time. This is clearly because Pola's memory mapping is haunted by the horrifying trauma of the Shoah. Her memory narratives all turn around her identity as a survivor of the camps. As such the commemoration is conceptually inserted into a wider collective concern in a more directly evident way than is the case with *Mimi*. The film's evocation of memory is of a traumatic one and the city space it explores is devastated by the same trauma that devastates Pola's memory. The sequence immediately following her discovery of the disappearance of 3 Marianska Street – an interview in her Warsaw hotel room – makes the connection between the present-day experience of loss and the assault on the Jews' *inhabiting* of Warsaw in the early days of German occupation: 'They immediately made us into sub-humans. We no longer had shirts, pillows, houses, homes. Everything had been bombed.'

After Pola points to the road where her home used to be, we cut to a shot that frames her hands tucking away her map of Warsaw into her bag – suggesting the failure of both mnemonic and city mapping to act as a reassuring guide in this confrontation with the past. However, in providing a testament to this the film itself becomes a kind of trace. The subsequent 225-degree pan of the road, with its roaring traffic where her house *used to be*, comes to rest on Pola, whose expression of restrained confusion and disappointment itself signifies the presence of an absence. The film starkly reveals disintegration in the face of trauma, allowing absences to haunt the filmed space without filling in the gaps.

Transitional Spaces and a Mobile Architecture of the Self

Both *Mimi* and *Pola à 27 ans* eschew the use of reconstruction or archive footage in favour of filming spaces in the present, juxtaposed with a remembering that takes place in between filmmaker and subject, and drawing in strangers implicated in the changing environments they negotiate. In both films this imbues the images of contemporary cities with the past as virtual layer, evoking not only the individuals' pasts but also those pasts as they intersect with a collective sphere. This points to the ways in which film is able to suggest both a physical and virtual 'beyond' of the frame: space beyond the visible. It

draws the viewer into an imaginative investment that mediates between past and present, absence and presence.

We can see then, that not only the city, but other forms of experience can be conceived in terms of de Certeau's 'moving layers'. Memories haunt urban spaces, while the vast, interconnected space of contemporary media forms a part of the intersubjective, mnemonic spaces through which the viewing, and thinking, subject must navigate. Like the city wanderer moving through inhabited streets and architecture, the subject navigates through the contemporary landscapes of media, memory and the metropolis. But these representational zones rarely 'map onto' one another with perfect coherence. Rather, they fuse to create a multi-dimensional, mobile space where disorientation is a constant possibility. As we move through time and space, the mental maps we produce of our mnemonic, urban and media environments are constantly subject to redistribution and sometimes to complete disintegration and fragmentation. But rather than understanding this as a growing threat to the spatio-temporal anchoring of the modern subject as some theorists have (see for example Huyssen 2003: 1; Robin 2003: 415), I would suggest that the geography of our social representations has always held the possibility of dislocation, but that this phenomenon can be reconceived and represented anew through contemporary artistic media, including film.

This leads me to my final proposition, which draws upon recent work in social psychology in order to develop a further understanding of how different experiential zones can mediate between individuals and others. Tania Zittoun (2005) has examined the role that films play in key transitional moments in the lives of young adults. From the complex models of selfhood and social representation that frame Zittoun's work I want to pick up on two key concepts that are relevant to the present discussion. The first revisits psychoanalyst D. W. Winnicott's theory of cultural experience. Winnicott argues that children's play forms the basis for adult cultural experience (see 1986: 36). Playing with certain objects as children allows us to negotiate the transition between the inner experience of the self and a reality perceived as external. For adults, cultural experiences constitute a similarly creative, communicative phenomenon, something that is both a part of our interior world and of the external – and, crucially, *social* – world. Winnicott calls this 'potential space' (1980: 46), and Zittoun glosses this as 'a transitional space, which is between socially shared reality and inner lives' (2005: 53). The second key concept is that of an *architecture* of the self. Using an architectural metaphor allows Zittoun to evoke 'a tri-dimensional interiority, structured and organised along lines of forces, or axes reflecting a person's most important socialisations and interactions' (2005: 40).

A crucial point about this understanding of subjectivity is that it accounts for an ongoing mobility: 'moves of consciousness are constrained by the architecture; yet themselves modify the architecture' (ibid.). Finally it is an intersubjectively constituted model of the self, for, 'it is made out of memories of past semiotic dynamics having engaged real, internalised, imagined, and generalised others' (ibid.). Zittoun draws on this to explore how cultural experiences, which, as in Winnicott's analysis, become internalised while remaining part of a socially shared reality, modify and effect the mobile architecture of the self. As part of a wider set of cultural experiences then, films constitute a symbolic resource upon which we draw in order to navigate the changing topography of our social world. They affect our interior topography and become a part of the inner constructions that enable us to understand our world and to remember our pasts. In this way, films can

provide us with a transitional space in which to negotiate the continually transitory nature of our spatio-temporal experience, which is to say the experience of change and loss in our lives and environment.

Over the course of this chapter I have moved between three spheres of experience: memory, media and the city. I have suggested that they resemble one another in three main ways: firstly, all three can be conceived in spatial terms, and require us to navigate through them. Secondly, all three constitute mobile spaces, constantly in transition as we move through them and they pass through us. Finally, these three spheres all mark points of intersection between the individual and the collective. These resemblances show that we can, like the eternally 'primitive' human evoked in *Level Five*, use the spaces that constitute our lives as lenses through which to view other ones. Films, however, as the wave of city-memory films in the French context suggests, remain particularly powerful modes of representation, for they are transitional spaces mediating between the shifting layers of our social experience.

NOTES

1 Translations from the French are my own throughout, except where the citation refers to the published English version of a text.

2 These techniques have been transmitted through Cicero's *De Oratore*, Quintilian's *Institutio oratoria* and the anonymous *Ad C. Herennium libri IV*. For a definitive discussion of the art of memory, see Yates 1996.

3 De Certeau is citing Jacques Derrida's notion of an 'errance du sémantique' at work in metaphor in *Marges de la philosophie* (Derrida 1972: 287).

4 The designation 'mainstream' is of course relative, and *Caché* remains an 'arthouse' title. During its release *Notre Musique* had 28,700 theatrical admissions in France, *Les Glaneurs et la glaneuse* 125,576, and *Caché* 509,787, so it reached a significantly larger audience. (By comparison, however, Sam Raimi's *Spider-Man 2* had 5,335,462 admissions in 2004.)

5 The scene also places itself in reference to a filmic cultural memory, recalling the famous city film about Nice, Jean Vigo's *À Propos de Nice* (1930), which opens with a series of sweeping aerial shots.

WORKS CITED

Barber, S. (2002) *Projected Cities: Cinema and Urban Space*. London: Reaktion.

de Certeau, M. (1984) *The Practice of Everyday Life*, trans. S. Randall. Berkeley: University of California Press.

Derrida, J. (1972) *Marges de la philosophie*. Paris: Minuit.

Freud, S. (1991) *On Metapsychology*, ed. A. Richards, trans. J. Strachey, seond edition. London: Penguin.

_____ (2004) *Civilisation and its Discontents*, trans. D. McLintock. London: Penguin.

Huyssen, A. (2003) *Present Pasts: Urban Palimpsests and the Politics of Memory*. Stanford: Stanford University Press.

Ricœur, P. (2000) *La mémoire, l'histoire, l'oubli*. Paris: Seuil.

Robin, R. (2003) *La Mémoire Saturée*. Paris: Stock.

Winnicott, D. W. (1980) *Playing and Reality*. Harmondsworth: Penguin.

_____ (1986) *Home is Where We Start From: Essays By a Psychoanalyst*. Harmondsworth: Penguin.

Yates, F. (1996) *The Art of Memory*. London: Pimlico.

Zittoun, T. (2005) *Transitions: Development Through Symbolic Resources*. Greenwich, CT: InfoAge.

16 TOLSTOY IN LOS ANGELES: *ivans xtc.*

Edward Dimendberg

To approach Bernard Rose's film *ivans xtc.* (2002) within the tradition of Los Angeles doc-
umentary media – the corpus of films, photographs and digital media which register the
city and its urban transformations – may at first glance seem an unlikely project.[1] Based
on Leo Tolstoy's short story *The Death of Ivan Ilyich* (1886), Rose's film might initially
seem unrelated to the long tradition of media investigations about Los Angeles by virtue
of its adaptation from one of the most celebrated works of short fiction in modern litera-
ture. That the British director's previous film was *Anna Karenina* (1997) proposes him as
a *metteur-en-scène* of literary works, just as the subject of *ivans xtc.* – the Hollywood film
industry – appears firmly anchored within the legacy of journalistic and literary treat-
ments of the culture of the Los Angeles entertainment industry.[2]

ivans xtc. (the title is always written in lowercase with the second word spelled in
a manner to evoke the drug, if not the commodified rock band) draws upon the life of
Jay Moloney, the Hollywood agent who helped director Rose realise his film *Candyman*
(1992). While employed at the Creative Artists Agency (CAA), Maloney had represented
Sean Connery, Dustin Hoffman and Bill Murray, before being fired in 1996 for cocaine ad-
diction. At the height of his career Moloney earned a salary of a million dollars per year,
yet eventually lost all of his possessions and ended up working as a janitor in a Caribbean
resort. In 1999 he hanged himself in Los Angeles, unbeknownst to Rose who screened the
final cut of the film on the day he learned of Moloney's death. Whether this confirms that
in Los Angeles life follows art or vice versa, it is a reminder that the boundaries between
cinematic fiction and reality in that city are shifting and porous. Filmmakers have long
recognised that storytelling and actuality are less antithetical poles than relays whereby
one leads to the other, and Rose trades heavily on this insight.

His film combines Tolstoy's tale of a middle-class parvenu who realises that he has
led a meaningless life and only attains self-knowledge, if not religious salvation, on his
deathbed, with the story of a mendacious agent modelled after Moloney in a manner that
elides commonplace distinctions between cinematic documentary and fiction. Most of the
cast are non-professional actors who play roles identical to their professional identities
in real life. The film's credits list eight 'Hollywood types' who appear as actors in the film,
including Hal Lieberman, a producer and former head of Universal Studios, and Adam
Krentzman, an actual agent at CAA. Filmed in high-definition video using available light,
ivans xtc. renders the urban space and film industry milieu in Los Angeles with the raw
energy of *cinema vérité* inflected by a personal directorial vision evocative of Alexandre
Astruc's (1968) notion of the camera stylo as a vehicle for personal cinematic expression.

A brief summary of the film's plot is helpful to the analysis that follows. Ivan Beck-
man (Danny Huston), an agent at the Media Talent Agency, dies of a lung tumour, much to

the surprise of his colleagues, none of whom ever knew that he was sick. Their immediate challenge is to reassure his clients, especially Don West (Peter Weller), a gun-obsessed big-time star whom Ivan has wooed away from a competing agency with the lure of making a film called *Weeds*. West agrees to this only upon the condition that the writer of the film, Danny McTeague (James Merendino), is removed as director and replaced by Constanza Vero (Valeria Golino), in whom West has a romantic interest. He believes that working with Vero, herself a lesbian, will dispel the rumours that he is gay. Upon learning that his contract has been terminated at the agency, McTeague provokes a fight with his agent Barry Oaks (Adam Krentzman) at Ivan's funeral that is broken up by West.

Ivan attends the premiere of West's latest film with his girlfriend Charlotte (Lisa Enos), who chastises him for promoting a bad script that he has not even taken the time to read. After successfully acquiring West as a client, Ivan receives a telephone call from his doctor's office summoning him to discuss some test results. The doctor (Dino DeConcini) informs him that he has a fatal lung tumour. Ivan visits a psychologist to discuss his fears, purchases a large quantity of new-age cancer treatment books and engages in a wild night of drugs and debauchery with West, his colleagues and several female escorts. Yet he is unable to tell Charlotte, his father or his sister about his illness. Only the two prostitutes whom he summons to his home one evening learn that he is about to die. After a night of drug consumption with them, Ivan awakes the next morning in a fit of screaming and convulsions. He is brought by paramedics to the hospital, where he is cared for by a kindly nurse and dies alone in his dark hospital room.

As a recent instance of the genre of the Hollywood film about Hollywood, whose examples include *Sunset Boulevard* (1950), *In a Lonely Place* (1950), *The Bad and the Beautiful* (1952), *Targets* (1968) and *The Player* (1992), *ivans xtc.* contains many of the features present in these earlier films. Mendacity and philistinism provide the counterpoint for the development of a more sympathetic leading character whose triumph or downfall leaves the structure of the industry untouched. Transformations in film industrial and economic practices are typically represented as generational conflicts. And iconic Los Angeles locations and gathering spots for the industry power elite are represented along a continuum that ranges from wistful nostalgia to aggressive hyperbole.

Already within the opening five minutes of his film, Rose proposes a new iteration of these modalities, organised around pathos and loss. Commencing at dawn on Mulholland Drive (the road above Beverly Hills that runs atop the Santa Monica Mountains [[[j] and was itself the title of David Lynch's Hollywood film of 2001), the film slowly pans across the rugged landscape at dawn. Richard Wagner's 'Tristan and Isolde' plays on the soundtrack. An eerie green fog shrouds the city in the distance, which slowly emerges in the golden light of the sunrise. From this series of long shots on the periphery, the film cuts to a shot of the empty El Capitan cinema on Hollywood Boulevard, a landmark where in 1941 the premiere of *Citizen Kane* took place. Its glittering illuminated marquee flashes on and off, despite the early hour and the absence of moviegoers. The succeeding shot of the deserted courtyard of Grauman's Chinese Theater conveys a similarly uncanny effect, for its space is typically crowded with tourists.

Both images set up a comparison between the depopulated peripheral natural landscape and the location of film viewing in the urban centre, in this case the neighbourhood of Hollywood whose redevelopment and attempted gentrification hinges upon the aura and cachet of the motion picture industry (see Stenger 2001). Film spectatorship

appears practically as a fact of immutable nature; the lights of the theatre seem to operate mechanically without human presence or intervention. But the second image and the empty box office suggests a more cryptic temporality. Have we arrived on the scene for film screenings too early, or too late? Being present at the cinema appears untimely, as is perhaps the very activity of traditional film spectatorship itself in the age of digital technology. That the first urban scenes in *ivans xtc.* develop this notion underscores the more general project of the film to question the modalities of cinema in an age of low-cost digital cinematography and distribution by DVD, cable and satellite.

The film's unusual depiction of temporality is further elaborated by the background image against which its title appears in the opening credit sequence. At this point the glowing orange sunrise suffuses the entire sky. Blackened and barren, the branches of a tree stand out against the dawn, as if to introduce death and mortality into a setting that portends warmth and new beginnings. If, as Reyner Banham (2000) famously suggested, Los Angeles is the city of second chances, a place whose impermanence elides any notion of finality, the conjunction of the daybreak and the barren tree introduces death and finitude into this landscape. The film soon emphasises this contrast by cutting to verdant Beverly Hills where the neatly-manicured trees on Palm Drive convey unstinting luxury.

As the credit scenes unfold, the gravelly voice of Ivan Beckman intones off-screen:

Last night I had this incredible pain. The pain was so strong that I took every pill in the goddamn house. Pills wouldn't do anything. The pain wouldn't go away. So I tried to find an image, one worthwhile image that would get me through it. And all I could find was shit. I couldn't find one worthwhile goddamn thing.

Here the film posits a link between the suffering of its central protagonist and Hollywood. Not only is Ivan's life lacking in worthwhile images but so by implication is the industry for which he works, as well as the city in which he lives. As an agent, Ivan is surrounded by images, yet their very abundance underscores their inadequacy, especially when invoked as a means of transcendence and a strategy for coping with unbearable pain.

Ivan's inability to conjure a picture, any picture, that would enable him to justify his life and transcend what he now understands to be its vacuity, articulates a challenge for the film. For if his world is in fact as hollow and worthless as he intimates, what utility would its cinematic depiction possess? In its ensuing two hours *ivans xtc.* transforms his unexamined existence into a meticulously observed and frequently gripping drama, thereby proposing itself as a corrective to Ivan's limited imagination, presented less as an individual shortcoming than the failure of an entire social class and industry.[3] *ivans xtc.* may be construed as an attempt to posit a worthwhile image that eludes its main character, whose brief instance of self-awareness at the conclusion of his life is appropriated by the film as a moral attitude.

We first hear Ivan's monologue as the opening credits of the film unfold but it is also repeated at the conclusion, shortly before Ivan's death in the hospital. It functions as a crucial point in the film's narrative loop that, like Tolstoy's story, commences with Ivan's dying, returns to his life and concludes with his death. Much like the celebrated opening of *Sunset Boulevard* in which Joe Gillis (William Holden) in voice-over describes his corpse being fished out of a swimming pool, Ivan's opening monologue is temporally indeterminate. Appearing at the film's origin and repeated at its conclusion, it is simulta-

neously a premonition and a flashback. It establishes Ivan as the enunciator of his own story, endows the film with the fatalism of *film noir*, and thus also recalls the opening of *Double Indemnity* (1944) in which Walter Neff (Fred MacMurray) recites his confession into his office dictaphone. Ivan's speech, like Neff's, is that of a dying man. Yet the fact that we initially hear it off-screen endows it with a transcendental presence beyond the narrative.

In its narrative mode, *ivans xtc.* owes a substantial debt to *film noir*, arguably the Hollywood film type in which the tension between story – the fabula in the phrase of Russian formalist critic Boris Ejxenbaum – and the presentation of situations and events to the reader or viewer – the sjužet – is most pronounced (see Ejxenbaum 1971; Prince 1987). The opening sequence of the film makes it clear that Ivan has died. After his casket is entombed in a mausoleum, the concluding event in the fabula, the sjužet then returns to the earliest event, Ivan's visit to his doctor for a medical check-up and chest x-ray. Apart from the first ten minutes and the final ten minutes of the film, everything in between transpires as a flashback. Suspense is eliminated and in its place the viewer adopts an attitude of critical distance toward the narrative, knowing its outcome while scrutinising details for clues or insights.[4]

Temporality is further explored in two successive shots of Sunset Boulevard that depict a woman sitting on a bench at a bus stand and another walking down the street. They render movement as blurs. Cars drive by at a less than normal pace, yet the effect does not generate insight into a process normally inaccessible to the human eye – such as an athlete completing a decisive action in a sporting competition – so much as it suggests fatigue, a momentary cessation of the mythmaking apparatus of the city. This technique is in fact antithetical to the accelerated cinematography employed in movies such as *To Live and Die in LA* (1985). Filmed from a stationary position on the street, not a moving automobile, and presenting two pedestrians, both, not coincidentally, women of colour, the film suggests that not everyone in Los Angeles engages in the rapid motion manifested by its principal characters, and confirms that such lifestyles do not comprise the totality of life in this city.

Ivan's piercing screams return the opening credit sequence to the location of his house, where sunlight streams through the windows. A portrait of Tolstoy appears on the barren ground, and in the next shot the Penguin paperback edition of *The Death of Ivan Ilyich* appears on a table next to the electrical cord of an absent laptop computer. Little evidence is provided by the film to suggest that Ivan Beckman has ever read the book, and its appearance alludes more to the authorial presence of the filmmaker, as does the succeeding shot of writing pads and pencils. If such motifs appear at first glance merely as clever reflexive tropes, they function no less as reminders of narrative sequence and temporality, the predetermined written ending of Tolstoy's story belied by its *vérité* sensibility. Juxtaposing two seemingly antithetical cinematic modes, director Rose undercuts notions of transparent literary adaptation or documentary authenticity. *Ivans xtc.* is both a retelling of a nineteenth-century classic and a new story in its own right.

At its most basic level, Ivan's life and behaviour provide the film with extended material for what one might call a case study in the phenomenology of lying and self-deception.[5] Everything Ivan says or does is motivated by its perceived utility to his professional advancement rather than personal conviction, let alone the truth. The film provides a sustained study of a character whose existence is based on falsehoods. After the premiere

of Don West's atrocious new film (held at the actual Academy of Motion Picture Arts and Sciences headquarters on Wilshire Boulevard in Beverly Hills), he flatters its producer about its success and ingratiates himself with a starlet whose banal performance he also praises. Similarly, he praises McTeague's mediocre script and urges his assistant to write a false report on its virtues so as to gain favour with Don West. Like Tolstoy's Ivan Ilyich, Ivan Beckman has for so long done what was expected of him by his social peers that he has lost any independent belief system and core individual identity. Dressed in the same designer suits as his male colleagues, he possesses a perfect blonde girlfriend, a BMW convertible, a house in the Hollywood Hills, and exemplifies the lifestyle of his class. Just as Tolstoy's Ilyich is ordinary among his class, so is Rose's Beckman, though the sense of entitlement and privilege he enjoys as a member of the Hollywood elite is arguably greater than that of the legal bureaucrat sketched by Tolstoy.

Ivan interacts with his colleagues with a jocularity that conceals the genuine lack of sympathy they feel towards each other. In one of the film's darkest comedic moments, the news of Ivan's death is presented during a morning meeting in the agency. As in Tolstoy's story, in which the first mention of Ivan Ilyich's death is in a newspaper, here the news is disclosed in a group setting, so as to provide an opportunity for divergent reactions to be voiced. After snide comments about Ivan Beckman's excessive drug and sex habits, his boss, Judy Tarzana (Carol Rose) calls for a moment of silence to commemorate his death but within seconds the discussion returns to agency business, especially the all-important matter of preventing other agencies from stealing his clients.

Equally insincere is the eulogy given by Ivan's sister, Marcia (Joanne Duckman), at his funeral. Although she is shown fighting with Ivan when he brings Charlotte to the family home for dinner, she celebrates their close relationship and claims that 'it would have meant the world to him to see how loved he really was'. Only his impending death forces Ivan to acknowledge his fundamental lack of connection to other people, first signalled by his doctor's request that he bring a friend along when he obtains his test results. Ivan's assistant, Lucy Lawrence (Morgan Vukovic) professes to being behind in work, and so he drives to the doctor alone. Even in his discussion with the doctor, Ivan attempts to minimise his symptoms and escape the gravity of the diagnosis he receives.

After learning of his cancer, Ivan retreats to the swimming pool roof bar of a West Hollywood hotel to drink a Martini. Here the film adopts the familiar iconography of the Los Angeles swimming pool as topos of luxury and desire, an image ubiquitous in countless films such as The Graduate (1967) and made famous in the art of David Hockney.[6] But if the pool typically evokes the light and airy climate of Southern California and its attendant carefree sensuality, here it delivers no such transcendence. Instead of the customary deep blue it appears to be an aggressive turquoise and seems to menace Ivan, and the sequence cuts back and forth between its water and the clear liquid of his drink. Accompanied by Schubert's Fantasie in F Minor, the piano music written by the composer in 1828, the year of his death and six years after his likely infection with syphilis, the sequence exudes a palpable aura of melancholy. Staring into the pool, Ivan spots a reflection of Melanie (Victoria Silverstedt) and Jessie (Crystal Atkins), whom he soon will join in Don West's penthouse. Moving from Martini, to the surface of the pool, to the reflection of the women, the film translates Ivan's anxieties into a series of metonymic displacements.

Not surprisingly, the final link in this chain is an image of women. Throughout the film, women consistently oscillate between roles as ravenous figures of desire or maternal

care-givers. Charlotte appears more interested in furthering her career than in any deep connection to Ivan. In the limousine ride to the film premiere, Don West snorts lines of cocaine from her naked thigh. He later diagnoses her to Ivan as suffering from a bad case of 'the bitch goddess' syndrome and castigates her for the opportunism he discerns as rampant in Los Angeles. By contrast, Rosemary Kramer (Caroleen Feeney), the nurse who tends to Ivan in the hospital, provides him with maternal affection. She kisses Ivan on the forehead, and it is plausible to interpret her as the wish-fulfilment corresponding to the early memory of his mother that Ivan describes to Francesca (Heidi Jo Markel) and Jessie, the two prostitutes he has summoned to his living room. One definition of the ecstasy alluded to in the film's title is thus a return to maternal plenitude at the moment of death.

In what is arguably the most riveting moment of the film, Jessie observes that Ivan is not responding as they are to the Ecstasy they have taken together. He shows them the medication he is taking for his cancer, and she notes that her mother was also prescribed it for cancer and later died. Ivan tells them of his diagnosis and impending death. Francesca and Jessie stare back with blank expressions, young citizens in a culture of youth. Ivan comments, 'You don't believe me. Why should you? Some time it will happen to you too. Your time will come.' This observation proves too much for them, and they flee Ivan's home, as if the very acknowledgement of mortality and human finitude is itself taboo in Hollywood. Yet Danny Huston's performance never slips into sentimentality or self-pity.

Paradoxically, although Ivan has taken more drugs than the women, he is less intoxicated than either of them. His ecstasy at the moment of his death in the concluding scene in the hospital appears less motivated by drugs than by his reconciliation with the truth of his own impending demise. Sitting in his hospital bed, attached to a respirator, the film presents him as silent while a stream of visitors enters his room. The exterior environment of Los Angeles is shown in a shot of an ugly office building that appeared in the credit sequence, as if to intimate that his fate remains inextricable from the city. He refuses to provide a telephone number to contact, thus underscoring his insistence upon facing death alone. Unlike Tolstoy's story, in which Ivan Ilyich is confronted by friends and family who refuse to recognise his condition, Ivan Beckman suffers the news of his death in near isolation. When a rabbi enquires whether he has anything to tell him, he scrawls on a pad 'Fuck God.' If Tolstoy's story remains, for many commentators, a parable about the possibility of human redemption, *ivans xtc.* strips it of any spiritual dimension, while nonetheless preserving the motif of the light as an allegory of human life present in Tolstoy's story. When the light from the window of his room is extinguished, Ivan dies and the film comes to an end without any final credits, save the music list and the sounds, once more, of *Tristan and Isolde*.

As much as it explores the demise of the character of Ivan Beckman, *ivans xtc.* is also an investigation of the end of a certain mode of filmmaking, at least if one accepts the rhetoric of director Bernard Rose, whose manifesto of digital filmmaking is worth quoting in full:

Walking through the Art Institute of Chicago I was struck by something, the gallery, which concentrates on European paintings, is arranged in chronological order. The flat two-dimensional early religious works give way to the Renaissance experiments with depth and perspective, which in turn gives way to the overblown work on nineteenth-century genre paintings, ugly gaudy canvasses with observation and subject matter taken entirely from convention.

And then comes the Impressionists. The breath of fresh air is palpable. No more sylphs dancing in the fake ancient settings. Now we get Manet's girlfriends – dressed and undressed as they are, not some paying patron or king. We see Van Gogh's bare room – the place in which he actually lived. The lily pond in Monet's back yard. The light fairly shines from these canvases –the real light, as it might fall on a haystack at different times of day.

This is the heart of the digital revolution. Most people are not constantly backlit in real life. At night the 'moonlight' does not come from a high crane with powerful arc lights that cast a blue glare as bright as any baseball stadium. Women do not wake up in bed with flawless hair and make-up. Industrial cinema is a legitimate form – but it is stuck in rigid conventions. Hamstrung by money, like traditional oil painting, industrial cinema has entered its decadent phase.

In digital cinema your girlfriend is your star. Your backyard is the set. Your life is the script.[7]

Here it is not difficult to recognise the claims of earlier cinematic revolutionaries: Walter Ruttmann, the Italian Neorealists, Jean Rouch, Jean-Luc Godard, John Cassavetes, Jon Jost, Robert Altman and contemporary filmmakers such as Gus Van Sant. In each instance the commercial realities of mainstream narrative cinema are faulted for their artificiality and limited access to reality. Practices such as location cinematography, filming with available light, direct sound, portable video, the use of non-professional actors and improvised dialogue are heralded as advances towards a more realistic cinema, as if confirming André Bazin's 'The Myth of Total Cinema' (see Bazin 2005). Indeed, for Rose, the example of his own film portends a seismic shift in the nature of Hollywood and the production of commercial entertainment:

We shot *ivans xtc.* for $136,000 and were able to theatrically distribute it internationally. We are the producers and owners. And that film was an experimental art movie, where we were trying things out. Now, for the same money, you could make a commercial movie, and your profit margin would go through the roof. Very soon, the distribution companies are going to have to act more like publishing companies. Running up costs to satisfy levels of executives isn't necessary. The audience will react against the kind of homogenised product that it produces. Kids have exposure to so much hardcore material on the Web that it's hard to imagine them enjoying the average R-rated teen comedy for much longer. We are now seeing the end of the domination of the studios, because they are going to go bankrupt. There is still a huge public desire for entertainment, and someone has to fill the gap. Writers need to take out the camcorders. That's the logical way to do it. Instead of merely being employed at a brothel, you should go get the equipment and make your movie. (Quoted in Waldman 2003: n.p.)

Whether or not the film studios will in fact go bankrupt remains to be seen, although one should note how adeptly they have weathered past challenges such as the arrival of sound, the imposition of the Production Code, the Paramount Decree forcing them to sell off movie theatres, competition from television and the introduction of home video, only to emerge more profitable after each one. Shifting audience expectations associated with

the Internet and the ubiquity of surveillance cameras may well lead to new modes of film production, as indeed the digital technology employed on *ivans xtc.* already has.

Filming with the then newly available SONY HDW-700A high-definition digital video camera, Rose was able to use extremely low levels of natural light, a production possibility that he interprets in political and economic terms: 'If you don't need to use large-scale, heavy lighting equipment, you don't need all the people to handle it and load it on and off trucks and you don't need somewhere for them all to go to the bathroom and you don't feed them. The implications are actually enormous' (quoted in Tonguette 2006: n.p.). All the cast and crew of *ivans xtc.* fit in two sports utilities vehicles that were driven from one filming location to the next, and Rose is probably justified in believing that unions, studios, equipment suppliers and others with a vested interest in the status quo would perceive the new working methods as a threat.

Although his film's extensive hand-held cinematography and employment of tracking shots and zooms entails a set of conventions different from much (though hardly all) commercial cinema, the conflation of these cinematographic options with greater realism *per se* should be avoided. Rose has suggested that every scene in a film entails one optimal placement of the camera for maximum dramatic effect, a remark that emphasises how much of *ivans xtc.* follows traditional Hollywood editing and spatial codes designed to facilitate identification with the characters and advance the narrative. Although the decision to film digitally enabled principal photography to commence six weeks after the screenplay for *ivans xtc.* was completed (the film was entirely scripted) and contributed greatly to the flexibility of the production, the film represents a continuity, as well as change, within narrative filmmaking traditions.

One might also note that Rose himself can be related to the tradition of British *émigrés* who have sought to make sense of Los Angeles in film and literature: figures such as Reyner Banham, John Boorman, Evelyn Waugh and Aldous Huxley. Here the common denominator that suggests itself is not a collective national identity so much as a keen eye for detail and a heightened sensitivity to all that is strange and sometimes disconcerting about life in the Southern California metropolis. If Rose has repeatedly emphasised in interviews that his film is not anti-Hollywood or intended to poke fun at the entertainment industry, his remark that Ivan Beckman, and not Danny McTeague, the hapless film director fired by the agency, should be regarded as its hero, also proposes a less astringent view of Hollywood than the one I have been developing.

According to this argument, it is the agent, not the director, around whom film production revolves. The auteurist project of realising personal films motivated by self-expression is secondary to the more general activity of getting them financed and produced. Just as Moloney was able to 'greenlight' Rose's *Candyman*, Krentzman informed him that Universal was firing him from directing *The Thief of Always* after he had spent three years writing it. The problem was that Rose had begun to film *ivans xtc.* on his own time. If McTeague emerges as a minor and unsympathetic character in the film, it is likely to be because an agent such as Ivan Beckman is infinitely more interesting to watch. Although Rose cast his wife Lisa Enos in the role of Charlotte and many in the film's cast are friends and relatives, the number of film industry figures who agreed to act in *ivans xtc.* should be remembered, as should the initial co-operation of the CAA Agency that allowed him to sit in on staff meetings before it later distanced itself from the completed film (see Tonguette 2006).

Not the least of the film's virtues may be the suggestion that it is possible to be a Hollywood insider and outsider simultaneously and that this liminal position affords the richest perspective from which to be an observer. If *ivans xtc.* treats its central protagonist with a deference and sympathy, or at a minimum a lack of judgement, this may well reflect Rose's fundamentally European directorial sensibility. Emphasising observation and milieu over action and moral judgement, the film is resolutely European in its preference for detailed presentations of tragic situations which elude happy endings. What Americans may regard as tragic, *ivans xtc.* represents without sentimentality, including Los Angeles itself, whose unvarnished manifestation in the film differs from common filmic depictions of its levity. While this may confound American critics or those intent on moralising about Hollywood, *ivans xtc.* presents a clinical portrait of what Bernard Rose takes to be an industry whose days are as numbered as those of its protagonist. Time will confirm – or not – the veracity of his judgement.

NOTES

1 This chapter is part of a work-in-progress on films produced after 1970 and CD-ROMS and websites that treat the built environment of Los Angeles and its history. Its overarching thesis is that both narrative fictional films and documentaries share specific representational conventions unique to the city. For a sample of the project and its concerns, see Dimendberg 2006.
2 For representative examples of these tendencies, see Dunne 1969 and Ulin 2002.
3 This sociological view of the Tolstoy story as a collective indictment of an entire social class was influential among early interpreters and later Marxist critiques. See Jahn 1993: 11–12.
4 For more characteristics of *film noir*, see Dimendberg 2004.
5 An important precursor in its exploration of a character blinded by self-deception, to which *ivans xtc.* appears indebted, is John Cassavetes' *The Killing of a Chinese Bookie* (1976).
6 On the architectural history of the swimming pool see van Leeuwen 1998. For its representation in the work of David Hockney, see Whiting 2006, especially 110–136. I am grateful to Vanessa Schwartz for drawing my attention to this connection.
7 See *ivans xtc.* press kit www.artlic.com/press/kits/ivans xtc kit.html.

WORKS CITED

Astruc, A. (1968 [1948]) 'The Camera Stylo', in P. Graham (ed.) *The New Wave: Critical Landmarks*. Garden City: Doubleday, 17–24.

Banham, R. (2000) *Los Angeles: The Architecture of Four Ecologies*. Berkeley: University of California Press.

Bazin, A. (2005) 'The Myth of Total Cinema' in *What is Cinema?* Berkeley: University of California Press, 17–22.

Dimendberg, E. (2004) *Film Noir and the Spaces of Modernity*. Cambridge, MA: Harvard University Press.

_____ (2006) 'The Kinetic Icon: Reyner Banham on Los Angeles as Mobile Metropolis', *Urban History*, 33, 1, 106–25.

Dunne, J. G. (1969) *The Studio*. New York: Farrar, Straus and Giroux.

Ejxenbaum, B. (1971) 'The Theory of the Formal Method' in L. Matejka and K. Pomorska (eds) *Readings in Russian Poetics*. Cambridge, MA: MIT Press, 3–37.

ivans xtc. press kit. Online. Available at: http://www.artlic.com/press/kits/ivans xtc kit.html (accessed 9 July 2003).

Jahn, G. R. (1993) *The Death of Ivan Ilyich: An Interpretation*. New York: Twayne.

Prince, G. (1987) *Dictionary of Narratology*. Lincoln: University of Nebraska Press.

Stenger, J. (2001) 'The Return to Oz: The Hollywood Redevelopment Project, or Film History as Urban Renewal' in M. Shiel and T. Fitzmaurice (eds) *Cinema and the City: Film and Urban Society in a Global Context*. Oxford: Blackwell, 59–72.

Tonguette, P. (2006) '*ivans xtc.* and the Future of Digital Filmmaking: An Interview with Bernard Rose'. Online. Available at: http://www.thefilmjournal.com/issue5/bernardrose.html (accessed 28 April 2006).

Ulin, D. L. (ed.) (2002) *Writing from Los Angeles*. New York: Library of America.

van Leeuwen, T. A. P. (1998) *The Springboard in the Pond: An Intimate History of the Swimming Pool*. Cambridge, MA: MIT Press.

Waldman, A. (2003) 'Q&A with Bernard Rose'. Online. Available at: http://www.wga.org/craft/interviews/rose.html (accessed 1 September 2003).

Whiting, C. (2006) *Pop L.A.: Art and City in the 1960s*. Berkeley: University of California Press.

17 THE TATTERED LABYRINTH: A SELECTIVE A–Z OF LONDON CINEMA

Chris Petit

Absolute Beginners. It's a shame to begin here but it does illustrate that London has been more ill- than well-served by cinema. Colin McInnes' 1950s Soho story was an obvious choice to film but it took until the 1980s to get made, when it got muddled up with the emerging world of Soho media. Like *Espresso Bongo*, from Wolf Mankowitz's short story, it's an example of conflicting commercial and artistic interests, summarised by a cheesy shot of David Bowie in an open sports car driving down the Mall.

Angry Young Men. The 1950s rebellion against convention produced a call for a grittier cinema, which was a non-metropolitan phenomenon. Later exceptions include Ken Loach's *Up the Junction*, *Poor Cow* and *Cathy Come Home* which were London based. More interesting than this realist strain was the romantic counterpoint that developed into the horror film. Thanks to censorship, these ended up with an atmosphere of gloomy criminality that suited London. Worth mentioning is *Horrors of the Black Museum*, a lurid piece of sadism that resembles a tabloid remake of Georges Franju. A later film, notable for its use of the river, to which all clues are found to lead, is *The Face of Fu Manchu*, which, if memory serves, was shot in Ireland.

Ballard, J. G. Ballard lives in Shepperton where the film studios are and is a rare example of a modern English novelist, as opposed to post-Victorian. *Crash* remains one of the most daring and imaginative London novels, a psycho-sexual autopsy that contains one of the great quotes never filmed – a perfect synthesis of a prose suggestive of the cinematic image while the sense of that image remains unfilmable: 'I realised that the human inhabitants of this technological landscape no longer provided its sharpest pointers, its keys to the borderzones of identity. The amiable saunter of Frances Wearing, bored wife of my partner, through the turnstiles of the local supermarket, the domestic wrangles of our well-to-do neighbours in our apartment house, all the hopes and fancies of this placid suburban enclave, drenched in a thousand infidelities, faltered before the solid reality of the motorway embankments, with their constant and unswerving geometry, and before the infinite areas of the car-park aprons.'

 Crash was filmed in Toronto, perhaps correctly because the London of Ballard's selective imagination has nothing to do with a London of reality. That said, *Crash* could still be remade in London as a mini-DV epic. As the book was an underground work there remains a space to do the same for the film.

A Bigger Splash. Jack Hazan's quasi-documentary of David Hockney's life in Notting Hill in the 1970s contains footage of a recognisable, everyday London more memorable than the one shown in *Absolute Beginners*. It manages to make over-familiar London locations such as Kensington Palace Gardens look interesting, even magical.

Blow-Up. What the late Raymond Durgnat called Michelangelo Antonioni's cold, muggy style was well suited to London. *Blow-Up* remains interesting for David Hemmings' spiffy white jeans and its locations. Few films have matched this in capturing the essential mystery of London, notably in the use of Maryon Park in Woolwich. There is a sense of London seen, which is rare. For a film about the metropolitan phenomenon of Swinging London, *Blow-Up* is notable for its use of suburban locations. Seen now, it can be read as a film about development, not only in the chemical photographic sense, but also in terms of prospective real estate: an up-market estate agent's glossy brochure, with locations anticipating the loft developments of the 1990s, notably Hemmings' studio which in terms of today's real estate I would price somewhere in excess £1.8 million given its Notting Hill location. Iain Sinclair has noted how Bram Stoker's *Dracula* anticipated the London property market with the Count buying up cheap housing. You can argue that *Blow-Up* works best as a vampire movie, as a piece of undernourished necrophilia, in which characters barely remember the details of their lives. There's the exchange at the end when Hemmings meets the model Verushka at a party and says, 'I thought you were supposed to be in Paris', to which she responds with unanswerable logic, 'I am in Paris.'

Borges, J-L, writer, who gave this chapter its title. 'I saw a tattered labyrinth (it was London).' Borges' remark reflects on the city's unknowableness, being so vast, and its interior quality. Most of the London films that come up in this piece are notable for being set indoors. It may sound facile to say this but they are the opposite of westerns, being interior, and the opposite of expansive. Most London films I've looked at again are about acquiescence. Whether this is a symptom of the city, I'm not sure, but we have a young foreign woman succumbing to madness in South Kensington; a gangster undergoing existential crisis holed up in Notting Hill; and a young toff being undermined by his manservant in Chelsea. In all these films it's a relief to get outdoors. Given Borges' description, perhaps the only way to show the city is as a montage using material from multiple sources. In itself, London is probably uncinematic because it's too clotted, literally and metaphorically.

Carfax. This was the location of Count Dracula's English estate, in Purfleet just to the east of where the M25 now runs. The location can be traced through the Anglo-Saxon church mentioned in the book. The other features of the landscape were the lunatic asylum and Dracula's abbey. The church is important and will feature again at the end of this A–Z.

Colonialism. Both the Americans and Germans have recognised the power of cinema as a vehicle for propaganda and I have no doubt that future civilisations will look back at American cinema as a primarily colonial tool. Britain missed out. Had the movie camera been an early rather than late Victorian invention, the English would have made use of it in the same way; or maybe not. Innate British conservatism would probably have treated

the movie camera with suspicion, refused to have invested or seen it for what it was. English cinema has always been in a state of post-colonial crisis.

Coutard, Raoul. Cinematographer, French. Film is a battleground Samuel Fuller said in *Pierrot le fou*, shot by Coutard, a veteran of Vietnam. Coutard stole images like no other cameraman. By steal I don't mean Jean-Luc Godard's plagiarism, I mean shot with a sense of speed and urgency that gives Godard's films their lungs. Breathless, indeed. London deserves more Coutards. English filmmaking remains a bureaucratic exercise. A major problem of British cinema is the high command entailed in most productions, with all its divisions and emphasis on orders being passed down, with further emphasis on clarity of instruction. In 1989 I made a drama for the BBC – *Miss Marple, A Caribbean Mystery* – and overheard the cameraman saying in withering tones to his assistant, 'Sir wants the camera over there.' To be addressed as 'sir' – but always with enough of a pause to suggest the insolence withheld – sums up a lot of what was wrong with the industry. It was cumbersome, insecure, bullying and reminded me of nothing so much as a boarding school I attended between the ages of 8–13. That tone still exists.

Durgnat, Raymond. English film critic, Swiss born, suggesting that the foreign eye sees more. Author of *A Mirror for England*, by far the best contemporary account of British cinema, first published 1970. I suspect the great unspoken debt owed by David Thomson, author of *A Biographical Dictionary of Film*, is to Durgnat. He's undeservedly forgotten. His students once reduced David Hare to tears.

East End, and certain postwar writers including Bernard Kops, Wolf Mankowitz and Alexander Baron. Baron's *The Lowlife* and Kops' *The World is a Wedding* worked the East End/West End shuffle. Harold Pinter escaped by taking the same material and turning it into high art. What Baron and Kops represented was undervalued by cinema though Baron worked regularly in TV, adapting classics for the screen. Mention should be made of *Espresso Bongo*, from Mankowitz's short story and, more interesting, *The Small Sad World of Sammy Lee* starring Anthony Newley.

The Face on the Cutting Room Floor. This was a bizarre murder novel set in the prewar Soho film industry, with a film editor as unreliable narrator and murderer. A profound oddity, quite unfilmable. It was written under the pseudonym Cameron McCabe, in reality a German *émigré* named Ernest Bornemann, who wrote London novels under his own name and was a jazz critic for *Melody Maker*. Michael Powell's film *Peeping Tom*, with its sadistic play on cinematic voyeurism, is probably the closest cinema has got to *The Face on the Cutting Room Floor*.

Focus Pulling. This is a greatly underestimated technical accomplishment and the responsibility of the camera assistant. In *Repulsion* focus is often pulled from a wide shot of Catherine Deneuve walking through London locations to a close-up of her blonde hair, which clearly obsessed the film's director, Roman Polanski, and all the time while the camera is tracking the actress who keeps walking. There are half a dozen shots in the film that must still reduce the focus puller to sleeplessness just thinking about them, including the final shot which pans away from a two-shot, that includes a close-up of the

traumatised actress's catatonic eye, pulling away around an abandoned room moving across various objects, including a close-up of a mantelpiece, across the floor, noting biscuit crumbs (in focus), and up to a photograph of the character as a child, ending on a big close-up of her eye in the photograph, and all this in the days before Steadicam. In *Peeping Tom*, you may remember, the central character and murderer is a focus puller and in one scene he is shown measuring the different focal lengths for a shot.

Hamilton, Patrick. Author of *Hangover Square* and *Rope*, both filmed by Hollywood but unrecognisably, backdating the former's prewar setting to Victorian melodrama. His hit play *Gaslight* was filmed twice, first by Thorold Dickinson then by George Cukor in Hollywood, but Hamilton belongs to a group of writers misused or ignored by British cinema. *Hangover Square*, a story of hopeless sexual obsession, set in Earls Court and, like *Peeping Tom*, inhabiting the fringes of the film business, is one of the great London stories never filmed. As is *The Midnight Bell*, set in a pub off Warren Street, a cautionary tale of drink and reckless spending (in fact since done by television, respectfully and drearily). Another well-known writer prettied up by cinema is Jean Rhys, whose *Voyage in the Dark* is another fine London novel. Hamilton and Rhys wrote of a *demi-mondaine*. Several lesser-known contemporaries working in the 1930s, influenced by Ernest Hemingway and American pulps, also were ignored by cinema. James Curtis's *They Drive by Night* was filmed but *There Ain't No Justice* and *The Gilt Kid* weren't, nor were Robert Westerby's *Wide Boys Never Work* and Robert Greenwood's *Only Mugs Work*, both about a vivid London lowlife. More recently I would cite Derek Raymond's police *Factory* series as an example of tough metropolitan writing that hasn't made the screen in this country. In France, yes. Raymond was adapted by Chabrol. Here, no.

Kersh, Gerald. Author of *Night and the City*. Kersh was a prolific, now forgotten novelist. *Fowler's End* is an important neglected London novel, as is *Night and the City* filmed in 1950. Durgnat notes the importance of a generation of Hollywood exiles on British cinema, notably Joseph Losey and, in this case, Jules Dassin, who viewed London's underworld with an expressionist eye, avoiding, as Durgnat said, 'the neo-realism for which critics looked in vain, but [capturing] something of the visionary sadism of Gerald Kersh, an author whose brutal best-sellers have understandably frightened producers'.

Kilburn. In the early 1980s I lived off the Kilburn High Road and one week a film crew took over the street to film Pinter's *Betrayal*. For the adulterous lovers' flat they used the equivalent to the top floor room that I worked in. In terms of electrical cabling it was like a giant squid had taken over the street. The clumsiness of this invasion was out of all proportion to what was finally shown in the film. Even in the couple of establishing shots made they managed to misread the area. Does that matter? Yes, actually: because everything that followed seemed false and the film lacked the confidence to transform those locations into an alternative reality.

Location (film crews). I briefly lived near the British Museum and on most days the whole of the length of the street opposite the museum was taken up with film crew vehicles. You know from the scale of the thing and the look of the donuts – there's always a table of donuts – that whatever they're shooting is going to be no good, because of all that

energy that has gone into sorting out the parking permits. By contrast, it is worth looking at US cop shows like *Homicide* and *The Shield*, both of which make extremely good and cinematic use of their Baltimore and Los Angeles settings, while presumably being hampered with the usual problems of teamsters and union crewing. Both are turned around in little more than a week and *The Shield* in particular features a lot of first-rate street work. Watching most London films, you sense we haven't learned how to shoot locations yet.

London Orbital or the M25. I made a film about this motorway and the question is where do you begin given that there's no beginning or end? We began in a sandstorm in the Californian desert, which seemed as good a place as any. I pass on a remark made by a Hungarian Minister of Transport who said there's nothing wrong with the M25, except that it doesn't go round Budapest.

Look at Life. This was a 1950s documentary series shot in colour: Belisha beacons, empty streets, shop fronts. As a child, these shots were as exciting as the credit sequence of *The Sopranos* today because they documented a suburban experience ignored by cinema. This struck me as quite extraordinary at the time, given that these areas were generally considered to be off any cultural map. *Look at Life* twinned with black and white murder investigations presented by Edgar Lustgarten, notable mainly for endless shots of old Scotland Yard, potently suggestive photographs of murder sites and Lustgarten's bogus authority.

Negative Space. This is a book of film writing by the American painter Manny Farber which, for my money, has always proved the most rewarding writing on cinema because Farber really sees film – with an eye – in terms of its component spaces and not as narrative. Writing around 1970, Farber argued that space was the most dramatic stylistic entity in Western art, seldom discussed in film criticism. To quote: 'There are several types of movie space, the three most important being: (1) the field of the screen, (2) the psychological space of the actor, and (3) the experience and geography the film covers.' I would argue that instead of space most London films offer location and rhetoric.

Occupation, as in military. It helps to have been occupied. Being blitzed isn't enough. There's no doubt a capital's cinema can be helped by enemy occupation. The cinema of Jean-Pierre Melville and the Parisian New Wave immediately after was in direct response to that occupation and gave those films a very strong sense of city as character, city in character, and identification with place. The Parisian films of Jacques Rivette offer an interesting reverse of the usual process: Paris is made the foreground, against which the action appears almost incidental. Rome too should be noted in that *Rome, Open City*, made in immediate reaction to its Nazi Occupation, was a cornerstone of neo-realism. We have no equivalent to these films.

Paris. This follows on from above. I would argue that Parisian cinema is inclusive. You get a real sense of Paris through what you see and what's shown. London is the opposite. It's exclusive both in the sense of its class structure and what we're not shown (which is often more interesting). London is essentially a secret and secretive city, so, on that level, we can't expect it to be all revealing. Parisian cinema, by comparison, thrives on recognising

the familiar and filming what's there. But in London this translates into heritage or real estate. There is no definitive London film.

Performance. Like *Peeping Tom*, *Performance* is a cul-de-sac film, which looked like it was about the beginning of something but in fact marked the end of a period. It's quite hard in cinema to get properly punished and Orson Welles was right when he said most directors don't get found out, but it's astonishing looking at *Peeping Tom* now to think it pretty much finished Powell's career. And Donald Cammell never really got over *Performance* and he worked only erratically after that. Both *Peeping Tom* and *Performance* are more interesting now for their associations and references than as dramatic entities.

Queens and Queers. Derek Jarman's *Jubilee* offers the best marriage, plus a sense of London grubbiness. Mention too should be made of Dudley Sutton in Sidney J. Furie's *The Leather Boys*, mentioned by Farber in *Negative Space* as being the best thing in the film, playing his part of a homosexual with 'real old-fashioned elegance, like a bit player. Compared to this, Rita Tushingham plays her lower-class sex kitten with a wild inappropriateness which might look better in a comic strip than in a movie.'

Repulsion. In his book on London, *Soft City*, Jonathan Raban makes reference to that loneliest of city sounds, lying alone listening to someone else's lovemaking: 'I am woken in the small hours,' he writes, 'by the sound of a girl achieving her climax; a deep shriek of pleasure that has nothing to do with me. I can hear her man sigh as close as if he and I were under the same sheet.' *Repulsion* features such a scene which is notable for its authenticity, in that the sounds are clearly not faked. We can only assume Polanski persuaded someone to record themselves for use in the film. The mystery comes at the end of the scene when the woman in question says her lover's name, Frank. But the character she's in bed with in the film is called Michael, which leaves the big question: who the hell was Frank?

Robinson. Written at the end of the 1980s, published in 1993. It was about Soho, the film business, emotional vagrancy, weather and a pornographic element that I thought would prove part of Margaret Thatcher's commercial legacy (and I was right). It was written as a prose film. I wanted to write a book that would have been impossible to write without cinema. At the same time I didn't want the book to be an audition for a film. In fact, I wanted to write something that couldn't be filmed (and so far I've again been proved right).

The Servant: again like *Perfomance* and *Repulsion*, undeniably a London film but again an indoors affair. I like Losey's films for their combination of exile and indolence.

Soft City. Jonathan Raban makes the important point that most people's response to London is to turn it into a superstitious city, marked by individual boundaries. Raban would argue that we are all psycho-geographers in that we all carry different maps of the city in our heads. Thus Iain Sinclair's London rarely connects with mine: in our own personal game of cultural Monopoly he traded me inner city Whitechapel for the North Circular, Ikea and the retail parks that were at the time unknown territory to him.

The Sorcerers. This was a Michael Reeves film set in Notting Hill, interesting for the question of dating films. It exploited the new permissiveness of the Sixties while in look and feel resembled something from the decade before, showing how in reality things catch up much later than you think.

Studios. In his book *London Orbital* Sinclair noted how the city's lunatic asylums anticipated the path of the orbital motorway. Ditto its film studios, representative of another kind of madness.

Surrealism. London is a strange unmatched combination of the mercantile and the surreal and of all writers Ballard has probably got closest to understanding this. Alain Resnais once had plans to film the surreal detective novels of the Belgian writer Jean Ray which he wanted to set in London as it was, according to him, the most surreal city he knew. For English cinema, there is a problem because surrealism in this country was pretty much annexed by comedy in whose preserve it remains. In this respect Cambridge has a lot to answer for, being responsible for Monty Python and all the rest. In terms of contemporary London, it is now a city of too many comedians and too many chefs.

Surveillance. I'm amazed by how much of London remains unshot, which is a tribute to the scale of the place. I made a film ten years ago entirely from surveillance camera images, partly because of their nostalgic quality, their uninterrupted sense of place and ordinariness, which recalled the Lumière brothers and the beginning of cinema; also because these cameras offered the first take of a post-human cinema, diaries made by machines. Images shown on screen in Morans builders and decorators in Kilburn High Road struck me as more authentic than anything we were shown of Kilburn in *Betrayal*.

Tanner, Alain. Swiss director. He made a little-known film on London by night shot around Piccadilly, called *A Nice Time*: just black and white shots of crowds in the streets, which is very effective as a catalogue of faces and expectations, and it had a real film rhythm. It's a kind of anthropological masterpiece.

Underground. A main component of city life, except for years no permission was given to film on it except at Aldwych station. Lack of official co-operation inevitably affects the way a city is seen on screen. Take, by contrast, Melville's *The Samurai* whose central set-piece is a long and elaborate and very precise tailing job in the metro, which would have been impossible in London. There are exceptions. A John Landis film closed down Piccadilly Circus for a car chase and a late John Wayne picture used Tower Bridge for a driving stunt, but these were expensive American films which purchased the impossible and did little with them.

Weddings as in Four and a Funeral. To go back to (1) that Anglo-Saxon church mentioned at the beginning and (2) the remark about what's not shown being more interesting than what is. *Four Weddings and a Funeral* used this church for its funeral. If you go to the location, what's interesting about it is what the film doesn't show. As you stand looking at the church, on the left is an enormous industrial box, a huge windowless, Donald Judd-type storage warehouse, completely of a different scale to the church. The exterior is

CITIES IN TRANSITION

colour-graded in different shades of blue to grey which gives this huge shed the feeling of a work of art. If you set up a competition asking people to guess what the building on the right was I doubt if anyone would even get close. It is, in fact, like the perfect operatic set for *Dracula*. The box is the asylum and on the right is the Proctor and Gamble soap factory that resembles a Richard Rogers version of Dracula's castle, except much better than anything by Rogers, a flaming red piece of post-industrial Gothic, with pipes and towers and smoke — suspiciously white smoke. It's changed recently because the immediate landscape which used to be overgrown with thorny bushes has been covered in tarmac. It is really one of the most extraordinary and dramatic London locations. I've always wanted to do a remake of *Dracula* using these three settings. And it's typical that when the location is used in a film it's framed in such a way to exclude those elements that make it so dramatic and unique.

Zevon, Warren. American singer, dead, who wrote the song *Werewolves of London*, which suggests that life in London is at best a posthumous experience. Which throws up a suggestion of what is often wrong about London cinema: it belongs to a past tense. Like much of English cinema, it lacks vision.

INDEX